AMERICAN PAINTING
from the Armory Show to the Depression

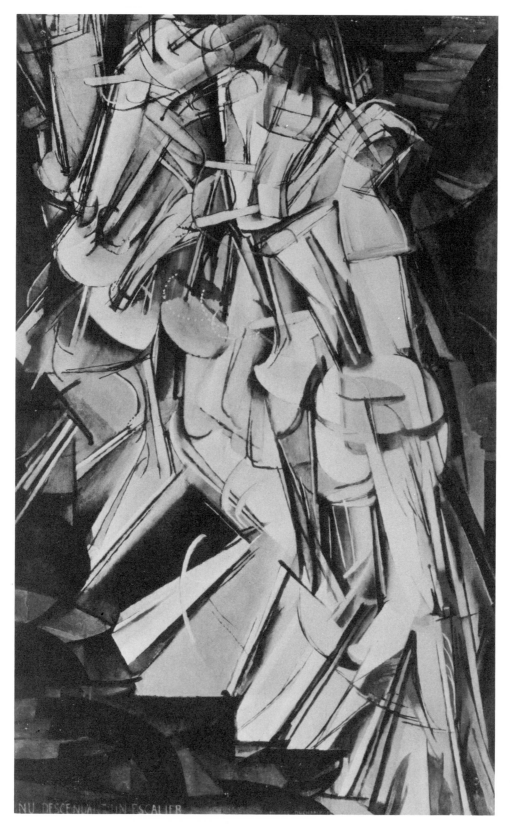

Marcel Duchamp, *Nude Descending a Staircase No. 2*
The Louise and Walter Arensberg Collection, The Philadelphia Museum of Art

AMERICAN PAINTING

from the Armory Show to the Depression

By MILTON W. BROWN

PRINCETON UNIVERSITY PRESS

PRINCETON, NEW JERSEY

COPYRIGHT © 1955 BY PRINCETON UNIVERSITY PRESS

L. C. CARD 53-10147

I.S.B.N.: 0-691-00301-7 (PAPERBACK EDN.)

I.S.B.N.: 0-691-03868-6 (HARDCOVER EDN.)

PRINTED IN THE UNITED STATES OF AMERICA

FIRST PRINCETON PAPERBACK PRINTING, 1970

SECOND HARDCOVER PRINTING, 1970

Preface

THE research and writing of this book, which was interrupted by military service during World War II, was begun more than a decade ago. Because of a lamentable dearth of scholarship in the area of American art, I was faced from the very beginning with the problem of reconstructing the history of a vital period in our culture out of a wealth of uncatalogued material—the works of art themselves in original and reproduction, catalogs of exhibitions, journalistic reports, contemporary articles, and eyewitness or participant accounts either set down for eternity on the printed page or passed on informally in verbal interview. The spadework on individual artists and specific events, which should be the grounding of a larger synthesis such as this work is intended to be, had not been done except in a very limited sense and even today is far from complete. However, in more recent years the literature on individual artists has happily been increased by several monographs and especially by the exhibition catalogues of the Whitney Museum of American Art and the Museum of Modern Art. In many cases these have duplicated my own work and gone more completely into specific phases of the period than was my original intention. I have attempted to include these more recent investigations of my colleagues within this field, but the major purpose of this work is the recreation of the total period, in which individual artists played their relative parts.

The extended period of time taken in the completion of this work makes it almost impossible for me to remember and thank by name the many people who by great and little favors, advice and information have made this book possible. In the course of my research, I visited most of the museums in this country, the staffs of which, by offering me free access to their files and stacks and by answering innumerable questions, have been kind and helpful. I have also been granted many favors by private collectors, practically all of whom have been graciously cooperative. To all these people and institutions too numerous to mention, I should like to tender a blanket but sincere thanks.

I am especially indebted to Paul J. Sachs of Harvard University and the William Hayes Fogg Museum of Art for the grant of the Fogg Museum Fellowship in Modern Art under whose auspices and support this work was begun. My heartfelt thanks go also to Dr. Walter W. S. Cook of the Institute of Fine Arts, New York University, for his constant moral support and encouragement, and to Dr. Walter Friedlaender of the same institution for advice and sympathy; to Dr. Robert J. Goldwater of Queens College for considered criticism freely given during the preparation of the book; to Lloyd Goodrich of the Whitney Museum of American Art and Elizabeth McCausland who read the completed manuscript and offered many valuable suggestions. They are, however, all absolved from any complicity in the matter as it now stands.

I would like to express my gratitude to the following libraries and photographic collections and their staffs—The Frick Reference Library, The New York Public Library, The Metropolitan Museum of Art Library, the Museum of Modern Art Library, as well as the American Art Research Council.

I am obliged also to the various museums, institutions, art dealers, collectors and artists who have helped me in tracing and obtaining photographs and who have granted me permission to reproduce them.

And lastly, but most profoundly, my thanks go to Margot Cutter, formerly of the Princeton University Press, whose interest in the manuscript helped make its publication possible, and to my wife who was a constant help in all stages but most especially in undertaking the tedious job of getting the original manuscript, the notes and the bibliography into shape during my army service.

Introduction

THE dates 1913 for the Armory Show and 1929 for the depression mark the limits of an important phase of American art. Like all such dates, they are somewhat arbitrary and in any case only approximate, but they do delimit that period in American art during which the influence of what is commonly called "modern art" made its first impact felt in this country. It was a period in which newer concepts of art developing in Europe displaced an older tradition of "realism" that had established itself in America in the first decade of this century.

However, the choice of these two dates raises an immediate question beyond those of the arbitrary and the approximate. The former, 1913, is an "artistic" date, the latter, 1929, an "economic" one; one the date of the Armory Show, the other the date of the stockmarket crash and the beginning of the depression. If one is to consider the history of art as a part of cultural history, then the significance of a purely artistic date such as 1913 comes into question. On the other hand, if one is to consider art as an autonomous phenomenon, then 1929 may appear puzzling.

Art is obviously not always a direct and simple reflection of society or of social events, but no matter how purely esthetic the result, it remains always a social phenomenon. Modern art, therefore, no matter how far removed it may appear from what we consider social reality, is still possible only within the context of a specific social climate. The Armory Show, though it may appear to be an historic accident, achieved importance only because conditions to a very large extent had been prepared for it by a decade of revolt, social as well as artistic. The painting subsequently produced in America under the influence of the modern movements in art had no simple, direct relationship to economic, social or political factors. There was in it, with only minor exceptions, no evidence of war, postwar depression, prosperity, industrial expansion or impending catastrophe. It is true that the aloofness from social events, the immersion in esthetic introspection was itself the result of certain historical conditions, but there is no denying that this aloofness did exist. Indeed, a fundamental characteristic of modern art is just this schism between art and society.

The stockmarket crash of 1929 and the depression which followed was a cataclysmic economic event which affected social relationships and consequently the relationship of art to society. It transformed American art. It shocked the American artist into an awareness of the times and inadvertently dragged the national government into the reluctant role of art patron; in the first instance inclining the artist to public rather than semi-private communication and in the second instance offering him an institutional function within society. Both factors led to the rediscovery of a broader public base for art and the development of new formal idioms through which a new content might be more broadly understood. The crisis of 1929 brought to an end a significant period of American art, a period which was important in its formative influences and rich in artistic production.

This study is concerned with the origins, nature and development of modern art movements in this country and their interaction with the already established tradition of realism. It is concerned not only with this struggle of styles but also with the relationship of these artistic developments to the changing social conditions which determined them.

Contents

Illustrations

xi

Revolt

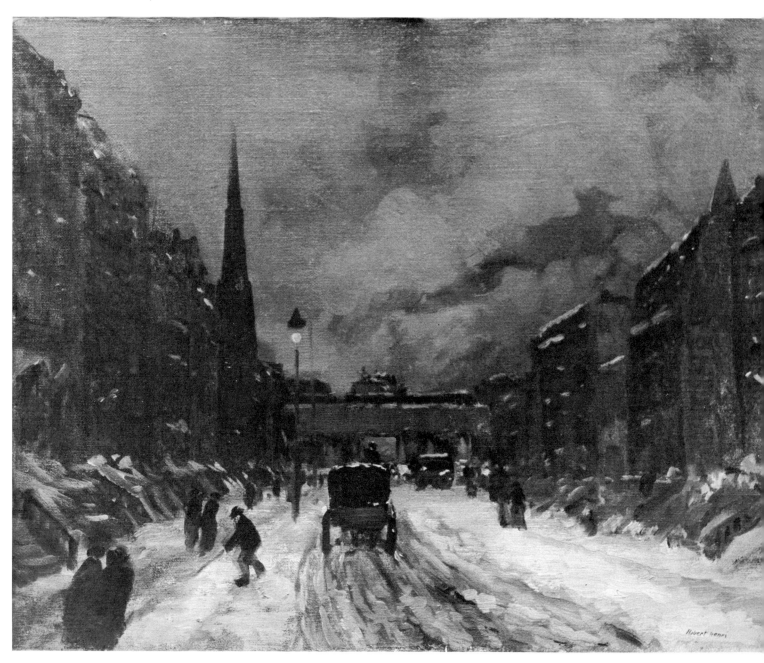

Robert Henri, *West 57th Street in 1902*. Courtesy of the Mabel Grady Garvan Collection, Yale University Art Gallery

◈ BACKGROUND

DURING the first decade of the twentieth century, American art was brazenly flaunting its delusions of grandeur. The impulse which had activated it briefly in 1877, when the Society of American Artists had split from the old Academy of Design in New York and a year later held its first exhibition, was strengthened by the first exhibition of French Impressionist painting held in America in New York in 1886. But the movement never really attained any importance and finally died in 1906 when the Society of American Artists, having grown gray in its conservatism, reamalgamated with its parent body to become the National Academy of Design.

At the pinnacle of American art during this era was the group known as "The Ten"[1] which combined the genteel school of Boston genre painting of Edmund G. Tarbell and Frank W. Benson, the more "radical" Impressionist stream of John H. Twachtman and Childe Hassam, and the academic tradition of William M. Chase. In that roseate atmosphere of inflated self-confidence every academy exhibition was hailed as an advance over that of the previous year, although, in reality, each was a dull repetition of the preceding. We boasted pridefully that our landscape school was the best in the world, when it was only a belated echo of the long-dead French tradition of Barbizon painting. The artists who went abroad to study in the various Parisian ateliers came in contact with and absorbed the formularized and lifeless art of the French Academy, of Laurens and Gérôme, apparently oblivious to the portentous developments which had occurred and were still occurring in another realm of French art. Comparing themselves as they did with European academicians, they were not unjustified in judging themselves the equals of what they considered the best that Europe had to offer.

America was impressed by the glamor of its most recent artistic heroes of the late nineteenth century, painters like George Inness, Thomas Dewing, John La Farge, George Fuller, Homer D. Martin, Alexander H. Wyant, Abbott H. Thayer, and George de Forest Brush. Added to these were the renowned expatriates, whose reputations were considered with some pride. James McNeil Whistler's fame as a pugnacious iconoclast, John Singer Sargent's amazing international success, Mary Cassatt's stature as an equal among her French colleagues seemed only further to establish America's artistic maturity. That Whistler and Cassatt had forsaken their heritage for another was more a proof that there were no national boundaries in art than that our own culture was too narrow for their comfort.

Although many of these painters lived and worked into the twentieth century, a new group, dominated by the facile brushwork of Chase and Frank Duveneck, deriving from Manet and Munich, and the Impressionism of Twachtman, J. Alden Weir and Hassam was in the ascendancy. The older men had already been relegated to the realm of tradition. At the same time, opposed to these newer Impressionist tendencies stood such pseudo-classicists as Edwin Blashfield and Kenyon Cox who lived on the borrowed magnificence of the old masters and considered the newer men superficial and formless. Academic honors were showered upon such perennial prize winners as Edward W. Redfield and Charles W. Hawthorne who had contrived to assimilate all the technical tricks guaranteed to bring success. American art was led by an array of technically proficient nonentities.

Of the now greatly revered trinity of American art, Winslow Homer, Thomas Eakins and Albert P. Ryder, still working at that time, only Homer had achieved official recognition. He had, however, long since retired to Maine to paint in solitude. Albert P. Ryder, the recluse, found a hermit's cave in New York City where he painted for himself alone, disregarding even posterity. Thomas Eakins, in virtual isolation from the art world, having already fought his battles against the provincialism of Philadelphia, painted also for himself, and whatever effect he eventually had upon American art came second-hand through his faithful disciple, Thomas Anschutz, that tireless teacher and deacon of the realist movement. Then there was Ralph Blakelock, who spent much of his life in an asylum, driven to insanity by poverty and the callousness of dealers, a tragic symbol of our artistic blindness. Denied the solace of a peaceful oblivion, he was "rescued" in his old age, a doddering shell, and exploited with crass vulgarity to boom the suddenly discovered market for the paintings of his bitter years of sanity. For years Louis Eilshemius battered to no avail against the portals of academic recognition, only to be discovered after the honors he sought had themselves become meaningless and his mind had moved into a realm of fantasy where belated recognition had no significance. Meanwhile, painters like Cecilia Beaux, Edward Redfield, John W. Alexander, and Leopold Seyffert, to name only a few, were commanding stiff prices and receiving academic honors.

Academic thinking was permeated by two apparently contradictory concepts—tradition and progress. Our academicians thought of progress as an extension of the tested virtues of the past. The new concepts of science which were revolutionizing our ways of living and thinking merely served to bolster their own special notion of progress. What had previously been only an empirical faith in tradition could now be transformed into a series of "scientific" principles. Artistic "science" to them was the discovery, through a study of the past, of immutable laws which must inevitably lead to a higher and greater art, a reasoning which is after all the common rationale of all academies. In twentieth-century America it served at worst to bolster the arrogant narrowness of the academician who could now substitute the word science for dogma, thereby accepting progress while denying no scrap of tradition. At best, if one can call it so, it led more intrepid and questing minds to the espousal of pseudo-scientific doctrines.[2]

Artistically, the academy was an agglomeration of many tendencies. It included disciples of the Barbizon school of landscape painting, slick portraitists in the tradition of Sargent and Chase, remnants of the Düsseldorf genre school, the brush wizards of Munich, students of the bastard style of French academic painting, Impressionists, the American proponents of the grand manner of classicism and Renaissance painting, and the various eclectic combinations and permutations of all these tendencies. Its standards of judgment were technical proficiency and conformity to some acceptable tradition, a scheme of things which unfortunately left little room for a vital art. No period in our art history was as self-satisfied, and with as little reason.

Organizationally, the academy was just as great a brake upon American art as it was artistically. Its self-perpetuating membership contrived to stifle all nonconformism through a rigid system of election of members.[3] Such honor was conferred as a reward for compliance with its standards. The letters N.A. were to most artists a mark of distinction. In a country where art was not a highly regarded activity, where it was in fact often suspect as dilettantish, unproductive and even unmanly, the academy offered the artist a measure of self-esteem in relation to other professions and at least some designation of acceptance among his colleagues. Many an artist could, perhaps unconsciously, forget ideals and accept the standards of the academy, for mem-

bership in it meant not only honor but also sales.

The market for American art was at this time restricted, the dealers were handling either old masters or the recognized academicians. The many new museums and the large number of collectors, even though their taste was improving and they no longer bought fakes and copies with their former abandon, were still not primarily interested in American art, or, when they did buy, were guided by established academic reputations, accepting the acclaim of the academy as synonymous with the acclaim of time. On the whole, with but few exceptions, the great American collections then being formed ignored native art.

There were few free artistic forums where an unknown or unconventional artist might be heard. The major art markets or publicity channels for art were the academy exhibitions. There were several academies in America at that time—in New York, Chicago, Philadelphia, and Boston. The New York academy, which called itself the National Academy of Design, had pretensions to recognition as a national institution, which it never saw fulfilled. By prestige, however, it was the recognized "Academy" and its exhibitions, together with the "Carnegie International" exhibits sponsored by the Carnegie Institute in Pittsburgh, were the leading national artistic events. These exhibitions were ruled by the twin evils of the "jury" and the "white card." The academy jury by its very composition tended to accept only what would pass the muster of divergent opinion, so that, like a compromise candidate in politics, the least controversial rather than the best available material was chosen. Even the faintest departure from the norm was sure to find some opposition and, consequently, rejection. The white card on the other hand permitted the hanging unjudged of several hundred members' pictures. Because the space remaining was limited, usually less than a hundred pictures were picked by the jury from the hundreds submitted by competing artists throughout the country. The younger artists were consequently faced with fierce competition in which they could hope to prevail only through conformity with accepted standards. Thousands of American artists, harried by the struggle for recognition, spent years painting pictures which might eventually lead to the coveted A.N.A. and finally the N.A., after which they might relax and paint without fear of competition. By that time, unfortunately, most artists could paint only academic pictures.

Discontent among the younger men was constant,

but confined to a discontent with the white card system as a restriction of competition. Whatever revolt existed was as yet directed against the organizational restrictions and not against the artistic principles of academic art. All they asked was a fair chance with their peers. The Academy itself answered this discontent with the excuse that it lacked space and used that argument to further its own plans for larger quarters and national recognition. It argued that larger quarters would give every worthwhile artist in America a chance to show at the Academy. National recognition would, in the hope of the Academy, place the mark of final authority upon its judgments. This aim was never achieved. Discontent was forced to seek other avenues of expression and the younger artists in America fought and finally achieved recognition through the expansion of non-jury exhibition facilities.

Throughout the twentieth century, the Academy has been completely out of step with the major currents in American art. It took its stand foolishly but foursquare against the course of history. And as the years went on it stood more and more isolated, more and more in disrepute until its name has become in time generally accepted as a term of reprobation.

The Academy, which in spite of its eminence, itself suffered neglect, was but another expression of American culture in the last decades of the nineteenth century and the first decade of the twentieth, a culture so provincial and philistine in character that it could not encompass such figures as Henry James and Isadora Duncan, Whistler and T. S. Eliot. They and many like them sought refuge in more congenial environments and there can be no doubt that this siphoning away of some of our best talents was a loss to American life.

The "Renaissance" in American letters and American art during the early years of the twentieth century was the work of those younger men who stayed here and fought provincialism and puritanism. These were the men who made up our realist tradition both in literature and art, the growth of which was the artistic expression of a general upheaval of the times.

The nineteenth century in the civilization of the West has been called the wonderful century, the century of science and liberalism. The twentieth century, on the other hand, has been labeled the century of disillusionment. The truth of such a designation of course is dependent upon the acceptance of nineteenth-century values. And from this point of view, the first decade or so of the twentieth century in America rightfully belongs to the nineteenth, since the faith in enlightened progress, the promise and optimism continued. There was indeed a culmination of the ideal of progress which placed its faith in man's inherent capacity for infinite development. It seemed that no problem of nature or society was beyond possible solution; in fact, solution was considered imminent. Science was triumphant; observation, experimentation and increasing control over nature were dominant, and the amazing enlargement of creature comforts strengthened faith in its virtues and powers. This was an age of abundance and many men saw in machine production the solution to all problems. Henry Ford's industrial organization of mass production was to be the symbol and bulwark of this attitude. Even a large section of socialist thought accepted this vision of an ultimate utopia through mass production. Man looked with hope into the future. Together with scientific and productive advancement there seemed to be a broadening of personal liberty, an expanding democracy and a growing brotherhood of individuals and nations which, unfortunately, hid a deep-rooted international economic rivalry that would eventually prick this bubble with the First World War and usher in the "period of disillusionment."

The years immediately preceding the war were years of optimism and progress. Faith in science, in democracy, in personal liberty, in individualism, in the illimitable horizon of man's hope, permeated our culture.

It is from these sources that the art of prewar America of the twentieth century springs. There are in all many different currents, but each finds its source in some aspect of these cultural attitudes.

During the first decade, as a facet of such developments, America witnessed a concerted assault against tradition in all fields. As man looked hopefully into the future, he broke with the restrictions of the past. The concept of progress out of which this revolt grew had a dual aspect. The first was an uncritical faith in the potentialities of the country and its people. The second was a critical attitude toward the abuses of society, but always with hope for the progressive amelioration of such abuses. Faith in the vigor of a young crude country was complemented by faith in the ability of the people to solve its problems. While the more conservative groups in society accepted optimism as a natural expression of the growing power and wealth of the

country, the more radical elements in their hopeful search for a better world exposed current abuses and deficiencies. During this time, America passed through a phase of fundamental questioning. The home, religion, education, the homespun virtues, the ten commandments were all questioned. The teachings of Freud, for instance, helped to undermine the accepted Victorian standards of American life. It affected not only the field of psychology, but also the growing realism of our literature as well as our very way of life. In a similar manner socialistic ideas affected not only labor-capital relationships but the cultural tenor of the period. No traditional forms of behavior were safe from attack and many were attacked merely for being traditional. There was growing up in America a group of men who with youthful vigor and a liberal faith were questioning the very foundations of our society and it was in such an atmosphere that the American "Renaissance" took place.

All this delving was bound up not only with the concept of progress but also with its handmaiden, "science." The nineteenth century was a remarkable era of experimental research in the physical sciences. Toward its end and during the first decade of the twentieth century, the practical application of such physical research resulted in an amazing array of inventions which increased our creature comforts. In America, especially, with its expanding economy the translation of theoretical science into applied mechanics only increased the faith in science. However, this condition was not peculiar to the United States; science had become the dominant note in modern civilization. The term science as well as the attitudes it engendered became so pervasive that other fields even attempted to borrow its character. We heard then of "social science," "political science" and even the "science of art."

The great changes in American economic life in this decade were due to several factors. Such mechanical innovations as the gasoline engine and electrical power were the basis for new methods of production. The mass production methods of Henry Ford and the principles of scientific management of Frederick Winslow Taylor were revolutionary levers which dislodged older forms of production. They led inevitably to mass distribution and even to so-called "scientific" salesmanship. New economic forms affected culture in many ways; they led to mass-production education, mass-production journalism, and mass-production art. The great growth of newspapers and magazines together with the development of reproductive processes enlarged the field of commercial and journalistic art. The growth of short-story writing in America was, for instance, directly dependent upon the development of magazines, just as the entire field of commercial art was due to the immense increase in advertising. Whatever the ultimate value of the artistic results, we cannot ignore the importance of these new forms for American art. It is no coincidence that the great majority of the realists both in literature and in art had their start and developed their styles as newspapermen. The stamp of background is indelible. The cultures which produced Matisse and Picasso, Proust and Joyce, were far different from that which produced Dreiser and Sloan.

The very rapidity of economic advance threw the older traditions and institutions out of kilter. New attitudes grew up with new conditions. Among the more enlightened sections of society new ideas took hold. Revolt became the nature of the day. At the basis of all this revolt was the recognition by the lower middle class of America, the so-called backbone of American civilization, nurtured on individualism and still clinging to the ideals of Jeffersonian democracy, that the phenomenal economic growth of America since the Civil War had resulted in the multiplication and entrenchment of gigantic monopolies—railroads, steel, coal, oil—and that these trusts were extending and consolidating their power in political life. The great trusts, glutted with power and contemptuous of restraints, were acting with such callous disregard of the common good that the situation was brought sharply before the people. The restriction of unlimited economic power and the protection of the individual in relation to organized wealth became national questions. The lower middle class dusted off all its democratic and liberal slogans and went out to battle the dragon of "monopoly." And just as in any great battle of this sort, all the liberal tendencies of the time flocked to its banners; the struggle itself unleashed many new ideas, uncovered many new abuses, began many new reforms.

With Theodore Roosevelt bellowing not too softly and wielding his big stick, with the muckrakers exposing corporate power and political corruption, the impetus toward all kinds of reform was immeasurably accelerated. At the same time, American labor was growing more militant both on the economic scene with the growth of the I.W.W. and on the political scene with the increase in the strength of the Socialist Party. This unrest in both

the middle and the working classes intensified the many different social reform movements of the period, for social justice, against child labor, for women's suffrage, for direct elections, for the abolition of war, against white slavery, and many others. With the election of Woodrow Wilson in 1912, the ideals of liberal democracy and international amity were strengthened and reforms were pressed even more vigorously.

Intellectual life in America, at least in such centers as New York and Chicago, was in ferment. Out of the small towns and farmlands young people were coming to the havens of cultural freedom, the bohemias of New York, Chicago, San Francisco. In these cities, just recently infused with new waves of immigration, the standards of thought and behavior were not those of the American hinterland. In them new ideas were rampant, ideas which questioned the very basis of morality, religion, and philosophy. Economic, social, cultural, and moral questions were all mixed together in a mass of indistinguishable ferment and there were few who separated one from the other. They attacked trusts and sexual inhibitions; they fought for free verse as ardently as for free love. The social reformer mingled with the esthetic radical.

Bohemianism was at once a refuge and weapon in the revolt of American art. Bohemianism, as such, is a complex phenomenon with a long history dating back to the early years of the nineteenth century. It is essentially an intellectual revolt against the confines of established society, resulting in the creation of an intellectual community within the framework of that society but with a different set of mores and an antagonism toward those outside the community. The cause of this growth of a society within a society is basically the failure of the intellectual group to equate its own activities with social ends.

The desire to *épater le bourgeois* is the intellectual's gesture at concealing his own sense of futility, that sense of futility which is so persistent an attitude in modern history. Since the revolt is mainly cultural and is lacking in a coherent program of social, political or economic action, but is even, on the other hand, antisocial, it tends to produce revolt for revolt's sake or art for art's sake. To these bohemias gravitated all sorts of rebels who found a haven in congenial isolation, a common cause in revolt or a common enemy in the philistinism of the middle class.

In America those artistic adventurers who left the farms and small towns for the greater opportunities of the large city were drawn to the bohemian milieus of Chicago and New York which were centers of artistic activity. In Chicago gathered some of the leading literary figures of the day. There was first of all Thorstein Veblen, that eccentric, bitter, and brilliant critic of the middle class; Arthur Davison Ficke; Witter Bynner; Maurice and Ellen Browne, guardians of the little-theater movement; the novelists Theodore Dreiser and Sherwood Anderson; the poets Carl Sandburg, Edgar Lee Masters and Vachel Lindsay; and, a little later, Sinclair Lewis, Maxwell Bodenheim, Ben Hecht, Harry Hansen, Burton Rascoe and Gene Markey. The Chicago group was almost completely literary except for the Polish sculptor Szukalski, and was devoid of any strong political or social orientation. This new and exciting intellectual atmosphere centered around a long succession of clubs and groups such as the Vagabonds, the Questioners, the Players' Workshop, the Fabian Club, the Cheese Box, the Cliff Dwellers, the Dill Pickle, and the Mary Garden Forum. Out of this set came the realist novel with Dreiser and Anderson; the American poetry "Renaissance" with the magazine *Poetry*, edited by Harriet Monroe; and *The Little Review*, mothered by Margaret Anderson, which, in its anarchistic revolt, its catholic rebelliousness, and its cult of unintelligibility, is probably the best expression of the Chicago bohemia.

Eventually most of them migrated to New York, which offered greater literary opportunities. The New York bohemia, located in Greenwich Village, was much larger and more varied; it had an active artistic group—indeed, in the plastic arts the revolt was confined almost entirely to New York—and was as a whole more concerned with political and social revolt than was Chicago's bohemia. Chicago mirrored the grassroots optimism of the young West, while New York was dominated by the critical reformism which grew out of the struggle for economic power in the industrial East.

Mabel Dodge's salon at 23 Fifth Avenue served for a time to draw together these various elements on common ground. Under the inspiration and direction of Lincoln Steffens, Hutchins Hapgood and Carl Van Vechten, her evening gatherings became famous. People from all walks of New York's intellectual life came here to eat and talk. In Mabel Dodge's own words, "Socialists, Trade-Unionists, Anarchists, Suffragists, Poets, Relations, Lawyers, Murderers, 'Old Friends,' Psychoanalysts, I.W.W.'s,

7

Single Taxers, Birth Controlists, Newspapermen, Artists, Modern-Artists, Clubwomen, Woman's-place-is-in-the-home Women, Clergymen, and just plain men all met there and, stammering in an unaccustomed freedom a kind of speech called Free, exchanged a variousness in vocabulary called, in euphemistic optimism, Opinions."[4] What appeared to Mabel Dodge as an intellectual circus organized for her own entertainment was for some of its participants a deadly serious matter. Big Bill Haywood, Emma Goldman and English Walling discussed revolution. Andrew Dasburg, John Marin, Picabia, Marsden Hartley and Arthur Lee talked of form and the new art. Here John Reed and Walter Lippmann spread their wings. Here the Tannenbaum case and the Paterson pageant found sustenance both intellectual and financial. Mabel Dodge, in her frantic search to find vicarious life in others, had her hand in every movement from the Paterson Silk Strike to the Armory Show. Further uptown, "291," Alfred Stieglitz's little gallery, was an anchorage for the esthetic rebel. There were other less famous centers more concerned with political action. Mary Heaton Vorse's studio served as the headquarters for the I.W.W. during the 1915 bread riots. The Liberal Club was a meeting place of writers, artists, and social reformers and on its walls hung some of the first modern art in America. The magazine *Masses* became the intellectual center for these groups and opened its pages to artistic as well as social rebels. In all this activity bohemianism was confused with radicalism; but at the bottom of it all was a sincere revolt against the confines of outworn traditions and social injustice.

The radical artistic tendencies within this ferment grew out of two sources, the earlier being the native school of realism led by Robert Henri, which will be discussed next, and the later, the modernist movement emanating from Paris with Alfred Stieglitz as its first American prophet. The realists were the first, in the early years of the century, to challenge established authority in art. Paradoxically, although they themselves were social artists, they prepared the ground for the later efflorescence of the nonsocial tendencies of modernism which replaced their own short-lived period of realism.

George B. Luks, *West Side Docks*. Denison University Art Collection

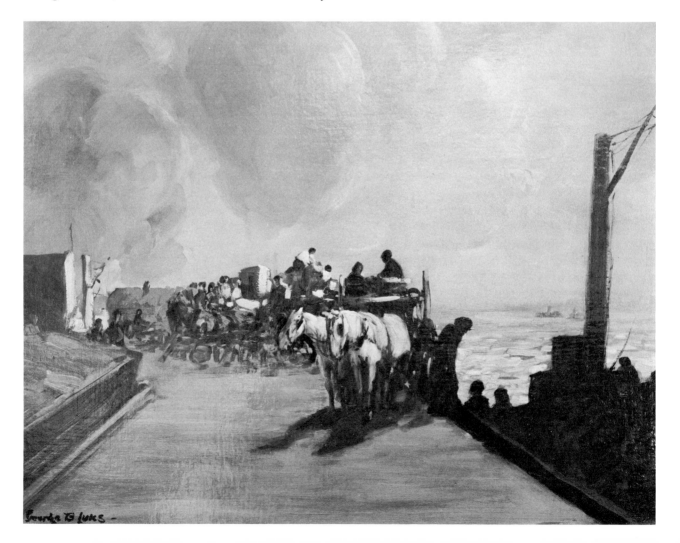

When Theodore Dreiser created the character of Eugene Witla in *The "Genius,"* he was describing with considerable accuracy a new and contemporary type. The earlier literary realist, Frank Norris, had also described an artist in *The Pit.* His Sheldon Corthell, an academic painter of the late nineteenth century, furnishes a sharp contrast to Dreiser's Eugene Witla, the realist of the early twentieth century. The cultured cosmopolitanism, the polished charm and suavity of Corthell are a far cry from the fevered vitality of Eugene Witla. In Norris' own eyes, Corthell is alien to American life, almost feminine in his sensibilities, a foil to the virile and ruthless masculinity of Curtis Jadwin, the financier and stock manipulator, hero of the novel. Corthell is alien in the sense that he is not concerned with the predatory struggle for power, the recognized arena of masculine activity, the basic condition of capitalist society, of which Jadwin is patently an exponent. The implication is that Corthell is not only weaker as a personality but somehow morally inferior. His interest in art, in beauty, in taste, in things which are completely foreign to the American man, in some evil way, it seems, can tempt the American woman to forget the accepted virtues and stray from the sacred precincts of the home. Here, as in *Main Street* of the twenties, culture is the concern of women; men have more important things to do. Eugene Witla, on the other hand, is much like Curtis Jadwin in his vitality and ruthlessness. Although in his position as an artist he may be foreign to American life, as a personality, in his aggressive vigor, he is part of it. Unlike Corthell he is more interested in the panorama of life than in the timeless values of art. He is not a man of means and established reputation, but an iconoclast fighting for recognition. If one disregards the amorous and financial complications in which Dreiser has involved him, Witla is obviously a composite picture of the artistic realist. His rather sketchy artistic education, his work for newspapers and magazines, and his eventual concern with art is the skeletal story of many of the realist painters. With passionate directness he wants to paint the truth, the people, the facts of life. He is scornful of tradition and rules, having sublime faith that if he can express what he feels so deeply he will be producing art, even though it deny recognized standards. His is a personality which is anxious for experience, contemp-tuous of conventions, naturally breeding revolt. It was men like Witla, a new generation of realists, who jolted American art out of its complacent acceptance of academicism.

The living counterparts of Eugene Witla are to be found in that group of realists which began its activities in Philadelphia in the early nineties, under the aegis of the great white knight of American art, Robert Henri. When Henri returned from Europe in 1891 to live at 806 Walnut Street, Philadelphia, and to teach in the Women's School of Design, he found in that city a group of young artists, among them John Sloan, William Glackens, George Luks and Everett Shinn, with whom for the next several years he lived and worked in close proximity. In Henri's studio they all gathered to discuss art, literature and life; they planned and argued and sometimes played at amateur theatricals. They created for themselves an exciting and invigorating milieu which in retrospect seems an oasis in a desert of debility. While there were others, James Preston, Elmer Schofield, A. S. Calder, Charles Grafly and E. W. Redfield, who were part of the circle and found the relationship stimulating, it was this group of five—Henri, Luks, Glackens, Sloan, and Shinn— who at that time laid the foundations for the later flowering of the famous "Ash Can School" of American art.

Luks, Glackens, Sloan, and Shinn were newspapermen, brought onto the scene of American art by the phenomenal development of newspapers and new reproductive methods. As visual reporters, they were trained in topicality, human interest, and speed. They served the press then as the camera does today. They were essentially illustrators and their work during that period was in no way superior to the large amount of hack illustrating of the time. It took Henri, back from Europe, steeped in the traditions of art, believing in the nobility and importance of the artist as a personality and a social force, as one whose "work creates a stir in the world,"[1] to infuse into this group a sense of destiny. He imbued them all with the creed of "life." He convinced them that expressing the vitality and richness of the American scene was worthy of being an artistic credo and not merely the subject of hack illustration. They had been immersed in the tradition of English illustration of Keene and Leech; he

pointed out to them the greater tradition of Daumier, Goya, Gavarni and Guys. It was through him that they learned of those great visual realists, Velasquez, Hals, and, above all, Manet. With messianic zeal, he lifted them, as he later did so many other younger men, to the realization of their own potentialities.

Henri is an important figure not so much as an artist, for his art has many limitations, but as a crusader and teacher. Aside from Stieglitz, there is no more important personality in twentieth-century American art. He is a legendary figure who bulks so large in our artistic development that his art in itself has never had an objective evaluation. Today his painting seems no different from that of many of his conservative contemporaries, fitting neatly into the tradition of superficial and brilliant brushwork, certainly not radical or revolutionary, as it was then considered. His work was distinctly mediocre, inferior to Sargent's and even Chase's. All his painting suffers from superficiality, for he lacked the ability to think deeply in artistic terms, although he was quite capable of doing so in human terms. His manner and technique are too dependent upon the surface and the moment. His search for life and

Robert Henri, *Willie Gee*
Courtesy of The Newark Museum, Newark, N.J.

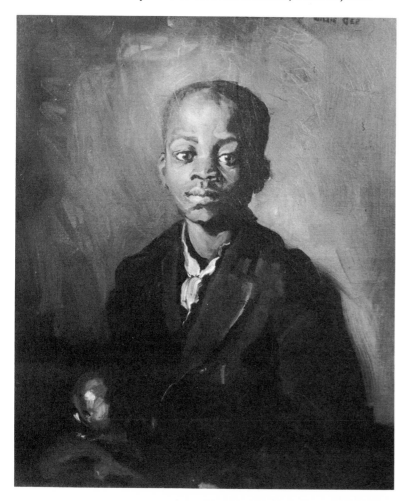

vitality are translated too patly into surface movement and slick brushwork. However, it is not as an artist that we must consider Henri, for he belongs to the older tradition of Sargent, Chase and Duveneck, but as an influence, since he gave his disciples the essentials of a philosophy which expressed the crusading America of that time.

The basis of Henri's character was an ethical concept of justice. All his activity and all his thinking were motivated by that idea. He was a crusader because he felt injustice in any form so strongly. Coupled with this ethical ideal, he had a sublime faith in the innate goodness and the illimitable capacities of man. Logically for his time, he believed firmly in progress and just as logically he sought out and condemned abuses. He was a liberal and a reformer.

Henri embodied the best aspects of this attitude in American life. His sympathy for the new was unbounded and undying. He championed many causes, from the attacks against the academy jury system to the Russian revolution. He believed in the new because the new meant life. He fought tradition because it seemed to him a bulwark against progress and because it tended to perpetuate conditions which he considered unjust. In this sense of justice he exemplified the best American democratic tradition; he was on the side of the underdog, whether it be the young struggling artist snubbed by the hierarchy of the Academy or the socially disenfranchised worker suffering the abuses of exploitation and poverty. Intellectually, Henri was motivated by a passionate search for truth in any and every field, in human relationships as well as in art, and in this search he retained always, as an extension of his sense of justice, an "open mind." He continued throughout his life to fight for open-mindedness and for the new, for he saw in the search for truth an expression of some inherent human drive toward a better life. His radicalism was nothing but an unshakable conviction that truth was more virtuous and more important than tradition. He told his students, "Every movement, every evidence of search is worthy of consideration. . . . Join no creed, but respect all for the truth that is in them. The battle of human evolution is going on. There must be investigations in all directions. Do not be afraid of new prophets or prophets that may be false. Go in and find out. The future is in your hands."[2]

Above everything else, Henri placed his faith in

man, in his goodness and capacity. He believed always in the importance of the individual and he instilled in his pupils a sense of the purpose and the destiny of man. Justice and progress, truth and beauty, these were all the province of man and man could potentially encompass them all with his brain and his heart and his will. Man developed as an individual, as an instrument of justice and progress, through living, through experience. "All art that is worth while is a record of intense life. . . ."[3] Henri made no distinction between the artist and the man. On the contrary, a painter to Henri was not worth his canvas if he were not first a man. An artist, then, had to live, he had to immerse himself in life. He had to express what was vital and real. The artist painted life, not pictures.

To Henri, art was not only a portrayal of life but also, somehow, the shining sword of virtue. It was a weapon in a great crusade. Art was an expression of the militancy which was fundamental to his character.

His was essentially the democratic and liberal ideal. Like Walt Whitman he had faith in man, in the common man, and the mass of men, and like Whitman he held aloft the ideal of a brotherhood of free individuals. These were the ideals for which Henri stood and they were the principles which he tried to inculcate in his many students.

The curious fact is that they found such limited expression in his art. In his hundreds of portraits, commissioned or not, in his early landscapes and street scenes, his sense of justice, his belief in progress, his militancy are hardly discernible. His sympathy for the lowly and his belief in the brotherhood of man find expression only by implication in his portraits of the people of many races and nations. Unlike Whitman, who sang magnificently of the vitality and power of democracy, Henri never achieved in his art an adequate expression of his ideals. That remained for his teaching.

Henri's intellectual impetus, which was to transform this Philadelphia group into an American school of realism, was only part of the story. The tradition of realism handed down by Eakins through Anschutz also had some effect upon the Philadelphians, all of whom had studied at the Pennsylvania Academy of Art. But their own contact with reality through their newspaper work proved the decisive element in their artistic growth. While such literary realists as Theodore Dreiser, Floyd Dell, Carl Sandburg, Edgar Lee Masters, and Sherwood Anderson were in Chicago savoring "life in the raw" as reporters, so the members of the Philadelphia group were acquiring experience as artist-reporters. Luks worked for the *Bulletin*, Glackens for the *Record*, the *Public Ledger*, and the *Press*, Sloan for the *Press*, and Shinn for five different papers.

It is interesting to speculate why the cradle of artistic realism was Philadelphia, while literary realism was centered in Chicago. The only plausible explanation for the emergence of a realist movement in Philadelphia is the existence of the strong Eakins-Anschutz realist tradition, together with the presence of Henri as a sort of catalyzing agent among this group of newspaper illustrators. Certainly there was nothing else in Philadelphia which made the growth of the group inevitable or even likely. As a matter of fact they took up art as differentiated from newspaper illustration only after moving en masse to New York. They apparently never missed Philadelphia and were even called later the "New York Realists."

Although the Chicago writers and Philadelphia painters had much in common, the work of the latter was essentially and completely a city art while the literature of the Chicago realists was at all times conscious of its midwestern agrarian backgrounds. During the eighties and nineties American cities had been undergoing a phenomenal development. Industrial expansion had engendered a new wave of immigration from central and southern Europe, with a subsequent increase in city population. This mass of industrial labor, these new ingredients in the American melting pot, whose languages, backgrounds and traditions were strange to American life, settled in slums and there retained to a great extent the culture and color of their national origins. The overcrowding, poverty and attendant filth created one of the major social problems of the time. Social reformers, men and women like Jacob Riis, Jane Addams, and Florence Kelley, in cities throughout the country fought for an amelioration of almost unbearable conditions. To the realists the crowded city was an exciting and colorful spectacle. It was romantic to some who, like Jerome Myers, thought of it as a "tapestry of romance" where "reality faded in a vault of dreams."[4] It was starkly oppressive to others, like Eugene Higgins, who said of it, "There is longing, envy, and unrest in the slums, and there is feeling, sentiment, and poetry as well. But considered in the bulk, the slums are hell—nothing less.

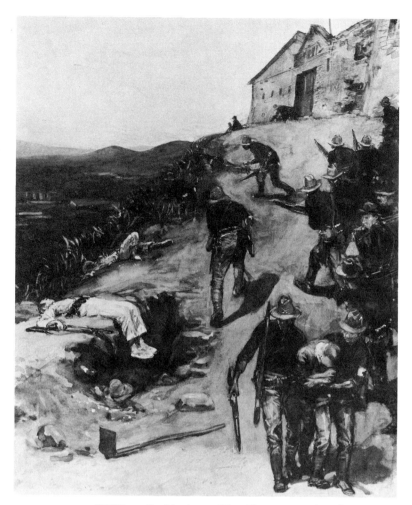

William J. Glackens, *The Night after San Juan*
Collection of Mr. Ira Glackens

There is struggle and strife, horrible suffering, livid agony of soul and body, want, misery, and despair going on there in monotonous, killing repetition."[5]

The migration of the Philadelphians began in 1895, and soon thereafter New York became the center of the realist group. First Henri and Glackens left for Europe, then Luks was sent to Cuba by the *Bulletin* as artist-reporter to cover the Spanish-American War. After some difficulty with the authorities which led to a characteristic hairbreadth escape from a firing squad, Luks came back to the United States and a job on the *New York World*. When Glackens returned from Europe in 1896, Luks helped place him with the *World Sunday Supplement*, and he soon caught on with the *New York Herald*, the *World* and various magazines—*McClure's*, *Scribner's* and the *Saturday Evening Post*. Shinn arrived in New York about 1900, and Sloan finally in 1904, in the same year that young Bellows came from the University of Ohio to study with Henri at the New York School of Art. Henri, returning from his sojourn in Europe in 1899, had settled

on 58th Street near the East River, and in 1903, joined the faculty of Chase's school, the New York School of Art, where he taught until 1907. He left after a sharp disagreement with Chase, who was both jealous of Henri's popularity and critical of his methods, to open a school of his own. After five years, he disbanded his school, accepted a post with the Art Students League, and at the same time, together with Bellows, held classes at the Ferrer School. During these years he taught and inspired almost an entire generation of American painters, among them George Bellows, Rockwell Kent, Guy Pène du Bois, Glenn O. Coleman, Homer Boss, Gifford Beal, Walter Pach, Arnold Friedman, Paul Dougherty, Patrick Bruce, Edward Hopper, and William Gropper.

While the Philadelphians were discovering a world of excitement in the slums and a replica of the Parisian latin quarter in New York around McSorley's, Haymarket and Sweeney's, other artists independently were concerning themselves with the New York scene. Jerome Myers was finding romantic realism on the lower East Side, which he had begun to paint as early as 1887, on his arrival in New York. However, it was not until 1900 that Macbeth bought two small paintings from him and not until 1908 that he had his first one-man show at the Macbeth Gallery. Eugene Higgins, unheralded, had just returned from Paris in 1904 in search of the "lower depths." The work of all these men had by this time become strong enough to be recognized as a tendency and they were labeled the "Ash Can School" and denounced as a "revolutionary black gang." In retrospect it is difficult to find in their pictures the reason for such antagonism, but if one remembers the prevailing sentimentality of American art at that time, it can be understood that the work of the realists was a shock to conservative academicians. Their expression of new aspects of American life was enough to incur the brickbats of academic anger. Their artistic philosophy was alien to the established esthetic concepts of the time, and their actions allied them to the more radical elements in the American scene.

In its fight against the academic style the Ash Can School stood for "truth" as against "beauty," for "life" as against "art," for the "real" as against the "artificial." They accepted Henri's advice: "Be willing to paint a picture that does not look like a picture."[6] The realists defended crudity and ugliness because such things were true. The gentility of the

12

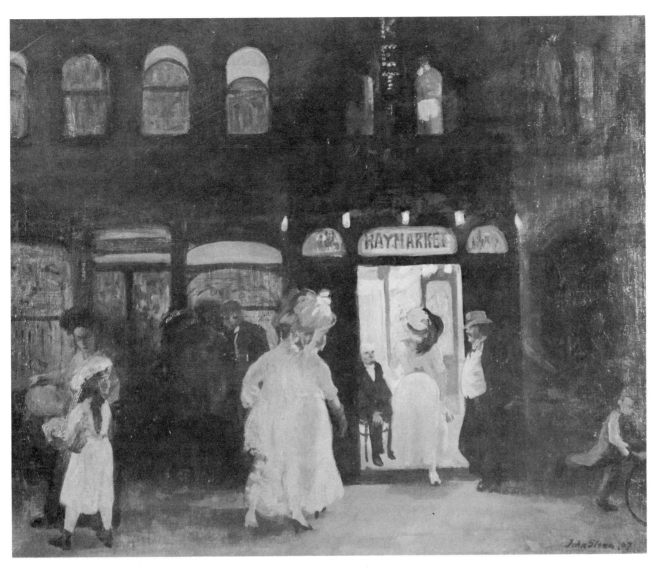

John Sloan, *The Haymarket.* In the Brooklyn Museum Collection

academicians was to them a sign of effeteness, nor was it expressive of the more vital aspects of American life. They saw lusty and vigorous activity around them, which with all its crudeness was still colorful and romantic and which the refined esthetic ideas of the academic painters were incapable of expressing. The realists loved life. Under Henri's guidance "life" became almost an obsession. They looked upon the tricks of art as lies which hid the truth. They became suspicious of that type of beauty which was the earmark of academic painting. The decorative picture, slick brushwork, academic formulas, foggy estheticism were all denials of what was real and earnest. They fought the isolation which was deeply rooted in American art. They refused to dodge the philistinism, the gaucheness of American life; on the contrary, they sought to live and picture that life in its common aspects.

If you got life into your art, they thought, then beauty would take care of itself.

In a sense this was a revolt against genteel vision, which sought an ideal and pleasant existence totally removed from the harshness of industrial reality, and the substitution for it of a democratic insistence upon the varied and particular aspects of the normal daily existence of the masses of people. Social significance was a consequent corollary of this self-conscious and militant democracy. As democratic realists, they were motivated by a sympathy for the lower classes, for the underdog, although their attitudes toward the subject of their concern differed widely. The poor and humble were to Henri a world of individual types, " 'my people' . . . through whom dignity of life is manifest."[7] To Luks they were like himself, vital, crude and colorful. To Sloan they were lovable and tender in all their

13

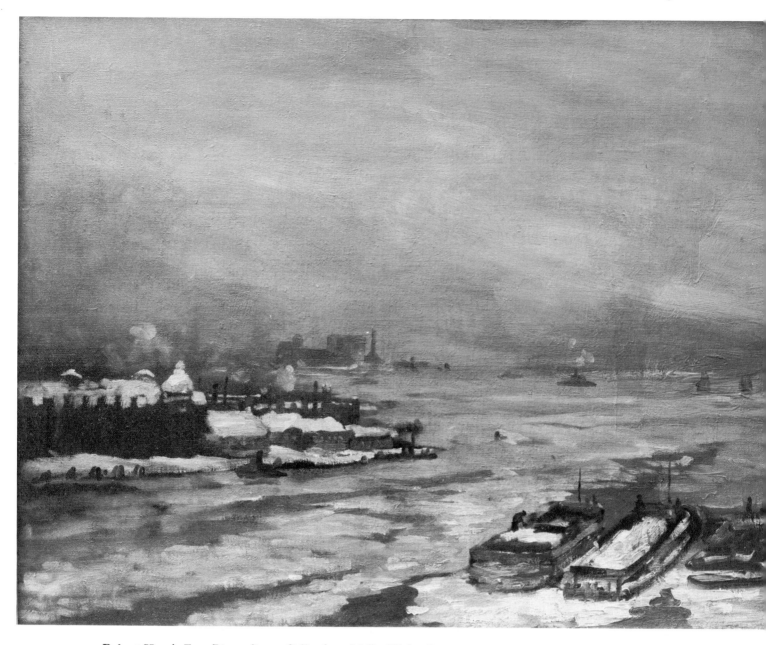

Robert Henri, *East River, Snow*. Collection of Miss Violet Organ

many aspects and he perhaps best expresses in his art that Lincolnian sentiment, "The Lord prefers common-looking people. That is the reason he makes so many of them." To Higgins they were forlorn and tragic. To Glackens poverty was glamorous and romantic. Myers found in the East Side slums a land of fantasy and color.

George Luks was rejected by the Academy but he was more typical and symptomatic of his times than those who rejected him. In his art and in his character he symbolized the spirit of American dynamism; as aggressive as a tycoon, as brash and

boastful as a "drummer," as flamboyant as a Richard Harding Davis, he was a swashbuckler in paint. This was not of course the cultured tradition of American life; it was rather the expression of a cruder side of America, an echo of the frontier.

Although Luks came from a family of more than average culture—his father was a physician who made drawings for amusement and his mother was a painter—he consciously flaunted his own colorful and partially fabricated career as coal-miner, pugilist and newspaperman as more representative of America, in order to deride the standards of a stuffy, Victorian respectability. He identified himself with

14

the lower classes, he drew strength from their hard vitality, he found color and laughter in their primitive living. And he did all this with bombastic exuberance. In his boasted though doubtful career as a pugilist he assumed such felicitously romantic titles as "Chicago Whitey" and the "Harlem Spider," but none was more descriptive of the man and the painter than "Lusty Luks," for above all else he was an embodiment of the animal vigor of American life.

In his boastfulness, his brash self-assurance, in his blasphemy and addiction to a more than occasional drink, he shocked the puritan morality of his contemporaries. Some of it was pose, some was bohemian mocking of respectability, a good deal of it was sheer vitality struggling against lifeless academicism, against the restrictions of formula, against the empty pretensions to artistic aristocracy.

Luks of all the realists was most expressive of the vigor and optimism of American society in this period of industrial and financial expansion. Lacking Henri's reformer's zeal and his intellectual understanding, Luks' slum scenes are more insistent on life than on poverty. He painted the poor not because of sympathy but simply because he found the congested and turbulent life of the slums more exciting than the humdrum existence of the middle class or the straitlaced formality of the rich. Amid poverty he found happiness, laughter, and the joy of living, and he gave his characters humanity and humor. To Luks America never ceased to be a land of high adventure, of romance, of easy success. To him the slums were a place of epic struggle and not of harshness, poverty, and dull resignation. If the slum marked the lowest stratum in American economic life, then slum-dwellers had the whole ladder of success to climb, and that was adventure. Failure was merely an interlude, neither dismal nor dishonorable, for in the land of economic opportunity and social fluidity success was within the reach of all. Luks painted the slums because they were the place of teeming humanity. Here was ferment and color. The city was to him the expression of the new America, modern, young, and alive.

The spontaneity of Luks' style was its hallmark, and also its major weakness. It was unfortunately all he had. He lacked the structural soundness of Hals or even Duveneck. Too many of Luks' paintings are all glitter and surface. Too often they are devoid of anything but vigor. There probably is not in all our history a more unequal painter, for he seems to have lacked the ability to plan, the power of sustained effort, or the slightest critical faculty. He slashed his impressions upon canvas with a sublime assurance which his capacities and his training did not warrant. Sometimes, but only rarely, the results were happy.

Among the best of his works were the early paintings of the Ash Can period, such as *The Spielers* (1905), *Little Madonna* (c. 1907), and *New Year's Shooter* (c. 1907), in which his impulsive manner expressed so well the spirit of the subject. They had a simplicity and charm which he never

George B. Luks, *The Spielers*
Addison Gallery of American Art, Phillips Academy, Andover, Mass.

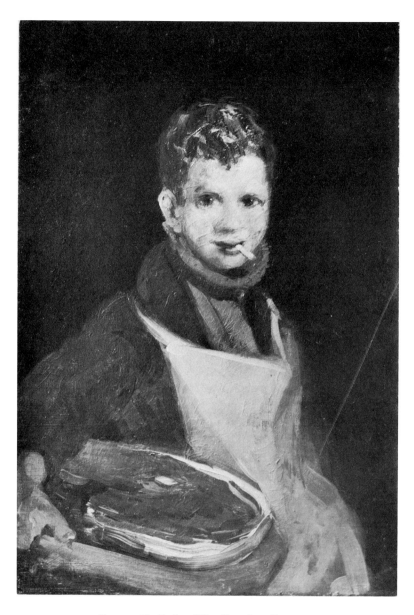

George B. Luks, *The Butcher Boy*
Collection Unknown

related styles—the latter deriving from Hals through Munich, the former from Hals through Manet. Luks found the bravura brushwork and the romantic warmth of the Munich version of Hals more palatable than the cold intellectual realism of Manet. The affinity of his *Butcher Boy* with Duveneck's *Whistling Boy* is obvious. But even here the looseness of construction and brushing is already a departure from the tighter Munich tradition and is a reversion to the Hals of the Dutch children series of the 1620's. Luks found in Hals' exuberance an echo of his own lustiness. He gloried as much in the spontaneity and vivacity of Hals' brushwork as he did in the earthiness of his characters.

Frank Duveneck, *Whistling Boy*
Cincinnati Art Museum

again equalled. He was also successful when the subject demanded vigor, as in *Wrestlers* (1905), or *West Side Docks* (1905). Here the nature of the activity seemed to call for a large and powerful, even if crude, attack and in such instances he foreshadowed the comparable efforts of George Bellows.

Although Luks was directly influenced by Henri, he was in many respects closer to Duveneck. But then Henri and Duveneck were offshoots of two

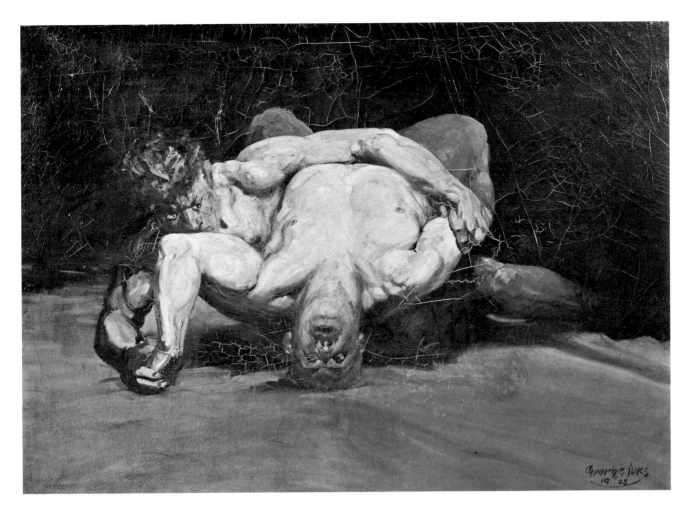

George B. Luks, *The Wrestlers*
Courtesy of Museum of Fine Arts, Boston

Aside from an occasionally successful portrait like
that of *Otis Skinner* (1919) in which the dramatic
personality of the actor lent itself to Luks' flam-
boyant technique, the great majority of his output
in later years was inept and garish. His landscapes
as a whole were mad dashes of paint which never
coalesced. In the last analysis, Luks' failure as a
painter was due to the inadequacy of his artistic
means. He had temperament and vitality, but he
could neither draw nor compose well. He painted
almost by instinct and when his instinct failed he
had nothing to fall back upon but the razzle-dazzle
of brushwork.

George B. Luks, *Otis Skinner as Col. Bridau in "The
Honor of the Family"*
The Phillips Collection, Washington, D.C.

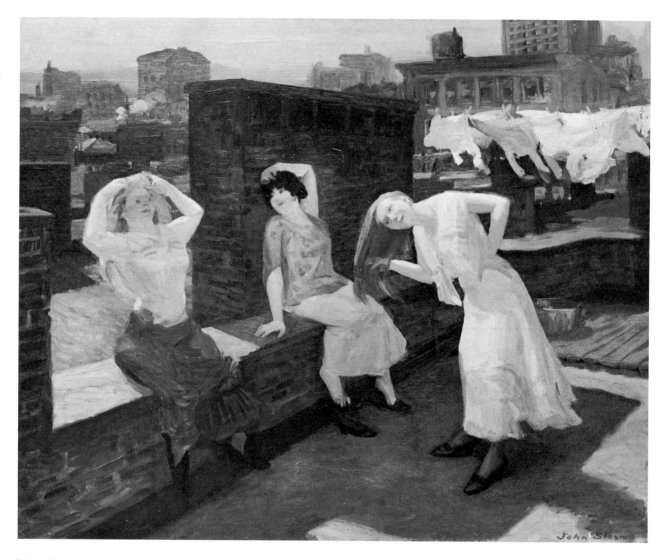

John Sloan, *Sunday*, *Women Drying their Hair*. Addison Gallery of American Art, Phillips Academy, Andover, Mass.

John Sloan was the most politically minded of the realists, the most definitely allied with the activity of social reform. His "agin the government" attitude led him unerringly into the midst of all the artistic struggles of those years. However, although his political awareness, expressed in his espousal of socialism, was more pronounced than that of the other realists, he was far from revolutionary. His interest in liberal crusades, in social reform, in the *Masses* was an outgrowth of his sympathy for people, for the shopgirl and the bohemian artist, for the housewife and the truck driver. But even in his sympathy he remained always the spectator, standing slightly apart, chuckling at the foibles of his fellow men. His art, like that of all of the Ash Can School, lacked militancy; the most one finds is

a jibing satire of pretension and snobbery. It was perhaps fortunate, therefore, that Sloan never attempted to convert his art into a weapon for socialism, for he was neither intellectually nor artistically capable of so complex a statement. The measure of his greatness is in the warmth of his reporting. Whenever he strayed outside the specific limits of his talent, his art suffered.

Sloan has always been thought of as completely American, not only because he, of all the "Philadelphia Five," was the only one who never left these shores, but more than that because his work has always seemed so indigenous in feeling. Yet his style had its roots in a long tradition of European art. Originally an illustrator, Sloan naturally derived his greatest inspiration from the graphic arts. His

18

earliest style, in the nineties, was an outgrowth of the then popular *style nouveau* as exemplified by the drawings of Aubrey Beardsley and the American poster style of Henry McCarter and Will H. Bradley. Contemporary interest in Japanese prints also had its effect. Sloan's pen drawings for *A Comic History of Greece,* on which Shinn was also one of the collaborators, and some posters of the same period are examples of a passing and not very promising phase of his career. However, he soon gave up this mannered, decorative style for the simpler illustrative technique of the English school of Leech and Keene, the *Punch* draughtsmen. At that time both he and Glackens collaborated in the illustration of an English translation of the works of Paul de Kock, in which they both exhibit the easy, humorous manner characteristic of *Punch.*

Henri's first influence upon Sloan was in introducing him to the works of Daumier and Gavarni, and their artistic descendants, Toulouse-Lautrec, Steinlen, and Forain. As American as Sloan's style seems, there is no denying its dependence upon the nineteenth-century European tradition of graphic art, and his subsequent development as a painter also was conditioned to a marked degree by this graphic background. The painting style which he, like all the Henri group, derived from Hals and Manet, served him from the beginning as a congenial vehicle for the expression of his ideas. In his painting, as in his drawing, there is an effortless

John Sloan, *Pigeons*. Courtesy of Museum of Fine Arts, Boston

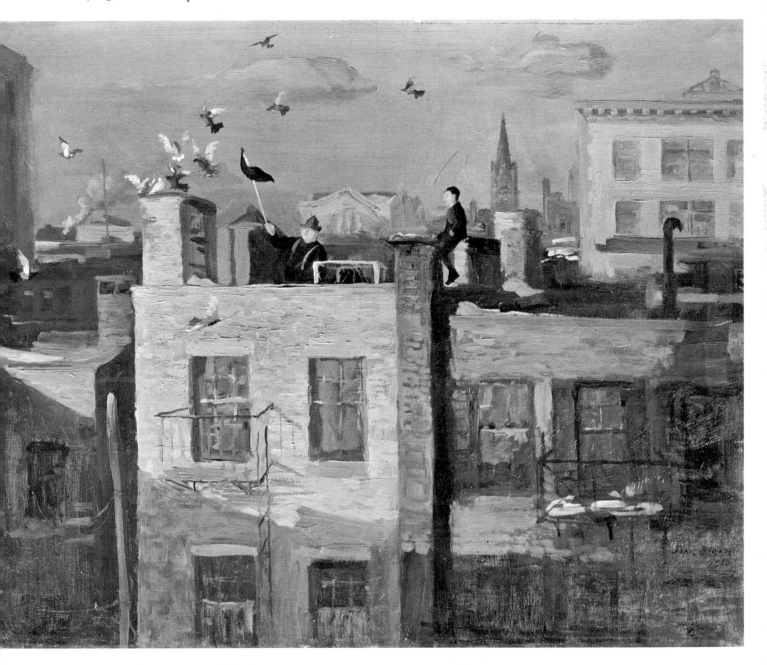

fluency which is never slick but also never profound.

Sloan will probably go down in American art history as the outstanding figure of the Ash Can School, and rightly so, for he caught the infinite variety of city life with uncanny accuracy. As a reporter of life on Sixth Avenue and in the "latin quarter," Sloan is unexcelled. His pictures grew out of a deep knowledge of that life and his penetrating feeling for atmosphere and character. It is through the homely incident that he leads us into the lives of people. His art is full of the human story, of the simplest acts of living—a man flying pigeons from a roof, young girls drying their hair or promenading under the "El" on Sixth Avenue, men drinking at McSorley's, a bohemian gathering at Petitpas, or a scene on the Staten Island Ferry. All these incidents, though they touch only the periphery of living, are so accurate in detail and mood that they seem for the moment to offer a glimpse into essentials and they leave a memory moving in its truth and gentle pathos. It is this human warmth together with his superb qualities as a reporter which set Sloan above his contemporaries. His illustrations of Thomas Augustine Daly's *Madrigali* and *Canzoni* are evidence of his ability to transform the dross of maudlin sentimentality into the gold of human sentiment.

Nothing that he did in later life surpassed the work of the period between his arrival in New York in 1904 and the Armory Show in 1913. Later, when he began painting first Gloucester and then Taos, when he gave up illustration for studio painting and art theory, Sloan was subverting the best in

John Sloan, *Sixth Avenue & 30th Street.* Collection of Mr. & Mrs. Jacob Rand

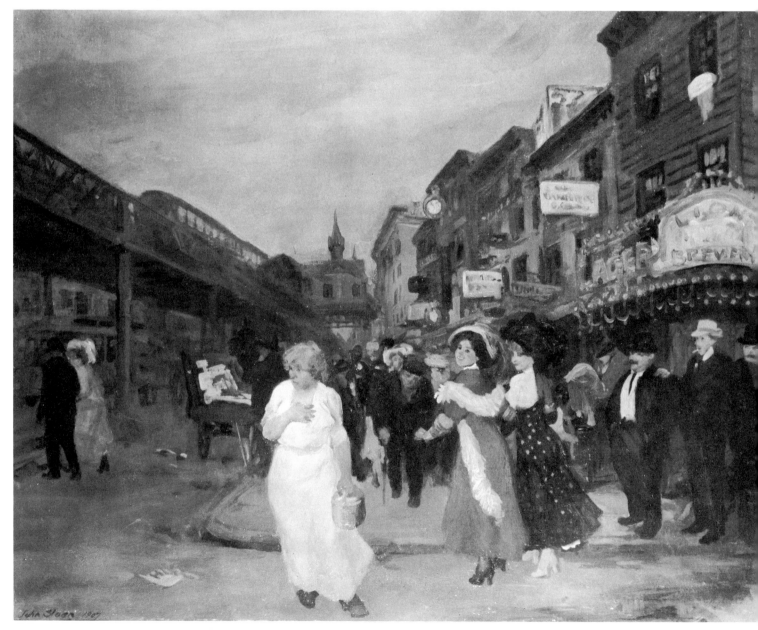

himself. His artistic means had previously been adequate, subservient as it was to his intentions, but once he moved out of his orbit as a reporter and illustrator his weaknesses became apparent. The more he became involved in the problems of art, in experiments in form and color, the less cogent was the totality of his expression. In his Gloucester period from 1914 to 1918 and his Taos paintings, beginning in 1919, the natural harmony between the sensitive gray tonality and the homely sentiment to be found in his early work was disturbed by an obvious preoccupation with beauty and with commonly accepted "artistic" subjects. The extension of his tonal gamut into the range of garish purples and greens obliterated the heart-warming intimacy of mood which was the special charm of his earlier style. This deterioration was due perhaps to the fact that he did not have the instinctive sympathy for these locales which he had for city life, perhaps to the fact that, in disregard of his own convictions, he now sought art rather than life, or perhaps to the fact that an era had passed and left him adrift in strange times.

The realism of William J. Glackens was almost entirely confined to his career as reporter and illustrator. As a painter he was concerned for only a short time with the concepts of the Ash Can School. He was never very much interested in the moral and social ideals of realism. To him the world was a colorful spectacle. If he sought his subject matter among the lower classes, it was because its people made good copy. They seemed to him less conventional and more spontaneous, rich in humor, gay and carefree, full of "human interest." His attitude toward slum life was complacently snobbish. He thought that people in the slums usually had a good time if they could stand the dirt. They didn't work hard and most of their time was spent in wine rooms exchanging philosophical observations. They appeared to him happier than the harassed business man. Because they were more primitive and less civilized than the average American, they made better subjects, and Glackens wanted to paint interesting pictures full of local color and action. Whereas Sloan offered us through human incident a glimpse of human emotion, Glackens always remained aloof, recording only the triviality of action. The Ash Can phase of Glackens' art had the virtues as well as the faults of reporting. Glackens was always a fine story-teller. A drawing like *Holi-*

William J. Glackens, *Washington Square (A Holiday in the Park)*
Collection The Museum of Modern Art, gift of Mrs. John D. Rockefeller, Jr.

day in the Park (1914) has a wealth of accurate observation presented with ingratiating charm. It even has, in its looseness, a form consistent with its content, and as with all Glackens' drawings, it has lightness, grace and facility. The composition as a whole is reminiscent of Brueghel, and each figure, in spite of the apparent confusion is, as in a Brueghel, motivated in its action. In reading the picture carefully one is amazed at its variety of incident and psychology. But in spite of its accuracy and richness, each incident remains interesting as an incident and not as art. This ability to recall the normal events of living without interpretation, ex-

21

William J. Glackens, *Chez Mouquin*
Courtesy of The Art Institute of Chicago

cept perhaps for a bit of humor and irony is characteristic of the journalistic style.

Occasionally in his drawings Glackens indulged in social satire of a mild form and in such instances his art resembled that of Forain. He had the same spirited line, the same facility and superficiality, though he lacked the acid quality of Forain's satirical wit. But no sooner did he give up illustration for "art" than he lost his interest in the social scene.

While under the influence of the Ash Can School he painted, very much like Sloan, in the Manet tradition. As early as 1905, however, he was already gravitating toward Impressionism. *Chez Mouquin*, which won an honorable mention at the Carnegie International of 1905, was already a far cry from John Sloan's *Coffee Line*, which also won honorable mention in the same exhibition. He was still paint-

John Sloan, *Coffee Line*. Estate of John Sloan

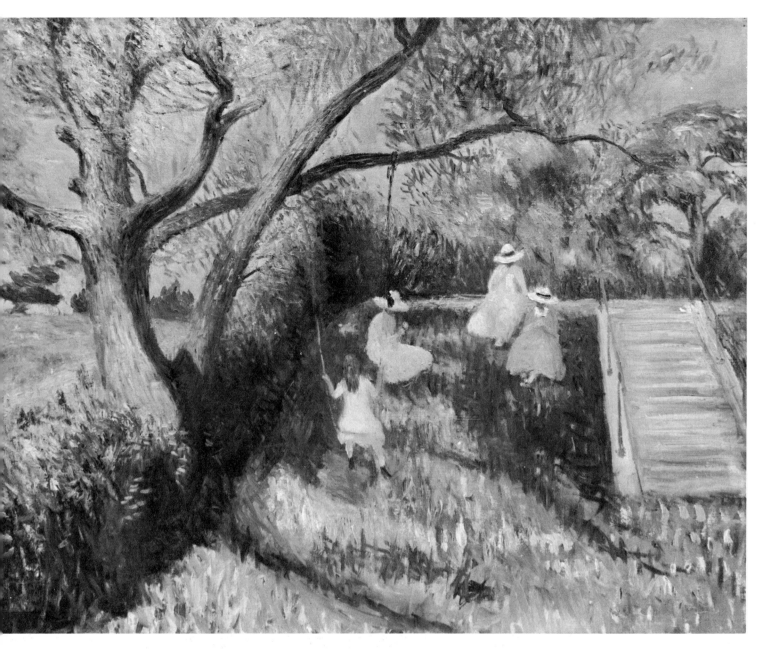

William J. Glackens, *The Swing*. Collection of Mr. Ira Glackens

ing like Manet, but Manet of *Le bar aux Folies-Bergères* (1881). The paintings of the next few years show a growing concern with Impressionism. With his very first efforts in Impressionism Glackens gave up the ghost of realism. By 1910 he had fallen under the influence of Renoir and the direction of his art as well as his style changed radically. His interest became centered around the sensuous subject matter of Renoir and the Impressionists—landscape, still life, nude—and his pictures became full of light and color. By the time of the Armory Show Glackens was completely enmeshed in the brilliant colorism of Renoir's late style with its hot reds and purples, and his art remains to this day the most complete and outspoken example of Renoir's influence in America.

Glackens was originally a realist because he was a reporter, and he maintained that style in drawing long after he had given it up in paint. Whereas Sloan transported his graphic style into painting, Glackens saw illustrating and painting as distinct categories. He apparently considered painting above realism, just as Sloan later considered it above social comment.

The refrain—Henri, Luks, Glackens, Sloan, and Shinn—echoes like a battle cry through the annals of American art. But who is Shinn? Everett Shinn was at one time an artist worthy of being included among the "Five." The works he produced in the early years of the century, like *The London Hippodrome* (1902), which keep cropping up at exhibitions of American art with monotonous regularity as if they were the sum total of Shinn's output, are among the best that the Ash Can School produced. Shinn's career as a realist, however, was short lived, and aside from some early paintings and pastels and his Trenton murals he has proved a minor figure in American art.

Shinn was a man of many talents and it was perhaps just this virtuosity which was his artistic undoing. Originally interested in science, he progressed from mechanical drafting to newspaper illustration and the Philadelphia Academy of Fine Arts. Here, as a true artistic radical, he studied five years without taking criticism. As a member of the realist group, he painted some of the usual subjects, the East River, an election rally, a fire, a matinee crowd; but even then his major interest was in the theater. He moved very soon and naturally out of the Manet orbit into that of Degas. As he became more and more involved in the theatrical world, he gradually lost his contact with the Ash Can School and its social philosophy, until he became merely a minor echo of Degas.

Through his friendship with Stanford White and Clyde Fitch he increased his acquaintance with the theater and the acting profession. He decorated the Belasco Theater and Clyde Fitch's home. This led to numerous commissions both as a decorator and a portrait painter and he painted most of the great theatrical figures of that era, Sir Henry Irving, Ethel Barrymore, Elsie de Wolfe, Julia Marlowe,

Everett Shinn, *London Hippodrome*. Courtesy of The Art Institute of Chicago

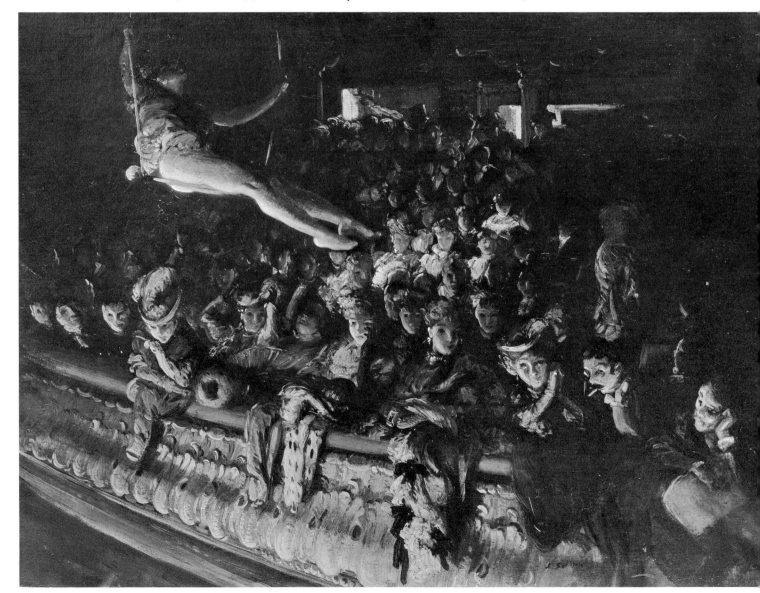

Everett Shinn, *Murals, Commission Chambers.* Courtesy Department of Parks and Public Property, Trenton, N.J.

Clyde Fitch, David Belasco, and David Warfield. In the theater and house decorations he deserted completely the realist tradition and developed a banal version of French Rococo. This revivalism may have been an appropriate style for the theater, since eighteenth-century art had itself been so theatrical, but as a contribution toward the development of art in America it was trivial, and even harmful in that it pandered to the fashion for period decoration.

When he was commissioned to decorate the Trenton, N.J., City Hall (1911) his usual Rococo revivalism was out of the question and he reverted then to the realist tradition. For the subject of these murals Trenton offered a possible choice between its industrial present and its historical tradition of Washington crossing the Delaware. Shinn, perhaps because of his realist background, perhaps because of his original interest in mechanics, chose industrialism rather than tradition. "What the Council Chamber should laud in an American city hall and should commemorate, is not past glories but present ones. The towns that look ever toward their pasts are lost towns."[8] Thus Shinn approached his problem. He spent six months studying the two major industries of Trenton at the Roebling Steel Mills

and the Mattock Kilns. He got all the details of machinery and costume and procedure right; he built a reduced model of the composition like a stage set and then painted two panels depicting the steel mills and pottery kilns of Trenton. They are not world-shaking. They did not, unfortunately, inaugurate an era of mural painting. That had to wait until the thirties, for Thomas Hart Benton and the Mexicans, Rivera and Orozco. The murals were important, however, in that they treated a contemporary industrial subject rather than an historical or allegorical scene. In the realm of American mural decoration, Shinn's Trenton murals are among the first instances of the use of such a contemporary subject painted in a realistic manner and as such they should have been a milestone in American art. Edwin Blashfield, presented with a similar problem in the Bank of Pittsburgh, produced a Greek-costumed tableau called *Pittsburgh offering its steel and iron to the world,* and John Alexander conceived for the Carnegie Institute *The apotheosis of Pittsburgh,* in which Pittsburgh as a knight in armor ascends heavenward through a bevy of Greek maidens. However, Shinn's murals never received much attention. Either Trenton was too far from New York or Shinn was not a recognized member

25

of the mural painters' clique. Only the *Craftsman* saw fit to hail the work as an expression of the tendency toward realism in art.

The panels themselves exhibited the limitations of Ash Can realism as used by Shinn. It was not a monumental mural art. The attempt of Shinn to enlarge the scene to heroic proportions merely laid bare his deficiencies in composition and form. What in a small picture might have been a spirited brush-stroke became in a mural painting a large, empty, and meaningless area. Then the composition itself was a little too ambitious for Shinn's ability. The figures never entirely found themselves in relation to each other or the whole. There are even unhappy passages of clumsy drawing. Shinn's failure was due both to his own limitations as an artist and to the character of Ash Can realism. After the Trenton adventure Shinn returned to the theater, wrote several plays, decorated some more houses, painted some more portraits, and worked as art director for several motion-picture companies. The Trenton City Hall decorations were his last efforts as a realist.

Jerome Myers, in spite of the poverty-stricken struggle of his early life and the desperate efforts that were necessary to remain alive and paint in his spare time, remained always gentle, not bitter. In one sense it is difficult to list him among the realists. His subject matter was consistent with the realist tradition, he never stepped out of his character as chronicler of the slum dwellers, and yet, in some ways, he never seems to have touched the slums. His art raises a question. Must realism be grim? Why are the sordid and the brutal, the painful and sorrowful more real to the realist than the pleasant moments of existence? Perhaps it is because among the poor life is so hard that the interludes of happiness are somehow less real than its persistent grimness. For them, poverty is a burden which darkens even those moments of natural joy. It is not strange that the realist who seeks a fundamental statement

Jerome Myers, *The Tambourine*. The Phillips Collection, Washington, D.C.

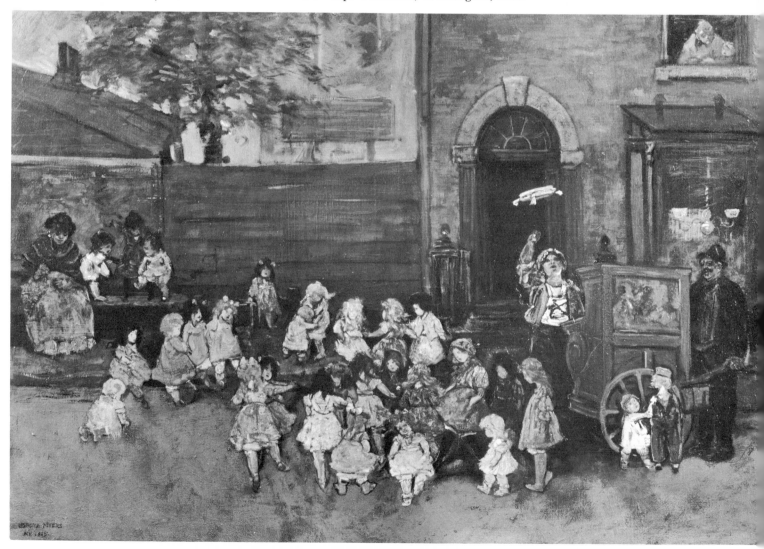

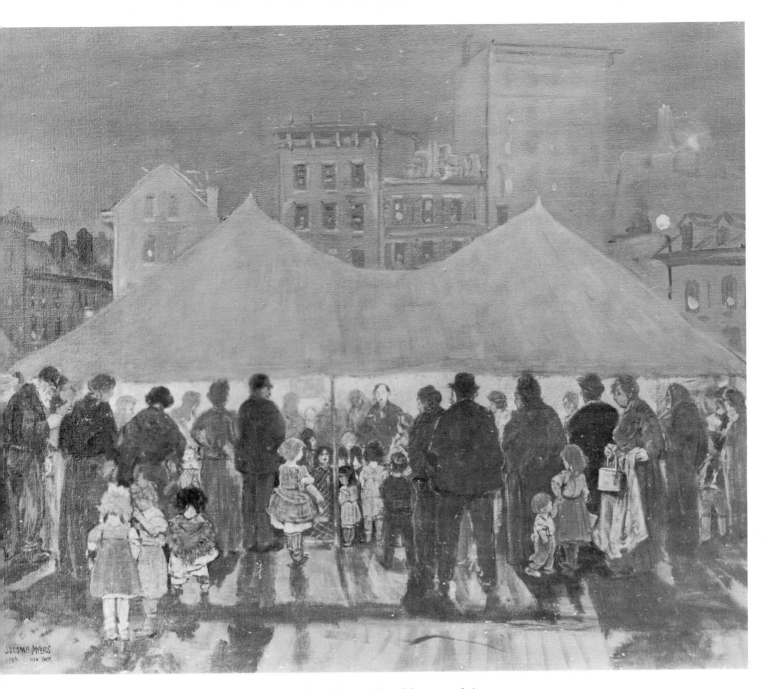

Jerome Myers, *The Night Mission*. Courtesy of The Metropolitan Museum of Art

about human life in the common people, rather than in the chosen few, should find the true character of their life in the difficulties of their existence. For the realist, misfortune, injustice, tragedy, whether due to the retributions of an angry deity, the ironies of fate, or social conditions, are the substance of the human drama. It is in this sense that Jerome Myers is not a realist. "Curiously enough," he wrote, and even he found it curious, "my contemplation of these humble lives opened to me the doors of fancy. The factory clothes, the anxious faces disap-peared; they came to me in gorgeous raiment of another world—a decorative world of fancy, like an abstract vision."[9]

In those times even the bare recognition of the existence of the poor was capable of invoking the charge of socialism, but Guy Pène du Bois, defend-ing Myers, described him as simply a "humanist" and a "realist." He did not preach equality and the distribution of wealth; as a matter of fact, he be-lieved the poor were well off as they were. Myers himself has described his pictures as "visions of the

27

slums clothed in dignity, never to me mere slums but the habitations of a people who were rich in spirit and effort."[10]

Jerome Myers found in the teeming life of the East Side a picturesque and colorful spectacle. The strange costumes and customs of immigrant peoples were a romantic contrast to the drab standardization of native American life. It was just this element of romance which American artists as a whole found lacking in the contemporary scene. To fill this void an artist like Chase cluttered his studio with an accumulation of romantic objects—copper vessels, rugs, swords and sundry *objets d'art*—and yet he would have considered the painting of tenement life as below the dignity of art. But Myers, less cultured and cosmopolitan, untrammeled by academic traditions, went directly to that exotic milieu itself in search of romance.

Even though he may have clothed it in romance, Myers, in recognizing the life of the poor as a fit subject for art, was acting as a realist. He painted children at play, dancing to the music of the organ grinder, old people at rest on stoops and river piers, religious processions, market and street scenes, fiestas, the whole colorful variety of life in the slums. We look in vain for the evils of poverty in Myers' art, for he saw those people only at play or at rest, in moments of evanescent happiness, in moments of freedom from the rigors of being poor. Although he was more immersed in slum life than any of the other realists, he never saw it as a social laboratory. He was even sorry to see the slums beginning to disappear. "It is not for me to say that conditions are not better in the beautified and sanitary New York of today. Yet I feel that the free play of children is more rare, and I know that picturesque types are seen less often."[11]

A curious feeling of remoteness pervades his paintings, for Myers' own personal detachment affected his art. All his scenes look as though they were seen from across the street. Not only a veil of romance, but a veil of distance lends a nostalgic charm to his art and makes his world a land of dreams. The primitive technique and lack of sophistication themselves give his people a doll-like quality. Although there is a gentle emotional feeling throughout his work it is confined to the total mood and individual characters never are seen with Sloan's psychological insight. His people remain always puppets in a pageant, whose mere existence and activity are more interesting than their individual experience.

To Myers the painting of life was not a principle, merely a predilection. He was not interested in fighting battles for art or for people. He had no grudge against established authority either in art or life. He felt on the contrary the necessity for its existence and was thrilled when the Academy accepted him.[12] It made him feel like the hero in a Horatio Alger plot. Unfortunately academic honors gave this poet of the poor a smugness which ill became him.

Unlike Jerome Myers, Eugene Higgins, the other independent realist, was grim. As the son of a stone-cutter, Higgins also had a poverty-shadowed youth. At an early age he was impressed by Millet's drawings for children and Victor Hugo's *Les Misérables*, even feeling himself a personification of Jean Valjean. Later in life he saw himself as a counterpart of Maxim Gorky, an artistic outcast who could not expect official recognition but must accept without question the status of an isolated and neglected genius. He even stated at one time that he was painting only "for men like Gorky, men who can feel and know!"[13] It was only natural that this painter of the downtrodden should have been acclaimed by the poet Edwin Markham as "the one powerful painter of the tragic lacks and losses, of the doomed and the disinherited—the painter who gives us the pathos of street and hovel and morgue, as Millet gave us the pathos of the fields."[14]

In 1904 Higgins, then in Paris and known as a "poor beggar in a garret who paints beggars and *misérables* because he is one of them,"[15] was accepted by his French contemporaries as an artist of talent. An entire issue of *Assiette au beurre* (January 9, 1904), that famous militant journal of social satire in art, which included among its contributors Steinlen, Forain, Kupka and Hermann-Paul, was devoted to the work of this previously unknown American. There were in all sixteen pages of pictures, called "Les Pauvres," illustrating a poetic text by Jehan Rictus. These drawings exhibited an individual style full of passionate sentimentality.

Higgins, in common with the rest of the Ash Can School, but to even a greater degree, was interested not in labor as such, but in the oppression and social degradation of the poor. He pictured the rootless outcast, the hopelessly beaten, those who no longer had even the opportunity to struggle for existence. His style at that time paralleled and even resembled in some respects the art of that other painter of pessimism—Picasso. Both men, Picasso in his "blue

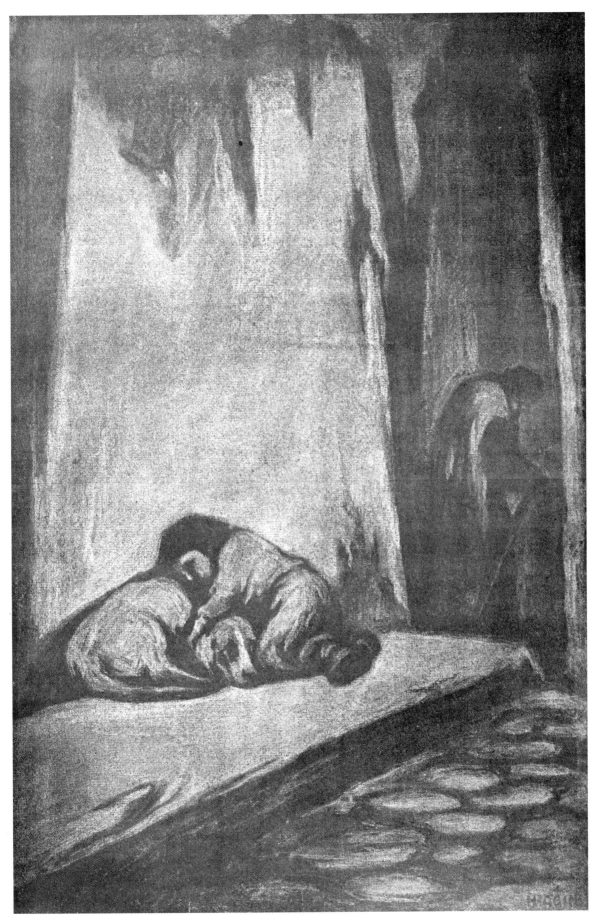

Eugene Higgins, *Les Pauvres*. From Assiette au Beurre, Jan. 9, 1904

period" and Higgins in his *Assiette au beurre* drawings, were influenced by the French tradition of social satire, from Daumier through Toulouse-Lautrec, Forain, and Steinlen, and strangely enough, Higgins even echoes Picasso's reliance upon El Greco. But if Picasso borrowed from Toulouse-Lautrec and Higgins from Millet it was due to a difference in attitude as well as in artistic perspicacity. Whereas Picasso's bitterness was tinged with pessimism, Higgins' bitterness was unbearably sentimental.

Although one cannot deny the fundamental sentimentality in Picasso, it is a sentimentality which, after the "blue period," becomes so subtle and often so disguised by a self-conscious mocking of its own existence, that one is surprised by its recurrent and sometimes uninhibited expression. In Higgins the sentimentality is completely naive. It is a sentimentality based on a deep romantic sympathy for the unfortunate, sympathy so deep that Higgins, like Millet, could not help but give to his people an heroic stature and a dignity which eventually defeated its own purpose. In Higgins' art the poor become less real as they become more idealized. In his search for universality Higgins created an unreality of character, time, and place. The peasants of his later works who drift moodily in a brooding landscape are even less real than the overdramatized shivering slum derelicts of his earlier style. Higgins is a social artist, a man who is deeply moved by evidences of injustice and oppression in life, but he is not strictly speaking a realist, for the specific manifestations of injustice and oppression are less important to him than the universality of the idea. His people have become symbols rather than human beings and his paintings have all the remoteness of biblical quotations. A good deal of this unrealness may of course be due to his rather uninspired academic style. One feels in Myers, for instance, the aptness in relationship between sentimental content and naive style. In Higgins, however, the pedestrian quality of the painting gives all his later work an unrelieved dullness. The intensity of feeling which was expressed in theatrical lights and darks in his early drawings and etchings tended to disappear as he conformed more and more to the academic norm, as he became more and more immersed in Millet.

As we have seen, the Ash Can painters were concerned with social problems, and yet, today in our eyes, their art seems not at all revolutionary or radical, lacking as it does the pointed propaganda which became so much a part of the social art of the thirties. But in their day a simple statement of fact concerning the poor, with however much added romantic flavor, contained within itself the implications of social reform. In fact some of the realists were active as social reformers. The social and political opinions of these men have been largely overlooked although a knowledge and understanding of such extra-esthetic beliefs is necessary for any complete understanding of their art. Henri was a philosophical anarchist. His belief in each individual's potentiality for perfection as the basis of a brotherhood of all men was essentially that of the anarchist. He placed above everything else the free spirit of the individual and the free expression of individual thought and feeling. His influence on Bellows in this respect was especially marked. In 1912 he and Bellows began to teach in the anarchist Ferrer School, not because of any allegiance with the organized anarchist movement of the time, but because he believed in the principles of complete freedom of expression with which the school was experimenting. He taught there from 1912 to 1918. John Sloan on the other hand was an avowed socialist. His participation in many artistic struggles was not, as in the case of Henri, the result of a desire to defend the rights of individual expression as much as a desire for the organization and expression of revolt. Sloan was one of the original founders of the *Masses* in 1911, was actively involved in its publication until its demise in 1916, and was again active in its reorganization as the *New Masses* in 1926. As an active member of the editorial board, he was instrumental in getting artistic contributions for the *Masses* from such realists as Henri, Bellows, and Luks.

In the pages of the *Masses*, the realism of the Ash Can School came into contact with political cartooning, another phase of American art which had developed out of newspaper art and which may be characterized as realism in action on the social and political scene. Boardman Robinson, then working for the *Tribune*, had broken from the older pen and ink tradition of cartooning and developed a style of drawing based on that of Michelangelo and Daumier, and the more recent French satirists Forain and Steinlen. It was a style of crayon drawing, sketchy, powerful and realistic. Robert Minor, whose work appeared in the *Masses* and later in the

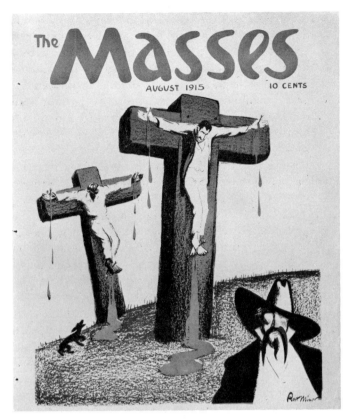

Minor, *Masses Cover*, August 1915
*In Georgia, The Southern Gentleman Demonstrates
His Superiority*

Robinson, *Cross Breaker*. July 1912

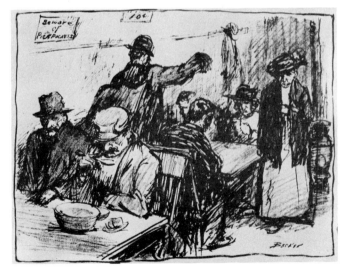

Becker, *Beware of Pickpockets*. February 1913

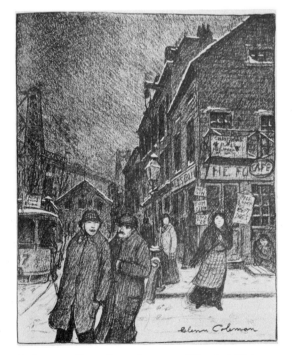

Coleman, *Class Consciousness*. March 1914

Cartoons from *Masses*

Liberator, followed in Robinson's footsteps, with brilliant intuitive artistic power. This tradition was to become a major element in American graphic art, through such men as Maurice Becker, Edmund Duffy, Clive Weed, Daniel Fitzpatrick, Fred Ellis, and Jacob Burck, as well as an important factor in the subsequent development of the social art of the thirties.

In the *Masses*, the beginnings of an art of social satire were developing with the drawing of Sloan, Bellows, Robinson, Becker, Glenn O. Coleman, Stuart Davis, H. J. Glintemkamp, Minor and Art Young. These men expressed in varying degrees the liberal intellectual atmosphere of the times. Some were radicals and some were not, but like the muckrakers Lincoln Steffens, Ida M. Tarbell, and Ray Stannard Baker, who were exposing the corruption of American politics and big business, they were all concerned with the abuses of poverty and inequality, searching out injustice and condemning it, often with greater artistic force than their literary brethren. Although the *Masses* itself was definitely socialist, a kind of cultural organ of the Socialist Party, the lines of "leftist" political thought were as yet not sharply drawn and the fact that the party itself was split into various factions made it possible for varying kinds of socialists, anarchists or liberals to find a common ground for expression in its pages.

However, aside from these rather limited activities in the *Masses*, the realists were not muckrakers in paint. Muckraking was a factual exposition of graft, corruption, vice, and brutality in American life. It was a symptom of and a sword for the reformist movement of the period. The Ash Can School was influenced and motivated by the same social forces. It grew out of the same liberalism, but it never became sharp enough to serve as a weapon in the struggle for reform. This may have been due to the limitations of painting as a method of critical exposition. It was probably more directly due to the lack of a tradition of social criticism in art which confined realism at that period to a colorful documentation of city life.

In the years before the first world war, during the era of liberal revolt and muckraking, the realists reached their peak. During these years they created their most complete and sympathetic picture of American city life. This was before Glackens succumbed to Impressionism and Renoir, before Sloan went to Gloucester and Taos, before Shinn became a decorator in the eighteenth-century manner. So strong was the current that even artists who would later on take entirely different paths were then working in the realist manner as illustrators or newspapermen. In the early years of the century Joseph Stella, later a Futurist, was making drawings of immigrants and miners in the realist tradition for several magazines; Arthur G. Dove, later an abstractionist, was also working as an illustrator; Walt Kuhn was a cartoonist and newspaper artist; and Jacob Epstein, the sculptor, fresh out of the Educational Alliance art school, made a series of sketches of his east side Jewish compatriots to illustrate Hutchins Hapgood's *Spirit of the Ghetto*. Some of the early paintings of Alfred Maurer show an affinity with the Ash Can tradition which is remarkable.

It was during this period also that the younger realists got their training from Henri and began to work in the realist tradition. Of these only Glenn O. Coleman and Edward Hopper can be rightly called Ash Can School painters. The others, like George Bellows, Gifford Beal, Rockwell Kent, and Leon Kroll, became the "muscle men" of American art. They expressed not the muckraking social consciousness of the period, but rather the excitement and the brash aggressiveness of American life.

Alfred H. Maurer, *At the Shore*
Estate of Curt Valentin

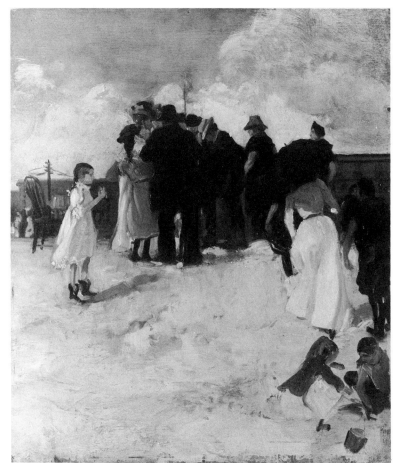

George Wesley Bellows' earliest exhibited works in 1906 reflected his dependence upon Henri and Duveneck, but as early as 1907, with *Forty-two Kids*, he strode forth full-grown onto the American scene as a major protagonist carrying the banner of the realists. He showed even then a Luksian gusto, a sense of action, a predilection for bigness, and a search for the monumental in the realm of the commonplace.

Bellows was immediately recognized as *the* American artist. Whereas the Ash Can School had been denounced as revolutionary, Bellows was accepted by the Academy. He was admitted to the National Academy of Design exhibition in 1907, won the Hallgarten second prize in 1908, and in 1909, at the age of twenty-six, was elected an Associate of the Academy, one of the youngest in its history. His reputation was made. His artistic personality was accepted by the public as the embodiment of such American virtues as normality, bigness, vitality, individualism, and democracy.

Bellows intrigued America, for one thing, because his was a success story. His career paralleled in the field of art the pattern of financial and industrial success. But also he had many of the same virtues revered in such successes. He was apparently normal, sane, and healthy. As a youth he had been an athlete, in his maturity he became a family man, as an academician he was stamped as a competent professional. He was not a sickly, sensitive, philandering bohemian, incompetent and outside the pale of normal society. America could excuse a sensitive soul if it were hidden within a rugged, manly exterior. It could accept an artist if he seemed so normal a person as Bellows.

To the American mind Bellows embodied the average man on an heroic scale. He had all the normal virtues, but he expressed them with exceptional largeness and gusto. Bigness and muscularity, in turn, were almost an obsession with Bellows. They led him to an excessive insistence upon size in composition and conception, and also to a naive pre-

George W. Bellows, *42 Kids*. In the Collection of the Corcoran Gallery of Art

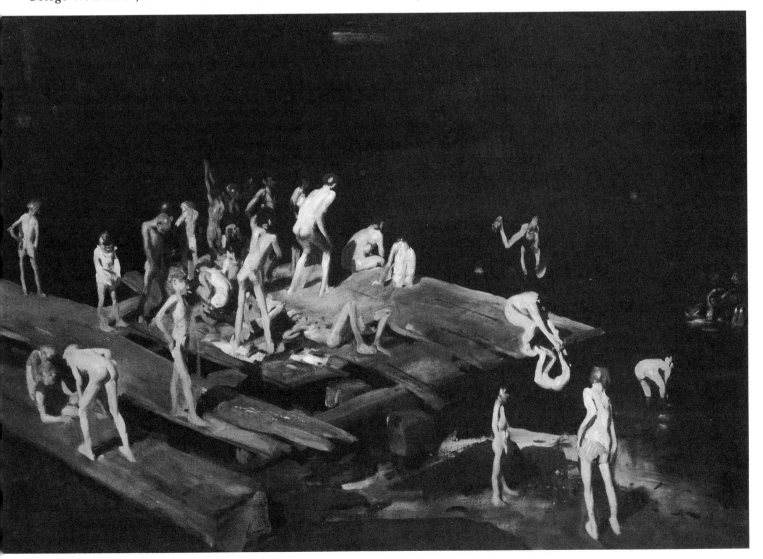

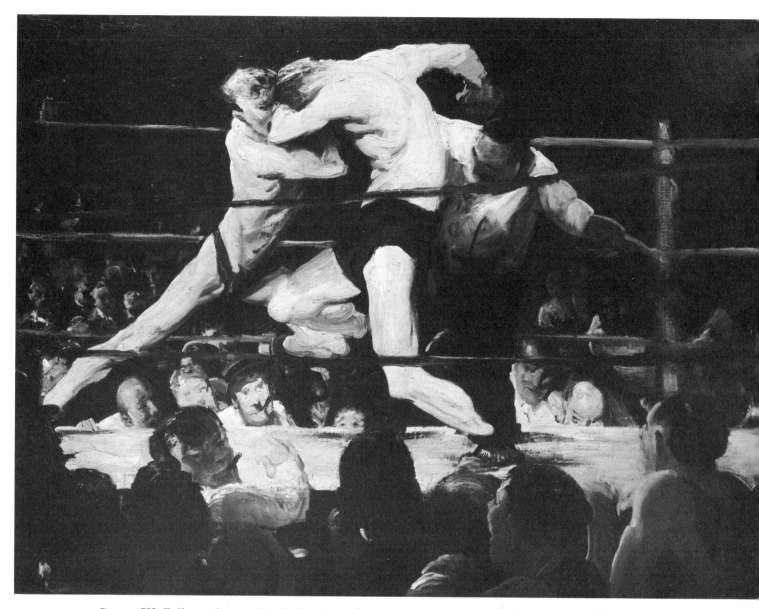

George W. Bellows, *Stag at Sharkey's*. Courtesy, The Cleveland Museum of Art, Hinman B. Hurlbut Collection

occupation with large canvases and large brushes. Hand in hand with bigness went the preoccupation with masculine vigor, which was evident in his choice of subject matter—large industrial landscapes, scenes of labor, the turbulence of slum life, violent recreation.

A comparison of the choice of recreational themes by artists of different countries can offer us an insight into national cultural attitudes. For instance, Degas' interest in the ballet, the general French interest in cafe entertainment, Picasso's interest in the artistic aspects of the circus performer, all of which deal with a refined and sophisticated estheticism in recreation, are far removed from the raw physical impact of boxing, polo playing, and wrestling, which absorbed such painters as Bellows and

Luks. This physical vigor was carried over into the actual technical execution, in slashing brushwork, lurid coloring, and harshness of form; and the quality of such paintings depends upon just this disregard for the elegant or the subtle. The American artists were not interested as were the French, in intimate, behind-the-scene rehearsals for esthetic performances, but in the actual momentary consummation of athletic prowess, and the character of their art is dependent upon the performance and display of violent physical activity. It may strike one as a sort of public muscle-flexing for the edification of the gaping mob, but it is motivated by a search for the truth of life, with the expectation of finding it in life's rawest forms. However, there is a difference between what the original Ash Can painters con-

ceived of as the truth—that is, the social truth of poverty, slums, and sentient humanity; and what the younger generation of realists substituted—work, construction, athletics. While the one implied social criticism, the other optimistically exploited the picturesqueness and power of the American scene.

Bellows, more than anyone else, managed to equate his radical tendencies with generally esteemed American concepts. Of course, the more radical aspects of his thinking were themselves ultimately based on fundamental ideals of the middle class, just as the larger social revolt itself was a revolt of that class against the rising power of monopoly. If Bellows as an individualist and a democrat was in some cases more radical than the majority of people, it was because he had grown up under such a militant exponent of those ideals as Henri. In its extreme manifestation, Bellows' individualism led him to an intellectual acceptance of anarchism and a sort of Nietzschean conception of himself and, as a matter of fact, of every artist as a superman. This radical individualism which he ex-

pressed in philosophic anarchism and in a general iconoclasm was overlooked by the public. Instead he seemed to them to be merely aggressive, a commendable trait, with faith in his own ego, which seemed in his case to be well justified.

Bellows owed most of his social philosophy, his acceptance of the democratic ethics of equality, justice, and social idealism, to Henri. Under Henri he developed a social consciousness and a sympathy for people. The intellectual side of his nature, which he fostered in accordance with Henri's belief that the full development of the individual was a prerequisite for the creation of a great art, led Bellows, who had a vigorous if not profound intelligence, to an open-minded consideration of ideas. In the field of art he accepted the general concepts of realism and the Ash Can School. He believed that art was the expression of its time and that artists must be actively contemporary. With Henri he fought for most of the progressive artistic programs of the day. This open-minded search for truth led to a rather unfortunate espousal of such pseudo-scientific theories as dynamic symmetry, as a result probably of

Gifford Beal, *Freight Yards*. Permanent collection, Everson Museum of Art

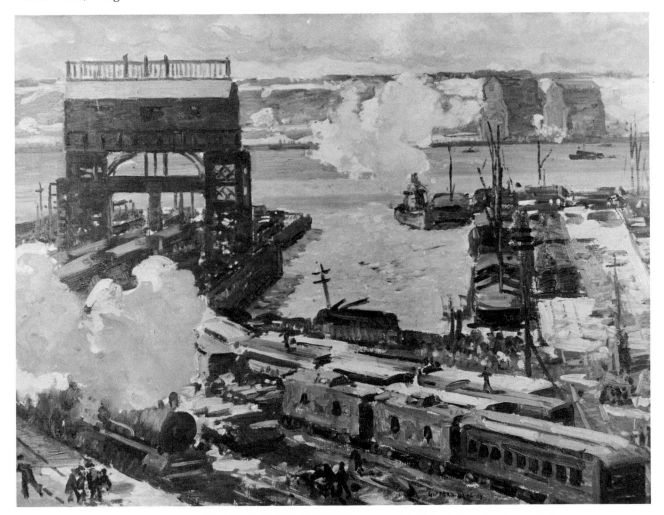

Leon Kroll, *The Bridge*. Union Memorial Hospital, Baltimore, Md.

a too optimistic faith in the efficacy of science. The same intellectual curiosity also led him to the theories of anarchism and socialism, many of whose doctrines he accepted in spite of their general disrepute.

Bellows, regarded for many years as the great American artist, has been compared with Walt Whitman and Jack London, as well as with Rudyard Kipling. However, he lacked Whitman's vastness of scope, his great human warmth and his depth of understanding. As for the comparison with Kipling, that is entirely unfortunate since Bellows was never a drummer boy for nationalism or imperialism, and it was only in the war years, carried away by the general wave of patriotism, that he lost his sense of values. Jack London is perhaps the closest parallel. London was also the same kind of split personality in whom idealism and Nietzschean individualism struggled for ascendancy. Both London and Bellows were vigorous, brash personalities, intellectually not quite capable of synthesizing the vastness and vitality of the America which they sought to express.

Bellows' art is not crude in the sense that Luks' is and yet it is more strident; his rawness is not as sincere or powerful. His work is aggressive, full of surface animation but lacking in depth. It is too often motivated by action for action's sake alone, and in his attempts to be monumental he was usually melodramatic. However, he remains a symbol of his time in his optimistic faith in American destiny and his love of the vastness and richness of American life.

The others of this group, Kent, Kroll, and Beal, were even further removed from the social consciousness of the Ash Can School. In his early work Rockwell Kent was intrigued by the rugged coast of Maine with its turbulent seas and heroic fisherfolk. With a cold, clean precision he tried to convey the vastness and grandeur of nature. Much of this early work is related to that of Bellows. The sense of grandeur, of the heroic, which Bellows could find in the city and in people, Kent could never see except in the still vastness of nature, which he repeatedly

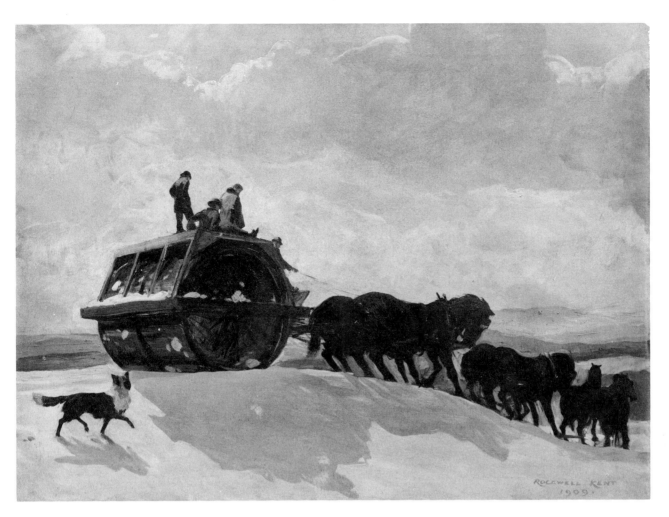

Rockwell Kent, *The Road Roller*. The Phillips Collection, Washington, D.C.

sought in his many wanderings. His people during this period were mannikins for scale rather than, as later, for symbolism. Kroll, on the other hand, found this bigness for a short time in the industrial expansion of the city. During a short period he painted, with greater vigor than he ever did before or after, the commercial bustle which characterized the great metropolis.

Among the realists the search for a new content went hand in hand with the struggle against the organizational rigidity of the Academy. Under Henri's leadership they waged a long fight for a more liberal exhibition system. It should be remembered that these men were not unknown; while they may have had difficulties with the conservative and unwieldy jury systems, they were men of recognized artistic standing. Henri, of course, had an unassailable position as a member of the Society of American Artists and later of the National Academy of Design, and even as a frequent jury member of the Academy. Glackens and Sloan received honor-

able mentions at the Carnegie International as early as 1905. However, these men were not content with acceptance or honor as was Jerome Myers, for instance, but were intent on principle upon an aggressive campaign against entrenched authority. They fought not for personal recognition but for the right of free exhibition. In 1907, when two of Luks' paintings were rejected for the eighty-second National Academy of Design exhibition, Henri, who was serving on the jury, precipitated the battle which finally led to the Armory Show and the Society of Independent Artists.

Henri, as one of thirty jurors for the 1907 Academy exhibition, had fought for the inclusion of pictures by Shinn, Glackens, Kent, and Springhorn as well as Luks. When Luks' entries were rejected, Henri withdrew two of his three accepted paintings as a gesture to underline his belief that new impulses in art should be encouraged. A few months later, in January 1908, the realists exhibited as a group at the National Arts Club exhibition of American art, with Henri, Luks, Sloan, Glackens, Higgins,

37

and Kent represented. It was at this exhibition, incidentally, as an example of the natural confluence of progressive tendencies, that photographs for the first time were hung together with paintings.

Also in 1908, Gertrude Vanderbilt Whitney opened the Whitney Studio Gallery, under the direction of Juliana Force, on West Eighth Street next to her own studio. Here the works of some of the realists (Henri, Luks, Sloan and Bellows) and others (Lawson, Allen Tucker, Cecil Howard, Jo Davidson, Paul Manship and James E. Fraser) were exhibited. This was expanded in 1914 into the Whitney Studio Club on West Fourth Street with three galleries, meeting rooms and a library, which in the fourteen years of its active life gave support to the general liberal tradition in American art that had grown out of the revolt of the realists.

In the same year the "Eight" had their history-making exhibition. Consisting of Henri, Luks, Glackens, Sloan, and Shinn, the original Philadelphia group, and Arthur B. Davies, Ernest Lawson, and Maurice B. Prendergast, this association was never a formal organization or an artistic school, but simply a union of men with similar liberal attitudes, who, joining forces, exhibited together only once, and yet became thenceforth a symbol of revolt in American art. As a group they gained an importance which went beyond their prestige as individuals. Both Davies and Lawson were painters of repute, but even they had a limited audience, Davies because of his over-refined and esoteric estheticism and Lawson because of his rather un-

compromising Impressionism. The rest were, in spite of their reputations, to some extent outside the recognized precincts of American painting, the realists for their painting of the "ugly" and Prendergast, America's one original Impressionist painter, because he was not like all the other unimaginative imitators of Monet. Aside from the fact that the exhibition was a clever promotional scheme on the part of the Macbeth Galleries, which handled the work of some of the men, for example Henri and Davies, and had exhibited some of the others, it was an example of the ideal group plan which Henri had always championed—exhibition by related artists, self-organized and self-selected, without jury or prizes—as against either the jury-selected Academy shows or even later the non-jury Independents. This plan was attempted again with some success in the MacDowell Club exhibitions, instituted in 1909, which were the proving ground for Henri's theory.

Meanwhile, in April 1910, as a result of the association of the "Eight," the "no jury—no prize" program had its first comprehensive trial at the Independent Artists exhibition in a hired loft at 29 West Thirty-fifth Street. Each artist submitted works of his own selection and paid for the space used. Twenty-seven artists were represented and sixty-three works were hung. Organized by Henri, Davies, Lawson, Sloan, Shinn, Glackens, James E. Fraser and Walt Kuhn, it was the forerunner of the Society of Independent Artists formed in 1917, and its personnel became the backbone of the Armory Show in 1913.

WHILE the Henri group was making a frontal attack on the entrenched power of academicism and the accepted standards of academic art, Alfred Stieglitz was undermining the same power and standards in a different way by introducing to America the more radical examples of European and American art. At the Photo-Secession Gallery also called "291," opened in 1905, Stieglitz first fought against the conservative elements in the field of photography and then took on himself the cloak of defender of all that was new and exciting in the entire field of art. In January 1908 he showed, for the first time in America, fifty-eight drawings by Rodin. They were without doubt too advanced for American taste. However, since Rodin's reputation as the world's greatest living sculptor was then held beyond question, the critical reaction was favorable though halting. In April of the same year, when Stieglitz presented, also for the first time here, the drawings of Matisse, which descend from Rodin, the critics, unrestricted by the glamor of reputation, hurled invectives with abandon. They called it "artistic degeneration," "subterhuman hideousness," yet recognized in it even if grudgingly a "bewildering cleverness."[1] From then on Stieglitz was in the midst of the battle for modern art. He exhibited subsequently the work of Alfred Maurer, John Marin, Max Weber, Abraham Walkowitz, and the photographer Edward Steichen, as well as Henri Rousseau, Cézanne, Picasso, and Toulouse-Lautrec.

Alfred Stieglitz, photographer, esthete, propagandist, and art dealer, was without doubt the most important single figure in the development of modernism in America. His photography, which has won him his right to artistic immortality, is something quite apart from those characteristics which make Stieglitz historically important in American art; the estheticism, which colored the attitude of his group, the propaganda, which served to further the cause of modernism, or the art dealing, which he vehemently denied. He has been reviled by some of his former disciples, and his importance as a factor in American art finally dwindled even during his own lifetime to a point where it was almost negligible. Thomas Benton, with characteristic sensationalism, later maintained "that no place in the world ever produced more idiotic gabble than '291' "

and that "the contagion of intellectual idiocy there rose to unbelievable heights," or even that Stieglitz "has a mania for self-aggrandizement and his mouth is never shut"[2]—an unusually apt example of the pot calling the kettle black—but all this cannot change the fact that Stieglitz, for years, gave all his energies and his fortune to the education of the American public and the support of many American artists.

At "291" Stieglitz introduced a long succession of European and native modernists to America. It was the one gallery in this country which consistently presented the controversial and revolutionary aspects of modern art. His magazine *Camera Work* was not only a noteworthy example of reproduction and printing, but it was also the staunchest defender of all the newest artistic currents. His gallery was a salon where artists could find congenial minds and derive new inspiration, and his pocketbook was a cushion against which discouraged artists could rest their weary spirits. To call him egocentric and dictatorial is not to deny the role he played in the transformation of American art and taste. Even Benton found understanding and companionship and perhaps inspiration there for a time.

Stieglitz as a person and his gallery as a place were one. He was a refuge where the artist could hide from scorn, forget neglect, and gain new confidence, and he was also a gadfly, goading America out of its lethargic philistinism. This dual function grew out of Stieglitz's attitude toward art and society—an attitude which was characteristic of the entire period of modernism in American art.

Stieglitz understood clearly the great schism between art and society as it exists in our time. Faced with this situation he assigned to society, to the great unappreciative mass of the public, the role of villain, and to the disinherited artist the role of hero. Confirmed in his belief in their essential antagonism, Stieglitz could not envisage a reconciliation between artist and public. His solution was, therefore, the fostering in isolation of individual artistic genius. In his own mind and in his disciples', he intensified the nature of the schism by glorifying the artist and sanctifying artistic labor. In a country where all artistic activity was suspect, he, like Henri, insisted upon the nobility and importance of art with an almost religious fervor. To Stieglitz the emanations of the artistic soul were miracles to be cherished. He was willing to act for the artist as a buffer against the unfeeling world. "291" became the symbol of

John Marin, *Tyrolean Mountains*. Ferdinand Howald Collection, The Columbus Gallery of Fine Arts

perfection in a vacuum, an oasis in the desert of crass commercialism where the creation of beauty was the sole objective and beauty itself was enshrined. Stieglitz believed, as an intense individualist, that reform could be achieved only by influencing isolated, responsive individuals. He saw progress not in the general education of the mass of people but as the result of individual achievement.

Whereas Henri believed in art as the expression of life, as part of life, and life as the province of art, Stieglitz saw artistic creation as an end in itself. He tended to consider the satisfaction of creation as the sole justification of life; he saw the creative process as a mystic phenomenon and art as the only true expression of the individual in our mechanized society. In spite of his dependence in photography upon a mechanism, the camera, Stieglitz was essentially anti-scientific in outlook, motivated largely by the same craft attitudes, for instance, as was William Morris at an earlier date in England. But, whereas Morris was tinged with socialism and accepted the machine as a means of mass production, Stieglitz distrusted both mass reproduction and mass education as a lowering of the standards of perfection. He believed that the further one moved from the

40

spontaneous expression of the spirit and the individual manipulation of material the further one departed from the true basis of art.

This singularity and exclusiveness of artistic activity was antithetical to the democratic ideal. "Democracy in art is the most illogical formula of reformatory ideals. . . . It is naught but the belief of good-natured, harmless, sermonizing little souls, foolish enough to think that they can remodel the world . . . art is by the few and for the few. The more individual a work of art is, the more precious and free it is apt to be; and at the same time, as a natural consequence, the more difficult to understand." Thus spoke one of the Stieglitz circle, and, insisting upon the necessity for superior sensibility in the enjoyment of art, he added, in writing of a Lautrec print, with sublime snobbery, "Should a pale seamstress or a fatted tradesman feel the same joy in contemplating it? Preposterous! . . . It would lose its subtlest, most intimate charm, if it were shared by the diffident crowd."[3] The glorification of the superior individual, his isolation from the common herd, the absorbing search for perfection, all led to a snobbish cultism.

As great as was Stieglitz's belief in individualism he conceived "291" as an ideal community of related and responsive spirits, as a sort of intellectual family with himself as the patriarch.

But Stieglitz's ideal of a family group of sympathetic creators did not last very long, perhaps, as Paul Rosenfeld thought, because of the inability of the artists to live up to the ideal, but also because that ideal was too closely identified with the personality of Stieglitz, whose messianic poses and monologues and dominating egocentricity alienated many of the group. Finally the war called an end to "291" and the Intimate Gallery which Stieglitz ran from 1925 to 1929 lacked its glamor and importance.

During the time of its existence, "291" was the focal point of all the leading modernists, and here before anywhere else they got a hearing. Many of our leading artists were launched or helped by Stieglitz—John Marin, Max Weber, Arthur G. Dove, Charles Demuth, Charles Sheeler, Abraham Walkowitz, Georgia O'Keeffe, Marsden Hartley, Oscar Bluemner, Alfred Maurer. In renouncing modernism for the newer artistic fashion of the "American Scene" Thomas Craven in his usual defamatory style characterized "291" as a "bedlam of half-baked philosophies and cockeyed visions," where Stieglitz

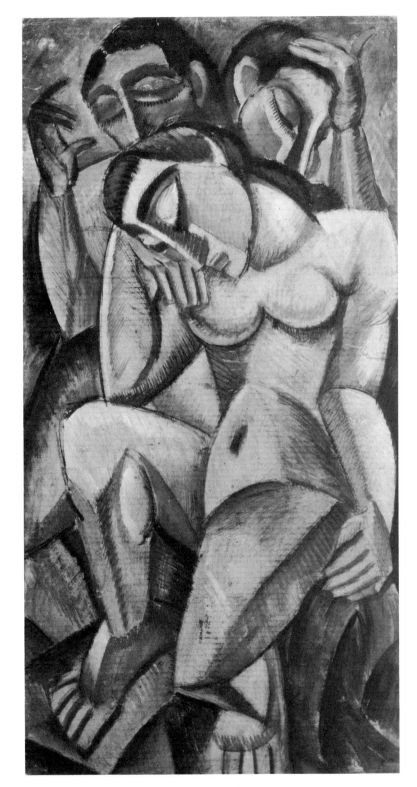

Max Weber, *Composition with Three Figures*
Collection of the Artist

41

Alfred H. Maurer, *Landscape with Farm*
Private Collection, courtesy Bertha Schaefer Gallery

"shrewdly managed to hold the position of arbiter, to maintain a reputation for superior acumen." He further accused Stieglitz, "a Hoboken Jew without knowledge of, or interest in, the historical American background"[4]—in a manner that may itself be judged un-American—of misleading American artists and popularizing foreign influences. Aside from the fact that it is ridiculous to blame so pervasive an artistic movement upon the connivance of one man, it is also true that Craven himself had only recently become conscious of American backgrounds, and until his conversion had been tub-thumping for these same foreign influences in the *Dial*.

After the depression, when art recaptured some of its social status and attained a greater degree of social orientation, Stieglitz had lost his contact with the newer currents. By that time he had renounced the dominance of French modernism, which he had helped to publicize, as the new merchandise of Fifty-seventh Street. In his last gallery, An American Place, opened in 1930, he was no longer the hub of artistic activity, but only personal representative for his faithful protégés, John Marin, Arthur G. Dove, and Georgia O'Keeffe.

At about the time Stieglitz was beginning to propagandize for modern art, several American artists who had been in Paris and had imbibed new ideas returned home. The first of these, Max Weber, came back in 1908 after three years in Paris, during which he had studied under Jean Paul Laurens and Henri Matisse. He had discovered for himself El Greco, Cézanne, and Henri Rousseau. His return and his first exhibition in the spring of 1909 in the basement of the Haas Gallery, a framing shop, was ignored by press and public. A few people came to see it and Arthur B. Davies bought two pictures. Weber met Stieglitz in 1910 and exhibited with Maurer, Dove, Marin, and Hartley at "291." The period that Weber spent with Stieglitz in 1910 and 1911 was important to both men. Whatever their later disagreement, Stieglitz helped Weber financially and morally and gave him a one-man show in 1911. On the other hand, Stieglitz admitted his indebtedness to Weber as the man who taught him about modern art. In 1907 Stieglitz together with Steichen had laughed at the Cézannes exhibited at Bernheim-Jeune. They even discussed a hoax on New York with an exhibition of paintings to be done by Steichen in the Cézanne manner. After his return to America Stieglitz's contact with European art was largely through Steichen and it was not until

Samuel Halpert, *Church Interior*
Collection Unknown

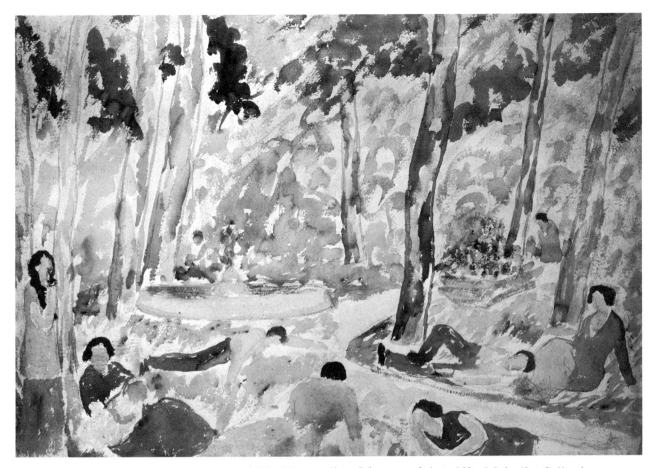

Abraham Walkowitz, *Summer*. Courtesy of The Metropolitan Museum of Art, Alfred Stieglitz Collection

he met Weber that his education in modern art really began. After that, "291" became the rallying point for modern art in America, a place where artists fresh from Paris and its new ideas could find appreciation, a place where people could see at first hand the cause of all the excitement.

Weber in his one-man show at "291" suffered one of the most merciless critical whippings that any artist has ever received in America. His paintings were attacked as "the high-water mark of eccentricity" and the "freakish manifestation of unrest." They were "a strange, insane obsession" whose "ugliness is appalling." "Such grotesquerie could only be acquired by long and perverse practice."[5] Royal Cortissoz, writing for the *New York Tribune*, found Weber's paintings "untrue to nature, ugly, and quite uninteresting" and concluded that "Post-Impressionism in the light of this exhibition need cause no alarm; it is only a bore."[6] Only a few critics recognized in Weber an artist at least of competence and were willing to accord him respect, attention and study.

Also there was Alfred Maurer, son of the famous Currier and Ives artist, Louis Maurer, who had shown brilliant academic promise by winning the Carnegie International first prize in 1901 and, to the dismay of all his admirers, had completely changed his style under the influence of modernism and had begun to paint in the manner of Matisse. When he exhibited for the first time, in March 1909, at the Photo-Secession Gallery together with Marin, his work was received with shocked incredulity. "Frankly, of all the pure forms of imbecility that have overtaken youth time out of mind, these are the limit. . . . To take this seriously is to write oneself down an ass. There is no health, sanity, intelligence, beauty or harmony in the performances. . . . Mr. Maurer had much better come home," was the opinion of one critic.[7]

In 1911 Samuel Halpert came back to America with a style much more easily acceptable than either Weber's or Maurer's. Never a vigorous painter, he had carefully contrived a combination of Cézanne and a rather academic vision. His reception was on the whole favorable.

Abraham Walkowitz, who had returned in 1907, was influenced by modernism only after his return and his contact with "291," and John Marin had not begun to experiment until after 1910.

The artistic ideas which Weber, Maurer and

43

Halpert brought from France and for which Stieglitz began to proselytize were those of Post-Impressionism. Post-Impressionism in itself is a negative and rather vague term. But its use in America was especially reprehensible since it lumped the Post-Impressionists with the Fauves, the Cubists and, indeed, any radical movement in art after Impressionism. America was treated to a telescoped version of French modernism from Cézanne to Picasso, and this lack of historical perspective had a great deal to do with our inability to understand modern art. But of course it did not have everything to do with it, since these ideas even when more logically presented at the Armory Show were too strange for American taste. The coterie around Stieglitz, which had its headquarters at "291" and met for lunch at the Holland House in the Prince George Hotel, consisted of the painters Weber, Marin, Dove, Walkowitz, and Hartley, the photographers Steichen (who still had ambitions to paint), Paul Strand, and Paul Haviland, and the critics Charles Caffin and Marius de Zayas. When they were together the problems and questions of modern art were endlessly discussed. This was the one place in America where modern art received a serious consideration and it was the center where much of the propaganda for it originated.

However, Stieglitz, to whom revolt was personal, was by nature not fitted to carry the fight to the philistine. He was content to build an esthetic haven for the artist. It remained for Arthur B. Davies, to whom revolt implied organization, to bring modernism out of the attic and into the public domain.

The Armory Show

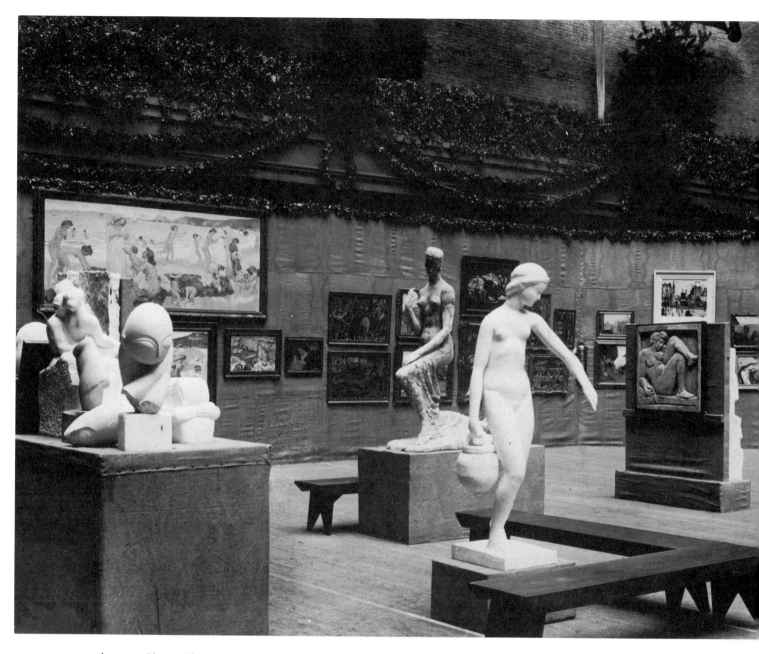

Armory Show, Sixty-ninth Regiment Armory, New York City. Photograph courtesy The Museum of Modern Art

THE EVENT

THE International Exhibition of Modern Art held in New York at the Sixty-ninth Regiment Armory from February 17th to March 15th, 1913, the exhibition known as the Armory Show, was without doubt the most important single exhibition ever held in America. It acted on the complacency of American art like a powerful shock. Smug academicians could attempt to ignore it and act as if nothing untoward had happened, but obviously something had happened, something which all the ignoring in the world could not undo. The artistic revolution, which up to then had been confined to "291" and small art groups, now became a front page event. The "madmen," "fakers," and "degenerates" of contemporary art could no longer be merely hush-hushed and ridiculed; abuse and sneers could not alter the fact that never in our entire history had art struck the public so forcefully. At the Sixty-ninth Regiment Armory, it was dragged out of the musty atmosphere of plush and horsehair and offered to the public as something alive and exciting. The editorials written about it were supercilious or outraged. So were the letters to the editor. Official art acted like an outraged virgin, furious, shocked, and bewildered that such things went on. The public, abetted by the newspapers, came to scoff, had their laugh, but left in bewilderment. Ignorance and misunderstanding were rife, but it was a grand circus nonetheless. Its effect upon the general public was a lowered opinion of Frenchmen and artists, but that opinion was never very high. The effect on the artist was profound and far-reaching. After the Armory Show American art was never the same again.

The history of the Armory Show is full of controversy and factionalism. The written accounts by Walt Kuhn, its secretary, Jerome Myers, and Walter Pach are not in disagreement as to facts but differ in emphasis. Naturally each man who was active at its inception and execution has a different recollection of what went on, dependent upon his own point of view and activity. And then again, the Armory Show was not the sort of thing about which people were objective.

For the origin of the idea of a large exhibition of modern art, we must go back to the Independent Show of 1910. The men who initiated that affair wanted to popularize the newer developments in American art. They believed, justly, that in America art was moribund as to patronage and exhibition. Indeed, it was a general feeling among the younger men that the public ought to be made aware of the full scope of American contemporary artistic achievement. They suffered keenly from the fact that most art buying was in the field of the old masters and of established foreign personalities, leaving the market for their own goods very restricted. They insisted with some nationalistic pride that American art should be given a hearing. Also, with pardonable personal interest, they felt that their own work should be offered to the public in an attention-catching manner. The MacDowell Club group shows were excellent in themselves, but too small and unpretentious to attract sufficient notice, and the facilities offered by dealers were distinctly limited.

Walt Kuhn, Jerome Myers, and Elmer McRae were exhibiting in 1911 at the Madison Gallery, 305 Madison Avenue. From conversations that these three had with the director of the gallery, Henry Fitch Taylor, arose the idea of a large exhibition of American art. A group was formed, which soon consisted of twenty-five members. Alden Weir was elected president, Gutzon Borglum, vice-president, and the Association of American Painters and Sculptors was launched. The question of an exhibition place was a difficult problem which they discussed at length but could not solve. At that point Arthur B. Davies was approached either by Kuhn, as he claims, or by Myers and McRae, as Myers claims. At any rate Davies was won over, although he was reluctant at first, and at the resignation of Weir, who was neither politician enough nor radical enough for the job, Davies accepted the presidency. The introduction of Davies into the picture was the turning point in the history of the project. Unlike the great majority of American artists, he was noninsular in his outlook, a man of culture, with sensitive esthetic taste, wide knowledge, and a liberal mind. He knew not only the art of the past, but also the work of the most radical of his European contemporaries. Furthermore, he was able, through his wide social and artistic contacts, to command the money necessary to finance a large exhibition. He brought a fervor and singleness of purpose to the task. Unhappily it was not matched by physical energy, but this was supplied by Kuhn, as secretary, and several others.

Until Davies became president, the Association was dominated by the Henri group who, in spite of their liberalism, were more interested in the national aspects of the proposed exhibition, and considered the idea of including some of the radical European artists merely for added publicity value. But in Davies' mind the idea grew steadily of presenting a picture of contemporary European art to shatter the narrow provincialism of American taste, and in his enthusiasm it overshadowed the original conception of an American exhibition. An exhibition of modern art at the *Sonderbund* in Cologne, of which he had seen the catalogue, seems to have clinched the idea, and he wrote to Kuhn about it. Kuhn, as a sort of physical extension of Davies' mind, left for Europe to see the *Sonderbund* show and with that trip the gathering of an exhibition of modern art was set in motion. Kuhn tells how, travelling through France, Germany, Holland, and England, he saw the new and revolutionary art of Europe for the first time with mounting enthusiasm, and with the help of Alfred Maurer, Walter Pach, and Jo Davidson, began to arrange for its American showing. Soon a little frightened by the immensity of the undertaking, he called for Davies, who came to Paris. Then Davies, Kuhn and Pach put the finishing touches on the arrangements and the material was all set for the invasion of America.

The plan, when presented to the Association, met with a good deal of resentful opposition. Many of the members had been unaware of the new European experiments, or for that matter even the older ones; made aware, they were set against them, and afraid of their competition. But since they were presented with an accomplished fact, and moreover since Davies was the only one capable of getting financial backing for a large show, the majority of the artists accepted the decision, although with some trepidation. Bellows took over the hanging job, Guy Pène du Bois and Frederick James Gregg saw to publicity, Allen Tucker looked after the catalog, and a committee headed by William Glackens set about assembling an American section.

The original idea of a non-jury show was given up somewhere along the road, and the selection of American exhibitors led to even greater disagreement than did the controversy over the inclusion of the European moderns. Some artists complained that the "Eight" controlled the A.A.P.S., others that Davies personally was interfering in all phases of the show. Leon Dabo, one of the leaders of the opposition, left for Europe just before the show's opening and on the eve of the opening Gutzon Borglum, in a sensational letter to the press, resigned as vice-president. The claim that Dabo and Borglum were the originators and organizers of the Armory Show, although circulated at that time, seems to have no foundation in fact.

Advance publicity had been widespread and provocative, and general interest was high. The hanging committee had done a remarkable job by converting the armory into a series of partitioned areas, the whole decorated with greenery. The size of the exhibition, containing as it did an estimated 1600 works, and the inclusion of last-minute entries created a great deal of confusion. But when the installation was completed and students were marshaled to act as guides, the presentation of modern art to the American public proved on the whole satisfactory. The works themselves proved to be sensational.

The Armory Show was not only a mammoth exhibition in a physical sense, but also a daring presentation of a new and revolutionary art. And even beyond that, it was a coherent and fairly comprehensive presentation of the nature and historic development of current artistic movements abroad.

The exhibition was actually two shows in one: a selection of modern art which was creating such a furor abroad and a cross-section of American contemporary art weighted heavily in favor of the younger and more radical group among American artists, who were, however, not as yet noticeably affected by the former. The American section was actually a representation of the works of those men who had been instrumental in the organization of the Armory Show, whereas the foreign section was a presentation of the new and controversial movements in European art. It was the latter which was the core of the exhibition and the focus of dispute.

Considering the limited acquaintance which Americans had with these European innovations, the selection was comparatively sound. In comparison with similar large exhibitions of modern art held abroad—the *Sonderbund* show in Cologne in 1912 and the two English exhibitions at the Grafton Galleries in London in 1911 and 1912—it may even be said to have been superior. The Armory Show, perhaps because it was slightly later in date, was much more radical in content, including as it did the latest work of the Cubists.

Its major weakness, as was pointed out at the time, was the absence of much of the German tradition of Expressionism and Italian Futurism. The

Futurists, however, had not been included in either the *Sonderbund* or Grafton Exhibitions. Nor were the German Expressionists shown in the Grafton exhibitions. Their inclusion in the Cologne show was natural as an expression of national interest in a native art movement. The absence of works representative of these schools in the Armory Show seems not to have been the result of an ignorance of their existence but due to either circumstance or choice. According to F. J. Gregg, who was connected with the exhibition, Kuhn and Davies rejected the Germans because they felt them to be merely imitators of the French. The Futurists were excluded, it seems, because they insisted on being shown as a group, but they were listed in the explanatory chart prepared by Davies as "feeble realists." A Russian group (although none of the later Constructivist or Suprematist pioneers in Non-Objective art) which had appeared in the 1912 Grafton show was not included in the Armory Show because of problems in timing. Whatever the reasons, then, the exhibition was predominantly French and not as comprehensive as it might have been.

An effort was made to explain this art to the public in terms of the exhibition itself. The nineteenth-century tradition of French painting, beginning with Ingres and Delacroix, was presented as the foundation of the contemporary developments. This section included, according to Davies' own classification: the "classicists"—Ingres, Corot, Puvis de Chavannes, Degas and Seurat; the "realists"—Courbet, Manet, Monet, Sisley, Pissarro, Signac, Cassatt, Toulouse-Lautrec and Morisot; and the "romanticists"—Delacroix, Daumier, Redon and Renoir. Other nineteenth-century masters included in the show but not listed in the chart were Goya, Whistler, Rodin and Monticelli, as well as the Swiss, Hodler. A great deal of space was given to the Post-Impressionist triumvirate—Cézanne, Van Gogh and Gauguin. The contemporary section included the late Impressionists—Vuillard, Bonnard and Denis; the Fauves—Matisse, Marquet, Derain, Vlaminck, Rouault, Dufy and Friesz; the Cubists—the painters Picasso, Braque, Duchamp, Gleizes, Léger, Picabia and Villon, and the sculptors Archipenko, Duchamp-Villon and Manolo; the Orphist, Delaunay, and his American counterpart, the expatriate Morgan Russell, the Synchromist. Among those who did not easily fall into such categories were the only Expressionists—the Norwegian, Munch, the Russian, Kandinsky, and the German, E. L. Kirchner; the sculptors, Lehmbruck, Maillol and Brancusi; the

"primitive" Rousseau; and Laurencin, Dufrenoy, Valloton, Segonzac and Fresnaye. Except for the exclusion of *Die Brücke* and *Der Blaue Reiter* groups and the Futurists, this selection of contemporary European art is still the basis for our present description of modernism. One must admit that even aside from the sensation it created, the Armory Show was an excellent job of exhibition making.

Curiously enough the first two weeks were rather disappointing. Press and artistic public had been reached, but it was not until the third week that the show suddenly caught on with the general public, and then success was assured. People crowded the galleries. The academicians acted aggressively boorish. The public was amused. The press exploited the occasion as a sensation. Odilon Redon was a public success. Marcel Duchamp's *Nude Descending a Staircase* was selected by press and public as the symbol of the incomprehensibility and ridiculousness of the new art. The *Art News* offered a prize for the best explanation of the *Nude Descending a Staircase*, and soon people were finding it difficult to get close enough to look for the nude. Picabia rather than Picasso was the object of most of the ridicule directed against Cubism, perhaps because, sensing its publicity value, he had come to America for the opening and had informed the press that "Cubism is modern painting. I think, in fact I am certain, that Cubism will supplant all other forms of painting."[1] This of course struck a responsive chord, for America in the spirit of progress was intrigued by any new discovery which might supplant outmoded methods. Cézanne, Van Gogh, Gauguin and especially Matisse came in for the largest volume of vituperation from the critics who revealed themselves to be narrow-minded and venomous to an astonishing degree.

While the public expressed in laughter its feeling of shock and uneasiness in the face of the unknown, and artists either came with closed minds and left in anger or came with open minds and left in esthetic turmoil, several collectors saw the light and began to buy. Dr. Albert C. Barnes had already begun to collect Cézanne and Renoir, and he came to the show only to proclaim that he had better stuff. But just as previously Barnes had begun to buy the moderns because he was convinced by Glackens that they were a better investment than the academicians he had been buying, John Quinn now was persuaded by Walt Kuhn that modern art was a good financial gamble. Arthur Jerome Eddy, sensing something new, came from Chicago and

49

bought seventeen modern pictures. And Bryson Burroughs acquired a Cézanne for the Metropolitan Museum of Art, the first ever owned by an American museum.

According to one report the exhibition had an attendance of one hundred thousand, although Kuhn states that the real number will never be known, considering the free tickets issued to schools and societies. Two hundred and thirty-five pictures were sold, evenly distributed between American and European artists, and including practically all of the thirty Cubist paintings. Eventually over a quarter of a million people paid to see the exhibition in New York, Chicago and Boston, and over three hundred pictures in all were sold.

The show closed with a champagne supper and a jubilant parade and snake dance. It had been a success. Even its opponents had to admit that it had "stirred the art interest of the metropolis, and indirectly and reflectively that of the country, to an unexpected degree" and it might "perhaps ultimately create a second so-called renaissance in these United States. . . ."[2]

After being dismantled in New York, the foreign section plus the American works by members of the Association were sent on to the Art Institute of Chicago, where the excitement continued unabated, and, if anything, became even more frenzied, since a scandal-loving public had been prepared by advance reports from New York and was further piqued by the fortuitous outbreak of a morals epidemic in Chicago, which had just recently caused the removal of a Paul Chabas nude, *September Morn*, from a dealer's window and a Fraestad barnyard scene from the Art Institute. Curiosity seekers were entertained by the Institute's vengeful art teachers, who toured the galleries denouncing and ridiculing the exhibits and inciting their students to riot, with the result that Matisse, Brancusi and Walter Pach were burned in effigy. All that was needed was the discovery of six toes on a Matisse nude to make it a journalistic field day. The exhibition was without doubt a smash hit in Chicago.

Boston, however, was made of sterner stuff. There was a slight stir in the morass of Boston academicism, but Brahmin snobbery sailed through the crisis untouched. Disapproval was not clamorous, merely icy with indifference, and the exhibition lost money.

Royal Cortissoz, at the dinner given for the press had said in graceful trepidation, "It was a good show but don't do it again."[3] However, once was enough. Modernism had been shown and it was to have its effect on America, in spite of the ridicule which was heaped upon it.

But for a while ridicule had its day. First, there was the Architectural League smoker, then *Les Anciens de l'Académie Julian.* The Freak Post-Impressionist exhibition held for the Lighthouse of the New York Association for the Blind enlisted the cream of the academic painters to put on a burlesque of the Armory Show, with "psychopathetic," "paretic," "neurotic," "ten Matteawan muralists" and other "nutty" groups represented. The effects were felt as far north as Hartford, Conn., where the Arts and Crafts Club put on a "fake" Cubist and Futurist exhibition.

The controversy raged in the newspapers and art periodicals. Kenyon Cox, acting as apostle for tradition and sanity, spoke in many cities against the heretics. The Fellowship of the Pennsylvania Academy canceled a scheduled lecture on the Armory Show by Robert Henri and substituted an hour of song by a local tenor which was at least not controversial. Also in Philadelphia, which seems to have served as a bastion of conservatism, the Contemporary Club held a meeting at which Kenyon Cox reviled modernism as "cheap notoriety," "incomprehensibility combined with the symptoms of paresis" and "dangerous anarchistic thought." M. Paul Vitry compared Rodin unfavorably with the academic French sculptors Bartholomé, Fremiet and Falguière. William Merrit Chase exploded his long pent-up rage in public by calling Matisse a "charlatan and faker" and Futurism a "gold brick swindle" and "a misdemeanor worse than obtaining money under false pretenses." Chase capped his extemporaneous diatribe by reading an appreciation of Matisse by Gertrude Stein amid great laughter. Only F. J. Gregg, a very mannerly voice in the wilderness, called out for an open mind.[4] But ridicule cannot change the course of history nor laughter impede a good business venture.

The Daniel Gallery, owned by Charles Daniel, former bartender, and directed by Alanson Hartpence, was opened in December 1913, with a first exhibition of modern Americans. In the same month the Carnegie Institute accepted a small exhibition of American "Post-Impressionists." The general tenor of revolt spread even to the National Academy, precipitating, as we shall see, a minor insurrection. In January 1914, Cleveland had an exhibition of "Post-Impressionism" at the Taylor Galleries. The Bourgeois Galleries, handling "old and modern masters," made its debut in February 1914. Before long

"291" and the Folsom Galleries, which had shown the more advanced moderns, Macbeth, who handled the "Eight," and the new Daniel Gallery had competitors. Many new galleries and societies opened their doors to both foreign and domestic modernists. The *Art News* complained in February 1914 that there were current at that time "six exhibitions, devoted to the 'Faddists' . . . in which the artists represented 'run the gamut,' from the Botticellian caricaturist Davies, to the eccentric interpreters of dreams and emotions, Marsden Hartley and Joseph Stella. And the procession goes on. What will the coming Spring Academy resemble after these shows?" The next Academy show managed imperturbably to resemble the last. One of these six "faddist" shows, in the Montross Gallery, offered a group of modern Americans, including Prendergast, Kuhn, Schamberg, Sheeler and Stella, which was later sent around the country, and for several years afterward this gallery exhibited the more radical moderns. Simultaneously the National Arts Club had an exhibition of modern Americans which was an echo of the Armory Show. Duchamp's *Nude* had travelled by now as far as Portland and San Francisco to repeat its New York sensation. The Carroll Gallery in March of the same year exhibited the Synchromists, S. Macdonald Wright and Morgan Russell, for the first time in America. In October 1915 the Modern Gallery, backed by Walter Arensberg and directed by Marius de Zayas, opened with an exhibition of Picabia, Picasso, and Braque. Young Americans also found increasing opportunities for exhibition in small club galleries like the Gamut Club, the Liberal Club, the Thumb Box Gallery and the Cosmopolitan Club. Modernism was capturing America. The physical presentation of this art to the American people was accomplished and the absorption of the new ideas by American artists was accelerated.

As an aftermath to the very successful life of the Armory Show, there was a serious and rather scandalous disagreement within the Association itself, arising out of the conduct of the exhibition. Although the excuse for the row was the accounting of expenses, the cause went much deeper. The old division between the group that had desired an American show and the group that had sponsored modernism now became sharper, for the former saw its art market seriously threatened while the latter felt its position strengthened by the success of the new art. At the annual meeting on May 18,

1914, the question of the financial report precipitated a crisis, and eight members, Henri, Lie, Dabo, Sloan, Sherry Fry, du Bois, Luks, and Bellows resigned. Rather tardily Jerome Myers added his name to the dissidents. The reasons given for the resignations were that they believed in complete freedom from the jury system, that their artistic principles would not be furthered by the society, and that the financial report was not ready eighteen months after the close of the show. They implied that Davies and a clique were dictating the policies of the Association and they discussed the possibilities of a new organization along the lines of Henri's group system.

Davies answered the charge by bringing the issues out into public view. He countercharged that the artists who had resigned were afraid that a change in taste might lead to a decline in the market value of their pictures and that they were interested only in their private merchandise. Although the dissidents had been the least active, he continued, they had also profited by the publicity and sales. They had been discontented with the aims of the Association from its inception and their defection was no great loss. The administration had acted in a conciliatory manner, but the minority had attempted to gain control of the organization. Furthermore, the minority was hostile to the fight against the art tariff; they were more interested in trade values than in the education of the public.

Guy Pène du Bois replied to Davies in the *New York Tribune*. It was, however, not so much an answer as an admission of the cause of the disagreement. He charged again that the books were not straight, insinuated that the Davies' clique had used proxies illegally, answered the indictment of self-interest by countering that the majority was also interested in sales and had become Post-Impressionists overnight because that was the new fashion. He further complained that in organizing the show of moderns at Montross' in February 1914, Davies had implied by his selection that the men included were the pick of the Armory Show. It was obvious from the controversy that the difference was a basic disagreement as to the future of American art, the one faction eager to establish modernism in America, the other anxious to retain the principles and direction of the American realists. The controversy was a death blow to the Association. It never again organized an exhibition of consequence, but then it had achieved considerable honor in its one great task.

51

◈ CRITICAL ATTACK

THE critical controversy which arose out of the Armory Show served not so much to clarify esthetic thought, since it was not conducted on a very logical or informed plane, as to extend the area of conflict. The controversy over modern art became a free-for-all, and every added attack helped to boom not only modern art, but art in general. Even some of its greatest detractors realized that the Armory Show had performed an immeasurable service in publicizing art.

Revolution versus tradition was the pivotal point of controversy. Curiously enough, each side at different times assumed opposite positions and arrived at contradictory conclusions. For instance, on the question of tradition, the modernists claimed that the new art was based on respectable traditions of the past. They asserted that its roots derived from the esthetic laws of all great art, that it dealt with essentials of art lost to, or disregarded by, the academicians. The Armory Show itself was planned to show a consistent development from early nineteenth-century French painting to the moderns. A chart, arranged by Davies as an explanatory state-

ment, attempted a chronological classification, dividing the artists into three major categories: classicists, realists, and romanticists. According to this classification, Picasso and Matisse as classicists were descendants of Ingres; the Futurists were realists ultimately deriving from Courbet, Manet and Impressionism; and romanticism had developed from Delacroix through Daumier, Redon, and Renoir to Van Gogh and Gauguin. Some of the moderns were found to fit into more than one category, as, for instance, Cézanne, who was both classicist and realist, and Gauguin, who was both realist and romanticist.

Although modernism struck Americans suddenly and seemed to them a complete reversal of accepted artistic principles, Christian Brinton pointed out that it had already had a long development, that it was an evolutionary rather than a revolutionary process, and that it was lack of knowledge of the development of modern art which led to the mistaken notion of revolution. It went back, he maintained, to the Orient, to Japan; it revived the age-old principle of simplification; it rediscovered the synthetic vision of primitive man; it was a turn from recent traditions of objective reality to more ancient concepts of subjective synthesis; and its fountain-

Beefsteak Dinner for the Critics, March 8, 1913, Healy's Restaurant

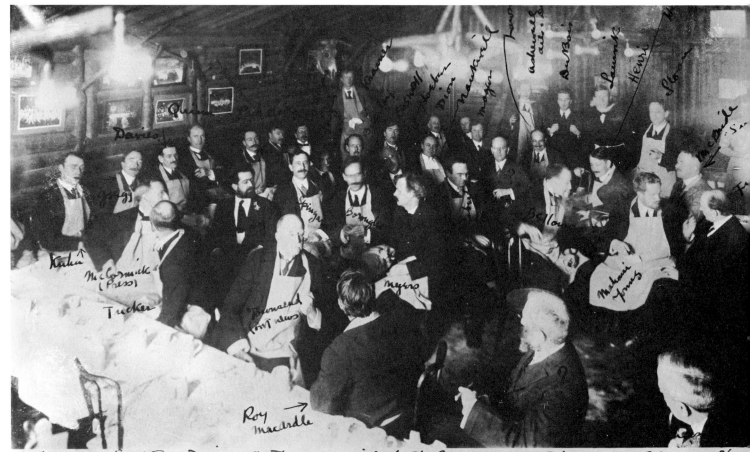

head was the great French artist Manet. To most modernists the new art was a brushing away of academic cobwebs, a sweeping away of accumulated junk, but at the same time a rediscovery of true and fundamental art principles.

The opposition, although it attacked mainly along the line that art must depend upon tradition and that the new movement was revolutionary and therefore bad, on the other hand attempted in some cases to belittle modernism as not being as new as it seemed. The return to the child and the savage, which to the moderns was a virtue, to their opponents was not. Duncan Phillips went so far as to attack it as reactionary, since it was a denial of science and a return to the primitive. And President Theodore Roosevelt, noting a resemblance between Cubism and paleolithic art, and between the *Nude Descending a Staircase* and a Navajo rug, also concluded that the moderns were retrogressive. Here were the moderns insisting that they were the defenders of the true traditions and the academicians scoffing that this revolution was not something new but something reactionary.

When it came to the question of revolution, they very neatly changed positions. The moderns argued that revolution was good and necessary and their opponents replied that modernism was an attack on tradition and that revolution *ipso facto* was bad. The major contention of the moderns was that the new revolution was a sign of life, a proof that art was not dead. In commenting on the Armory Show, Stieglitz said of the modern artists, "If a name is necessary in writing about these live ones, call them 'Revitalizers' . . . They are breathing the breath of life into an art that is long since dead, but won't believe it."[1]

Arthur Wesley Dow, who was influential in the transformation of art instruction in the United States, defended modernism in principle by asserting that the history of art was the history of revolutions, that revolutions were evidence of new energy and that experimentation was to be valued. Most artists felt with Glackens that "Our own art is arid and bloodless. It is like nothing so much as dry bones,"[2] and saw the new art as a clearing of decks for the coming of an American renaissance. The Armory exhibitors were praised by John Quinn because they had the courage to revolt against the lethargy of the public, which was afraid of fundamental changes. If one were anxious to live, then one must accept change, for life was growth and progress.

On the other hand, the conservative group reacted most violently to modernism as an attack upon fundamental laws of art. A great deal of this reaction was hysterical and may now seem bewildering, but it should be remembered that basic concepts previously accepted as almost divine law were being inferentially denied. The curious fact in all this controversy was that the moderns never specifically denied any so-called fundamental law. All this was assumed by the conservatives, for the new art was so completely unlike their own version, that they assumed in it a denial of all previous art. Academic art was built on what they considered tried and true laws, and modern art seemed a negation of these laws. It struck them as nothing less than a negation of the laws of the universe. The good academicians, like puritanical pedagogues, called on God for witness, "For that which is good in art is that which is obedient—that which is beautiful is that which is reverent—obedience to law, order, principle—reverence toward that which is behind, above and transcends law—God!"[3] Thus wrote Edward Daingerfield, implying that the modernists were not only revolutionary but even anti-God. Not as comprehensive, perhaps, but just as vehement was the claim of Kenyon Cox that the "real meaning of this Cubist movement is nothing else than the total destruction of the art of painting—that art of which the dictionary definition is 'the art of representing by means of figures and colors applied on a surface, objects presented to the eye or to the imagination.' . . . Believing, as I do, that there are still commandments in art as in morals, and still laws in art as in physics, I have no fear that this kind of art will prevail, or even that it can long endure. But it may do a great deal of harm while it lasts."[4]

Like Cox, both Frank Jewett Mather, Jr. and Royal Cortissoz saw in the Armory Show an attack not only upon established art, but upon the universe in general. Wrote Cortissoz, "Post Impressionist, Cubist, or Futurist, however they may be designated, their cue is to turn the world upside down,"[5] and Mather, ". . . the layman may well dismiss on moral grounds an art that lives in the miasma of morbid hallucination or sterile experimentation, and denies in the name of individualism values which are those of society and of life itself."[6] The chorus of denunciation was loud even when the tune was a little repetitious. Duncan Phillips, then newly baptized in the cult and finding in J. Alden Weir the best in American art, was unprepared for the

shock of the Armory Show and found that it threatened the foundations of the home. "The bond which holds together the motley army of iconoclasts is the common desire to overthrow the established standards taught in the schools and respected in the homes. They wish to revolutionize modes of thought, life and language by making new measures of value. They wish to make art as democratic as the circus by making it as easy as any other kind of unskilled spontaneous expression. . . . A dread of hard work, a hatred for culture, and a passionate desire to be different—these . . . are the incentives of the hitherto hopeless failures who could not compete with the past. . . ."[7]

There were more specific denunciations as well. In some cases modernism was damned by association with the political anathemas of anarchism, socialism and, after 1917, bolshevism; in other cases, by charges of degeneracy, insanity, immorality, incompetence, charlatanry, foreignism, ugliness, unintelligibility or individualism.

Radical political philosophies like anarchism were such great bogies to the general public that mere association with the term was enough to bring anything into disrepute. Manet and the Impressionists were in their day similarly labeled with the *spectre rouge* and were the object of organized political attack in the 1870's. The critics of modern art did not miss an opportunity to apply the label of anarchy to modernism. Daingerfield characterized modernism as the "chatter of anarchistic monkeys."[8] Cox wrote, "There is only one word for this denial of all law, this insurrection against all custom and tradition, this assertion of individual license without discipline and without restraint; and that word is 'anarchy.'"[9] Mather, admitting that there was value in experiment, modified his remark by adding, "Yet I feel that all such gains in detail come to very little indeed so long as art is unguided by any sound social tradition and left the prey of boisterous and undisciplined personalities. . . . Of course the view is possible that Post-Impressionism is merely the harbinger of universal anarchy."[10]

Another critic denounced modern art as undemocratic and socialistic and warned that the chaos of revolution would be the fruit of its seed. Curiously enough when war broke out in Europe, many of these men believed that it would be the salvation of a Europe suffering from "the licentiousness of over-aestheticism, the dry rot of social ennui and the madness of ultra culture."[11] America, they felt,

must be protected from the results of too much culture. Later on when bolshevism became the *bête noire* of political thinking it also supplanted anarchism as an epithet in the esthetic arena.

Degeneracy, as a corollary to over-refinement or too much culture, was a charge flung at many of the modern masters. This might be a blanket indictment, or specified as degeneracy of the mind or insanity, or as degeneracy of morals or immorality. The charge of insanity was the more popular form of attack. An exhibition of art by inmates of an insane asylum was current in England at about the time of the Grafton Exhibition of 1912. Some psychiatrists made rather rash deductions from comparisons between the work of the Post-Impressionists and the insane, notably Dr. T. B. Hyslop, who published an article in the *Nineteenth Century* magazine which was republished in America in the *Century* and which purported to establish psychologically the insanity of the modernists. This document was resurrected periodically as a sort of artistic "protocols of Zion." Charles Vezin, one of the more frenzied defenders of sanity, at one time offered a reprint of the article free to anyone who would write for it. Other critics did not resort to so-called psychiatric proof, but pronounced the modernists insane nonetheless. Kenyon Cox thought that a visit to the Armory Show was like a visit to a "pathological museum where the layman has no right to go. One feels that one has seen not an exhibition, but an exposure . . . individualism has reached the pitch of sheer insanity or triumphant charlatanism." Gauguin was to him "a decorator tainted with insanity,"[12] and of Rodin's drawings he said, "If they be not the symptoms of mental decay, they can be nothing but the means of a gigantic mystification."[13]

Mather, reviewing the Armory Show, complained, "On all hands I hear in the show the statement, At any rate, this new art is very living and interesting," and he even admitted that "So much may be said for much of the Post-Impressionist and Cubist work"; but, he added, "something like that might be one's feeling on first visiting a lunatic asylum. The inmates might well seem more vivid and fascinating than the every-day companions of home and office. Unquestionably, Matisse is more exciting than, say, George de Forest Brush; it doesn't at all follow that Matisse is the better artist. So is a vitriol-throwing suffragette more exciting than a lady."[14] Duncan Phillips was bewildered by this social malady, of which he did not know the cause,

and he asked why we endured it. He blamed the public for countenancing "paranoiacs" in our midst, and he blamed democratic education because its extension of intellectual and esthetic training was antithetical to a real taste and culture. The Futurists and Cubists were to him "representative of degeneracy in painting," their pictures "mad-house designs," and Cézanne and Van Gogh "unbalanced fanatics."[15]

To those who accepted academic ideals of beauty, the painting of "ugliness" was an immoral act, because it degraded public taste instead of elevating it, as art should, with the result that in many cases ugliness became synonymous with vulgarity and immorality. An anonymous article in the *American Magazine of Art* expressed the general attitude of the academicians. It contended that the deliberate turning of modernists toward the ugly was a menace to the development of art and the retention of high and pure ideals. Nature itself was never vulgar, the human form was the perfection of beauty and to distort either nature or humanity was to desecrate the noblest work of God. Modern art, in stooping to vulgarity, was pulling down the ancient temple of art. Life was lovely and stood for everlasting truth, but modernism strove for deformity rather than perfection.[16] In the same vein Cortissoz thought that whatever Matisse's original ability, it was now "swamped in the contortions of his misshapen figures" and that his paintings were "*gauche puerilities*."[17] Cox elaborated this idea. "His method is to choose the ugliest models to be found; to put them into the most grotesque and indecent postures imaginable; to draw them in the manner of a savage or a depraved child, or a worse manner if that be possible. . . ."[18] Finding in modernism a "professed indecency which is absolutely shocking," Cox went even further by characterizing the art of Matisse as an "exaltation to the walls of a gallery of the drawings of a nasty boy."[19] Harriet Monroe, who should have known better, in an article in the *Chicago Tribune* called Matisse's pictures "the most hideous monstrosities ever perpetrated in the name of long-suffering art."[20] Mather echoed "monstrous" and added "epileptic" and, for good measure, "irresponsible nightmares."[21] In Matisse's *Madras Red* he found "wilful if powerful distortions, a childish symbolism, fairly appalling ugliness." And of the whole school he said ". . . the Post-Impressionist or Cubist picture is spawned from the morbid intimations of symbolist poetry and distorted Bergsonian

philosophy. In fact, the unwholesomeness of the new pictures is their most striking and immediate condemnation."[22] Duncan Phillips in a review of the Independents' Show admitted that he was "unable to throw any light on the perplexing subject of these atrocities enclosed in frames and christened with titles" but they were "indecent," "grotesque" and "stupid."[23] He found Matisse even cruder than Amy Lowell, and he argued that although distortion is in itself legitimate it must be toward beauty and not ugliness. The entire Armory Show appeared to him "quite stupefying in its vulgarity." He announced, "The cubists are simply ridiculous. Matisse is also poisonous."[24] Henry Rankin Poore with impassioned moralism complained, "What of our growing sons and daughters to whom art has heretofore been an education and to whom a visit to an art gallery brought wholesome pleasure. Must they be forbidden the rounds of the galleries lest they be brought in touch with this unsanctity; or shall they persist at the risk of losing the delicate edge which in some American homes is still thought worth preserving. Instead of the robust American art which has commended itself to all Europe as our original product, we now find much that is tainted with this covert lewdness brought here by the progressive 'derivatives' who have sipped second-hand inspiration from the poisoned springs which every Continental art centre has recently developed."[25]

One of the simplest criteria of judgment in the academic rulebook was technical ability. This meant fidelity to nature, which was rather loosely interpreted to cover all the academic manifestations from the poetic mood of the tonalists to the objective luminism of the Impressionists. Faced with the strange searching methods of Cézanne, the decorative distortions of Gauguin, the violent expressionism of Van Gogh, the Fauvism of Matisse with his "child vision," or the analytical fragmentation of Cubism, the immediate and concerted reaction of the academician was to cry incompetency.

The modernists could not draw, disregarded proportions, and painted barbarically, the academicians asserted. This incompetence was assumed to be due to a lack of rigid academic training, laziness, or lack of ability. Edwin Blashfield assumed that the moderns were substituting freedom and feeling for discipline and training, and he decried the effect that such an attitude would have on students seeking to avoid study and to discover short cuts to art, overlooking the fact that the modernists attacked

only academic training and rejected academic methods as a formalized short cut to art. Cortissoz thought Cézanne had never mastered a sound technical method and was "simply an offshoot of the Impressionist school . . . who never quite learned his trade," and Van Gogh's art was "incompetence suffused with egotism."[26] Cox agreed that Cézanne was "absolutely without talent" and went even further back to attack such established masters as Manet and Whistler who, he claimed, "suffered from lack of training."[27] Since Matisse was acknowledged as having once been an expert academic draughtsman, the charge of incompetence was not often leveled against him, that was reserved especially for Cézanne.

However, Matisse was the butt of most of the charges of charlatanry. It was assumed in many cases that modernism was the result of a desire on the part of the artist to hide his incompetence, as well as an attempt to shock and bewilder the public and so to achieve notoriety. Mather warily labeled Cubism a "clever hoax or a negligible pedantry," and in a slightly more adventurous vein, called Futurism "charlatanry and shameless puffery."[28]

Individualism is a time-honored trait of character in the American hierarchy of values, and yet the modernists were reviled for that also. In art, as in all other fields, individualism apparently was considered a virtue only so long as it remained within the established framework of social precepts. The moment it came into conflict with the status quo it became suspect. Sometimes this individualism was labeled irresponsibility, sometimes, when it seemed to have gotten quite out of hand, it was called anarchism. Cox saw the development of nineteenth-century European art as a progressive degeneration from social laws to individual whims, the result of a basic social maladjustment. "The lack of discipline and the exhaltation of the individual have been the destructive forces of modern art. . . ."[29]

Unintelligibility was a corollary of individualism in that the expressive forms of art had become personal rather than social. The moderns were accused, and with justice, of speaking in a language foreign to the public. The answer that the public might attempt to learn the new language the academicians considered presumptuous, to say the least. Cox wrote, "The men who would make art merely expressive of their personal whim, make it speak in a special language only understood by themselves, are as truly anarchists as are those who

would overthrow all social laws. But the modern tendency is to exalt individualism at the expense of the law."[30]

Perhaps the most deep-felt, though often subconscious, reaction of the American artist toward modernism was an antagonism toward its foreign origin. In many cases it assumed a narrow provincialism, suspicious of all that was alien. No statement made at that time, however, can compare with the blatant chauvinism of the retrospective opinion of Thomas Craven, who in 1934 wrote a denunciation of modernism as a capitulation to foreign art. "What fine old American families were represented in this assault on the fortresses of academic culture! Benn, Bouché, Bluemner, Dasburg, Halpert, Kuhn, Kuniyoshi, Lachaise, Stella, Sterne, Weber, Walkowitz, Zorach—scions of our colonial aristocracy! There were other painters of true American lineage —Benton, Burchfield, Chapin, Coleman, Demuth, Dickinson, Hartley, Marin, McFee, O'Keeffe, Sheeler, Wright and Yarrow, but most of them at this time, thanks to Stieglitz and the French, were alien in method and point of view."[31] This foreign invasion was viewed with alarm both as destructive of American tradition and as a competitive threat in the art market. Jerome Myers, rather sadly, bewildered at what had grown out of his pleasant ideal of an American exhibition, complained that "Davies had unlocked the door to foreign art and thrown the key away. Our land of opportunity was thrown wide open to foreign art, unrestricted and triumphant; more than ever before, our great country had become a colony; more than ever before, we had become provincials. . . . While foreign names became familiar, un-American propaganda was ladled out wholesale."[32] Others, however, welcomed the coming of foreign artists and influences, seeing in them a harbinger of an American renaissance or a shift of the art capital of the world to America. Frederick MacMonnies, for instance, believed that foreign artists should be welcomed no matter what their ideas and considered the invasion the fortunate "inception of a brilliant era for America."[33]

If the level of criticism was low, it was because American critics were as unprepared for the European visitation as they were for an exhibition of art from Mars. They knew neither the background nor the philosophy of these new movements. Christian Brinton wrote, "We are indeed a fortunate people. Separated from Europe by that shining stretch of

56

sea which has always so clearly conditioned our development—social, intellectual and aesthetic—we get only the results of Continental cultural endeavor. We take no part in the preliminary struggles that lead up to these achievements. They come to our shores as finished products, appearing suddenly before us in all their salutary freshness and variety. The awakening of the American public to the appreciation of things artistic has, in brief, been accomplished by a series of shocks from the outside rather than through intensive effort, observation, or participation."[34] But why this should have been considered a fortunate state of affairs is not clear, considering that it left us unprepared to meet the shock of each incomprehensible innovation. In this case, the reaction had been either a complete traumatic experience, affecting the rational brain processes, an instinctive counterattack against what was alien, or an attempt to laugh the whole thing off as a passing aberration or hoax.

Beginning with the earlier "291" exhibitions, the critics produced a really remarkable body of vituperation. Cortissoz, attempting to brush the whole business aside like a pestiferous fly, called modern art "a gospel of stupid license and self-assertion which would have been swept into the rubbish heap were it not for the timidity of our mental habit. When the stuff is rebuked as it should be, the Post-Impressionist impresarios and fuglemen insolently proffer us a farrago of super-subtle rhetoric. The farce will end when people look at Post-Impressionist pictures as Mr. Sargent looked at those shown in London. . . ."[35] Duncan Phillips was afraid of all the attention being given to "extravagant fools" and counseled that if neglected they would certainly die out.

There seems to have been a generally hopeful attitude that modernism was a passing phase which would soon be forgotten, and there were periodic reports from abroad that it was already dead in France and was seeking its last refuge in America. Harry B. Lackman, the American painter, just returned from Europe at the outbreak of the war, assured America that modernism was dead just as earlier Dr. Abraham Bredius, touring America, advised us that "painting is dying in France." Perhaps the final seal of reassurance was offered by Thomas E. Kirby, the noted art auctioneer, who felt called upon to interrupt an auction at the Plaza ballroom to advise the audience that modern art was a "temporary craze" which "would soon pass and that

such art as that exemplified by Gérôme, Meissonier, Rosa Bonheur and Bouguereau would come again into its own."[36] But even the *American Art News*, although it was willing to agree that modern art was a passing phase, thought the latter prediction a little rash.

With the outbreak of the war, the opinion grew that war would cleanse Europe of this cancerous decadence. Duncan Phillips unconsciously even echoed the fascist philosophy of Futurism, which he so vehemently opposed, when he said, "War is a good cleanser. We need war. For if war is itself a madness it is also a cure for madness."[37] All in the hope that modernism would be destroyed. But neither scorn, nor disregard, nor vituperation, nor war saved America from modernism.

What did the Armory Show do for American art? Was it a sellout of American traditions, a surrender to "an imported ideology"? Or was it the coming of age of American art? One must disregard the vicious connotations which Craven implies in "imported ideology" and which a whole school of critics made use of at the time, but it is true that the Armory Show cut short a developing tradition of American realism. However, it is also true that the Armory Show for the first time brought America abreast of European developments. Before this, American art had managed to absorb European influences a decade or more after those forces had reached their height abroad. Even at the Armory Show we can observe this cultural lag at work; for Cézanne, Van Gogh, and Gauguin were there presented comprehensively for the first time and appeared as scandalous as the Fauves or the Cubists. But now the latest European movements and artists also were represented. We were, then, again importing influences, but importing them while they were still alive, and that was in itself progress. Our artists abroad would no longer blindly seek out the academy when there was a living tradition to be found. Europe's museums and vital artistic traditions rather than the formal training and prizes of the academic *ateliers* would be the mecca for our young students. We already had representatives like Weber, Maurer, and Halpert, who had taken part in the development of modernism. But further, whereas Whistler and Cassatt had found Europe necessary for their continued artistic activity, these men of the later generation found that they could return to their native land.

Modern European art had been shown at "291"

and the Folsom Gallery, but the Armory Show was the first comprehensive exhibition of the new art and the first to achieve enough publicity to affect the attitude of the public. The effect of this publicity cannot be overestimated, for it was the opening wedge for all later exploitation of modern art. The public was made aware of the existence of a strange phenomenon which it could investigate if interested. The art market was revolutionized by the introduction of a new, limitless, valuable product which changed almost seasonally, thereby periodically renewing the consumer's market.

The American market for European academic painting was almost immediately wrecked and that for our own academicians followed not long after. Artists could not help but react to the powerful challenge of the new art. They felt the surge of new life and vitality as it shattered the dullness and the aimless maunderings of academicism. Many of them plunged into the new experimentation and were exhilarated by it; some found the going too difficult and got out very soon; others drifted along with the current; while a few, and only a few, struck out boldly and made their own way.

Maurice B. Prendergast, *Flying Horses*. Kraushaar Galleries

◈ AFTERMATH

THE spread of modern art in America has sometimes been described as a contrived commercial campaign to sell French art. The art dealers, both European and American, realized immediately after the Armory Show that there was a market for modern art in America, or that at least one could be stimulated. But it should be remembered that a receptive public was necessary before such proselytizing could be effective. The art-buying public could not have been high-pressured into acceptance by dealers if it had not been educated first by the American artist. American artists brought back to these shores the news of modern art; American artists organized and collected the Armory Show, American artists were instrumental in the formation of many modern collections. It was Davies who helped form the Bliss collection, Glackens who convinced Barnes that Renoir and Cézanne were good investments, and Kuhn who talked Quinn into buying the new art. These American artists were not being sold a bill of goods by the dealers, but were making a revolution for art's sake. As it happened there were dealers who were wide-awake enough to climb aboard the bandwagon when it got under way, and eventually modernism became the fashion. It was then, when the art market had changed, that some of our artists became modernists because modernism was fashionable and offered the path of least resistance. But to understand the infiltration of modern art in America, it is necessary first of all to understand modern art as a social phenomenon, for it is not an aberration nor is it the product of a dealer's commercial dream, but an outgrowth of social conditions.

Although modern art was a foreign importation, it was acceptable to American culture because it fulfilled the needs of a vast unrest not confined to America alone, an unrest universal in the western world, an unrest which permeated all the arts. Modern art in general is socially predicated upon a chasm existing between the attitudes of the advanced elements of the cultured group and the general concepts fostered by the dominant class in society. This intellectual group attacked what it considered to be the narrow "tradesman's" morality of the middle class, its deification of success, its predatory scrambling for wealth and power, its un-ashamed acceptance of the evils attendant upon its anarchic rapacity, its denial of a basic human morality in its attitude toward exploitation or war; for, although it may have accepted, consciously or unconsciously, the basic economic and political ideas of the larger group of which it was a part, it had early in the history of the ascendancy of the middle class, in the first years of the nineteenth century, proclaimed its disavowal of the intellectual and cultural consequences of that society. The schism once created, with time grew wider and wider until the artist accepted as fundamental an individualistic and non-social attitude, and in some cases actually proclaimed an anarchic and anti-social philosophy. The energy which motivated the revolt against middle-class values did not seek channels of social expression, because the artistic group was still dominated by the social values of that class. Its energy was directed to purely cultural revolt, and toward this end it had already developed a non-social heritage and non-social forms. The concept of art for art's sake, which is nothing more than a philosophical acceptance of a social condition wherein art is disenfranchised, became with time the curtain behind which art developed without social check to the heights of individual and personal expression.

Isolated artists, or even groups of artists, can turn to social revolt only when they identify themselves with a class in social revolt. The artists during the nineteenth century who identified themselves with various insurgent groups and expressed social attitudes are the exception. The great majority, those who make up the major artistic tendencies, did not fight against their social dislocation but even intensified that dislocation by accepting it as a basic principle of their artistic credo. They fought instead against the established esthetic concepts of their society. The dynamics of an art predicated upon individualism will inevitably lead to the exploitation of the limits of individual expression. The activity of one or even a few artists along social lines did not disturb the general development of the dominant individualistic tendency of art. It is only when new social attitudes are evolved that art alters its directions.

This is important, for in the Ash Can School America had a socially oriented art. The fact that it was superseded by the radically non-social art of modernism is testimony to the inherent weakness of its social position. As an expression of middle-class

59

revolt it suffered from the same weaknesses which beset the social movement itself; and in the disillusionment which followed the war its individual members gave up the ghost, leaving the field to the non-social modernists. The younger artists looked upon the new art as an answer to their own dissatisfaction with academicism, the emptiness of which was apparent. The infinitely reiterated academic formulas had become meaningless impediments. The modernists' search for what they called basic principles aroused the questing spirit of American artists. It was a call and a promise. It talked of elemental concepts, of color, of form, of design. It denied the dead hand of dogma and the gloss of technique. It offered to troubled minds the promise of stripping art to essentials; it gave them the illusion of struggling with fundamentals. They felt that at last American art was coming to grips with basic artistic problems and they felt for the first time a true brotherhood with all the greatness of the past. Modernism in its arrogant disregard for the public and its militant exaltation of the artist as a genius above the judgment of the philistine mass, offered the American artist a sense of self-esteem which was a far cry from his natural feeling of social inferiority. From pride in technical ability he turned to pride in himself as a creative personality. And so, many of them gave up almost overnight the painting of academic pictures and went to work on "fundamental problems" and "personal expression."

The hardened academicians of course remained untouched, but the Henri group, the realists, the former leaders of revolt did not escape the impact of modernism. However, almost to a man they and many of Henri's students could make no adequate adjustment, simply because the social attitude was so strongly ingrained in their artistic outlook. They might open-mindedly admit modernism as having experimental value; they might even personally dabble in it, but they never publicly succumbed to the modern influence. Their belief in art as an expression of life, their cultural identification with the people, their sense of social responsibility did not permit them to wander away in personal exploration of esthetic problems without reference to social reality. In their revolt against the Academy they had tried to substitute living reality for the preoccupation with formulas of the past; now they could not accept the modern preoccupation with abstract formal problems. In his attitude the modernist differed from the academic painter who accepted his non-social position only in that the former proclaimed his non-social outlook as an artistic virtue.

Of the "Eight," three—Davies, Prendergast, and Lawson—were not realists, and in their art the influence of modernism is evident. Prendergast, before the Armory Show, had the most radical style of the "Eight." He was the one man in America who had had some personal contact with the older giants of modernism, perhaps the first to recognize the significance of Cézanne, whom he fondly called "Old Paul." Prendergast was by temperament incapable of proselytizing, but in his seclusion he had evolved a style which was a direct outgrowth, in fact the only original American outgrowth, of Impressionism. Prendergast developed an individual decorative technique, in which the dabs of color became so large that they were no longer subservient to the "scientific" rendering of light but instead became components of a colorful mosaic pattern. After the Armory Show his later development was toward a more vigorous patterning and an almost Fauve-like simplicity of form. But the modernist movement was important for him not so much because it affected his style as because it made the public

Maurice B. Prendergast, *Portrait of a Child*
Kraushaar Galleries

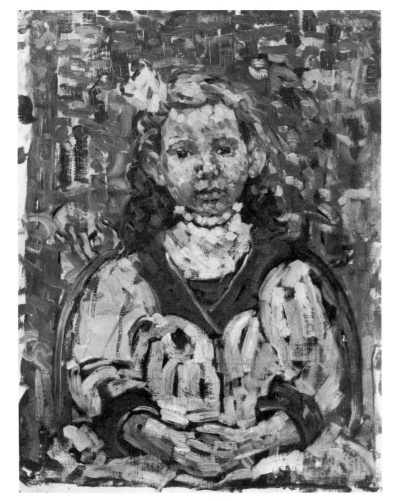

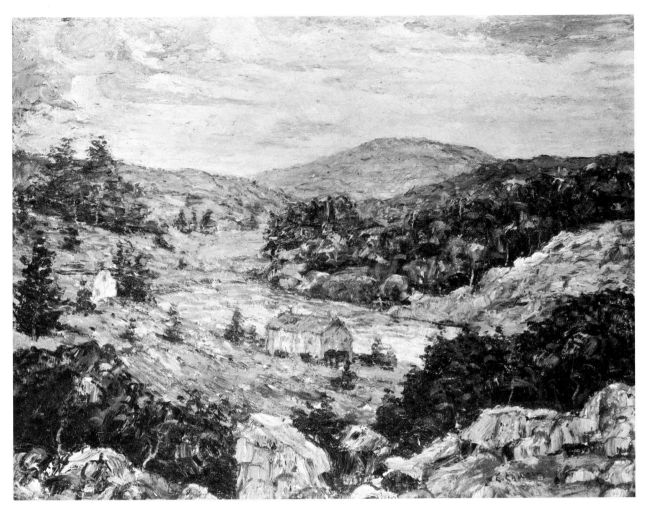

Ernest Lawson, *The Valley*. Ferdinand Howald Collection, The Columbus Gallery of Fine Arts

conscious of his existence. It took the Armory Show to disclose that America had an artist who had been quietly working for years in the modern tradition and it was only after the show that Prendergast began to get the recognition he deserved but never sought.

On the other hand, Ernest Lawson, who had been an orthodox Impressionist, after the Armory Show was more obviously influenced by Cézanne. Acquaintance with Cézanne's painting convinced him that Impressionism had lost contact with form in its insistence upon surface light, and in his later work he made an obvious attempt to recapture solidity. Although he never completely assimilated Cézanne's structural methods, Lawson managed to introduce a measure of form into his art and some resemblance to the Aix master. At least, in the later paintings his color became richer, with an almost crushed-jewel opalescence, as he dropped the coloristic haze and the pastel prettiness inherited from Twachtman.

Although Davies at the time of the Armory Show was a man of more than fifty, an artist with a peculiarly individual style, the show influenced him more profoundly than it did any one else of the "Eight." A product of the tonalist school of painting and Whistler, he had developed a unique decorative style. He was completely eclectic, with archeological fervor seeking minutiae of beauty in the art of the past, reflecting an amazing number of influences and yet retaining a personal flavor. There were influences from Italian art, especially Botticelli, in his linear rhythms and a connection with the English Pre-Raphaelites in his idyllic fantasy. It seems he resented the imputed dependence upon Italian art and proclaimed instead his kinship with Greece, but here again not the Greece of the classical period and the monumental style, but the more intimate style of Hellenistic illusionism, Pompeiian frescoes, modelled terra cotta, and luxury objects. His closest connections with European painting were perhaps with Puvis de Chavannes and Hans von Marées, with whom he shared a predilection for noble composition and, especially with Marées, a rapturously sensuous romanticism which was at the same time fragile and intellectual. He was a

61

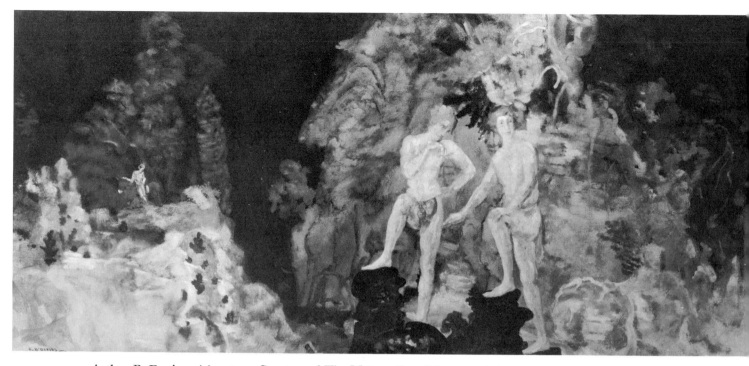

Arthur B. Davies, *Adventure.* Courtesy of The Metropolitan Museum of Art

fastidious and sensitive craftsman, enamored of the emotional quality of color, and with a mind intensely alive, if not profound.

Davies' intellectualism had led him to dabble in esthetic theory, first in the relationship of sound to color and then in the curious idea of "inhalation."[1] It was to interest him also in Cubism, which appealed to him as an intellectual system and at the same time as an experiment in abstract color and rhythm. The Cubist style which Davies contrived was far removed from the analytical Cubism of the French painters Picasso and Braque, and was based on a rather superficial knowledge of its principles. Even his most radically Cubist pictures are based on a "realistic" drawing upon which is superimposed a prismatic patterning of color and line. The pattern is usually achieved by simplifying the underlying anatomical structure into geometric shapes and by accenting and coordinating the major rhythmic lines. The color is high-keyed and arbitrary. The basic material form is never destroyed or rearranged. Full of sweeping rhythmic lines and prismatic facets of color, it resembles the German translation of Cubism by men like Franz Marc more than it does the original French.

The other members of the "Eight," the five who were the nucleus of the realist school, did not entirely escape the tide of modernism. Glackens had already been influenced by French Impressionism, so that his transition to Renoir was quite natural.

After he gave up illustrating and turned exclusively to painting, his style became more and more Renoiresque, and in his subject matter, in conformity with the same French tradition, he left the land of slums and poverty and took up instead the picturization of the activities of the leisure class. This mutation is not at all strange if we remember that Glackens' interest in realism was fundamentally an illustrator's interest in the picturesque. His earlier style may have had less of the mark of "art" upon it, but his later manner with all its competence was merely a minor echo of his French master.

Shinn, very soon after his arrival in New York, had become interested in the theater, painting portraits of actors, decorating interiors of theaters, and even writing plays. Long before the Armory Show he drifted away from the Ash Can School. His revival of eighteenth-century French Rococo style made him a popular interior decorator but did nothing to enhance his position in the American artistic scene.

Henri and Luks were unaffected by the Armory Show, but Sloan eventually was converted to a new attitude. He recognized in modernism a movement toward the roots of art and he considered it a "medicine for the disease of imitating appearances."[2] He saw in Cubism not art but the grammar and composition of art. He became engrossed in questions of form and finally gave up realism in a search for a technique of rendering form three-dimen-

62

sionally. The resulting cross-hatched nudes of the late twenties and thirties are one of the tragedies of American art. The impact of modernism in this case was so strong and yet so completely unassimilable that Sloan, set loose in a field where he was neither emotionally nor intellectually acclimated, was destroyed as an artistic personality. His impassioned attempts to defend the validity of his conversion and his own belief in the importance of his experiments cannot hide the fact that his later work is negligible.

The stimulus of revolt was felt even within the rigid confines of the National Academy. Although in no sense connected stylistically with the new movements in art, the many dissatisfied artists of the Academy absorbed some of the pervasive unrest and, deriving from it a new measure of courage, staged a rebellion within that citadel of conservatism. The abuses of the annual exhibition system had long rankled among unrecognized artists and the revolt flared in December 1913 when not all of the "accepted" pictures were hung. This dissatisfaction was aggravated to some extent by the hanging of two landscapes by Mrs. Woodrow Wilson, an act which many artists considered blatant favoritism.

Led by Ernest Albert, the dissident artists planned an exhibition of "rejected" works. But the great difficulty in such an undertaking was still the important problem of prestige. The better-known artists, even if sympathetic, were rather loath to make themselves unpopular with the Academy, while the lesser known artists were afraid of advertising their failure. However, they derived added courage when Caroll Beckwith, an academician of unquestioned high repute and conservatism, issued a statement calling for a new society. Sixty artists answered Albert's call and an "unhung" show was planned. John W. Alexander, president of the Academy, attended the meeting and made a speech in which he attempted to direct their dissatisfaction away from the Academy and toward the support of the pet expansion project of the institution. The abuses, he claimed, were merely due to lack of space; once the Academy had larger quarters, its policy could become more liberal. The group continued its plans, however, and constituted itself the National Society of American Artists, very soon renamed the Allied Artists of America.

The group claimed that it was not in opposition to the Academy but was interested in giving Ameri-

Arthur B. Davies, *Dancers.* The Detroit Institute of Arts

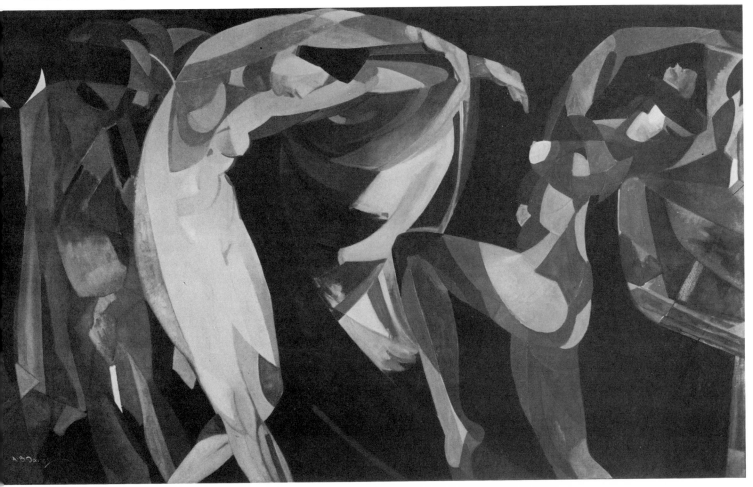

can art wider scope. It announced that the movement was "in no sense an art revolution," that they had nothing to do with the "extremists," but were simply attempting to stir the Academy out of its rut and to awaken public interest.[3] This of course was an admission that the Armory Show had aroused an uncomfortable amount of interest and that something drastic had to be done to counteract the new competition. The stated purpose of the Allied Artists was to find new exhibition facilities for New York artists. Lacking both a vital program and the courage to carry on a vigorous fight, the organization never became anything more than an adjunct of the Academy. The artists of both academies continued their seemingly endless production of formula pictures.

Meanwhile the more radical artists intensified their assault upon accepted artistic dogmas. January 1914 saw a group of American moderns exhibiting at the National Arts Club. In March of the same year the Synchromists invaded America with their first exhibition at the Carroll Galleries. The Synchromists were Morgan Russell and Stanton Macdonald-Wright, two Americans who had studied in Paris. Russell, who had been a pupil of Henri in America, was swept into the stream of modern painting when he went to Paris. With a basis in the painting of Cézanne, common to most of French modernism, and a good deal of philosophical gymnastics, also common to French modernism, he formulated a system of "color orchestration" to "build form." Macdonald-Wright, who had no formal training, painted in the Impressionist manner until he met Russell in Paris, when he discovered Cézanne and began to experiment with color in relation to space. Together they devised a system which was an abstraction of basic Cézanne principles. They attempted to realize form in space through the optically regressive or aggressive nature of colors, at the same time tending toward increased abstraction. In 1913 Russell exhibited the first Synchromist painting, *Synchromie en Vert*, in the *Salon des Indépendants*. Macdonald-Wright had two paintings in the show which were as yet strongly under Matisse's influence. In June of the same year the first Synchromist exhibition was held in Munich and in November it came to Paris at Bernheim-Jeune. Accompanying the exhibition were two manifestoes in the accepted modern tradition, directed against their special enemy, Orphism, an enemy, incidentally, upon which Synchromism leaned rather

heavily. Perhaps the attack was so vehement because Russell and Macdonald-Wright had borrowed so unblushingly from the Orphists. Historically Synchromism is one of the integral steps in the general development of French modernism, exploiting a formal idea derived from Cézanne. Though its influence was temporary and limited, Synchromism was the most advanced and radical manifestation of abstract art in those years.

When he returned to America in 1913, S. Macdonald-Wright convinced his brother Willard Huntington Wright that Synchromism was "the" new art. The latter found it an answer to his desire for "scientific" method in art and, intrigued by the finality of its philosophical program, he tried to prove in his book, *Modern Painting*, that it was the last step in a progressive development of esthetic theory. This unqualified defense of Synchromism diverted and finally ruined one of the most promising art critics America had produced up to that time. The evaporation of Synchromism led Willard H. Wright to an unreserved espousal of the color organ as the visual art of the future, and finally to fame as a writer of detective stories under the pseudonym S. S. Van Dine. S. Macdonald-Wright found refuge in Chinese philosophy and Morgan Russell faded into oblivion.

Futurism, in its original, official Italian version, had been ignored by the Armory Show and its leader Marinetti was piqued to the point of banning it forever from America. J. N. Laurvik, who was in charge of the art section of the Panama-Pacific Exposition at San Francisco in 1915, managed with perhaps not too much effort to get Marinetti to rescind the ban and send a group of Futurist works, including paintings by Balla, Boccioni, Carra, Russolo and Severini. At the Exposition they had a room to themselves. The catalog of the Exposition also contained a Futurist manifesto covering nineteen points, an attack directed equally against tradition and French modernism. Aside from the work of some Americans, the rest of the Fair contained no modern art, since the French section, like all the national sections, was an official representation and therefore completely academic. There was nothing more advanced than Renoir, Degas, Signac, Marquet, Redon and the three late Impressionists, Denis, Bonnard and Vuillard. Although the Futurists were something of a sensation in San Francisco, their effect upon American art as a whole was negligible, proof again that New York was beyond

doubt the artistic center of the country, but also that the nihilism of Futurist thinking was completely foreign to the American mind of that period.

In the years immediately following the Armory Show, it became evident that the Americans, neophytes in modernism, could not successfully compete with their more famous French contemporaries. The feeling that the Armory Show had given the latter a little too much publicity persisted among many of the Americans and in an effort to bolster the market for American art the Forum Exhibition was held at the Anderson Galleries, March 13 to 25, 1916. Its instigators were Alfred Stieglitz, John Weichsel, W. H. Wright, W. H. de B. Nelson, Christian Brinton and Robert Henri, and the artists were a group selected from among those associated with Stieglitz and Daniel. In answer to the contention that American modernism contained much that was bad and that the Armory Show had unfortunately not established standards of value, the Forum Exhibition was announced as a "critical selection" of "good examples" which should set the standard for the public and help to educate it to an appreciation of modern art. It was also hoped that an exhibition of more modest dimensions than was the Armory Show would help to create closer contact between the artist and the public. As a step toward such a closer understanding the catalog contained introductory remarks by the sponsors and a short statement of intention by each of the sixteen participating painters. The exhibition itself was important in that it showed what the Americans had been doing in the three years since the Armory Show.

The various statements as well as the works of art showed a unanimity in basic concepts. There was an insistence upon the "pure" in art and a denial of subject matter and reality. The tendency toward abstraction was evident in such titles as *Figure Organization No. 3* by Thomas Benton, *Improvization* by Andrew Dasburg, *Movement* by Marsden Hartley, *Organization No. 5* by S. Macdonald-Wright, *Invention—Dance* by Man Ray, *Cosmic Synchromy* by Morgan Russell. Even Benton, who was one of the less abstract artists, wrote that he believed "the representation of objective forms and the presentation of abstract ideas of form to be of equal artistic value,"[4] while on the other end of the scale Macdonald-Wright, Russell and Dasburg went all out for pure art unencumbered by recognizable objects.

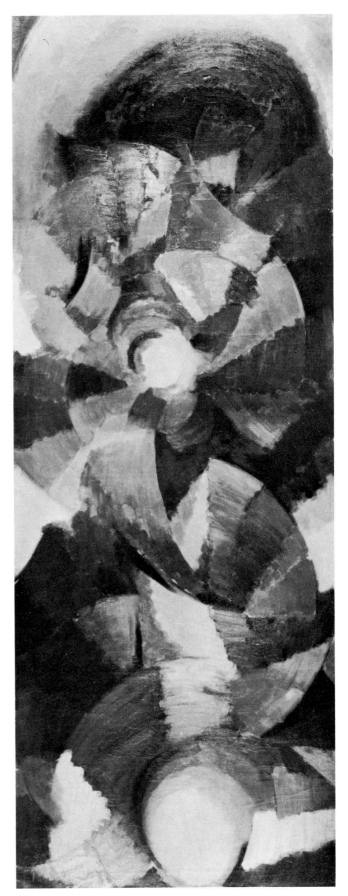

Stanton Macdonald-Wright, *Conception Synchromy*
Stendahl Art Gallery

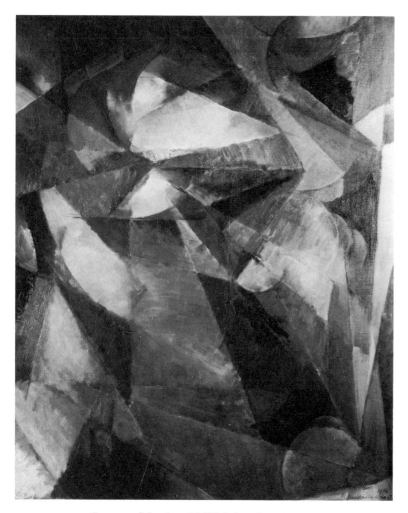

Stanton Macdonald-Wright, *Synchromy*
Collection of Mrs. Robert F. Shawan

Marin, McFee, Man Ray, and Sheeler. Dasburg joined the ranks of Macdonald-Wright and Russell as a Synchromist while Dove, Walkowitz and Hartley were experimenting with a personal style of abstraction. George F. Of alone went back to an older tradition in his allegiance to Renoir.

The Independents' Exhibition in 1917 was the culmination of a long anti-Academy struggle. It united the liberal academic artists and the modernists on the platform of "No jury—No prizes." The development of a vital and varied art in France was ascribed to the opportunities of exhibition offered by the *Salon des Indépendants* and it was believed that American art could flourish only if it were given the same freedom from conservative juries and academic standards. It was a final blow aimed at the dominance of the Academy, setting up another sensational form of competition to it in the large jury-free exhibition. This first Independents' exhibition contained some 2500 works by 1300 artists from thirty-eight states of the Union, a veritable bedlam of styles in varying degrees of competence.

The major criticism from the conservative side was that the exhibition contained too much that was amateurish and too much that was modern. Henri, still campaigning for the small group show,

Andrew Dasburg, *Improvisation to Form*
Collection Unknown

They all insisted upon the predominance of the artistic personality and the inner feeling, in the firm belief that the real world centered around the artist. It followed then that expression was more important than representation and that sensibility was superior to intellect. Bluemner claimed that there should be no outer restraints upon the inner laws of painting, Dove that the "reality of sensation" is all that counts, and Marin that art was the constructed expression of the inner senses. Zorach saw his art as expressive of the "inner feeling which something in nature or life has given me." Marsden Hartley, Walkowitz and Sheeler stressed personalism and individuality. Art was either an emanation of some inner urge or a personal reaction to reality.

Just as their ideas conformed to the general pattern of modernist thinking their art fell within the general modern artistic categories. Ben Benn, Alfred Maurer and Zorach were dependent upon Matisse. Cubism was most influential, affecting Bluemner,

66

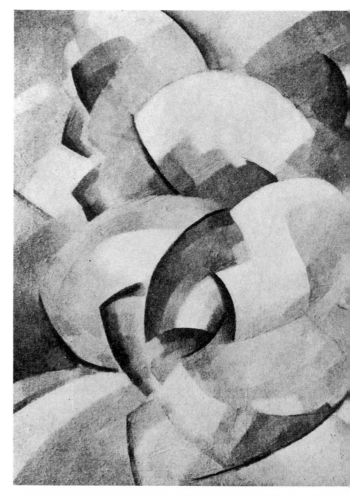

Man Ray, *Invention—Dance*
Collection of Mr. William N. Copley

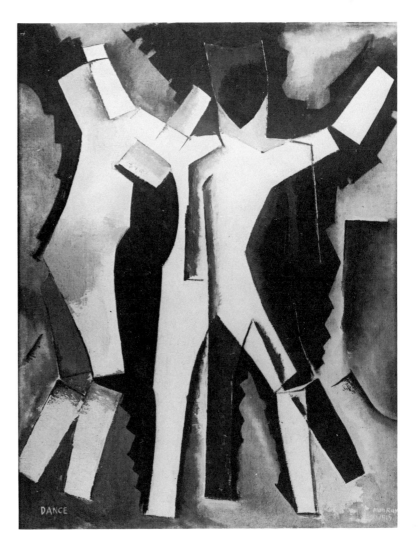

criticized the messiness of alphabetical arrangement. The exhibition was not even free of criticism from the extreme modernists. Marcel Duchamp resigned on the eve of the opening because the hanging committee, in spite of the doctrine of freedom, refused to accept a work which it considered a hoax and not art. It is not strange that Duchamp, imbued with the compulsion to carry a principle to its logical conclusion, should expose the major weakness of American modernism, namely, the inability to understand extremism. Whereas the French modernists, as pioneers, were constantly exploring and expanding the boundaries of art with almost ferocious logic and disregard of all artistic dogmas, the Americans were even at the very beginning applying brakes upon the development of modernism. The Americans missed to a great extent the destructive aspect of modernism as an angry revolt against established conceptions and were prone to accept its more constructive aspects as the basis for a new esthetic. The Independents' Exhibition was an attempt to rival the success of the Armory Show; however, coming as it did immediately after America's entry into the World War, it was ignored in the excitement.

Interlude

◈ THE WAR YEARS

THE direction of American art was not changed by the World War. The events of the war found their way into only a fraction of our art and if those years of crisis had any influence it was through the subsequent effects upon our social and cultural atmosphere. The war years, as far as art was concerned, were merely a hiatus. Nor can this fact be attributed to the briefness of our participation, for the same phenomenon is to be seen in the art of Europe, where the people were involved for a much longer time and their lives were much more thoroughly dislocated. European art, it is true, was affected by the disillusionment engendered by the war, which gave rise to a series of nihilistic tendencies culminating in Dadaism, but even these tendencies were already apparent before the war and inherent in the modernist movement.

Any war creates a general dislocation of normal life, during which all the various groups in society must make adjustments. But it is only natural that an art which has no social function in peace will find it difficult suddenly to assume social duties in a war situation. However, under such conditions, and in spite of the essentially non-social character of the art of that time, an effort toward readjustment was made. On the whole artists fell into two groups, those who, believing that art could have nothing in common with war, retired or, rather, continued their retirement from life until more normal conditions should again prevail, and those who, shocked out of a routine complacency and suddenly becoming aware of the enormous new needs, attempted in some manner to make their art serve. This does not take into account that small group of artists who expressed anti-war sentiments. Before America's entry into the war, pacifist sentiment among artists was deep-rooted. In 1915, for instance, in a competition for young sculptors on the subject of war, a project suggested by Daniel Chester French and sponsored by the Society of Friends of Young Artists, almost the only work submitted which glorified war was that by a certain Louis Ulrich, who was, incidentally, awarded the first prize. After the United States' entry into the war, this pacifist tendency was submerged under an avalanche of patriotic fervor reinforced by a rigid censorship, and those artists who were out of sympathy with the war found it politic to remain silent. The suppression of the *Masses* in 1916 put the final taboo upon the expression of any opposition to national policy.

It should be remembered in a consideration of art in relation to war that the history of art for more than a century had militated against its playing an active and integrated role in community life; rather, the artist in our time has been relegated to the task of producing luxury objects for a rather narrow stratum of society. However, as a citizen in time of crisis the artist may be impelled to contribute to the national effort in some manner and, resurrecting, in spite of a long history of non-social activity, the concept of art as a mover of men's souls, the artist then seeks the means of making his talents count.

During a period of war there are many tasks which the artist may perform, both as citizen and artist, which are not necessarily within the province of art proper. He may serve in the armed forces or offer his technical abilities to further the war effort. Propaganda, on the other hand, is an extension of a natural function of art, the exploitation of its capacity for inspirational communication. Effective propaganda demands two things of the artist, first, the ability to appeal to a great mass of people, and second, the ability to understand and translate contemporary ideas. America produced no single artist during the war capable of such a synthesis. The war itself aroused little deep human idealism, fought as it was on the grounds of national rivalries, and as a result many artists were out of sympathy with its aims while some even opposed it openly. The field of artistic propaganda was left, therefore, completely in the hands of commercial artists, who were capable of appealing to great masses of the public even if they were incapable of important esthetic expression. The result is that today, as a record of that period of great strife, we have only a series of completely mediocre posters, a few isolated paintings and prints, and, subsequently, a series of sculptured memorials which are indeed war atrocities.

The artists who worked on the *Masses* or were connected with that group campaigned against the war, and when the *Masses* was banned in 1916 they bowed to censorship without really changing their opinions. One exception was George Bellows who, carried away by the tales of German atrocities in Belgium, did his famous series of twelve lithographs of the "Huns," a series which is no credit to Bellows either as an artist or as a thinker. It certainly does not belong with the great war scenes of Forain or Steinlen. Childe Hassam's few paintings were merely

71

Impressionistic views of New York bedecked in the colorful panoply of war. Luks caught some of the excitement of patriotism during those war days. But these efforts of Luks merely highlight his failings as an artist, his inability to compose a large subject and his hurried, slipshod technique.

As we have seen, immediately after the outbreak of war in Europe, there was a good deal of discussion as to what its effects would be on our own art. Conservative artists and critics shared the feeling that in spite of the disadvantages of war, this particular war would benefit America. The belief was general that the center of art would move to America as a haven of culture and that the emphasis would also shift from European to American art. They pre-

dicted that the effect of the war would be salutary even upon Europe, since in the heat of strife the old world would be purged of the decadence of modernism. The latter attitude was amazingly widespread and predictions of the death of modernism were rampant.

From the beginning the sympathies of the majority of American artists were with the Allies, or more properly with France, the foster mother of the arts, where so many of them had spent such pleasant years. Some of the more francophile, and especially those who were practically expatriates, volunteered their services to France. These artists were defending a way of life, a culture which they loved intensely, the symbol of an ideal artistic

George B. Luks, *Blue Devils Marching down Fifth Avenue*. The Phillips Collection, Washington, D.C.

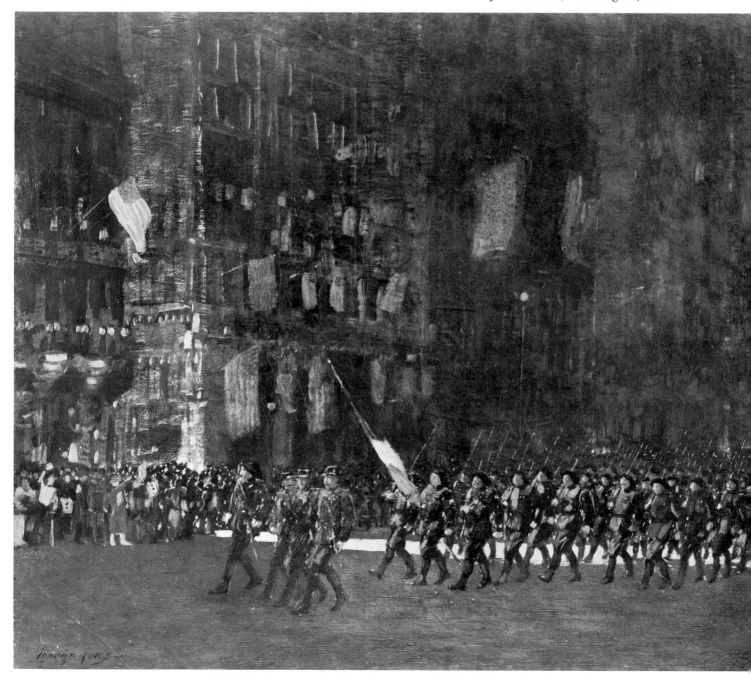

existence which they found nowhere else in the world, certainly not in the land of their birth. In fighting for France, they were defending what they thought to be the spiritual home of civilization; and postwar disillusionment only increased this love of France and especially Paris, the mecca of the mind, the refuge of the disenfranchised artist, in a sense the international capital of creative spirits. Thus, early in the war, the American Artists Committee was formed to raise funds for the relief of French artists and throughout the war American artists' organizations worked to ease the lot of their fellow artists in France.

Although the war produced no art of value, a great deal of art activity did take place in a haphazard sort of way. This work was neither well organized nor centralized. Just as the artists were unprepared to serve their government and people, the government was unprepared to use the artist. The greater part of the initiative came from individual artists and artists' organizations. As early as 1916, it was proposed that a movement be undertaken to "mobilize the artists of this country for national defense work, the plan being to stimulate patriotism by means of paintings, cartoons, and posters to be *contributed free* by the artists. . . ."[1] Originally the government ordered posters directly from commercial lithographers; but after a good deal of opposition and the artists' offer of free services, the policy was changed. Most of the poster work was eventually done through the Division of Pictorial Publicity, a section of the Committee on Public Information which was headed by Charles Dana Gibson. This board organized production of art propaganda, passed on submitted works, and sent them to Washington where final selection was made. During its life the board produced for some fifty-eight government agencies about 700 posters, 287 cartoons, and 432 cards and designs for newspaper publicity. Separate governmental agencies also had their individual artistic contacts. For instance, Lieutenant Commander Henry Reuterdahl had a near-monopoly on Navy work, although that agency also used Albert Sterner, George Wright, James Daugherty, and even European artists like Brangwyn and Raemakers. The Marine Corps had its own staff, and the United States Shipping Board issued posters on labor and patriotic production. Some unusually large painted posters were produced, one tremendous effort of fifty by a hundred and thirty feet in Chicago by Robert Reid, three

large paintings for the fourth Liberty Loan by Reuterdahl, and another mammoth job by N. C. Wyeth and Reuterdahl to decorate the Sub-Treasury Building in New York City.

The quality of the poster work varied, but even at its best as, for instance, in the work of Adolph Treidler, one of the leading American commercial poster men, it was no better than the run of commercial posters. It is interesting in this connection that Treidler's work, which was dependent upon the German poster style, met with some opposition similar to that which banned the works of German composers. Matlack Price, a critic who previously had praised the German poster style as the finest in the world, denounced the German influence on American posters after our entry into the war. "The hour is at hand when the art of this country can and must be emancipated from the influence of German technique" was the patriotic stand taken by Price. He charged that the German style had attained an alarming foothold in our art schools and, promoted by German agents, was part of the insidious propaganda to undermine our institutions. "It is the duty of every art teacher, art director and

Adolph Treidler, *Farm to Win "Over There,"* Poster

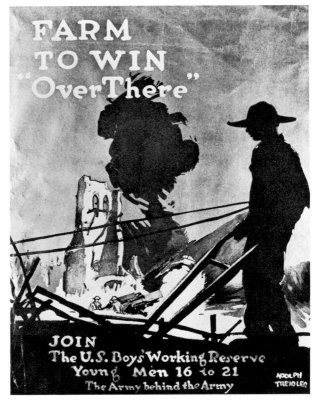

73

art editor, as well as of the judges in every poster competition, to deny consideration to any submitted work which is clearly based on the German commercial art idea."[2] In spite of this vigilance against subversive influences, our posters did not improve. A competition for war posters sponsored by the National Arts Club was postponed in 1918 because none of the works submitted was judged worthy of reproduction. The artists themselves recognized their shortcomings but fell back upon the explanation that art was after all not a child of war. The failure was admitted in the catalog to an exhibition of war art at the Carnegie Institute in 1918: "While it is true that patriotic motives have called into this field a few eminent painters whose records will be of great historical and artistic interest, it is not probable that these records will find a lasting place in the annals of art. Neither is it probable that the war will greatly effect the tendency or purpose of modern art. Art is the very opposite of strife, of warfare, of brutality."[3]

In another phase of war work, the artist acted as

George W. Bellows, *Dawn of Peace*
Cincinnati Art Museum

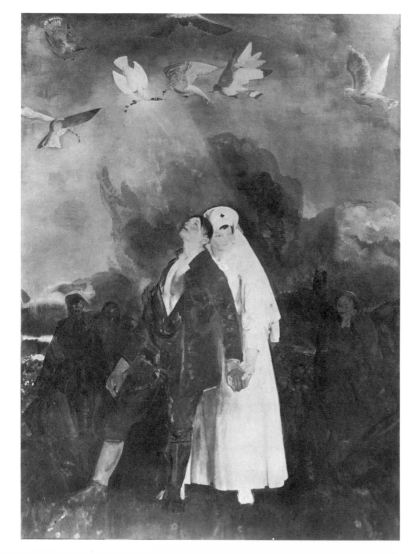

reporter. Several artists were officially assigned to report in graphic media the action of our overseas armies; but in this case, also, none of the works produced was of any great artistic value. Samuel J. Woolf, who went abroad as a free-lance war correspondent and also served as an ambulance driver and cook, made a number of paintings and sketches which were exhibited in New York in 1919. Lester G. Hornby was with the American troops in 1918, and his drawings were reproduced in *Harper's Magazine*. Will Foster did drawings for *Scribner's*. Jo Davidson modelled busts of generals and statesmen as did Robert J. Aitken. Another group of artists confined themselves to the reporting of war production. Joseph Pennell did over one hundred lithographs, some of which were published, and Vernon Howe Bailey produced a series of lithographs and drawings which were exhibited throughout the country. Some of the paintings which were done independently but may be classed as reportage are those of Luks, Gifford Beal, Hayley Lever and Childe Hassam. Others which might be classed as inspirational were the famous *Carry On* by Blashfield, for which the Metropolitan Museum of Art let down its ban on war art, admitting it for exhibition and finally purchasing it, William Ritschel's *Crusaders*; three paintings by A. V. Tack; two paintings of the *Dawn of Peace* by George Bellows; and two by Maxfield Parrish for the Red Cross.

Around the fringes of art production a good deal of "art for war" work was going on. There were many special exhibitions and committees. Most active in such work were A. E. Gallatin, Duncan Phillips and A. V. Tack. Duncan Phillips arranged an exhibition of war art for the American Federation of Arts. Gallatin served as chairman of the Committee on Exhibitions, Division of Pictorial Publicity, for the United States Government and chairman of the Committee on Arts and Decorations which was part of the Mayor's Committee on National Defense in New York City. Immediately after the armistice, Gallatin, Phillips and Tack arranged the Allied War Salon, containing 800 works from Europe and America. The part that museums played was curious and mixed; for example, the Art Institute of Chicago was used to hold war meetings and was a center for war loan drives, but the Metropolitan in New York refused even to exhibit war art.

Although a great effort had been made to popularize art as a war weapon, unfortunately art itself never rose to the task. No sooner was the war over

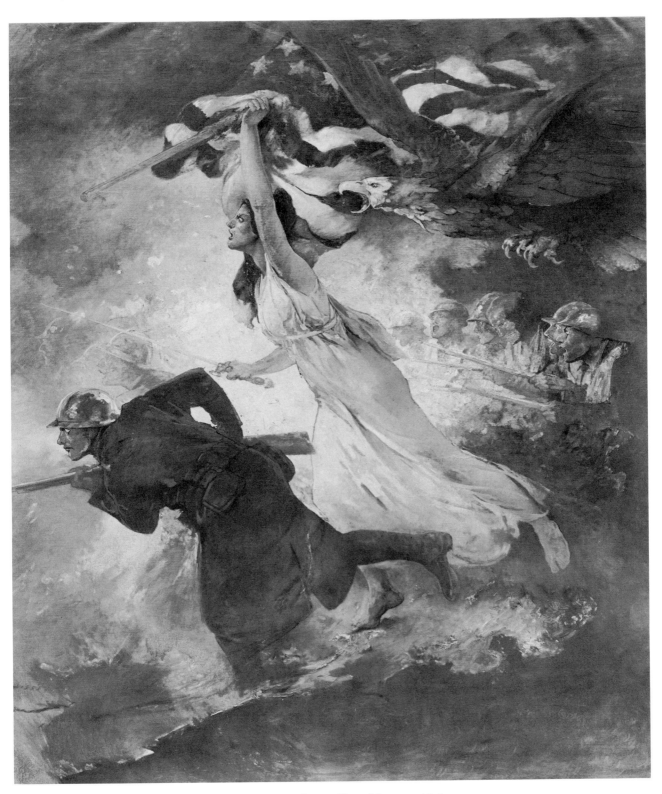

Edwin H. Blashfield, *Carry On*. Courtesy of The Metropolitan Museum of Art

than the artist hurried to forget his fruitless efforts. But at last awakened to the historic situation, after the armistice the government through the National Arts Committee commissioned eight artists to go abroad and paint portraits of the war great.[4] The result was not calculated to change the general picture of mediocrity and, if anything, dragged the average down. Nor was the pageantry which greeted peace and the homecoming troops very memorable. The Victory Way and Victory Arch were, fortu-

75

nately, temporary constructions which could perhaps in the heat of the moment pass for pomp.

Those artists who could not convert their art to war production sought other ways of serving, with varying degrees of enthusiasm. Camouflage was a favorite division of service, where many painters and sculptors were active. Others did topographical drawing. One curious example of art in the service of war was the production of landscape targets, paintings which were used to teach rifle shooting. This work was largely voluntary, some 300 landscapes were painted and exhibitions of them were held at the Salmagundi Club in April and the Arden Gallery in May 1918. All these landscapes later were shot to pieces in target practice.

Anti-German feeling grew apace as the war progressed. Although during the nineteenth century the cultural relations between America and Germany were quite strong and in art the influence of the Düsseldorf and Munich schools was especially prominent, toward the end of the nineteenth century and during the early twentieth century the artistic center for Americans had shifted to Paris. The tendency among American artists was to consider German culture as alien. The war increased this feeling to the point of hatred, creating a violent, unreasoned emotion against the "Huns." After our entry into the war this attitude became particularly virulent. The art dealer Hanfstängl suffered a good deal of unfavorable publicity because of his German sympathies and was finally forced to close his shop. Joseph Pennell's suspension from the Philadelphia Art Club for some comment that was construed as pro-German created something of a furor. When the University of Pennsylvania tried to pussyfoot its way around the controversy by cancelling the award of an honorary degree to Pennell, the resultant blast which he issued created quite a diversion for a time.

In much the same spirit was an article in the *Chronicle*, "Unmasking the Museum Conspirators," which contended that the $50,000 Riesinger fund at the Metropolitan Museum of Art was used to maintain German influence in America. The writer added that since nothing good had come out of Germany since Dürer, the money was being used to buy worthless modern art. He also charged that the director Dr. Edward Robinson had studied in Germany and had been decorated by the German government, and concluded that, since German opera had been banned, German art should be relegated to the cellar of the Museum. In 1918 when the bust of Frederick the Great was removed from the War College in Washington, a medal of General von Makensen was removed from the spring exhibition of the National Academy of Design. After the war this anti-German feeling found expression in demands for the payment of indemnities through confiscation of art masterpieces, for as was claimed by the *Tribune*, which had been carrying on such a campaign during the war, after all the Germans were incapable of appreciating great art as civilized people should.

The total effect of the war on American art was not great. It was more an interlude than anything else. We lost no major artistic figures in the holocaust. Our connections with Europe were strengthened in the common effort. The United States was drawn irrevocably into the web of world affairs, and our art assumed, as did all art, a more international character. But this development had already begun before the war. What is most important is that the war produced at least among intellectuals a deep sense of disillusionment. Our social artists lost faith in the efficacy of social reform. Art for the most part sought forgetfulness by burying itself more deeply in formal problems.

Post-War

The "roaring twenties," the "golden age," when America was riding the crest of economic plenty, was curiously enough the heyday of the "lost generation." While business reveled in increased profits, expanding markets and a growing American economic power, the intellectuals of America were sitting disconsolate in the rubble of their ruined hopes. The writers of the "lost generation," probably the most autobiographical group in the history of literature, took a masochistic pleasure in exposing and minutely analyzing the nature of their own inadequacy, exhibiting their stoicism, their ability to endure, which had replaced their will to act. In a larger sense this was a revulsion against the betrayal of the ideals of the prewar world. It has been named rightly, from the point of view of culture at least, the "age of disillusion." The ideals for which the previous generation had fought and upon which the young men of the twenties had been weaned were now completely shattered. To them the "war to end wars" stood revealed as a boldfaced imperialist struggle for power and the peace written at Versailles as an expression of that power. The war "to make the world safe for democracy" had unleashed instead the forces of reaction. It is no wonder then that the men who had taken part in the struggle viewed the result with disgust.

Cynicism became a defense against life made empty and faith destroyed. The reform movement which had been an expression of the optimistic and aggressive character of the middle class gave way to a pessimistic fatalism. To many during this decade capitalism appeared stripped of its cloak of democratic idealism, in all its naked rapacity. The intellectual class of the entire western world was repulsed, yet finding no basic ideals or faith to which it might rally, it sought salvation in self-immolation by destroying the last vestiges of its own idealism. Intellectuals attacked with a furious nihilism every social, moral, and intellectual ideal they could get their minds on. André Gide poignantly cried at that time, "While our fields, our villages, our cathedrals have suffered so much, our language is to remain untouched! It is important that the mind should not lag behind matter; it has a right, it too, to some ruins."[1]

In spite of their small number and apparent isolation, this group of young men who came back from the war profoundly affected our culture. The point of departure for all the frustration, cynicism, and disillusionment was the war itself which seemed the symbolic climax of our social malfeasance. With amazing unanimity the literary men of the world expressed their revulsion; in France, Romain Rolland in *Clerambeault* and Henri Barbusse in *Under Fire*; in Germany, Erich Maria Remarque in *All Quiet on the Western Front* and Stefan Zweig in *Sergeant Grischa*, and in Czechoslovakia, Hazek in *The Good Soldier Schweik*. In England R. C. Sherrif wrote *Journey's End* and in America John Dos Passos wrote *Three Soldiers*, E. E. Cummings, *The Enormous Room*, Stallings and Anderson, *What Price Glory*, Ernest Hemingway, *A Farewell to Arms*, and Humphrey Cobb, *The Paths of Glory*.

This denunciation of war was merely the beginning of an attitude of general pessimism toward contemporary society. Not only had there been betrayal at the peace table, but it seemed that all the idealistic dreams of reform were dead. Monopoly had grown immensely during the war and, now firmly in the saddle, had tightened the bit. The "brotherhood of man" gave way to the "American plan." For a decade *business* was to be the symbol of American life. During the Harding-Coolidge era business assumed the aspects of morality, of ethics, and even of spiritual values. "Economy," said Coolidge, "is idealism in its most practical form."[2] "The business of America is business."[3] One could collect a new galaxy of maxims to supplant the older moralisms of honesty and frugality. Business sold itself as the new millennium, prosperity was a cure-all, and the American destiny was a limitless highway paved with gilt-edged securities.

We have sometimes reviled our intellectuals for retiring to an ivory tower; but the act of retreat itself is evidence that they, at least, were skeptical of the rotarian pipe dream of perpetual prosperity. In this they were unconsciously more perspicacious than big business men and even their so-called "scientific" henchmen, the economists. In place of the promise of ever-expanding production and inexhaustible profits, they saw a frightful picture of a world devoid of human values. Their hopes for world freedom had been cynically demolished. Prewar reformism had failed to correct abuses by merely exposing them. One of the few legacies of reform was the unhappy "experiment" of prohibition, which was not only a restriction upon individual liberty, but a new source of corruption and

lawlessness. Government, under the guidance of business, was helping to destroy the backbone of reformism by attacking the power of organized labor and persecuting radicals.

In the face of reaction the intellectual succumbed to despair. He saw the labor movement under a servile bureaucracy as a travesty on his ideal of it as a liberating force in society. He saw the radicals as an ineffective, isolated group, torn by internal dissensions, fighting among themselves rather than united against the common enemy. Politics appeared on the whole a vulgar occupation controlled by crooks and big business; and government was a trough where monopoly gorged itself. Beyond everything else ideals were looked upon as sentimental and impractical. It was the day of the "practical man." It was much safer, then, in the face of the overwhelming power of business and reaction, to assume a cloak of cynicism, to keep intact one's urbanity and sense of humor, to grow callouses upon one's sensibilities, so as not to be moved by the truths of existence.

The American intellectual of the twenties could make one of several choices. He could either capitulate and extol the spiritual values of business, which, incidentally, very few did; he could retire into himself and his own clique; or he could fight a sort of guerrilla engagement against the abuses of a life dominated by the dollar. It was a guerrilla war because there was no real army to carry the revolt. The lower middle class had gone down to defeat before the power of monopoly, and with it went its ideal of reform. The intellectual group, which had been in the vanguard of this movement, found itself cut adrift. Intellectuals could not at that time find an anchor in the working class, first, because organized labor itself was in a demoralized state without any positive program for action and, second, because they themselves were incapable of assuming leadership in the organization of revolt. Cut off from a social base or even a consistent social philosophy, they were relegated to a position of sniping at superficial social aberrations.

Muckraking, which after all was based on a critical optimism, gave way to "debunking" which was essentially a critical pessimism or perhaps more accurately a critical cynicism. Whereas the early realists and muckrakers, like Theodore Dreiser and Lincoln Steffens, had the reformist zeal to find some solution for, or at least some meaning in, corruption and injustice, the "debunkers" like Sinclair Lewis

and H. L. Mencken laid bare the philistinism of the "booboisie" with a cool intellectual aloofness. Under the leadership of Henry L. Mencken, this became a supercilious game, which found its expression in witty cynicism. The attack was directed particularly against respectability, social, intellectual or sexual. It inveighed against the emotional and esthetic meagerness of our cultural life. It laughed at the ethics of business and the corruption of government. It jeered at our provincialism. It even, in the hands of Mencken, became perverted into a scoffing at "democracy" and "the mob," and, betraying both its cynicism and its middle-class origin, it laughed just as bitterly at reformers and revolutionists as it did at the status quo. Debunking became, as Alfred Kazin has written, "America's journalistic Dadaism."[4] The only ideal—if it can be called that—which the intellectual had left was the inviolability of the individual. If he believed in anything, it was in the sacredness not only of his person but of his expression. The saying became infinitely more important than its comprehension, for the audience was after all only the mob while the expression was the emanation of a superior being. The twenties spawned a number of small magazines, each of which, in willful isolation, spoke in esoteric accents to a small coterie of kindred spirits. The intellectual accepted his isolation and even gloried in his exceptionalism.

The plastic arts during the twenties, although impelled by the same cultural ideas, were never a simple counterpart of the literary developments. The reason for this difference, aside from certain inherent expressive characteristics and limitations, stemmed from the nature of patronage. For instance, the expansion of publishing had by the twenties created a wide mass market for literature,[5] and as a result the writer could express even his dissatisfaction to so wide an audience that he became a really important instrument in the formation of social attitudes. The artist, on the other hand, was almost as narrowly limited as he had been a century before. Art was still a luxury object produced for a small class of wealthy connoisseurs. The artist was isolated from a mass audience by the very nature of artistic production. At the same time the stylistic development of art had evolved to a point of esthetic isolation. The plastic arts as a whole, then, were isolated because of material limitations as well as obscurity of content. Whereas the development of literature in America was predominantly along realistic lines,

with only minor excursions into literary experimentation and abstraction, the more radical esthetic tendencies in the plastic arts fought specifically against the realist tradition. In literature one could be a radical realist; in art one could be either a radical or a realist. The revolt in art was directed against outmoded forms and not against social attitudes.

Modernism in America as well as abroad was an escape as well as a revolt—an escape from social problems and a revolt against the established artistic forms which were, in the minds of radical artists, symbolic of middle-class society. The radical artist of the twenties was not interested in exposing the philistinism of American life, but in shocking it. Those artists who nursed the tenuous tradition of realism and refused to accept the doctrines of pure art were in the minority. The twenties were dominated by the modernists.

After the war American art was in a state of chaos; not the chaos of disintegration, but of uninhibited exploration. The struggle against complacency had been successful. The earlier provincial boastfulness had given place to an earnest groping for maturity. America was open to influence and counterinfluence, to experiment and theory, and now even current European art innovations found immediate echo here. Yet with all the servile borrowings during the twenties, foundations for a native art were being laid and some of our finest painters reached maturity in the modern idiom.

During that time painters ranging from the academic "right" to the modernist "left," artists steeped in the traditions of the nineteenth century and those professing to envision the future were working side by side. With the death of William M. Chase and Thomas Eakins in 1916, Albert P. Ryder in 1917, and Frank Duveneck, J. Alden Weir, Kenyon Cox, and R. A. Blakelock in 1919, a whole era seemed to have passed from the scene. But the remnants of the past still hung on. The Academy, of course, made no concessions to time, clinging timorously to the coat tails of eternity, and some of the leading figures of another generation were still active. Sargent lived until 1925 and Cassatt until 1926, both still almost completely aloof from American art. Of the "Ten," Hassam, Tarbell, Metcalf, Benson, Reid, Simmons, and Dewing were still on the scene, although time had already tarnished their earlier glamor. The old Ash Can School had finally received belated recognition; Henri was already a legend

and Luks an institution, and Sloan sold twenty paintings to George Otis Hamlin at one clip. Impressionism was at the height of its popularity with Hassam, Frieseke, Melchers, Lawson, Tucker and Glackens to carry on. Hassam was getting dry and mechanical. Frieseke and Melchers, who returned to America during the war, although excellent technicians, had changed their academicism no whit by steeping it in sunlight. Lawson continued on his honest though pedestrian course. Glackens was engrossed in Renoir, and only Allen Tucker, inspired by the violence of Van Gogh, offered something new in his crude but impassioned language of light. Prendergast gained a little of the recognition he deserved before his death in 1924, but almost the whole of his life had been spent in obscurity.

Eilshemius, an echo of the nineteenth-century Hudson River School, whose naive lyrical gift has a special charm for modern tastes, was "discovered" by Duchamp at the Independents' Exhibition in 1917 and had his minor hour of triumph at the *Société Anonyme*, after which he sank back again into obscurity. Obscurity also held the "primitives" who were at work during those years. John Kane was painting his Pittsburgh landscapes with a simple strength, in his own way capturing a glimpse of industrialism which none of the realists could match. Emile Pierre Branchard's barren surfaces were reminiscent of the pristine quality of Cubist-Realism. Only Canadé gained some recognition for his strong though repetitious self-portraits and then, again, only in modernist circles. It was not until the thirties that the vogue for "primitives" burst upon America.

The Academy was at least alive enough so that some artists spoke about its being dead. Although the moderns on the whole ignored it, some of its more liberal members sought once again to reform it. Dreaming of the days when the Society of American Artists had managed to liberalize the National Academy, they joined with the near-Academy crowd in October 1919, to form the Society of American Painters, Sculptors and Engravers which was renamed in 1920 the New Society of Artists. However, their exhibitions in the following years were, if a little less stuffy than those of the Academy, no less boring.

Meanwhile modernism was gaining ground, though not without opposition. The Pennsylvania Academy of Fine Arts held a modern exhibition in 1920, and a second exhibition of American moderns the following year. In 1921 the Metropolitan Mu-

seum of Art held its famous modernist show. The *Société Anonyme* was circulating a selected group of moderns. The new art even invaded the deep South when an exhibition arranged by Forbes Watson was shown in Dallas, Texas. The Dikran Kelekian sale created a stir in the art market. A new artists' society was founded, the Modern Artists of America, with Henry Fitch Taylor as president. In October 1923 the Anderson Galleries held the first American exhibition of German modern art arranged by Dr. W. R. Valentiner. The Pennsylvania Academy of Fine Arts exhibition of 1921 precipitated a free-for-all. The *Morning Telegraph* apologized to Paul Burlin for the violent attack of its critic after Burlin had threatened to sue. As an aftermath a symposium of physicians at the Philadelphia Art Alliance pronounced modern art insane and a report of the session was printed in the University of Pennsylvania *Weekly Review*. Then Dr. Albert C. Barnes got into a cat-and-dog fight over modern art with Dr. Francis X. Dercum. The twelfth annual convention of the American Federation of Arts heard the sculptor Herbert Adams assail modern art as "queer," "pervert," "feeble-minded," "insane," "rubbish" and "bunco." Cortissoz at the Philadelphia Art Alliance reiterated that it was time to rebel against the moderns, and Homer St.-Gaudens, returning from abroad, announced that English art was influenced by the "bolshevistic tendencies of modern youth."

The modernist activity incited the conservatives to revolt in their turn. The Society of American Sculptors was formed in opposition to the National Sculptors Society, with a program whose watchword was Americanism. In 1923 the League of American Artists issued the rather sententious opinion that "the time has arrived when the American artist is the equal, if not the superior, of the foreign artist. . . . America is marching on to an artistic renaissance which will carry the nation to a great cultural height. Like ancient Greece, whose art blossomed when womanhood was immortalized, America has laid the foundations upon which a structure will stand throughout all ensuing ages."[6] There was a split within the Chicago Society of Artists because the "radicals" had gained control and this time the conservatives, paradoxically, were forced to form a new group, the Painters and Sculptors of Chicago, under the leadership of Lorado Taft. At least American art was no longer complacent.

It was obvious by the early twenties that the old-line academic painters were through. To the public the leading figures were men like Bellows, Kroll, Speicher, and Kent, former rebels, who had had contact with the newer idioms. Bellows had lost his rough edges and was painting with colorful virtuosity. Kroll had renounced even his limited vigor for a stilted refinement. He had absorbed just enough of Cézanne to give his art a sense of plasticity and a slightly modern flavor, just as Speicher had borrowed enough from Renoir to give his portraits warmth. All three painted in a full, lush style in which "paint quality" was the new norm of excellence; Bellows with flashes of brilliance, Speicher with a kind of solid opulence, and Kroll with powdered artificiality. A consummate knack for mixing sentimentality, voluptuousness and academic formulae made Kroll a great prize-winner. Rockwell Kent's earlier vigor was replaced by a polished decorative style whose crisp freshness won immediate popularity. For the art world there were new gods. Modernism was definitely in the ascendancy. Critical art journals like *The Arts* and *Creative Art* featured the moderns, and only the *American Magazine of Art* obstinately sustained the academies. Young artists were no longer interested in the shades of Raphael or even in Manet, but walked with Cézanne and Renoir, Matisse and Picasso, and students went to the Art Students League, where freedom rather than tradition was the rallying cry.

CRITICS

WE HAVE already seen that the reaction against modernism was extreme in America. The public as well as the art world was entirely unprepared for so violent an assault upon accepted patterns of thought. Against the general inertia a small coterie of artists and critics fought a valiant battle, influencing the development of a taste for modernism in America until it encompassed almost the whole of the art world and even affected the general public.

The history of taste, although one of the more fascinating aspects of the history of art, has as yet not been given due study. Art history should be concerned not only with the creation of art, but also with its effect. Because art is still primarily considered as an isolated phenomenon, art objects are naturally considered as immutable material objects to be analyzed with all the precision accorded to facts. Such a consideration, of course, is necessary and basic. But an art object, or a group of art objects, is not only a product of a specific social organism; it also evokes a reaction from the society for which it was made, and has a subsequent existence, varying in relation to changing social situations. The history of taste is concerned with the effect of art and with audience response rather than with the production of art. The changing reactions to artistic products are as invaluable as clues to the interpretation of a cultural epoch as are the works of art themselves.

There are two major divisions within the study of taste. First, there is the investigation of audience response contemporary with the production of art, which has been accepted in a limited sense by many art historians as integral to the understanding of the art object and of the relation of the art object to its contemporary milieu. The art picture of any period is made more complete and, what is essential for art history, infinitely more objective through a study of contemporary taste. An art object then assumes a fixed place in its own time and does not need to exist only in relation to the fluctuating subjective judgments of later times. The second phase of the study of taste has to do with the investigation of the history of the art object subsequent to its own temporal milieu. This category of art history, which deals with the consideration of art as a living reality, gaining new significance or losing

old meanings in relation to a changing world, and with the effects of tradition and the revival of styles, has as yet not been adequately explored. As our attitude toward art history as a specialized study of art objects gives way to the study of art objects as aspects of social existence, then a myriad social relationships pertaining to those objects attain a new importance.

An investigation of the nature and development of taste during the period of modernism in American art is, therefore, important to an understanding of that period. Unfortunately a complete analysis of the taste of this period, which involves a study of all the arts including the minor arts, fashion, etc., is beyond the scope of this work. We must confine ourselves to a consideration of critical opinion as the expression of public taste in relation to painting and to the development of taste among collectors. It should be kept in mind throughout this discussion that no matter how virulent critical opinion might be, if modern art could win itself a group of sustaining enthusiasts it could continue its development regardless of public ignorance, indifference or even antagonism, simply because modern art in its historical development is a private rather than a public art, a personal rather than a social expression.

The early twentieth century saw a great cultural expansion in the United States. As a part of this general expansion, there was an increasing interest in art, which was reflected in the establishment of a number of new museums and art schools. Unfortunately, however, American taste remained provincial. The great majority of our collectors were still soft touches for unscrupulous dealers, although some were aware of more permanent values. America was still a dumping ground for the second-rate, the inflated, and the faked merchandise of the European art market.

An art public which was only beginning to be conscious of art obviously could not be expected to appreciate such highly complex esthetic theories as were germane to modernism. The violent reaction even of the critics was often an indication of their ignorance of the meaning and intentions of the new art. Instead of attempting to understand, the majority of critics and artists arose like knights of old to protect the sacred honor of art from an imagined affront.

First among those knights of the academic round-table was Kenyon Cox. As the recognized spokes-

man of strict academicism he took the lead in denouncing modernism as a capitulation to anarchy. The most learned among academic artists, he was aware of the historic development of modernism, but this led him to castigate with unrelenting logic not only the contemporary exponents of individualism but the entire tradition beginning with Manet. His criticism was based not simply upon a personal dislike of the new art or an inability to comprehend it but upon moral and social grounds. His article, "Artist and Public," the clearest presentation of his position, exhibits a rational ability and an historical understanding that in many of his other articles and speeches disappear in the heat of anger. He contended that the basic social factor out of which all the abuses of modernism arose was the divorce of the artist from society which had occurred after the French Revolution. The isolation of the artist he analyzed as the true cause of the dilemma of academic as well as modern art. He understood, therefore, something which few of his colleagues did, that the work of the academic and conservative artist was circumscribed by the same conditions as was that of his brother modernist. This isolation, he continued, has eventually led to a complete misunderstanding of art until the "misfit artist genius" has become the accepted type, and the pattern of starving artist and stupid public seems normal. Because of this, the artist has come to doubt all success and all understanding. Neglect and incomprehensibility become the hallmarks of greatness. At the same time, the shift from the patronage relation between artist and consumer to the public exhibition as the market for art has led to all the evils of the salon picture, such as sensationalism, technical display, and virtuosity.

Cox clung grimly, however, to what was for him the one stable factor in the artistic firmament, tradition, which in conformity with contemporary pretensions, he considered the "science of art." He inveighed against modernism because it capitulated to the evils of individualism and, what was even worse in his mind, exploited them. He contended that all great art was expressive of the artist's ideals, which should be synonymous with the ideals of his time. He stated, further, that art is created for man, it has a social function to perform and mutual understanding between artist and public is therefore necessary. He believed, however, that the public was not supplying the artist with ideals worthy of expression and that such ideals were necessary for a renaissance of art.

It is a pity that Cox, who understood the social conditions of modern art with greater clarity than so many of his contemporaries, should have stooped in his criticism to the usual charges of insanity, charlatanry, and incompetence. But stoop he did, and much of his writing and lecturing descended to mere vituperation and invective, presumably because of his moral indignation at the attack upon those eternal principles which he believed existed above and beyond any social dislocations.

Frank Jewett Mather, Jr., who at that time was the art critic of the *Nation*, was perhaps the most scholarly critic of modernism. Like Cox he considered the failings of contemporary art as being directly due to social causes, and he also saw no salvation in the modern movements. "Post Impressionism," he wrote, "is the feeblest imaginable reform for real artistic evils deeply based in the hesitancy of the present social order. Whenever, out of the clash of democracy with socialism and anarchy, a central social tradition is attained, the artist will readily find his place."[1] Since Mather's attitude was not so narrow as Cox's, and his scholar's taste was more catholic, he placed his faith, not so much in academic tradition, but upon a stable social organization in which art would have a definite place. He distrusted most of all the modernist's search for freedom and originality, a function he relegated exclusively to the "genius." To him as well as to Cox, individualism was the bogeyman of art. He contended that the goal of modernism, the translating of the "isolated ecstatic state," of the personal introspective emotion, was a psychological impossibility, thus condemning modernism *a priori*. "So far as Post-Impressionism rests on a desperate struggle for originality and a false theory of emotions it is a negligible eccentricity which will soon run its course."[2] But actually his criticism was based on personal taste and judgments of quality. In writing of the Armory Show he said, "The trouble with the newest art and its critical champions is that fundamentally they have no real breadth of taste. . . . Where something like taste exists, the new brusque procedures are readily assimilated." After which he went on to praise Othon Friesz and Augustus John. "A glance at the coquettish sensual designs of the late Charles Conder, at the delightfully intimate landscapes with figures by George W. Russell, and at Jack Yeats' keen visions of Irish political humors will tend to efface the irresponsible

nightmares of Matisse, and the calculated discomforts of the Cubists."[3] If we consider that his taste led him to choose Corot, Constable, Millet, Theodore Rousseau, and Puvis de Chavannes as the "great painters of the last century,"[4] we can easily understand that he could have no sympathy for Manet, Cézanne, Van Gogh, Gauguin, and their artistic progeny.

Royal Cortissoz, art critic of the *New York Tribune*, third member of the anti-modernist triumvirate, although the least perceptive, was the most influential because of his position on an important newspaper. He remained until his death a peculiar phenomenon of American art life, a critic who viewed and discussed the passing artistic scene for over fifty years only to remain completely impervious to the march of events. Whereas it is normal to consider the past according to our contemporary standards, Cortissoz exhibits a curious case of reversal in which the past continues to criticize the present. In reading Cortissoz one has an uncanny feeling that the nineteenth century is imperturbably chugging beside the speeding twentieth and with indestructible self-confidence predicting the return of the horse. Cortissoz kept inviolate not so much his mind as his eye, which was steeped in the academic art of the last half of the nineteenth century. His judgments were neither social, moral, nor esthetic. Brought up in the era of Sargent, Chase, Boldini, and Fortuny, his major criterion of value was technical competence, and he placed above everything else the elements peculiar to that type of artistic display: virtuosity, elegance, and taste. With remarkable consistency, which can be explained only by the fact that his judgments were based on criteria entirely incompatible with contemporary tendencies, Cortissoz managed to be wrong in almost every major judgment he propounded on modern art.

The conservative position was also espoused by such leading academicians as Edwin Blashfield, Carroll Beckwith, and John Alexander, to name only a few. Miss Leila Mechlin, secretary of the American Federation of Arts and editor of the *American Magazine of Art*, used her position to combat the threat of a modern artistic revolution, and the magazine became the most consistent and unrelenting opponent of the new developments. The *Art News*, as a news weekly under the editorship of James B. Townsend, gave modern art a largely unsympathetic but fair amount of coverage. Its opinion varied a great deal depending on the specific critic involved. In its pages, James Britton managed to present a more favorable picture of modernism than was usual. *Arts and Decoration*, under the guidance of Guy Pène du Bois, at first was a staunch defender of modernism and gave its entire March 1913 issue over to the Armory Show; but after the schism within the Association of American Painters and Sculptors, du Bois expressed his pique in its pages by a constant sniping at modernism.

The criticism of modernism in academic circles was based largely upon a fear of the extension of freedom. Modernism was rightly considered an attack upon the standards of value and methods of training fundamental to academicism. However, academic reaction was the result not of a rational consideration of the situation but of an instinctive defense against a threatened usurpation of its own dominance in the art world. Such blind and unreasoning fear created a ferocious and equally unreasoning attack upon the cause of the disturbance. A lunatic fringe of academicians and critics rose to heights of frenzied incoherence and sank to depths of critical absurdity in defense of "eternal principles." The most complete and most extreme expression of this attitude was presented in the *Art World, A Monthly for the Public Devoted to The Higher Ideals*. The *Art World* throughout its short life was a journal where such words as "morality," "ideals," "beauty," and "truth" were always printed in capital letters.

It was issued for the first time in October 1916, with F. Wellington Ruckstuhl, a fire-eating academic sculptor with a demented abhorrence of modernism, as editor, and Charles De Kay, one of America's more ridiculous critical exhibitionists, assisting him. From the first this magazine was obviously a "crusading" journal. It intended to direct American genius along the lines of art that would equal our preeminence in industry and commerce. It was to be a "distinctly American Magazine." Its excessive nationalism was part of a general attitude which revealed itself as a psychopathic bigotry with amazing analogies to later developments in fascist ideology. While the destructive concepts of Futurism were being perverted to the uses of fascism in Italy, here in America an artistic system which directly foreshadowed the Nazi artistic credo was being propounded. Fortunately, although these doctrines did have an influence upon a section of artists and

public, they never took root in America, and the *Art World* eventually died of its own extremism.

Ruckstuhl's artistic philosophy was an agglomeration of Cox's social theories of the degeneracy of modern art, the usual academic criteria of value, and his own fantastic perversions of the history of art. He believed in and practiced the "measurement" of art values by a set of standards classified as subject, expression, composition, drawing, color, and technique. The greatness of art was commensurate with its ability "to stir the highest emotions of the largest number of cultured people for the longest period of time."[5] With these high ideals in mind, the *Art World* campaigned on the one hand against the anarchy of European art and on the other for the beautifying of gas tanks by placing domes upon them.

A feature of each issue was the analysis of a group of art works according to the stated standards of *Petronius Arbiter*, who was obviously none other than F. Wellington Ruckstuhl. Some of these judgments will probably remain forever as the nadir of stupidity. For instance, in a study of ethics in art he compared Couture, Giotto, and Manet. Couture's *Romans of the Decadence* was designated as "the greatest ethical work in the world," a large photogravure of which "should be placed in every public school in our country." Giotto's *Chastity* (Church of St. Francis, at Assisi), although ethical, was ineffective because it was too cryptic and symbolic, and not immediately understandable. Manet's *Nana* on the other hand was an unethical work, a deliberate affront thrown in the face of the public, inane and artistically worthless, whose drawing was unworthy of a Frenchman of the Academy Julian, whose color was repellent, and whose painting was puerile. It was the "incarnation of the disease called 'modernism,' whose chief symptoms are commercial noise, aesthetic aberration and moral degeneration. And all such as defend, buy or condone such work are inexorably tainted with the disease."[6] Manet who, with Baudelaire and Rodin, was Ruckstuhl's *bête noire* came in for continual attack. In comparison with Lord Leighton, the English academician, not only Manet but all modernism came off rather badly. Leighton's *Captive Andromache* was styled a great work of art, and Ruckstuhl asked, "Is there any one in the world today who can do any better?" and concluded, "Not a single modernistic painter from Manet down was, or is, fit to tie the shoelaces of Leighton. . . ." In comparison Manet's *Dead*

Christ was a "childish conception" and the "silliest clap-trap."[7] Even in the judgment of historical style Ruckstuhl showed no greater acumen. He classed Gérôme's *Death of Caesar* as great, while he found Tintoretto's *Ascension* merely clever, faulty in drawing and composition, and trivial in conception.

An intrepid dispenser of opinions, Ruckstuhl judged Raphael's *Transfiguration* the greatest painting in the world and Velasquez's *Maids of Honor* the cleverest. In comparison with these paintings, Titian's *Venus and Amor* was trivial because the figure of Venus was not idealized. The nude, said Ruckstuhl, should not arouse passions, the female figure should never appear "naked," and to represent it in imperfection or decay, except in medical books, was an esthetic and social crime. The highest interests of the race demanded the idealization of woman, and Titian made Venus too fat. Ruckstuhl usually ranked pictures according to the scale of *great* (sublime in the esthetic and ethical sense), and *clever* (lacking only the sublime spark), *trivial* (unimportant) and *degenerate* (definitely harmful ethically and esthetically). In this case the example of degeneracy was Degas' *Woman Making Her Toilet*, a disgusting subject conceived on a degraded plane, ugly in composition, expressive of nothing, badly drawn, ugly in color, and immoral. Although not openly pornographic, as other modern works were, its appeal was to sexual and alcoholic degenerates. This was " 'strumpet art' . . . redolent with the moral effluvia of the cabarets and rat-holes of the Quartier Bréda and the Place Pigalle."[8]

Ruckstuhl's twisted puritanical morality found expression in a virulent attack upon the so-called immorality of modern art. As a watchdog of American virtue he declaimed that "whatever the degenerate painters of the past have done, no American painter, having a 'decent regard for the opinion of mankind' as Jefferson said, at least in our democracy, should paint and send to a public exhibition a picture of a naked woman alluringly lying on a bed." Why nude femininity is especially dangerous in a democracy was not explained; but he advised boycott of exhibitions which contained nudes. To him the depiction of the female nude seemed to be an attack upon the foundations of law and order, for, "The cornerstone of civilization is woman."[9] He denounced Rodin's *Helmetmaker's Wife* as degenerate, since the body of a woman must be rendered only in "its most perfect form, and then only in a spirit of utmost chastity and reverence. . . ." The

86

creation of such a degrading work is, ". . . for an artist, a mistake, to exhibit it a degrading sin, to foist it upon a public museum . . . a disintegrating social crime."[10]

But more serious than these fantastic judgments is the esthetic philosophy developed in the pages of the *Art World*, a philosophy which coincides with the sinister Nazi esthetic developed later in Hitlerian Germany. In an editorial, "The Artist; Pilot or Parasite?"[11] the author, in a violently demagogic attack upon modern art as degenerate, alcoholic and sexopathic, appealed for a new art of "strength," "red blood," "virility," "sanity," "common sense," "native instincts," and "racial purity." American art without foreign taint must lead the struggle against the aberrations of individualism toward a collectivism (expressly not socialism) which, paradoxically, is somehow compatible with the concept of a superman. All this was based on optimism, sacrifice, and glorification of tradition. In another article called "The Domination of American Music by Trade Unions," Edwin Litchfield Turnbull inveighed against the influence of organized labor in art.[12] American music, he charged, was threatened by a small minority of trade union musicians who were trying to dictate art standards. Did Michelangelo, Shakespeare, and Beethoven, he asked, belong to trade unions and work eight hours a day? "Is this a free country?" he demanded, "Are we, who submitted calmly to the spectacle of organized labor putting a pistol to the heads of an American President and Congress, the same Anglo-Saxons (sic) who fought for freedom under George Washington?"

The *Art World's* career of defamation continued through its influence beyond its own life and outside its own pages, when, at the time of the exhibition of modern art at the Metropolitan Museum of Art an anonymous leaflet signed by "A Committee of Citizens and Supporters of the Museum" was distributed in front of the museum. From the style of argument and writing there can be no question that Ruckstuhl was its perpetrator. This document, one of the most rabid examples of proto-fascism in this country, depended largely upon what was at that time the new bogey of bolshevism, the mere pronouncement of which was expected to paralyze man's logical faculties. The Hitlerian use of this term in relation to art was long predated by this little known and long forgotten piece of scurrility. It began with the blanket statement: "We believe that these forms of so-called art are merely symptoms of a general movement throughout the world having as its object the breaking down of all law and order and the revolutionary destruction of our entire social system." It then went on to name and describe the three causes of modernism. The first was bolshevism. Modernism was the application of bolshevism to art. The triumph of bolshevism in art was the deification of ugliness. Bolshevism was the gospel of mental impotence, sweeping away all standards of discipline and training, which would open the temple of art to the mentally lame, halt, and blind of the human race. The second was human greed. And here the Nazi technique of the purposively paradoxical juxtaposition of revolution and capitalism is obvious. Modern art was the product of satanism, of the Paris Commune and the Russian Revolution but organized and planned as a commercial venture by traffickers in fraudulent art. The culprits then were not only the bolsheviks, but also the financial elements in the art world. The third cause was simply insanity. The entire movement was dubbed insane. John Quinn in answer labeled it "Ku Klux criticism," for this was the period of the revival of Klannism in America which, like Ruckstuhlian art criticism, was our own native manifestation of the worldwide development of fascism on the verge of its first political victory in Italy.

The *Art World* and the anti-modernist leaflet were not isolated phenomena; they were part of the larger social picture of war and postwar reaction in the United States. America was undergoing at the time a campaign of hysterical anti-labor, anti-radical repression. This was the period of uninhibited strike-breaking, of the Palmer raids, of the revival of the Ku Klux Klan, of the new, stringent immigration laws and of the farcical Dayton "monkey trial." It was the end of the age of liberalism and the beginning of the era of prosperity. It is not strange, then, that this atmosphere should have stirred the lunatic segment of the art world, fostered "sanity in art" movements, and bolstered the provincialism and philistinism of the millions of chamber-of-commerce and ladies-club members against the threat of "alien" culture.

The case of Leo Stein is a strange one. He did not logically belong among the conservative critics and yet his criticism was consistently anti-modernist. Tinged with bitterness and a sense of failure, his

writing stand somewhere between and above the two opposing groups. He was endowed with a fine mind and a firsthand knowledge of modern art, superior to that of any other American critic, but unfortunately, his judgment was constrained by the haunting memory of the Renaissance. In the light of the all-encompassing humanity of a Michelangelo or a Giotto he could never condone the esthetics of modernism.

Leo Stein and his sister Gertrude were among the first to discover the young moderns, Matisse and Picasso, and their studio in the Rue Fleurus was for many years a center of artistic ferment. Since he had been a part of the artistic revolution, Leo Stein actually knew modern art and artists as few men of his time did, and yet when he returned to America during the war his first criticism, an article on Cézanne, in the *New Republic* in 1916, was a statement of his essential disappointment in the significance of modern art. He criticized Cézanne as an artist of limited gifts, even as inept, and he criticized his art for the narrowness of its range of life experience.

Stein's esthetic thinking was keyed to a lofty conception of art as the richest and fullest expression of man's consciousness of nature and society. He saw art as a human and social function, and as such necessarily full of human and social meanings, and the recognition of this lack in modern art was the basis of his eventual antagonism. He could not accept the substitution of a personal and purely formal art for one based on human experience and expressed in commonly intelligible symbols. As modern art became more and more individualistic and less intelligible, Stein's criticism became more bitter. At first his attack was leveled against the egocentricity of the artist, in a manner similar to that of Cox and Mather. "Our painters," he wrote, "have lost all sense of purpose other than that of satisfying their individual desire, and regard a public demand as a mere impertinence. In consequence they wander in a quagmire of uncertainties led only by the will-o'-the-wisps of their most questionable genius, and hope for profit from the bulldozing of a public too timid to insist upon its rights and too nervous to trust to its own judgment."[13] This from a man who was one of the earliest adherents of modernism. When he contended slightly later that first-rate men were no longer entering the field of art, he was already indicating that he considered the failure of art as not entirely the fault of the artist, but the result of a dislocation in society which relegated art to a place of secondary importance. However, understanding this did not make him a man of sympathy and probity, but instead a sort of dyspeptic Jeremiah in esthetic Jerusalem. His pessimism became so pronounced that he began to see contemporary art as no more than "a stimulus to barren emotion, richer than alcohol perhaps, but just another kind of dope." Some day he hoped—and it was because his hope was so high that his disappointment was so great—that when art would be assimilated as an active ingredient in life it "would be the greatest power in the world."[14] Meanwhile it was a purposeless occupation for men incapable of any other activity.

Stein's most violent anti-modernism seems to have been the outgrowth of his disagreement with Cubism, and it usually took the form of a personal assault upon Picasso. It should be remembered that Stein knew his way about in philosophy and that the philosophical pretensions of most of the new movements appeared to him as nonsense. It is curious, however, that as an esthetician he should have fallen into reasoning that if the philosophic basis of an art was fallacious then the art itself was consequently worthless, without realizing that the pseudo-philosophical theories which accompanied modernism were often no more than publicity handouts, in many cases quite unrelated to the artistic productions.

He seems to have resented the attempts of artists to be philosophers as an invasion of his personal domain and to have developed a contempt for the intellectual ability of artists as a group. Matisse, who never concerned himself with the many complex esthetic theories of modernism, was the only artist that Stein could praise for intellectual ability. Picasso he scorned as a "metaphysical novice."

His attitude toward Picasso, however, was tinged with something more than intellectual disagreement. At the bottom of it all there seems to have been a deep personal disappointment. He had seen in Picasso the promise of a great artist, a man whom he described as "pathetically, disastrously human." Picasso's renunciation of the human for the formal, in Stein's eyes was the result not only of the forces of circumstance, but also of defects in Picasso's character, which led finally into a "wilderness of foolery and waste." He managed always to couple Cézanne, the "inept," and Picasso, the "ingenious," as the father and son of the modern debacle of art,

in which the former failed honestly because of his limitations while the latter hid his failure in virtuosity. "Picasso fooled first himself and then all the world with solemn nonsense. Whenever he throws off the disguise he is found out."[15]

At that time Stein was still demanding integrity of the artist. Later on he questioned why "the least important class in the community should be held to the highest standard of conduct," and considered it "sheer fatuity to hold the artist to any other standard of integrity than that of the community in general,"[16] and obviously in Stein's eyes the community's standards were abominably low. In the end Stein became perhaps the most destructive esthetician we have ever had. His conclusion at last was that art has no purpose, criticism is a farce, appreciation is a delusion, and standards are nonexistent. His *ABC of Aesthetics* is the alpha and omega of surrender. In attempting to clarify his esthetic thinking he eventually destroyed everything in it including his own fundamental, emotional faith in art.

Modernism, strange as it may seem, did have a few champions among the critics of the daily press. Henry McBride, who had followed in the liberal tradition of the *Sun* art critics, Charles Fitzgerald and James Gregg, was a consistent defender of the new art, the most ardent opponent of the conservatives and the sharpest critic of academicism. Charles H. Caffin in the *New York Evening Post* and *New York American* was also on the side of the radicals. On the *Art News* both James Britton and D. Putnam Brinley, who was active in the presentation of the Armory Show, were often sympathetic although by no stretch of the imagination either consistent or profound. James Huneker, then in the twilight of his career as a critic, having mellowed considerably and having established himself pleasantly in a mundane bohemianism, caught a gleam of the new light now and then and lent his pen to the defense. His criticism was dictated, however, largely by an already antiquated predilection for Impressionism rather than by an understanding of the nature of the new phenomena, so that his opinions were erratic, sometimes sympathetic, but often superciliously unreasoned.

Christian Brinton and J. Nilson Laurvik, both free-lance critics, had a much clearer perception of what was going on. Laurvik and Brinton were interested in the introduction of European modern developments in America, Laurvik in the Scan-

dinavians and Brinton in the Russians. They, more than any of the others, were aware of the history of the development of modernism. They were both consequently insistent upon its non-revolutionary aspects, declaring that modernism was "reactionary" in the sense that it was a conscious return to a more primitive vision.

Brinton's concept of modernism, like Cox's, was based on a social explanation of its development. Democracy, he contended, had liberated the artist from patronage and, in setting him loose in society, had created a condition for which the artist was "paying the penalty of isolation." The social consciousness of the artist on the other hand was increased insofar as "painting was no longer content to minister modestly unto life; it had learned to echo in theme and treatment the social, political, and intellectual complexion of the age."[17] He recognized the entire movement as presaging "a profound spiritual rebirth in the province of esthetic endeavor"[18] which was bound to benefit American art if we had the courage to grasp the opportunity. Brinton was the only critic who, knowing the field well, pointed out the incompleteness of the Armory Show. He questioned the absence of the *Dresdener Brücke*, the *Berliner Neue Sezession*, the *Münchener Neue Vereinigung*, the Stockholm Eight, and the Futurists; and specifically Marc, Meštrović, Minne, Burliuk, and Van Dongen. He criticized the ballyhoo for Redon and concluded that the show lacked both the concentrated interest of the London Grafton Exhibition and the inclusiveness of the Cologne *Sonderbund* Show. He blamed the talk of revolution upon the general lack of knowledge and insisted that modern art was a return to the synthetic vision of primitive man.

On the latter point Laurvik was in agreement. His explanation of modernism, however, differed from Brinton's, and he was not as sympathetic with its more recent developments. His little pamphlet, *Is it Art?*, published in the same year as the Armory Show, treated the nineteenth century as the century of scientific realism in art with the lineage of Courbet, Manet, Monet, and Degas culminating in the "great realist" Cézanne. Picasso and the other followers of Cézanne he considered the creators of an introverted art, a turning away from realism toward metaphysics. He regretted that the contemporary modernists did not measure up to the stature of Cézanne or Gauguin and questioned their "pseudo-primitivism" as the goal of art. However, both

Brinton and Laurvik, although critical of some of the aspects of modernism, on the whole were its staunch advocates.

The most brilliant defender of modernism, without doubt, was the versatile Willard Huntington Wright. In his criticism for the *Forum* and his book *Modern Painting*, the first important American contribution to the discussion of contemporary art, he championed with infectious fervor not only European modernism but its American protagonists as well. The pity is that his entire attitude was conditioned by a personal bias in favor of Synchromism. It is difficult to ascertain how much of his judgment came from his brother, S. Macdonald-Wright, and how much was his own. His penchant was for the theoretical aspects of esthetics, and the historical exposition and argument in *Modern Painting* could have been due largely to his brother. But a comparison of the *Creative Will* and *The Future of Painting* with the earlier *Modern Painting* would seem to indicate that the errors in judgment might have been his own, for he was inclined toward overstatement and extreme logical abstraction, and since a belief in "progress" in art analogous to the accumulation of knowledge in science was fundamental to his attitude, he conceived the development of art as a simple historical progression from lower to higher forms.

Unfortunately, *Modern Painting* was written with the obvious purpose of publicizing Synchromism. The entire exposition was based on the *a priori* assumption that Synchromism was the final development in an historical progression toward perfection. Wright equated the rationalizations of this single manifestation with the general purpose of art. As a result he concluded that Synchromism was the final establishment of a universal artistic language, after which there could be no further discovery, no schools, no changes, but merely the production of esthetic objects. Not only did this vitiate to a great extent the commendable observations in his history of the development of modernism, but it led him in his later writings to a complete renunciation of painting as an art. He stated originally that "Painting should be as pure an art as music, and the struggles of all great painters have been toward that goal. Its medium—color—is as elemental as sound, and when properly presented (with the same scientific exactness as the harmonies of the tone-gamut) it is fully as capable of engendering aesthetic emotion as is music."[19] Synchromism had created a "scien-

tifically rationalized" palette upon which such esthetic emotion could be produced. The next step that Wright took, one which followed logically enough, was that all painting, even Synchromism, was inferior to the color organ and would eventually give way to an instrument for the production of color music. Wright was obviously led astray, as were so many modern estheticians, by the conversion of an original theoretical defense or rationalization of a single style into a universal and exclusive principle of art.

Wright was not above distortion and special pleading. He was prone to excessive praise where his personal sympathies were involved, as in the cases of S. Macdonald-Wright and his young friend Thomas H. Benton, at that time decidedly influenced by Synchromism. This personal bias, plus overenthusiasm for American painters, led him to make some rash statements. He claimed that George F. Of was America's best landscapist, that McFee was almost as good as Picasso, and that Man Ray was better than Juan Gris. He also was not above changing his opinions rather abruptly. One year he described Demuth as a party, together with Weber and Davies, to the worst phase of modernism, and the next year, as a fusion of the good points of Degas, Matisse and Picasso. But on the other hand, he was often capable of acute judgment, for example when he characterized the art of both Sterne and Halpert as a compromise between modernism and conservatism and Marin as one of "the most significant and genuinely personal"[20] figures in American art.

In spite of an overlavish display of erudition and a rather irritating tendency toward superiority, Wright brought to his criticism vitality, freshness, and a crusading zeal for the young American art, which, in the short time that he was active, helped to give American artists a needed infusion of confidence.

The evolution of the taste for modernism had its documented expression in the odyssey of Duncan Phillips. Originally a rabid detractor of modernism, he developed in time into a collector and defender of all but its most radical manifestations, his taste, like that of Albert C. Barnes, stretching as far as Fauvism. The space here given to Phillips is not a measure of his importance to American art, but a study of his esthetic growth offers a case history which is revealing in connection with the general development in American taste.

Phillips began his career as art amateur and critic with a set of esthetic values based on what he called impressionism; not the luminism of Monet, but the older tradition of Velasquez whom he considered the "greatest painter of all time,"[21] in that day, of course, a perfectly acceptable position. The Armory Show shocked Phillips as profoundly as it did most of his contemporaries and he rushed to the attack, staunchly supporting Cox's rear with his *Revolutions and Reactions in Painting*, and reaffirming his stand several years later in *Fallacies of the New Dogmatism in Art*. The former was reprinted in a volume of essays called the *Enchantment of Art*, published in 1914, and later in a second revised edition in 1927. In the introduction to the second edition, Phillips recognized the extent of his odyssey. "I am embarrassed by some of the premature judgments of my youth," he wrote, "The book seems to me today the work of another person. . . . The mistakes of judgment which I made were after all no greater, considering the abandon of the outpouring, than the mistakes I make today."[22] His explanation that he was "repelled by the so-called 'modern movements' because of the arrogance and intolerance and the muddle-mindedness of their often absurd manifestos"[23] is only a rationalization of his earlier failure to understand the "revolution" in art.

The revised version of *Revolutions and Reactions* is a complete reversal of attitude on Phillips' part, not merely a pruning away, of "the more conspicuous blemishes of careless thinking, ill-considered judgments, verbiage and redundancies."[24] In some cases there are minor verbal changes which rob the original version of its sting; in other cases a complete deletion of obviously faulty observations, in still other cases additions and qualifications to change the sense of a passage.

While he originally considered the Armory Show as "stupefying in its vulgarity," he later modified the passage to read merely "stupefying," which was certainly true. His indictment of the modern artist—"Instead of trying to become like the Old Masters, he tries to be what nobody ever wanted to be before him"—is deleted completely, for it is plainly not much of an indictment. And also deleted is the opinion, "As Kenyon Cox puts it, they no more deserve consideration as technicians than the bad boys whose nasty smudges in colored chalk they unconsciously imitate."

His belief in 1914 that "John S. Sargent is certainly one of the great artists of all time" became in fifteen years an obvious overstatement, with the result that not only was an entire paragraph in praise of Sargent scrapped, but the earlier description of Monet as an unemotional observer who had "left us nothing but the thing all too plainly presented for the sake of a special sort of truth," was later assigned to Sargent whose name is substituted for that of Monet.

His characterization of Cézanne and Van Gogh as "unbalanced fanatics" was changed to read, "the challenging Cézanne and his excited disciple Van Gogh." The "mad house designs of the cubists" which appeared in the original article was altered successively to "incoherent designs" and then to "incoherent ideas." Deleted was a comparison of Signac with Picabia and an attack on the Cubists as charlatans. Whereas he originally thought "the present decadence then set in with Cézanne and Van Gogh and Gauguin, with Moreau, and Conder and Beardsley," he changed this unreasoned opposition to Cézanne's art to a recognition of its importance in the reintroduction of form, as a revolt against romanticism and naturalism, and as absolutely sincere. But he could not, even as late as 1927, refrain from the charge that some of Cézanne's followers were impostors.

In the case of Matisse, for whom Phillips had reserved his most violent dislike, he made a long apology. However, even in his confessional he seemed unwilling to admit the extent of his sin. He reprinted as his original opinion of Matisse, "Certainly this man has created patterns unworthy of the mere ignorance of children and savages." The original was not quite so restrained. It read, "Certainly this *person* creates patterns unworthy of the mere ignorance of *little* children and *benighted* savages, *patterns not only crude but deliberately false, and insanely, repulsively depraved.*"

As a final touch to his conversion a comparison of the illustrations of the 1914 and 1927 editions shows the removal of Monticelli, René Ménard and George Inness in favor of Cézanne, Renoir, Manet, and Prendergast. In the early twenties, Phillips had become a collector of modern art and founded the Phillips Memorial Art Gallery. If his taste still remains rooted in Impressionism, his odyssey has been nonetheless adventurous.

◈ COLLECTORS

ALTHOUGH the modern collector does not play as vital a role in the development of art as did the patron of other times, he still is a far from negligible factor, for, aside from satisfying his own purposes, he performs the contemporary social functions of supporting the artist and influencing taste.

American collecting before the Armory Show was concerned almost exclusively with the acquisition of works of the past. The great reservoir of tradition which Europe had accumulated in the form of art objects became a potential short cut to culture and tradition for American collectors who could either discriminatingly or indiscriminatingly plunder them, legally, of course, and with considerable profit to their European custodians. To the tycoons of the late nineteenth and early twentieth centuries collecting art presented the highest form of conspicuous consumption, indicative of wealth and refinement. At the same time, the natural tendency of collectors to acquire objects of established value had a great deal to do with the continued subservience of American art to the imported traditions of European art of the past. American artists who painted in the manner of those historic styles which were currently being collected managed to find occasional patrons. The man who collected English portraits, the Barbizon school, or naturalistic genre paintings occasionally also included the work of their contemporary imitators. Those who collected the Renaissance masters, Medieval art or the Italian primitives, unfortunately for living artists, usually ignored contemporary Americans. The American artist's chances for success, then, were dependent in a great measure upon his ability to satisfy a taste circumscribed by specific historical traditions. This is not to say that the collector is the dominant factor in the development of taste. The evolution of taste as a whole is governed by deep-seated social compulsions, which cannot be dictated or materially altered by the idiosyncrasies of an individual collector. However, the monetary support offered the artist and the social prestige of the collection have a good deal to do with supporting specific norms of taste. In a sense it is a matter of selection; a tendency will flourish only if enough support gravitates to it. Although a single artist may manage to go on painting in spite of starvation, an entire art movement cannot advance on an empty stomach.

Modern art, for instance, may not have received popular acclaim; but its artists almost from the very beginning either had support from loyal amateurs or perspicacious dealers, or were individually self-supporting.

Whereas the role of the American collector as a patron was limited during this earlier period, the growth of the taste for modernism, directing the collector's interest, as it did, to contemporary manifestations and hence to living artists, caused him to regain the position of patron at least to some extent. However, the major importance of the first American collectors of modern art was not so much as patrons of individual artists but as instruments in the propaganda for modernism. Perhaps it was a desire to defend their own taste which led them to many activities which would have been unthinkable to such collectors as J. P. Morgan, Joseph E. Widener, Henry C. Frick, Henry Walters, or John G. Johnson. These newer collectors differed from the latter in a fundamental respect. None of them were rulers of vast financial or industrial empires. In many cases they were living on inherited wealth. Money to them was not an instrument of power, but simply a condition which allowed them freedom to indulge their intellectual and cultural predilections. They were a strange and new phenomenon in the field of American collecting. If not as rich as their more orthodox brethren, they were intellectually, at least, more adventurous. They were less concerned with the accumulation of luxury objects as an expression of wealth, prestige, or power. Of all the early collectors of modern art in this country only Albert C. Barnes was a throwback to the Midas type, and even he in other respects ran true to form.

The urge to proselytize was a distinctive characteristic of this group. They seemed to feel that only a public educated to understand and appreciate modernism could eventually vindicate their own judgment. Instead of hiring experts to catalog their collections and printing the results in sumptuous form as a further evidence of affluence, the new collectors themselves attempted to defend and explain modernism in publicly circulated books. Albert C. Barnes, Arthur Jerome Eddy, Katherine Dreier, Duncan Phillips, and A. E. Gallatin wrote and lectured on modern art, and Barnes, Dreier, Phillips, and Gallatin, as well as Lillie P. Bliss, institutionalized their collections for educational purposes rather than as memorials, which the National Gal-

lery, the Walters Gallery, the Frick Museum, or the Morgan Wing of the Metropolitan Museum of Art were intended to be. It is remarkable that in such a small group there should have been such concentrated fervor for the transformation of public taste. Nor can the effect of their efforts be overestimated. The *Société Anonyme*, the Barnes Foundation, the Phillips Memorial Art Gallery, the Gallery of Living Art, the Museum of Modern Art—these are the institutions which have helped to support the growth of modern art and create for it a climate of favorable opinion. Our taste today is in no little measure the product of these efforts.

Of all these new collectors only a few had begun to collect before the Armory Show. Gertrude and Leo Stein, who deserve mention for their pioneering in support of modern art, are more logically to be considered with French collectors than here with the Americans. Claribel Cone, who had begun to buy Matisse and Picasso under the impetus of the Steins, lived abroad a great deal and her collection was practically unknown in America. Albert C. Barnes, for all his claims of priority, at that time had probably bought nothing more radical than Cézanne. The others of this early group, John Quinn, Lillie Bliss, Arthur Jerome Eddy, Katherine Dreier, and Walter Arensberg, were directly influenced by the Armory Show, and of these Quinn, Bliss, and Eddy actually purchased from the exhibition.

After the war, during the prosperity of the twenties a new and essentially different group of collectors arose, among them Duncan Phillips and A. E. Gallatin, who in most respects resemble the earlier collectors and should be listed with them, and also Adolph and Samuel Lewisohn, Chester Dale, Stephen C. Clark, John T. Spaulding, Helen Birch Bartlett, Lewis Larned Coburn, A. Conger Goodyear, Mrs. John D. Rockefeller, Jr., Carroll Tyson, and Henry P. McIlhenny. With the exceptions mentioned, this second wave reverted to the traditional concept of collecting, the accumulation of objects. Modernism, by that time, if not completely established in public taste, nevertheless was recognized by a sizable body of opinion. In the twenties modern art had become a legitimate field of collecting. In the thirties it was to become the major field. Since masterpieces of the past had become progressively scarcer and prohibitively priced, the great majority had already gravitated through private collections to the eternal rest of museum possession and no

new collections could hope to rival the mammoth accumulations of previous generations. Only one major collection of old masters was formed in the twenties, that of Andrew Mellon whose wealth was fabulous, but even it would have been impossible had not the Hermitage placed some of its priceless possessions on the market. The trend toward modernism, supported by the handful of zealous collectors following the Armory Show, gained momentum only after the war; but by the late twenties it was already firmly established.

Art consciousness grew prodigiously during the twenties. Prosperity was evidenced in the growing civic pride with which almost every fair-sized city in the United States which did not previously possess an art museum established one. This era of the Chamber of Commerce and the Rotary Club was also the era of the Ladies' Club and "culture." From 1921 to 1930, sixty new museums were formed and thirteen new buildings were erected at an estimated cost of $16,000,000. At the same time there was a phenomenal expansion of the art market, and fabulous, record prices were paid for art objects in almost all fields. Although the American buyer had been dominating the European art market since the turn of the century, and although it was estimated in 1923 that $350,000,000 had been spent for art abroad since 1910, even this pace was accelerated in the twenties.

At first modern art played no appreciable part in this postwar wave of buying which was confined almost exclusively to the more acceptable and traditional periods. There was even an unanticipated boom in American "masters," so that academicians lived for a while in the hope that "solid" and "national" values were finally coming into their own. In January 1922 an Abbott Thayer figure-piece was sold for $40,000 and almost immediately afterwards Winslow Homer's *Eight Bells* brought $50,000, a new record for a modern American picture. This price was soon topped by a $60,000 figure for George Inness' *Spirit of Autumn* and, during 1922, three George B. Fuller paintings were sold at approximately $40,000 each. Such exaggerated prices were not to stand up against the increasing influx of French modernism. Before very long the dominant figures in the modern art market were to become Manet, Monet, Degas, Cézanne, Renoir, Seurat, Van Gogh and Gauguin, to be joined shortly by the contemporary painters Matisse and Picasso.

The first evidence that modernism had forced a

leak in the art market dike was the Dikran Kelekian sale in 1922. The collection included most of the leading French painters from Ingres and Delacroix to Matisse and Picasso as well as the Americans Cassatt, Whistler, and Arthur B. Davies. At the sale, one hundred and sixty-one paintings sold for a total of $254,870, with the "sensational" $21,000 paid by Lillie Bliss for a Cézanne *Still Life* as the top price. In spite of Kelekian's statement that he had lost money on the sale, the results were startling for America. In 1939 Kelekian estimated that the Seurat *Poudreuse* which had gone to John Quinn for $5,200 to be worth $100,000 and the Van Gogh *Self-Portrait* now in the Detroit Institute of Arts, which went for $4,200, could bring $50,000. Lillie Bliss was offered $150,000 for her Cézanne several years after its purchase. Even in 1926, when the market was much more favorable, the executors of the John Quinn estate felt that the American market was insecure and sold part of the collection in Paris. However, the American portion of that sale was so successful it served as conclusive proof that modernism had won its place in the art market at least.

When Bryson Burroughs purchased Cézanne's *La Colline des Pauvres* from the Armory Show for the Metropolitan Museum of Art, it was a landmark in the museum's history. The step was so precipitous that the museum's director, Dr. Edward Robinson, was reluctant to acknowledge it. This purchase was evidence that America had come a long way since 1908 when Sir Charles Purdon Clarke, then director of the Metropolitan, in one statement branded Impressionism as something "invented in the absinthe shops of Paris," dismissed William Blake with the dictum that "a Blake is not worth the paper it's on," and lavished fulsome praise upon such immortals as Alphonse de Neuville, José Villegas, and Albert Bierstadt.[1] Although Burroughs was himself open-minded and progressive, the very nature of the museum setup, with its many checks and counter-checks, militated against the Metropolitan, or, for that matter, any other museum in the country, playing a decisive role in the recognition and dissemination of modernism. Although it was important that the Art Institute of Chicago had housed the Armory Show, that John Cotton Dana had had the courage to give Max Weber a one-man show at the Newark Museum in 1913, and the Metropolitan had presented an exhibition of modern art in 1921, museums on the whole were still morgues for masterpieces. It remained for individuals with cour-

age and foresight, with faith in their own taste and no need to appease either tradition or trustees, to pioneer in the collection of modern art. As America had found men with vanity and millions to seize upon the plastic traditions of Europe, it now somehow found men with courage and the necessary amount of money to buy living art, and the new collectors of modern art in their own way were even more amazing than their colossal predecessors.

The most remarkable patron, for he was more patron than collector, was the brilliant lawyer, John Quinn. A second-generation Irish-American, graduate of Harvard Law School, student of James, Santayana and Thayer, Secretary to the Secretary of the Treasury during the Harrison administration, he made his fortune and his fame as a banking lawyer. A man of dynamic energy, he was also intensely interested in culture, or, perhaps more accurately, the creators of culture. He found that although he lacked the creative gift, as a patron he could participate actively in the cultural life of his time. With his heart apparently divided between his ancestral heritage and the land of his birth, he took an active part in the Irish Renaissance, was a close friend of William Butler Yeats, A. E., J. M. Synge, and Lady Gregory, and at the same time was closely allied to the entire group of American artists who fostered the Armory Show. He served as counsel for the A. A. P. S. in its anti-customs-tax fight and was influential in the final repeal of the tax on contemporary art.

Quinn was probably the most adventuresome collector America ever had. He made up for his lack of critical perspicacity by a personal acumen which led him either to judge artists by their personalities or to rely on the most advanced opinion in artistic circles. He bought art as an expression of his faith and support of an artist or an artistic tradition. He was thus a true patron of modern art as well as the modern artist. It may have been part of his vanity to collect personalities as others did material objects, but the result was a much more vital and human relationship. He supported the creative intention rather than its material result. The Quinn collection therefore should not be judged by the quality of its objects, although in that sense, also, it was amazing, but as the expression of a belief in living art. He bought Cézanne because he was the ancestor of modernism, he bought Augustus John because he was his friend, he bought Jack Yeats

because he was an Irishman, and he bought Walt Kuhn because he wanted to help a young American artist of promise.

Of course, any collection formed as Quinn's was, was bound to be unequal. It contained such magnificent Seurats as *The Circus*, bequeathed to the Louvre, *The Models*, bought by Albert C. Barnes, and *La Poudreuse*, now at the Courtauld Institute; a large selection of Picassos, which for that time was thoroughly representative of his artistic evolution; and Rousseau's *The Jungle* and *The Sleeping Gypsy*. If the large English and Irish section was not up to the level of French art, that was not Quinn's fault. For the same reason, Quinn's American group was also not imposing, although it was representative. It contained most of the "Eight," such leading modernists as Marin, Weber, Maurer, Sheeler and Hartley, and a rather disproportionate number of works by Kuhn.

The John Quinn Sales in 1926 and 1927 "gave the *coup de grâce* to American esthetic conventionality."[2] The $700,000 realized from the collection was a shock to American values. Whatever one might think of modernism it was impossible to deny that the monetary value of modern art had multiplied incredibly in a few short years. Some people, it appeared, were willing to pay good money for these strange pictures. Quinn had been as crazy as a fox. But even craziness was okay if it paid off. From calling modernism insane and a hoax and periodically announcing its doom, the press and public turned to pointing the finger of accusation at the negligence of our museums. Why had they not foreseen the trend as did Quinn and bought while the stuff was cheap? Whereas previously modernists had been dubbed crackbrained revolutionaries, now museum directors were denounced as blind old fogies.

The Armory Show was just the thing to attract Arthur Jerome Eddy, who throughout his life was a champion of the new, whether in economics, transportation or art. He espoused with the same fervor his theories of competition and monopoly, the automobile, or Post-Impressionism. Eddy was a Chicago lawyer who, like Quinn, could never confine all his energies to the practice of law. He wrote fiction, esthetics, criticism, and was capable of undertaking anything which offered the promise of excitement. One of the first pictures he bought was Manet's *Philosopher* and that at a time when Manet was still an unknown to most American collectors. He had also been in advance of his time in his appreciation of Whistler, had his portrait painted by the master, and in 1903 published a critical essay, *Recollections and Impressions of James A. McNeill Whistler*.

Eddy came to New York for the Armory Show, was inflamed with the new revelations and bought a large number of the most extreme works, including the *Nude Descending a Staircase*. But he not only bought modern art, he fought for it. By 1914 he was so steeped in modernism as a sort of combination patron-apostle that he poured out his enthusiasm in *Cubists and Post-Impressionism*. This exciting mixture of idealism, faith, evidence, and argument reads like the impassioned plea of a defense attorney for the life of his client. It is at once an appeal for tolerance and an explanation of motive and cause. It is noteworthy as one of the first books to appear in America on the subject of modern art and, in spite of its special pleading, an astonishingly informative volume. Although it lacks the tightly constructed historical argument of Willard H. Wright's *Modern Painting*, it is richer in material and in knowledge of the entire contemporary field. Perhaps because of his interest in Kandinsky he gave adequate recognition to the German Expressionists, whereas Wright was concerned only with the straight line of development of French art towards Synchromism. Like Wright, however, Eddy's conjectures as to the future of art were erratic.

Eddy liked crusades; but perhaps even more than that, he delighted in shocking the conservative milieu in which he moved. He enjoyed the bewilderment and uneasiness with which his colleagues and society friends viewed this strange new art, and he enjoyed the intellectual exercise in its defense. The picture which he hung in his office and which he changed periodically was a symbol of his seeking as well as a goad to the mental somnolence of his stuffed-shirt colleagues.

Dr. Albert C. Barnes, who gained some notoriety through his egotistical posturing, his boorishness, and his poison-pen letters (which on the whole were rather dull), had, without doubt, the finest collection of modern art in America, perhaps in the world. Although his eccentricities managed to overshadow the magnificence of his possessions, history will undoubtedly remember him for the latter rather than the former.

After Barnes made his first several millions, he began, in the accepted manner of American businessmen, to buy pictures and, in the accepted manner of his time, by artists like Millet, Diaz, and Corot. However, about 1910 he had an awakening; and here the story is slightly confused. According to John Sloan, William Glackens, an old schoolmate of Barnes, convinced him that the dealers were playing him for a sucker and suggested that Barnes let him go to Europe and buy some real art. According to Barnes, he became convinced of the importance of the new art and himself sent Glackens to Europe to buy pictures by Monet, Renoir, Degas, Cézanne, Matisse, Picasso, and others. Whatever the truth may be, by the time of the Armory Show, Barnes was already launched in his career as a collector of modern art. From the very beginning, unlike Quinn, he was out for the best. All his defense of modernism, all his esthetic teaching has the ring of vindication of his personal taste.

Barnes' taste was apparently formed at the very outset by Glackens' preference for Renoir. The collection, centering around the work of Renoir and his counterpoise, Cézanne, is largely concerned with the nineteenth-century French tradition of Impressionism and Post-Impressionism—Manet, Monet, Pissarro, Sisley, Renoir, Cézanne, Van Gogh, and Gauguin. This may explain his predilection for Matisse among contemporary painters, as the direct descendant of Impressionism; and it may explain his taste for Glackens, Prendergast, Pascin, and Soutine. It may also explain his apparent inability to fathom the bewildering versatility of Picasso. He never could understand Cubism, whose demise he announced rather precipitously in 1916, for it did not conform to his own so-called scientific esthetic principles—principles which are derived from the "pictorial" tradition which extends from the Venetians to Renoir. This same bias has even colored his evaluation of Cézanne.

His interest in esthetics later led to a widening of the scope of the collection to include examples of other art epochs, in order to provide material for comparison and to "correlate . . . the main principles that underlie the intelligent appreciation of the paintings of all periods of time."[3] His very fine collection of primitive African art and provincial American crafts, which he used for the same purpose, is the outgrowth of his taste for modernism.

In the early twenties Barnes became engrossed in esthetics and eventually developed what he called "principles of scientific method" adapted to the plastic arts. He recognized the weaknesses of the "pseudo-scientific" theories and attacked the "systems" of Denman Ross and Jay Hambidge. He offered instead his own "scientific" method as "a type of analysis which should lead to the elimination of the prevailing habit of judging paintings by either academic rules or emotional irrelevancy," with the guarantee that the analyses were "compiled exclusively from my own observations recorded in front of the paintings themselves."[4]

The formation of the Barnes Foundation in Merion, Pennsylvania in 1925 as an educational institution and the publication of the *Journal* was a pioneering effort in modern art education, which unfortunately was dominated by a desire to propagate his own conception of "scientific" methods. Aside from the nominal and honorary inclusion of John Dewey and the adherence of the estheticians Laurence Buermeyer and Thomas Munro, the entire setup of the foundation was an expression of Barnes' own vanity. The foundation never functioned effectively either as a school for artists and teachers, since it was so completely dominated by its opinionated angel, or as a force in the development of American taste, since Barnes was soon at odds with every other art institution in the country and with much of the art public. He refused to admit students, scholars, and teachers, except of his own choosing, to his collection and, since he also refused to lend his pictures, the collection is known only to a limited few. The rather pathetic fear that someone might disagree with him led finally to such exclusiveness that, as far as American art or taste is concerned, the Barnes collection might as well be housed in the Fiji Islands. The recent death of Dr. Barnes threw the whole question of the foundation as a public institution into the courts and, although the foundation was sustained, it is to be hoped that its policies in regard to visits and loans will be liberalized.

The Lillie P. Bliss collection, which in 1924 became the nucleus of the Museum of Modern Art, was initiated at the Armory Show. Through the urgings of Arthur B. Davies, Miss Bliss bought a Renoir, two Degas and two Redons from the exhibition and, at about the same time, a Cézanne landscape, *The Road*, the first of twenty-six works by that master which eventually constituted the most important section of her collection. Aside from the

works of Arthur B. Davies and Walt Kuhn, both of whom acted as artistic advisors to Miss Bliss, there were no American paintings included. Miss Bliss had neither Quinn's adventurousness, Eddy's enthusiasm, nor Barnes' voraciousness. Her collection was confined to the recognized masters of French modernism. She neither ventured rashly nor bought lavishly. She collected, even as a pioneer, conservatively, with consideration and taste. Although a retiring person she was nonetheless a staunch proponent of modernism. She was active in inducing the Metropolitan Museum of Art to arrange its first exhibition of modern art in 1921 and was instrumental in the formation of the Museum of Modern Art.

It is not entirely accurate to list Katherine Sophie Dreier with the collectors, for she was never as interested in the personal accumulation of art as she was in proselytizing for it. With this object in mind she projected, with the assistance of Marcel Duchamp, an international society to promote the understanding of modern art in America, and in 1920 they formed the *Société Anonyme, inc.*, its title typical of Duchamp's involuted wit, the first museum for modern art in this country. Although most of the monetary support came from Katherine Dreier, her sister Dorothea, and the friends they could interest, the *Société* was strictly speaking an institution and not a private collection. The funds went not into purchase but into the program of the young museum, for exhibitions, publications, and lectures. The museum attracted some of the more radical artists, Man Ray was active from the beginning as one of its directors, Marsden Hartley was its secretary, and Joseph Stella was an active member. The *Société* presented the most advanced aspects of modernism: Cubists, Simultaneists, Futurists and Dadaists, and, what was especially noteworthy, gave equal attention for the first time to the German modernists through the works of Kandinsky, Campendonk, Klee, Schwitters and others. Among the Americans who were exhibited, Marsden Hartley was listed as a Cubist and Dadaist; James Daugherty as a Cubist and Simultaneist; Patrick Bruce as a Simultaneist; Joseph Stella as a Futurist; Walkowitz, Man Ray, and Schamberg as "belonging to no schools, but imbued with the new spirit in art"; Dorothea Dreier as a Post-Impressionist and Katherine as an Expressionist.[5]

In its short and sporadic existence as an active institution, the *Société* did a great deal to spread the message of modernism. An exhibition of modern art was arranged and circulated, opening first at the Worcester Art Museum in November 1921. Lectures were given at the museum by Marsden Hartley, Joseph Stella, Man Ray, Christian Brinton, Phyllis Ackerman, and Katherine Dreier, whose lectures were published as *Western Art and the New Era*. Here Eilshemius, dug out of obscurity by Duchamp, also had his say, if not to the world at large, at least to a small group which was receptive. The *Société* under Duchamp's leadership was governed by a spirit of adventure and, during the few years from 1921 to 1923, was a rallying point for all that was most radical in American art. Its collection today is part of the Yale University Art Gallery.

The most retiring of all these early collectors is Walter C. Arensberg. He neither wrote, lectured, nor institutionalized his personal taste. Originally confined almost entirely to Cubism and only later expanded to include certain of the more abstract phases of Surrealism, the Arensberg collection, of all American collections of modern art, is the most consistently expressive of the collector's own personality. The mark of his scholarship and taste is evident throughout. It is immediately apparent that here is not merely a collector but an *amateur*.

Arensberg's interest in modern art was first aroused when he saw the Armory Show on its last day in New York, in the turmoil and excitement of its closing. This interest was further stimulated through his friendship with Duchamp, in whose intellectual capriciousness he found a kindred spirit for his own sophisticated mentality. They both enjoyed the verbal jugglings, the pranks, and the mental "hot-foots" that they perpetrated upon the members of their circle and themselves. In the years immediately after the Armory Show and during the early twenties, Arensberg was an active figure in New York's intellectual world. His studio on West Fifty-seventh Street served as a salon for leading literary and artistic radicals. He wrote free verse, translated Mallarmé's *L'Après midi d'un faune*, and gave financial aid to such literary and artistic experiments as the small magazine *Others*, edited by Alfred Kreymborg, and the Modern Gallery, run by De Zayas.

The Arensberg collection, recently given to the Philadelphia Museum of Art, is predicated upon certain facets of Arensberg's own personality—his

fastidious taste, his intellectuality, and his love of the esoteric. It is the most extensive collection of Cubist paintings in this country, containing not only remarkable examples by Picasso and Braque, but also the lesser figures like Gris, Gleizes, Metzinger, Gromaire and Delaunay. Especially noteworthy are the Duchamps, among which is the *Nude Descending a Staircase*. The analytical quality of Cubism, its intellectual coolness, its puzzle-like complications all appealed to Arensberg. The metaphysical gymnastics of Cubism must be a joy to this man, who has dedicated himself to a minute and scholarly investigation of the works of Shakespeare in a search for supposedly hidden cabalistic signs, which, if deciphered by means of complex maneuvers involving chess, the magic ring, magic squares, anagrams, acrostics, and other devices of cryptography, would establish Shakespeare as a figment of Francis Bacon's deviousness. The Arensberg collection exhibits admirably this love of cerebration for its own sake.

In the collection one finds the most primitive carving on a field stone and the most sophisticated examples of modern Parisian bookbinding, Rousseau and Picasso, African sculpture and Paul Klee, because they are all esoteric, because they would appeal only to those with especially sensitive and refined taste. Here is perhaps the most esoteric of contemporary attitudes in which it is not so much the object itself, as its associative overtones which are the touchstone of its significance.

The importance of a collection is not always in direct proportion to its quality. In America there are some very fine collections which are almost unknown, and there is one extensive early collection of modern art which played no part as a general influence, the Cone collection, the joint accumulation of the sisters Claribel and Etta, which has recently been given to the Baltimore Museum. Claribel was introduced to modernism early in the century by her cousin, Gertrude Stein, when she went abroad to study in Paris. She began as early as 1906 to buy Matisse and Picasso. Her connection with Matisse was especially close, and the collection today contains a complete chronological survey of his development. However, this collection was publicly shown for the first time only in 1930, in a memorial exhibition for Claribel Cone. Before then it was known only to fellow collectors and friends, and today it is rather a shock to realize that more

than forty-five years ago, when Cézanne was unknown in America, a citizen of Baltimore was quietly collecting Matisse and Picasso.

Of course the Steins had discovered modern art in Paris at an even earlier date. Although their activity was within the sphere of Parisian art movements, their salon in Paris and their collection served as the doorway through which many of our young American artists got their first glimpse of a new art. Both A. E. Gallatin and Duncan Phillips, as has been mentioned, were converted to modernism at a slightly later date but they resemble the members of the earlier group in their efforts to proselytize.

A. E. Gallatin, whose interest in art dates back to the turn of the century, went through a long evolution similar to, if not as violent as, that of Duncan Phillips. A devotee of Whistler, later a defender of the Ash Can School, he did not succumb to modernism until about 1922 when he bought two Cézannes and a Picasso. In 1927 he converted the collection, which had grown to include most of the contemporary French painters and some Americans, into the Gallery of Living Art, housed in the reading room of the Washington Square College of New York University. Although Gallatin subsequently acquired several outstanding works and improved the quality of the collection, which has now become part of the Philadelphia Museum of Art, at that time it was composed of rather sketchy and slight examples of the leading modernists. It was a minor collection which presented the tendency without the quality of modern art.

Of Duncan Phillips' esthetic adventures we have written at length. His conversion led to the collecting of modern art, the establishment of the Phillips Memorial Art Gallery in 1920, and the publication of a journal. He did not become interested in modernism until after his purchase in 1923 of *Le Déjeuner des Canotiers* by Renoir. Even in 1924 he still had no pictures by the really advanced moderns. His collection contained mainly the Impressionists and Ash Can painters—Lawson, Twachtman, Prendergast, Weir, Sloan, Luks, du Bois; and among the French painters he had no one more advanced than Pissarro, Sisley, Monet and Renoir. It remains only to mention that Phillips' taste is still firmly rooted in Impressionism, although, with very laudable intentions, he has attempted to create a museum to cover the whole realm of modernism, foreign and native.

Although these collections, and others, included

some American artists, it was usually either because they were echoes of a particular French tendency in which the collector was especially interested or because of personal friendship. Thus Lillie Bliss included Davies and Kuhn; Barnes bought Glackens, Demuth, and Prendergast; Quinn collected a representative group of American painting; Arensberg included a few Americans who worked in the Cubist idiom. On the whole, however, these collectors were patrons of French art. Among the second generation collectors Phillips, Lewisohn, and John T. Spaulding made some effort to acquire representative Americans.

There were, however, only a few collectors concerned enough with American art to support the young native modernists against the overwhelming preference for the publicized French masters. Of these Ferdinand Howald was the earliest and the most devoted. With almost complete anonymity and almost alone he collected works by American modernists, until by the time of his death on March 29, 1934, he had amassed the most comprehensive collection of a formative period in American art, a collection which is now divided between the Columbus Museum of Art and his niece, Mrs. Shawan, also of Columbus, Ohio. Included are some of the finest examples of the period: thirty-five Demuths, twenty-three Dickinsons, nineteen Hartleys, thirty-two Marins, sixteen Prendergasts, and works by Albert Bloch, Peter Blume, Louis Bouché, Fiske Boyd, Emile Pierre Branchard, Charles Burchfield, Arthur B. Davies, Arthur G. Dove, Elsie Driggs, William J. Glackens, Rockwell Kent, Yasuo Kuniyoshi, Ernest Lawson, George Luks, S. Macdonald-Wright, Henry Lee McFee, Edward M. Manigault, Kenneth Hayes Miller, Jerome Myers, Jules Pascin, Man Ray, Morton L. Schamberg, Saul Schary, Alice Shille, Raphael Soyer, Niles Spencer, Abraham Walkowitz, Max Weber, and William Zorach.

Modernism

John Covert, *Brass Band*. Courtesy, Yale University Art Gallery, Collection of the Société Anonyme

◈ THE CUBIST TRADITION

IN RECENT YEARS there has been an effort on the part of some scholars to push the dates of American experimentation in abstraction back before the Armory Show. This seems a misguided attempt to give our native artists a role in the original development of modernism in which they played a minor and fairly unimportant part. This attitude seems also to have been bolstered by hindsight and the perhaps natural vagueness of memory of some artists. From the available records it would appear that the major experimentation toward abstraction, which grew out of Cubism, Futurism and Dada, occurred after the Armory Show.

It is true that the majority of artists of this generation were in Europe earlier. Maurer had arrived in Paris in 1900, Karfiol and Kuhn in 1901, Halpert in 1902, Sterne, Demuth and Pach in 1904, Weber, Marin and Carles in 1905, Russell and Walkowitz in 1906, Macdonald-Wright, Bruce, Dove and Marguerite Zorach in 1907, Dasburg and Benton in 1908, Schamberg, Sheeler and Stella in 1909, William Zorach and Dickinson in 1910, Hartley, Bluemner and Covert in 1912. But on the whole, even if they were in some cases in contact with the leaders of modernism in Paris, they seem in most cases not to have been affected by its more radical phases. Maurer and Weber were influenced by Matisse and the Fauves, Weber to some extent by the earliest phases of Cubism, although his major efforts in Cubism occurred only later, beginning in 1910, after he had returned to the United States. Marin also experimented with Cubism only after his contact with that style at "291." Certainly Sterne went no further than Cézanne and Gauguin, Halpert no further than Renoir and Marquet, and Karfiol no further than Picasso's Pink Period. Hartley's abstractions date from his introduction to German Expressionism during his sojourn in Munich in 1914-1916.

Of those painters who developed toward abstraction earliest, Stella was influenced by and became part of the Futurist movement as early as 1910, Bruce exhibited with the Orphists in Paris in 1913, and Russell and Macdonald-Wright were influenced by the Orphists at about the same time. Only Dove seems to have evolved a personal abstract style before the Armory Show. It is questionable whether one may legitimately include among the American artists, at least of that period, Feininger, who lived in Germany from 1887 to 1937, or Konrad Cramer, who came to this country in 1911 from Germany where he claims to have been affected by the *Blaue Reiter* group (which was formed in 1912 in Munich) and did his first abstractions dated 1912.

All of these men could have known of the radical experiments that were current in Europe either through personal contact abroad or through the exhibitions at "291" before the Armory Show, but the fact remains that an inspection of the dates of paintings exhibited during that time or in the more recent retrospectives points to a much later involvement with abstraction. If the evidence does exist, it has not been made public and conclusive, and seems largely dependent upon the testimony of artists who now after some forty years recall with perhaps less than complete accuracy the events of their youth.

Of all the modernist styles Cubism was unquestionably the most influential. While other artists and other schools had isolated and sporadic disciples, Cubism was the one movement which was truly widespread. Cubism appealed to the American artist because of its rationalism. Fauvism and Expressionism demanded a basic faith in one's esthetic

Morgan Russell, *Synchromie Cosmique*
Collection of Mrs. Willard H. Wright

Konrad Cramer, *Improvisation No. 1*
Collection of the Artist

sensibilities, a "wildness" in relation to accepted norms, a wildness whose rightness was never rationally demonstrable. The American artist, for the most part esthetically naive and inhibited, required a rational explanation for his departure from convention. He was almost congenitally incapable of the emotional excesses of Fauvism or Expressionism. At the same time, because of the ingrained optimism of his heritage, he was unsympathetic to the pessimism of Dadaism. Futurism, which, in its concern with machine civilization, should have found some echo in our own advanced industrial society, was never influential, first, because we saw the machine not as a destroyer of the individual spirit, but as a creator of material comfort and, second, because the social violence which infested Futurism was inimical to our own tradition of reformism. The other extremist doctrines never caught hold because they were either unpublicized or too esoteric for the neophyte American modernists.

Cubism appealed as a search for fundamentals, for the essential truths of the material world. This search for what was basic rather than peripheral

seemed to place the artist on a solid footing, almost comparable to the scientist. He was no longer painting things as they appeared, but was stating a deep and fundamental truth about them. The simple geometrical reduction of an object seemed to assume the importance of a philosophical principle or a law of nature.

It should be pointed out, however, that the appeal of Cubism was in the rationalism of its theory, rather than in its results. Except in its very simplest and earliest stages Cubism is no more demonstrably rational than Fauvism. The appearance of Cubism with its calm, almost monochromatic, classicism seems rational only in comparison with the appearance of Fauvism with its highly emotional distortion of form and excitement of color. Actually one can no more explain the intellectual contrivance of Cubism than the emotional expression of Fauvism. There was a curious contradiction in the acceptance of Cubism; for, though some artists were attracted to the rationalism of the theory, and most of the argument for Cubism was based on its rationality, they were conscious of the fact that it was really an intuitive process. They even insisted upon the sanctity of the personal reaction. It was this quality that Jay Hambidge and his followers, for instance, could not tolerate, even while agreeing that Cubism was a progressive step in the direction of a return toward fundamentals of design in form and color.

The period of the greatest Cubist influence dates from the Armory Show through World War I. During the twenties Cubism, having been assimilated or deserted, dropped into the background. The phenomenal growth of abstract art in the United States during the thirties and later is not an outgrowth of these earlier Cubist experiments, but is an entirely new development arising out of new conditions under different influences and affecting a completely new group of artists.

In this early period, however, many of the younger artists were experimenting with Cubist ideas. It is almost impossible to name an artist of note who was not, even if the allegiance was only temporary and superficial. It may be said that the general pattern was toward a progressive assimilation or eventual rejection of Cubist elements rather than a consistent and logical investigation of its possibilities. One aspect of post-Cubist developments in Europe was toward the pure abstraction of the Dutch *De Stijl* or the Russian Constructivist groups, and a comparable though aborted tendency

Patrick H. Bruce, *Composition II*
Courtesy, Yale University Art Gallery, Collection of the Société Anonyme

under the aegis of Duchamp and Picabia is to be discerned in this country. The men who experimented most intensely along these lines were, for one reason or another, active only temporarily in the United States, leaving behind only what amount to archeological fragments, accounts of works destroyed, and in some cases only the memory of names in exhibition catalogs. Aside from the Synchromists, who had their short day in the light, men like Man Ray, John Covert, Patrick Bruce, Konrad Cramer, James Daugherty, Walter Pach and Clifford Williams left little impression on American art. John Covert in the short period from 1915 to 1920 created at least a few works of some originality and interest, but eventually left art for business. Konrad Cramer painted some unusually advanced abstractions which have been dated as early as 1912, but turned later to photography. Patrick Bruce, who with A. B. Frost, Jr., another American, exhibited with the Orphists in Paris, lived permanently in Paris from 1907 on and exhibited here with the *Société Anonyme* group during the early twenties paintings that were strongly influenced by the abstractions of Picabia.

Man Ray, in the few years that he was active in the United States before his expatriation in 1921, was among the more adventurous of the painters working out of Cubism to pure abstraction. He was one of the few who experimented with textures and materials, and he developed a style which was less dependent upon his European mentors. If his works of that period do not show great artistic power, they have at least the saving grace of a fertile imagination; and if he was dependent to a very great extent upon the stimulation of Duchamp, his art never degenerated into empty imitation. The brightness and talent for invention which marked Man Ray as an artist of promise was recognized by the Dadaists when he arrived in Paris, and for him, as a Duchamp disciple, the intellectual excitement which he found in that atmosphere was especially enticing. Man Ray worked in Paris for the next twenty years until he became so French that people forgot that he was an American and so famous as a photographer that they forgot his youthful promise as a painter.

Man Ray, *Jazz*
Ferdinand Howald Collection, The Columbus Gallery of Fine Arts

Arthur G. Dove, *Reaching Waves*
Courtesy of The Metropolitan Museum of Art, Alfred
Stieglitz Collection

Of those painters who worked more consistently and continuously, Arthur G. Dove and Stuart Davis were the exceptions to the pattern of a return to reality in the American experiment with Cubism. Dove showed a tendency toward complete abstraction from the outset and Davis eventually reached that point via a long process of experimentation with a Cubist rearrangement of reality. Dove always vacillated between pure abstraction and references to reality, but he was the lone consistent exponent of abstract art in America until the end of the twenties when Davis returned from Paris, but even then it was not until well into the thirties that Davis achieved a completely abstract vision.

As early as 1910 Dove, after returning from Europe where he had met Maurer and had been introduced to modernism, exhibited his earliest abstract paintings in Chicago. By 1912 his first one-man show at "291" had established him as one of the foremost American exponents of abstractionism. The term "abstract" is used advisedly; for Dove was not essentially a Cubist. His art was outside the general limits of Cubism, unconstrained by its "classical" formula. Also, it was not always entirely abstract. In many cases he emphasized certain simplified patterns perceived in nature, creating a new visual experience beyond the original segment of reality, but still retaining the elements of it. In other cases, however, he expressed the emotions evoked by experience in completely abstract shapes. Dove did not evolve from one attitude to the other; he expressed himself simultaneously in either as he felt the need. At times he was impelled to state his emotional reaction to an experience in abstract terms, at other times he found in natural forms an adequate vehicle for his emotional content. However his color always remained less abstract than his form. At first Dove painted in somber tones, in the subdued grays, greens, and browns of Cubism, although even then with a deeper and more earthy quality, but he soon emerged into a higher key attaining the full range of the Synchromists. His use of a kind of radial gradation of color within a form is also a Synchromist or Orphist legacy.

Dove's untrammeled spirit, his disregard of formula and mannerism, expressed itself not only in an original style of abstraction, but also in his experiments with *collage*. *Collage* had been invented by the Cubists but in such examples as *Grandmother* (1925) Dove was utilizing this technique, which the Cubists used as an experiment in esthetic relationships, to express an integrated intellectual and emotional concept. In Dove's hands, *collage* was not a manipulation of materials, but a symbolization of experience. In a sense he was a proto-Surrealist without the trappings of moral decadence or the Freudian symbolism of conscious Surrealism. It was characteristic of him that he never exploited the sensational aspects of *collage*, working thus only when it served him as a more expressive medium than the traditional paint.

Basically, Dove's art is rooted in nature. As abstract as his art may become, the shapes of hills and trees, the colors of soil and sky, of water and grass, permeate his style, give it an earthy vitality unique in abstract art of that period, which usually was overwhelmingly addicted to geometry. Dove at times descended to pretty pattern-making, he was

Arthur G. Dove, *Grandmother*. Collection The Museum of Modern Art, gift of Philip L. Goodwin

sometimes and too often repetitious, but at his best he was a sincere poet of nature, expressing her many moods from flamboyant joyousness to dark tragedy.

When Stuart Davis returned from abroad in 1929, he introduced a new note in American Cubism. Unlike the earlier painters who had been influenced by analytical Cubism, Davis derived from its synthetic phase, which was a reaction from the almost completely abstract culminations of the analytical style and a turn to a new concern with natural forms and an emancipated palette of brilliant, sing-ing color. Davis and Jan Matulka, a painter who had formerly been interested in mechanism, in the late twenties were experimenting independently of each other with this new type of Cubism. In its early stages the art of both painters was almost naively dependent upon natural forms, although previously Davis had worked in a more abstract manner. It consisted of a simple transcription of visual experience in which all the natural elements were retained, though restated in flat patterns of sharply contrasted colors. The basic design was almost a tracing of an original naturalistic picture

107

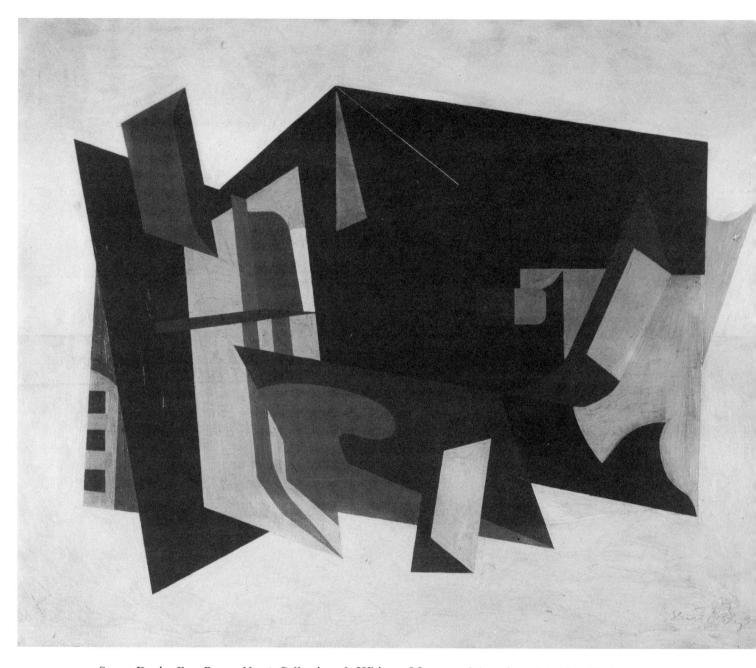

Stuart Davis, *Egg Beater No. 1.* Collection of: Whitney Museum of American Art, New York

whose normal spatial and formal relationships were destroyed through a slight degree of distortion, but mainly through the arbitrary use of color in flat areas. In 1929 and the early thirties, Davis had not approached pure abstraction; he was still stating his visual concept of reality in form and color symbols.

Perhaps it was because Davis had been a realist, concerned with social art, that he, unlike Dove who was immersed in nature and the other Cubists who were tied to the traditional studio props, was more concerned with picturing the characteristic environment of American life, its cities and buildings, its

"coffeepots" and gas stations. He saw these elements as abstract symbols of America, just as he saw reality in terms of artistic abstraction. At that period he can almost be called an "American Scene" painter, for though his style had an obvious Parisian derivation he painted the American landscape with a precise feeling for local color, and a cleanness of surface reminiscent of Cubist-Realism.

The most radical manifestations of modernism in America were due not only to French influence, but were actually the product of temporarily expatriated

108

Stuart Davis, *House and Street*. Collection of: Whitney Museum of American Art, New York

Frenchmen at work in America. The Armory Show brought to these shores several leading French modernists, Marcel Duchamp, Francis Picabia, Albert Gleizes, and Jean Crotti, and even inspired some to predict the shift of the world art capital from Paris. The new arrivals themselves, like Picabia, were intrigued at first glance with the remarkably modern and industrial aspects of New York, as well as with its crude vitality, so different from the superestheticism of their own cafe circles. Perhaps it was a subconscious search for a social basis for their art which fostered the illusion that the modernism of American life would be sympathetic soil for the flowering of modernism in art, an illusion which was soon dispelled by the cold, anti-artistic attitude of America. It drove them very soon back to the warmer if more decadent arms of Parisian estheticism and isolation.

Marcel Duchamp, the most influential of these visitors, was active here for several years and exerted a pronounced influence upon a whole section of American art. A brilliant young artist in his early twenties when he came here for the first time in 1915 after being invalided out of the French army,

he was already one of the more vigorous intellectual and theoretical minds of the Parisian group. Cursed with a logical faculty which, throughout his life, interfered with and actually stifled the exploitation of his creative ability, Duchamp was driven by a phobia against repetition to move rapidly from one theoretical position to its logical consequence, stopping only long enough in most cases to embody it in a single artistic form. At the time of his arrival in America he had already passed through phases of Fauvism, the Cubism of Picasso and Braque, and Futurism, and was already exploring the intricacies of what was later to be known as Dadaism. His interest in certain inherent mechanistic and constructivist features of Cubism, however, soon led him in new directions. As early as 1911 he was approaching the renunciation of painting as an autonomous art. His *Nude Descending a Staircase* (1912) by his own admission is a negation of painting as such, the elimination of color and the simulation of wood being an attempt to focus attention upon the mechanical construction of the composition. The next step in this mechanistic tendency was his development of "glass construction," which allowed

109

for the amalgamation of two independent personal predilections, the one, for precise mechanical construction, the other, for the irrational, accidental aspects of chance. These glass constructions consisted of abstract compositions in paint and metal foil, contrived with meticulous mechanical precision upon panes of glass. The result was a window or transparent screen which might be viewed as an isolated abstract pattern or, when placed within a room, as a sort of foreground frame behind which shifting haphazard groupings would create continually changing pictures. In his earlier experiments, Duchamp was preoccupied with esthetic construction, but in these glass compositions there was for a time a balance between the rational aspects of artistic manipulation, from which he was soon to turn, and the irrational nature of chance into which, with perverse logic, he was subsequently to move. His history is a piecemeal renunciation of

Marcel Duchamp, *The Large Glass* (*La mariée mis à nu par ses célibataires, même*)
Estate of Katherine S. Dreier

conscious esthetic construction in favor of accidental conformations to which esthetic connotations might be imputed.

The theorists of Cubism propounded the manipulation of esthetic materials as a basis for the creation of a new art, but for Duchamp Cubism was merely a starting point from which he could proceed to a manipulation of objects and then to a manipulation of objects and ideas, as in his "ready-mades." In these contrivances, which consisted of ordinary manufactured objects to which he gave cleverly twisted titles, we have a contraversion of all the accepted and traditional aspects of art, a dissolution of the boundaries between the arts and between the artistic and the non-artistic, the negation of art as either a craft or a specific compartment of social and human activity, in short the beginnings of Dadaism. On the other hand, in these "ready-mades" he elevated the artistic impulse to unprecedented heights. In them the artistic idea became superior to artistic creation; ideas themselves took on esthetic significance, and had the ability to transform the most gross and common material objects. Duchamp, in his "ready-mades," was taking ordinary objects and, through manipulation or esthetic arrangement or the application of "taste," imparting to them the quality of artistic creation, giving them artistic meaning. Then even conscious esthetic manipulation was denied in the *Trois stoppages-étalon* (1913), which was created by simply dropping strings haphazardly upon a blank surface and fixing them there for eternity. A whim of fate was, then, as legitimate a work of art as the protracted labor of a Giotto, a Michelangelo or a Van Eyck. Finally, his *Fontaine*, a urinal signed R. Mutt, which he submitted to the first Independent's Exhibition in 1917, was a completely Dadaist denial of art itself, in its anti-estheticism, its attack upon conventional attitudes, both esthetic and moral, its cynicism, its pretensions to wit, and its nihilistic denial of everything but individual caprice. Although he fought for its inclusion in an exhibition of art, the object itself was an obvious mockery of art. In 1920 he sent Walter Arensberg a hermetically sealed glass bulb containing air from a street corner in Paris. It was a fantastic joke, but in the almost worshipful attitude toward the cuteness of the idea, in the elevation of this witticism to a state of esthetic exaltation, Duchamp and the Arensberg circle were expressing disillusionment with accepted standards of human behavior.

Whatever Duchamp's ruthlessness in the destruction of both the traditions of art and art itself, he was still at that time pampering the individual creative soul. The last step in his hegira was to deny even that. He culminated his gradual retirement from art by turning to chess, perhaps because the game offered a problem to be solved through logical, precise, mental manipulation, which is in itself almost esthetic and which, with all its intricacy, is completely meaningless. But even chess could not escape his destructive logic, for he took to playing a Dada chess in which only illegal moves were allowed. In the forties, returning to make satchel-catalogs of his complete works in miniature, he became an archeologist digging among the dry bones of his youth and promise.

As a brilliant personality and a leading exponent of modernism, Duchamp soon became the guiding spirit of an artistic group in this country. He was active in the arrangement of the first Independents' Exhibition. In 1920, together with Katherine Dreier and his disciple, Man Ray, he was instrumental in the formation of the *Société Anonyme*. During this period he was also the center of the Arensberg salon where he came into close contact with Demuth, Sheeler, and Stella. His Dadaism, supplemented though it was by that of Picabia within the Stieglitz circle through the publication of the magazine "291" from February 1915 to March 1916, never had any profound effect upon American art. It affected Man Ray deeply enough so that he migrated to the more congenial atmosphere of Paris. It affected most of all the work of John Covert whose pictures, like *Brass Band* and *Time* done in 1919, were directly dependent upon the Dada inventions of Duchamp and Picabia. Perhaps it affected the now forgotten Inje-Inje movement led by Holger Cahill in the early twenties, which, as described by John I. H. Baur, produced nothing of any great importance. It affected Demuth also, but only in a limited way. The whimsical obliqueness of Duchamp's titles, which were essential elements of the entire esthetic idea, were taken up by Demuth as witty postscripts to an otherwise comparatively prosaic vision. But, in contrast to such isolated examples of Dadaist influence, the effect of Duchamp's mechanism was much more widespread. It is perhaps due to him more than anyone else that the mechanistic element in Cubism took root in America.

The introduction of mechanical forms into painting is difficult to credit to any single person. The

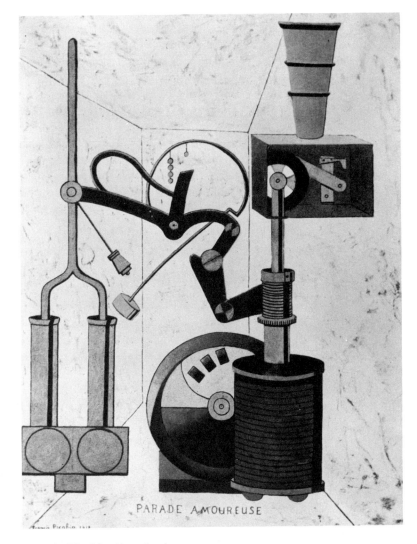

Francis Picabia, *Parade Amoureuse*
Collection of Mme. Simone Collinet

Futurists were the first to use such forms with a consciousness of their implications. Mechanical forms were used also by the Vorticists and later by Fernand Léger, who, although he is generally accepted as the leading exponent of the use of mechanical forms, did not use the machine as subject until about 1918, even though prior to that date his experiments in Cubism sometimes assumed a mechanical appearance. Duchamp's early concern with mechanical forms and his experiments in glass constructions came to fuller fruition in the Russian school of Constructivism. At any rate, Duchamp and Picabia (*Very Rare Picture upon the Earth*, 1915, *Parade Amoureuse*, 1917), were among the earliest exponents of mechanical forms in painting. In this respect Duchamp and Picabia were closer to the Futurists than to the Cubists. In the *Nude Descending a Staircase* (1912) and *The Bride* (1912), Duchamp attempted to render the phenomenon of motion. His later interest, as in the glass construc-

111

tions, is in mechanical forms as such rather than in movement. Joseph Stella, who had been in direct contact with the Futurists and had returned from Italy in 1913, also renounced the motor aspects of that school in favor of a more static representation of mechanical forms in his *Brooklyn Bridge* (1917) and later in the whole series of *New York Interpreted* (1922).

Whoever may deserve credit for the earliest in-

terest in mechanical forms, it seems natural that such an innovation should have found immediate acceptance in America. The wonder is that it did not have a greater effect. It would seem that America, with its great industrial and mechanical development, with the material aspects of this development visible on all sides and integral to normal existence, should logically have gravitated to some artistic expression of what was virtually a national

Joseph Stella, *Brooklyn Bridge.* Courtesy, Yale University Art Gallery, Collection of the Société Anonyme

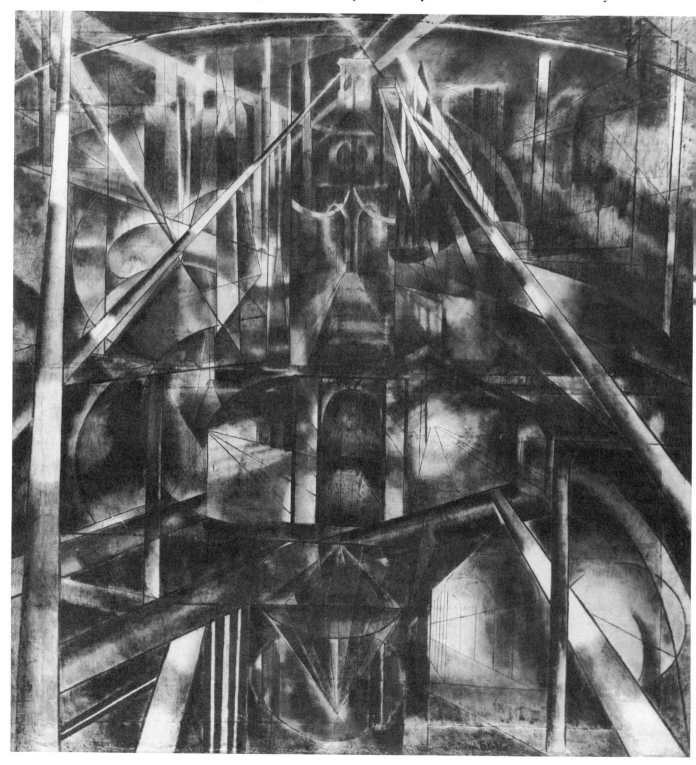

characteristic. Dreiser, in *The "Genius,"* sensed the artistic potentialities of the industrial scene, but his artist-hero's paintings, which dealt with the drama of American industry, had no counterpart in reality. The imposing structures of industry, grain elevators, steel mills, and skyscrapers were accepted by some artists even in the nineteenth century as artistic material, but always with emphasis upon their "picturesqueness." Joseph Pennell, for instance, found a great deal of his inspiration in industrial subjects and in this sense was a pioneering figure, but his vision, conditioned as it was by a dramatic interest compounded out of Whistler and Piranesi, did not plumb the nature of industrial forms, but clothed them rather in a romantic garb more fitting for Gothic cathedrals and Venetian canals. Somewhat later, such men as Marin and Walkowitz saw in the tremendous industrial mound of New York what Robert Delaunay saw in the cathedrals and the Eiffel Tower of Paris, a fearful and disorganized oppressive force.

The realists, who might have grappled with this problem, never did. They were more interested in "the people," in the human element of an industrial society rather than in the machine. This interest was motivated by a general sympathy for the lower classes, but in their urban existence, rather than their industrial role. They saw the people, one might say, in their extracurricular activities and never in relation to the machines which they tended. On the other hand, the artists responsible for the development of mechanism in painting were almost completely oblivious to the human factor and confined themselves entirely to the material forms of industry. The expression of the industrial theme in terms of its own inherent, precise, clean, powerful masses was apparent in the experiments of Duchamp and later was taken up by a whole group of American artists. Today it is clear that no art of that time was capable of handling the complex problems of social relationships in modern industrial life. The Futurists, with their glorification of the machine and their philosophical nihilism, even though aware of the problem, were incapable of any rational solution of the man-machine relationship, save that of fascism. The Russian Constructivists, who were politically allied with the revolutionary proletariat, were not much nearer a solution, in spite of theoretical gymnastics. The Parisian school by its very nature was divorced from the larger problems of social existence.

Whereas the more purely esthetic experiments of the Parisian Cubists affected individual artists in America, it was the mechanical aspect of Cubism, through Duchamp, which had the greater effect, precipitating an important phase of American painting, which resembled Purism in some respects, but which might more accurately be designated as Cubist-Realism. This simplification of forms down to fundamentals is the stylistic or esthetic equivalent of machine production and mechanical precision. Although the origins of this artistic idea may be traceable to the formal research of Cézanne, after Cubism it becomes inextricably involved with the concept of industrial and mechanical functionalism.

Certainly both Purism, in a theoretical sense, and the American phenomenon of Cubist-Realism, in an actual sense, are impossible without the machine age. Cubism, it is true, was not the outgrowth of functionalism. Duchamp-Villon's Cubist architecture, a model of which was included in the Armory Show, was definitely not functional. It represents merely the translation of traditional architectural members into Cubist forms. However, even if it cannot be said that Cézanne's search for fundamental form or Cubism are the result of industrial rationalism, the two streams—Cubism and functionalism—do eventually coalesce and finally influence each other. How this evolution actually occurs is debatable, but it is interesting to note that Purism, which Amédée Ozenfant considered a rationalization of the empirical and decorative character of Cubism, was an attempt to return to "an architectural or classical idea." In *Après le Cubisme*, written in 1918 together with the architect Charles Jeanneret (Le Corbusier), in various articles during the same year, and in *L'Esprit Nouveau* which he and Jeanneret edited from 1920 to 1925, the amalgamation of Cubism and Purism with functionalism was consummated. Ozenfant contended that a "classical" or "architectural" art must use "universal" forms, that is, forms which are devoid of incidental, accidental, or personal emotive qualities, and that "mechanical" forms are as valid as "organic" ones as norms of beauty. His own paintings are architectural organizations of these mechanical and organic forms. At the same time, Le Corbusier, having experimented with Purism, was applying the same esthetic principles in his architecture.

The esthetic ideas generated by Cubism ultimately affected the formal aspects of functionalism, while functionalism caused the Cubist experiments

113

Charles Demuth, *Trees* Ferdinand Howald Collection, The Columbus Gallery of Fine Arts

to be adapted to an international architectural and decorative style. The element which functionalism as a style extracts out of the many theoretical principles of Cubism is that of essential form or the simplification of an object to its basic cubic structure. This principle, essential also to both Purism and Cubist-Realism, is not much more than the original Cubist tenet founded upon Cézanne's dictum of nature seen in terms of the cylinder, the sphere, and the cone.

Cubist-Realism was never a school. It was without manifesto, or even conscious program. But, in spite of the lack of formal organization among its exponents, it was an artistic style recognizable and influential in American painting. In it an attempt was made to impart to all matter a sense of fundamental mass, clarity, and precision. Ornament as such was eliminated as were the peculiarities and accidents of light, texture, and atmosphere. Although most of the artists who finally evolved toward Cubist-Realism began with Cubism, none of them lingered long over experiments with abstraction; instead they almost immediately applied Cubist principles in their simplest forms to reality. It is perhaps impossible to designate any single artist originator of the style. Demuth and Sheeler approached it from different angles, and if Demuth arrived at the kernel of the idea first and was the innovator, Sheeler carried it to a more complete fruition and was its leading exponent.

While Ozenfant was developing his Purist esthetic in Paris in 1918, Charles Demuth, in close contact with the sources of French modernism, had taken the first steps in Cubist-Realism as early as 1917. Demuth's water color style had grown out of Cézanne's, with a stiffening dose of Cubism. From

114

Charles Demuth, *After Sir Christopher Wren*
Anonymous Loan to the Worcester Art Museum

Duchamp he had acquired a taste for mechanical forms. He was never, however, interested in abstraction as such and in his earliest experiments in Cubism objects are clearly recognizable. Even in his still-lifes, in which he was most dependent upon Cézanne, he never went as far toward abstraction as did the French master, but rather adapted the latter's method to his own decorative vision of reality. Neither Demuth nor Sheeler was motivated by theoretical formulae as were the Purists, the Suprematists, or the Constructivists. Demuth's earliest experiments in Cubist-Realism, *Trees and Barns* (1917), *Houses and Tree Forms* (1919) and *After Sir Christopher Wren* (1919) show an emphasis on simplification of form and on pattern. He made no attempt in these or in later works of the early twenties to destroy or greatly distort the recognizable character of forms, but attempted only to simplify and systematize. Excepting such works as *Incense of a New Church* (1921), in which an imaginative reaction to industrial forms is presented, Demuth clung rather strictly to the apparent shape of things.

Some critics have found difficulty in reconciling Demuth's aloof esthetic dandyism, so fully expressed in his sensitive water color still-lifes and flower-pieces, with his interest in such a powerful theme as the industrial scene. Demuth's use of this subject, however, was not the result of an interest in industrial life. In the shapes of buildings he found that mechanical precision which he could only ascribe to natural forms, and which made his still-lifes so brittle and rigid. His fastidious temperament stripped the industrial scene of all its crudeness and discovered instead a cool delicacy in the neat juxtaposition of architectural surfaces. But in spite of this attitude, Demuth's architectural paintings were the earliest, and remain among the finest, examples of American industrial landscapes.

In his paintings of industrial subjects, Demuth's personal style is characterized by a fragile decorative manner and a predilection for the "ray-line," a derivation from the dynamic, directional lines of Futurism. He used the ray-line, usually, in a rather empirical fashion, extending the edge of some real object to the frame or to a point of intersection with other linear extensions. Only rarely does it distort the appearance of an object and never seriously. The ray-line in Demuth's scheme suggests a spotlight or light-ray, for when it crosses another ray-line or some object, it affects the shade of the

Charles Demuth, *Incense of a New Church*
Ferdinand Howald Collection, The Columbus Gallery
of Fine Arts

Charles Sheeler, *Bucks County Barn*. Ferdinand Howald Collection, The Columbus Gallery of Fine Arts

geometric area thus created. In many cases, however, the lines are merely superimposed and seem to be superficial and fortuitous divisions of the surface. The work of Lionel Feininger, who employed a similar system of ray-lines, is much more logically constructed. At this early date, however, Feininger was still dominated by the Futurist tendency toward the disintegration of form.

In contrast to the Purists, Demuth never confined himself to simple "basic" shapes, but from the outset was interested in complex architectural forms, finding material in both traditional New England architecture and modern industrial buildings. These he treated with linear precision rather than a feeling for mass. His style is limited by two-dimensional Cubism, and recession into depth is only implied. The faint water color washes or flat oil paint areas seem to cling ascetically to the surface plane and the parallel movement of the ray-lines helps to destroy any vigorous movement in depth.

Charles Sheeler gave Cubist-Realism the three-dimensionality which eventually became its outstanding feature and which Demuth's style lacked. Sheeler, as well as Demuth, was a product of the Pennsylvania Academy of Art and a pupil of William M. Chase. However, at the time of the Armory Show, all evidence of Chase's influence had already disappeared. Some of the flower-pieces he did in 1912 show a strong, rich, painterly style, but after the Armory Show there was a complete break in his development and his dependence upon Picasso became evident. In 1915-1916 he began making Cubist experiments and even playing with Synchromism. In the series of barn studies of 1917-1918, he applied these Cubist lessons in a manner somewhat similar to Demuth's. They show a comparable reliance upon two-dimensional Cubism; but in spite of their textural play, they are concerned less with decoration and more with construction. The ray-line which complicated the work of Demuth is absent.

116

Almost at the beginning, Sheeler discarded such modernist baggage in his search for a simplified realism.

In a study of Sheeler one inevitably encounters the name of a now almost forgotten painter, Morton L. Schamberg, Sheeler's comrade of student days and closest personal and artistic companion, who unfortunately died in 1918 at a very early age. With Sheeler he had fallen under the spell of Duchamp's vigorous mind and before his death he created a small group of works whose style, suggesting Purism, developed out of the mechanical constructions of Duchamp.

Schamberg, more than any other American of that period, utilized mechanical objects as the basis of his art. Although Picabia is generally given credit for this innovation in his *Objet qui ne fait pas l'éloge des temps passés ou c'est clair comme le jour* (*cette chose est faite pour perpetuer mon souvenir*) and his *Parade Amoureuse* (1917), it should be remembered that Schamberg was painting similar

Morton L. Schamberg, *Telephone*
Ferdinand Howald Collection, The Columbus Gallery of Fine Arts

subjects without Dadaist titles at the same time, and certainly before Léger. Schamberg, like the majority of Americans (one might almost call this typically American), lacked the complex esthetic mentality and was seemingly unaffected by the involuted philosophies of his European contemporaries. He was more simple and direct in his approach to the machine world. Unlike Giorgio de Chirico, or even Duchamp and Picabia, who contrived mechanical-looking objects, or the later Constructivists, who made new mechanical contrivances, Schamberg dealt with the commonly recognizable objects of our machine age. These objects were to him simply machine forms, neither clever constructions to mock the mechanical world nor fantastic inventions of minds steeped in mechanics yet lacking reason for mechanical creation. Like Léger in France, Schamberg saw in the machine a rich new source, not of theoretical disquisition, but of artistic inspiration. This was true in varying degrees of all the Cubist-Realists. The machine, which is both a part of our lives and symbol of modern civilization, to them

Francis Picabia, *Machine Sans Nom*
Rose Fried Gallery

was not an object for esthetic juggling but had an integrity of its own. They allowed the machine to dictate in a sense the form which its artistic realization should take. As Cubist-Realism developed it shed its earlier garments of Cubism and Futurism and became more and more a direct, realistic representation of the machine.

Curiously enough, Charles Sheeler, whose name has become almost synonymous in America with the representation of the machine, was then primarily concerned with reality of form and not specifically with mechanical forms. By the early twenties, Sheeler had left his period of Cubist wanderings behind and, having derived from Cubism certain principles of simplification, was attempting to apply them to visual reality. Whereas his earlier work had a distinctly Cubist character, that of the twenties shows an almost photographic insistence upon reality. The paintings and drawings of this period in many cases self-consciously avoided artiness of arrangement or composition, personal emotive quality, or any additions to the simple statement of fact. There is, however, in most of his work of the early twenties, such as the series called *Suspended Forms* and *Demarcation of Forms*, an insistence upon the cubical character of matter. Like the Purists, Sheeler worked with fundamental shapes in an effort to arrive at an architectonic statement; but unlike the Purists, who sacrificed the real in the creation of an abstract architecture of form, he enhanced the architectural quality of the real. He intensified structure through an insistence upon its basic, solid form and through a simple and precise rendering of reality. Whatever feeling there is for abstraction in these works is merely the result of a simplification of form. During this period, when Sheeler's art was poised between reality and abstraction, he produced works which, for their cold, objective honesty, their cleanness and their simplicity, are among his finest.

To a considerable extent Sheeler's artistic character is dependent upon the camera. Perhaps the clarity and precision of his style are more directly related to the clear-focus photography that he and Paul Strand were doing about 1917 than to Cubism, although Cubism itself had affected the style of photography with which he and Strand took first and second prizes at the Wanamaker exhibition in 1918. Strand, by all standards the more original and daring photographer, already was experimenting with abstraction in 1917. By moving close to an object and selecting one section of the larger unit,

and by the use of unusual angles and lighting, he managed not only to present a new and striking facet of that unit but also to give the effect of an abstract composition. Demuth's vision in *Paquebot, Paris* (1921-1922) of the same time was strikingly similar to Strand's in its segmentation or "accidental" abstraction. This attitude, however, has never been normal to Sheeler, although it occurs in some of his work. Except for occasional examples in both photography and painting, Sheeler has a more prosaic, aloof, and impersonal attitude. All his work is circumscribed by an unrelieved directness. It is as if he were always looking for the front of an object in order to present it in full face. However, following his collaboration with Strand in the production of the film *Manahatta*, made in 1922, which was shown with much acclaim by the Dadaists in Paris, Sheeler's style showed a definite mechanist tendency. It was at that time that he painted *Church St. El* (1920) with its unusual perspective angle and its semi-abstraction. In a similar vein are his *Staircase, Doylestown* (1925) and *Stairway to Studio* (1924). Sheeler soon lost the equilibrium between photography and painting, between abstraction and reality, which he attained in these works of the early twenties, and regained it only

Charles Sheeler, *Still Life*, *Pitcher*
Estate of Alfred Stieglitz

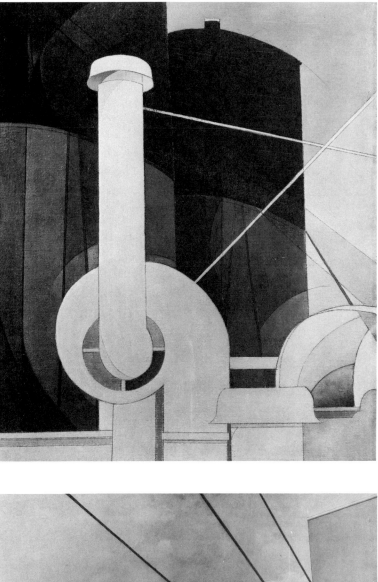

spasmodically in the years to follow, as for example in *Upper Deck* (1929) and *Barn Reds* (1938).

In the later twenties Sheeler succumbed to the dominance of the camera. As his vision became chained to photography, he moved from Cubist-Realism to a literal transcription of reality. He gave up the simplicity which Cubism had taught him to see, and substituted the accidents and complexities of the camera for those of paint. Now only occasionally did the unusual angle and abstract pattern lend interest to his compositions. Sheeler's series of photographs of the Ford River Rouge Plant and subsequent paintings of the same subject based on the photographs, which popularized the industrial scene as a legitimate subject for American painting, marked a turning point in his style, for at the end of all his artistic wandering he had at last attained a position of servility to the fact comparable to that of the less adventurous, more academic Luigi Lucioni.

Theoretically, Cubist-Realism might have developed without the influence of the machine, but actually mechanical forms and the industrial scene were inextricably part of the style. For some Cubist-Realists the machine was a motivating factor, for others the search for simplified, geometric forms eventually led to the machine as a logical subject matter. In the work of some artists, however, the style became divorced from mechanical forms and its principles were applied to natural and non-mechanical subjects, so that two general tendencies developed within Cubist-Realism—the representation of the mechanical on the one hand, and of the organic on the other.

Among the more mechanically minded, besides Sheeler and Schamberg, were Joseph Stella, Louis Lozowick, George Ault, Niles Spencer, Stefan Hirsch, and Henry Billings. To the organic group belonged Georgia O'Keeffe, Elsie Driggs, and Edward Bruce with his American version of *Neue Sachlichkeit*. Demuth stands somewhere between, equally interested in both the mechanical and the organic. Preston Dickinson was influenced by Cubist-Realism only in a limited way, his art always retaining a highly personal flavor. Among the younger men Peter Blume, who later worked into Surrealism, began as a Cubist-Realist.

Stella and Lozowick, among the artists of the mechanical group, were originally interested in Futurism, and in their early work experimented with

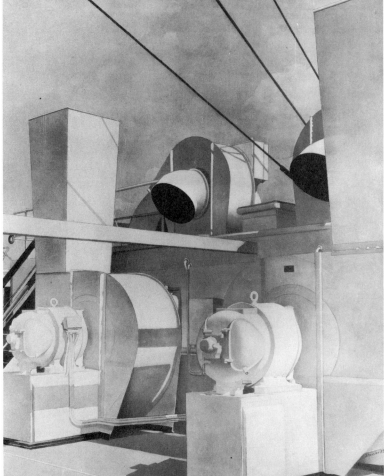

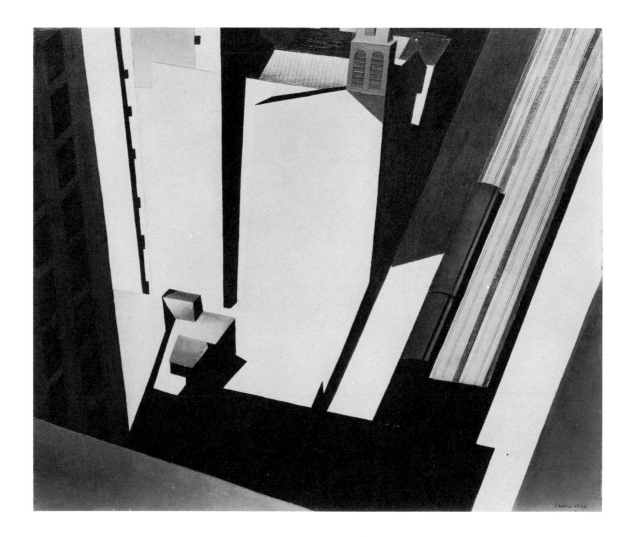

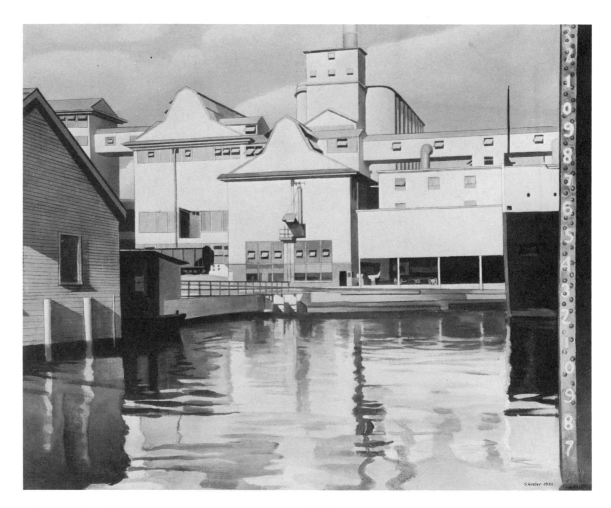

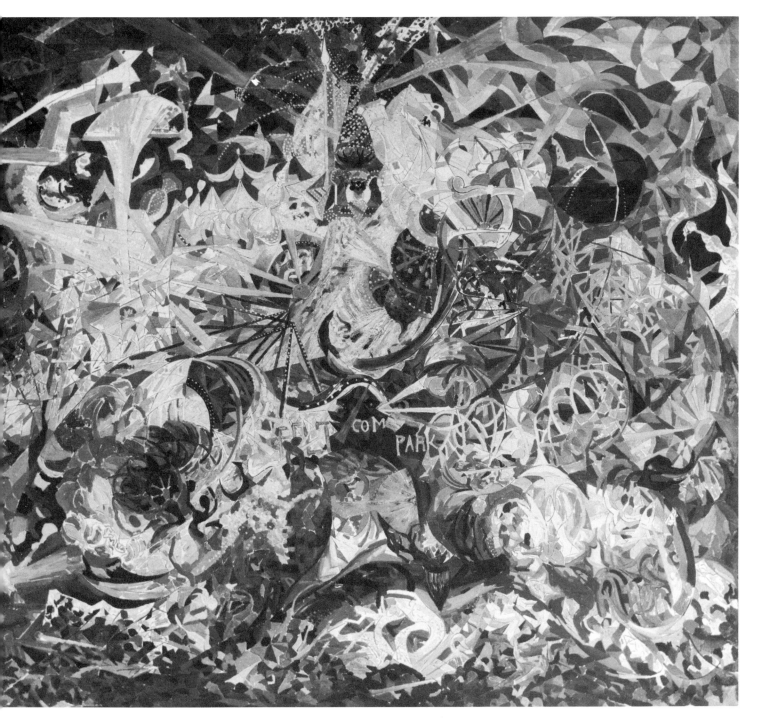

Joseph Stella, *Battle of Light, Coney Island*. Courtesy, Yale University Art Gallery, Collection of the Société Anonyme

the rearrangement of reality. The aim of both was to create an emotional equivalent rather than a naturalistic representation, and this led them deeper into abstraction than any of the other Cubist-Realists. Although Stella began as a full-fledged Futurist in his *Battle of Lights, Coney Island* (1913), he later renounced the motor aspects of Futurism for a less mobile though still essentially dynamic representation in his five panels *New York Interpreted* (1922). This dynamism, which served to differentiate Stella and Lozowick from the other Cubist-Realists, who were concerned primarily with static mass, resulted from a transformation of the disintegrant kinetic principles of Futurism into a system of rhythmic movement within an essentially static mass. The larger form retained its basic weight and stability, but the rhythmic organization of smaller units lent it a dynamic, surging movement.

121

In this way they were attempting to express the controlled but titanic forces inherent within the static shells of industrial forms, to describe the pervading dynamism of the machine, its soul rather than its external shape. It was only natural that Stella and Lozowick, as well as many of the other

Joseph Stella, *The Port, New York Interpreted*
Courtesy of The Newark Museum, Newark, N.J.

Louis Lozowick, *Oklahoma*
Collection of the Artist

Cubist-Realists, should find their greatest inspiration in the New York scene, its skyline, its buildings, its elevated railways and its bridges, just as it was natural that Duchamp, Picabia and Archipenko should be inspired by it and that the English Vorticist, C. R. W. Nevinson, who visited New York in 1922, should paint several pictures of the city's overpowering mass.

Stella worked in this style for only a short period, but during that time created what are still the most creditable paintings of his career. His style later deteriorated into blatantly colored mysticism, but

Niles Spencer, *Corporation Shed*. Ferdinand Howald Collection, The Columbus Gallery of Fine Arts

even in his weird flower and bird compositions the remnants of Cubist-Realism are to be found.

Lozowick, on the other hand, moved from the semi-Futurism of such works as *Coney Island* and his series of paintings of American cities to a thorough-going Cubist-Realism, becoming progressively more realistic. Although Sheeler has received most of the credit for the exploitation of the industrial scene as subject matter, Lozowick explored the same field much more conscientiously and consistently. Perhaps it is because his work has been confined almost exclusively to lithography that his importance has not been widely acknowledged. Although his style is strikingly like that of Sheeler's in its coldness and mechanical precision, it is always more sombre and more Cubist. Also, he lacks the latter's flair for creating pleasant pictures. In all his work there is an iron stiffness relieved only by the inventiveness of his pattern.

In the work of Niles Spencer, Stefan Hirsch, and George Ault, we have the simplest expression of Cubist-Realism—a picture of the world reduced to blocks and cylinders. Here the world is so cleansed of all accidental encumbrances that it becomes a desert of geometry without life or atmosphere, a neat wasteland in which people and their activities are out of place. Unfortunately, this simplification is so thorough-going that even the imposing mass of gigantic structures is reduced to the appearance of children's building blocks. This creation of a Purist three-dimensionality within a vacuum defeats its own purpose; for in removing all reference to human activity it reduces the structures in size and significance. They are no longer imposing either in weight or dynamic power, instead, they become contrived stage-set models. In stating the one truth of their cubical character, these artists destroyed all their other connotations.

123

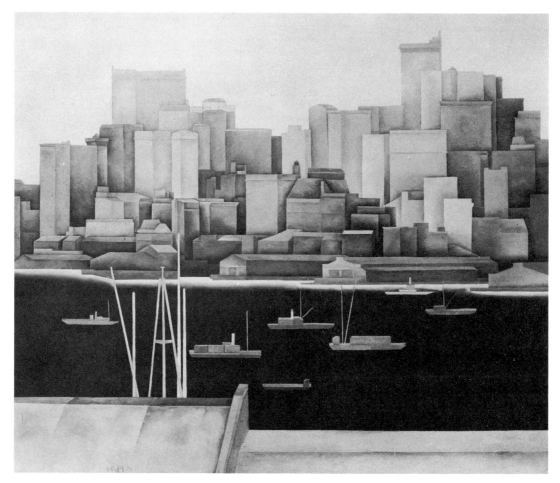

Stefan Hirsch, *Manhattan*. The Phillips Collection, Washington, D.C.

George Ault, *Brooklyn Ice House*. Courtesy of The Newark Museum, Newark, N.J.

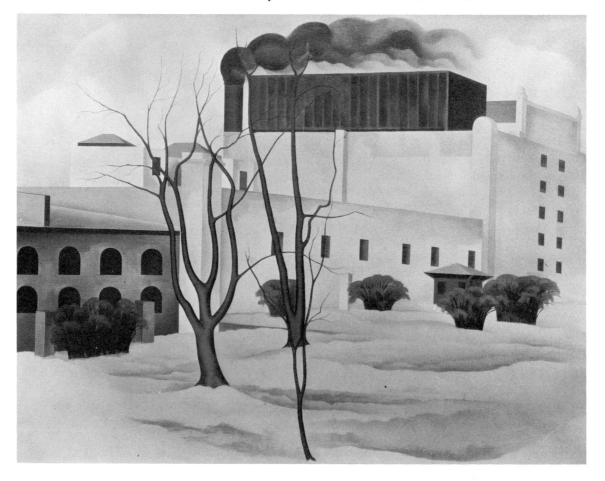

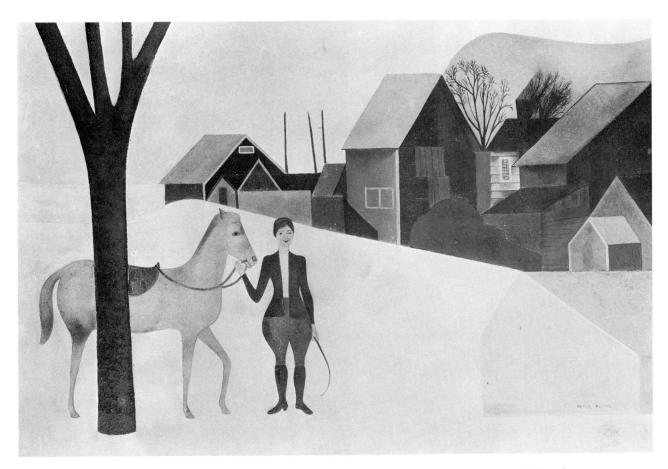

Peter Blume, *Home for Christmas*. Ferdinand Howald Collection, The Columbus Gallery of Fine Arts

Certainly the most precocious artist of the twenties was Peter Blume. At the age of twenty he had painted so charming a picture as *Home for Christmas*, which was memorable for its solid construction, as well as its naive humor. Blume was then searching for plasticity of matter in the Purist idiom, constructing still-lifes with simple volumes. But by 1928 he was already beyond the study of simplified form and, in *The Bridge*, had produced a larger composition with adroitness. His paintings of 1929 were honest and rather sober efforts, tightly built and executed with a feeling for abstraction. At that time he was still dominated by Cubism, given to compositional distortion and simplification of surface. His evolution toward realism and Surrealism had not yet begun.

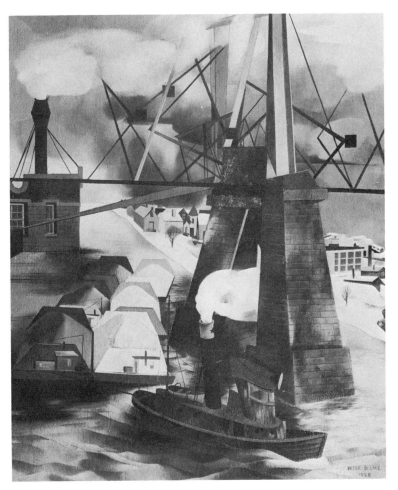

Peter Blume, *The Bridge*
Collection of Mr. & Mrs. Martin Janis

The remarkable thing about Georgia O'Keeffe is that in spite of the mélange of material which she has assimilated, her art still remains unique, completely and unmistakably marked by her personality. However, in the face of the rhapsodic critiques which extol her art as the expression of the "essence of womanhood"[1] or "the symphonic surge of the earth's dynamic splendors,"[2] one is constrained to insist that she belongs rather prosaically to the general stream of Cubist-Realism, and that her art, even while welling up in a "shamelessly joyous avowal of what it is to be a woman in love,"[3] has found opportunity to acquaint itself with contemporary sources. As a member of the Stieglitz circle, she came into contact with and absorbed Demuth's clean crisp surfaces, Sheeler's sterilized volumes, and Paul Strand's closeup technique in photography, adding to these her own sense of decoration, and coloring the whole with a curiously cold passion.

After her arrival in New York in 1916, when Stieglitz exhibited her drawings for the first time, O'Keeffe became interested in a decorative abstraction. Eventually she grew dissatisfied with the formlessness of such designs and turned toward a more precise style. During the early twenties she vacillated between the complete abstraction of *Music—Black, Blue and Green* (*c.* 1923) and the stylization of reality of *Lake George* (*c.* 1924). She had already fully developed the characteristic O'Keeffe manner—broad, clean color-areas, sharp definition of edges, imperceptible color gradation, and striking pattern.

By the middle twenties her position as a Cubist-Realist became clear. Such efforts as *Alligator Pear* and *Calla Lily* (1925), in which she renounced abstraction as such for a closer study of nature, are similar to Sheeler's crisp rendering of objects in the early twenties. Her first characteristic flower-pieces date from about 1925, and in them she shows for the first time the feature which was to become the trademark of her style, the microscopic vision that derives from Paul Strand's closeups.

Under the impact of Cubism, Strand had turned in 1917 from his brilliant realistic portraits to the study of abstract manifestations in nature. Attempting to emulate the Cubists, but unable as a photographer to rearrange the world arbitrarily, he sought in it at least the appearance of abstraction. He found that through the use of new angles of vision he could discover new, exciting and often abstract forms in the most common objects or scenes. By his selection of points of view, he revealed abstract patterns of mass, light, and shade in the city's buildings and streets. By moving his lens closer to an object he could break through its outline and give it a new visual quality, destroying its normal aspect as an organic entity, its normal relationship to background, its normal psychological associations, and revealing instead a strange, abstract configuration. Thus by moving in on objects, Strand in *Circular Forms* (1917) and O'Keeffe in *Calla with Roses* were both introducing us to a new world of pictorial experience. This microscopic vision is in one sense the opposite of the high-angle shot which Strand also exploited. Both grew out of the enrichment of our common vision through such modern scientific developments as the camera, the airplane, and the microscope. It is not strange that the traditional concepts of space and scale, and the visual references which had obtained for centuries almost without change, should have undergone such complete revision in America, where the practical application of science was most widespread. Here again there was no theorizing, but simply an almost unconscious application to art of new visual experiences.

Georgia O'Keeffe, *Blue and Green Music*
Courtesy of The Art Institute of Chicago, Alfred Stieglitz Loan Collection

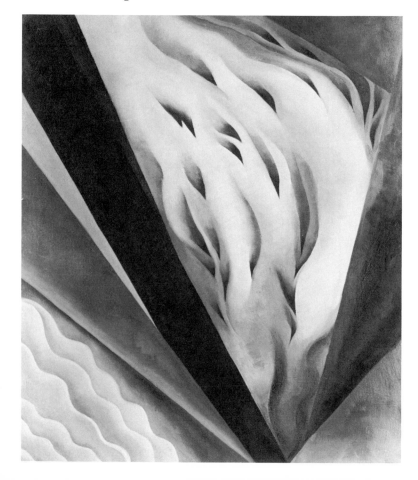

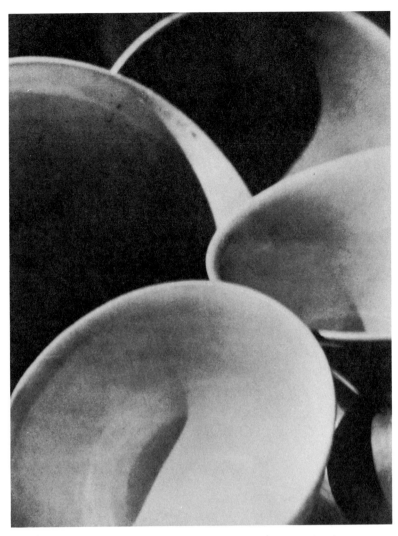

Artistically speaking, the microscopic vision which is basic to O'Keeffe's style has a dual nature. Its major appeal rests upon a heightening of reality. In enlarging the details of some common object, it brings to our attention facts which we have never perceived, and thus increases our awareness of common things, but at the same time it destroys the normal appearance of things, presenting us with startling formal relationships which have all the characteristics of abstractions. In O'Keeffe's hands this vision has been exploited to underline the experience of finding in the ordinary the appearance of the extraordinary.

O'Keeffe has been more successful in her flower-pieces than in her representations of buildings. In the latter her prettiness of color is an intrusion, her lack of strength obvious. Such paintings as *The*

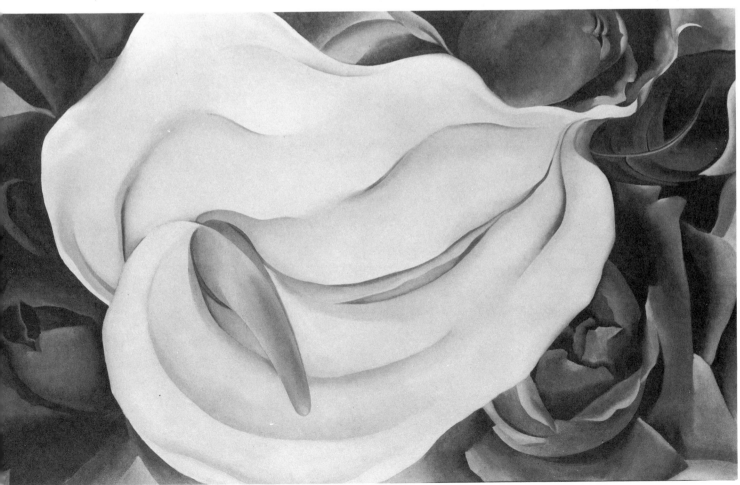

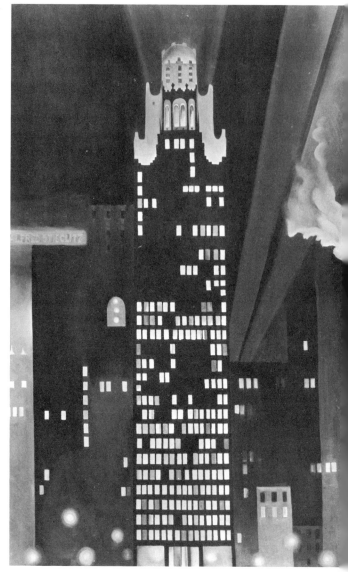

Shelton (1928) and *The American Radiator Building* (1929), in which she introduced irrelevant embellishments, are decorative designs no more substantial than flower petals. In her flower-pieces, however, she managed to express herself fully, in bright-colored decorative patterns based on the microscopic vision. The great popularity which she has enjoyed has probably been due to her ability to make certain features of modernism palatable by combining abstraction with reality and presenting them in pretty colors and polished surfaces.

Although Preston Dickinson was a painter of limited talents, when he died prematurely in 1930 he had already developed an interesting personal style. He was prone to garish color and poster-like design but in his more sober moments he could be a sensitive colorist and a fine composer.

Dickinson was profoundly affected by the Armory

Show, and Cézanne's influence became immediately apparent in his landscape painting. However, he converted Cézanne's structural style into a kind of Fauvism in which the patches of color never coalesced, but carried on a violent and discordant clamor. After the war his style changed again. He turned to a Cubist-Realist simplification of form, which he combined with a rather dainty version of Oriental design. Like Demuth, he had the curious combination of an essential fragility of style and an interest in industrial landscapes, factory buildings, and bridges. Like O'Keeffe, Dickinson was enamored of pretty colors, but his were less obvious and usually more inventive in their combination.

Dickinson's interest in pastel did a good deal to weaken his style; he fell prey to its easy decorative quality and its highly pitched and shallow color. In some of his landscapes, which show a strong Chinese feeling, he managed to utilize the delicacy of the pastel medium through a tasteful and judicious spotting; but in his still-lifes the flamboyance of color destroys the simplicity of form. However, his last still-lifes in oil show a successful conquest of this disturbing tendency. Although rich and daring in color, they reveal a new restraint. His forms gradually became simpler and had a new cleanness derived from the Cubist-Realist idiom of smooth surfaces and crisp edges. He differed from the other Cubist-Realists in that he did not strip the object of all non-essentials or accidents of light and shade, but made them elements of the design. He composed without originality but with taste.

The general development of Cubist-Realism was, as we have seen, from Cubism to realism, from the simple abstract surface to the meticulous rendering of nature. Although not revolutionary in an esthetic sense, since its exponents on the whole were interested not in experimentation with abstraction as such, but in its utilization for their own ends, Cubist-Realism was still an important movement in two respects. It established the machine and the industrial scene as legitimate and even central concepts in American art, and, in its insistence upon the clean and unencumbered surface, it helped to influence, not only a considerable group of artists, but American taste as a whole.

It would be impossible to deal with all the artists who dabbled in Cubism, but among those upon whom it had a significant, even if in some cases

Preston Dickinson, *Still Life with Yellow Green Chair*. Ferdinand Howald Collection, The Columbus Gallery of Fine Arts

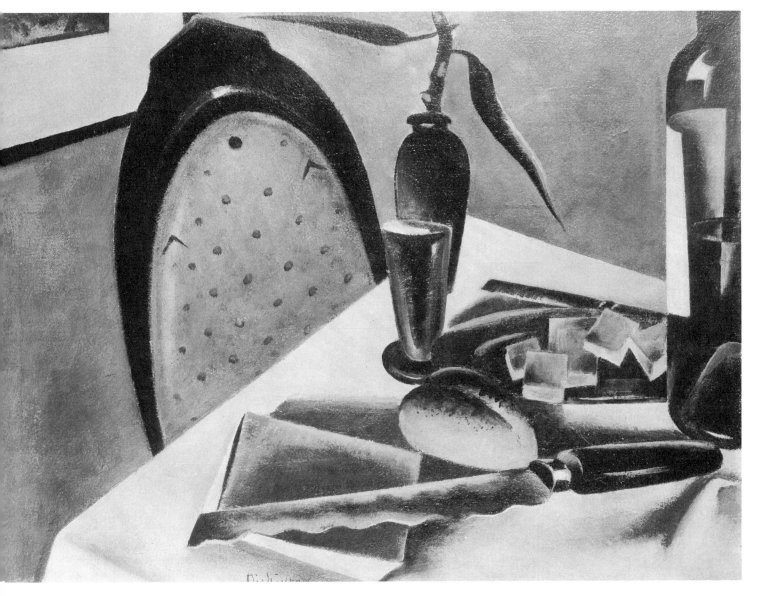

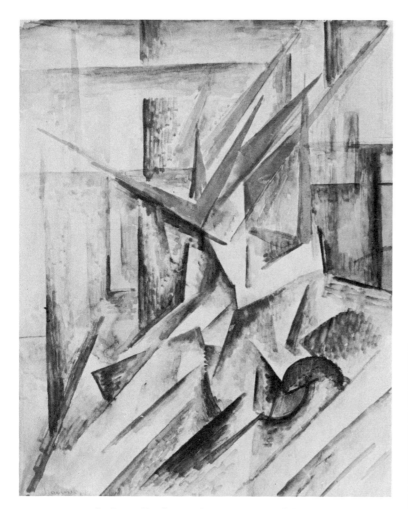

Andrew Dasburg, *Sermon on the Mount*
Collection of Antoinette Mygatt

these years was very close to Dasburg, and, working with him at Woodstock, absorbed the concepts of Cubism from Dasburg's fervent preaching. They were both then part of the *avant-garde*, producing muted but tasteful designs which did not completely deny natural forms. In the twenties their Cubism became less and less pronounced. Dasburg later found in the landscape of the Southwest an apt vehicle for his Cubist vision. McFee, on the other hand, soon moved entirely out of the Cubist orbit, retaining only a scaffolding of Cubist-influenced form which passed for intellectuality and sound construction. In the twenties his art still contained enough formal compactness to appear promising.

transitory, influence were Andrew Dasburg and Henry Lee McFee, the Zorachs, Marguerite and William, A. S. Baylinson, who for many years continued to paint fragmented figures in a Cubist manner, Alfred H. Maurer and Oscar Bluemner.

Andrew Dasburg, at that time part of Mabel Dodge's inner circle, was one of the leading proselytizers for Cubism, and his article in the *Arts* in 1923 was among the more rational considerations of the subject to appear. Dasburg for a while was also influenced by the Synchromists and from there he evolved in a logical progression toward "pure" art. However, Cubism had made a lasting impression on him and he later returned to a modified version of that style. Henry Lee McFee during

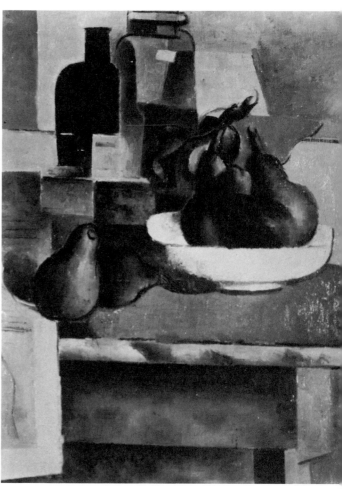

Andrew Dasburg, *Still Life*
Collection Unknown

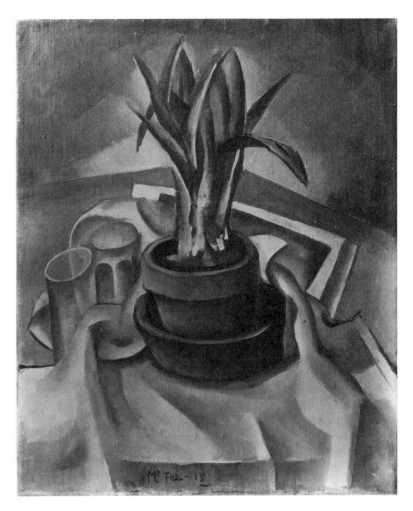

Henry Lee McFee, *Still Life*
Collection Unknown

Oscar Bluemner, although influenced by Cubism, worked in an independent vein. Bluemner, like Dove and unlike the Cubists, was not interested in the complex dissection and rearrangement of form, but in a simplification of reality as were the Cubist-Realists. However, he sought dramatic patterns in sharp contrasts of light and shade and in the exaggeration of cubical forms. An inner emotion motivated his world, transforming it into something fantastic and eerie. There was in Bluemner a definite romanticism, a somber mystical quality, an anthropomorphism which, in spite of his obvious Cubist derivation, relates him to Ryder and the romantic realism of Burchfield, and raises the question whether he, together with Dove, does not rightly belong with the Expressionists. Certainly his clean almost Cubist-Realist surfaces were merely the superficial trappings of his manner, a manner which to some extent links many of the Stieglitz protégés.

Oscar Bluemner, *Silktown on the Passaic*. Collection of Mr. Robert Bluemner

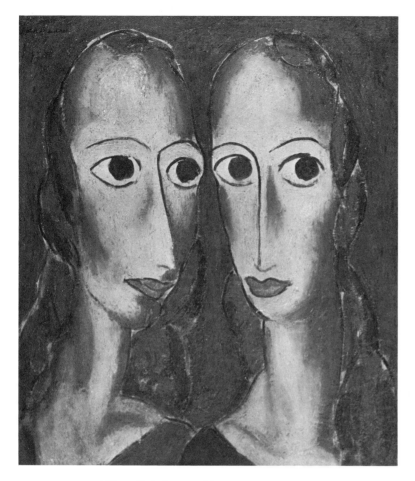

Alfred H. Maurer, *Two Heads*
Bertha Schaefer Gallery

Alfred H. Maurer, *Still Life with Ashtray*
Bertha Schaefer Gallery

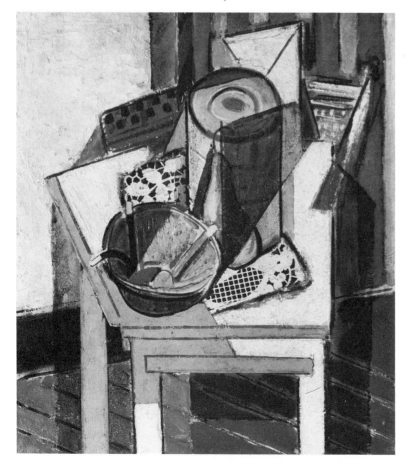

Alfred H. Maurer belongs to that tragic fraternity of artists who during their lifetimes have suffered the tortures of neglect. Even now, two decades after his suicide in 1932, he has hardly found the recognition which often comes even to the neglected after death. One must wonder, then, whether there is something essentially uncommunicative about his art. Too little is known of his intimate trials to establish a connection between his inner conflicts and his artistic output, but psychological conjecture aside, there is an essential duality in Maurer's art which makes it difficult to decide whether to class him among the Cubists or the Expressionists. What we know of his earliest paintings in the modern vein, between his conversion about 1906 and his return to America in 1914, would place him in the entourage of Matisse. He painted then in the primitive, almost "automatic" style of the Fauves, in that manner which was most difficult for the uninitiate to comprehend and for which Matisse had been reviled with such vehemence. It was no wonder that his work left the public cold and his father outraged. Rebuffed, hurt by his father's bewilderment and lack of sympathy, Maurer was not strong enough to forsake his family ties, and yet he was too honest to deny his own principles, and so he turned into himself and painted out of inner anguish. The torment shows in his portraits of himself and his pictures of the same, infinitely repeated woman. In these paintings he is a Fauve. There is a tortured sadness in the large, glaring eyes, a strangled, inarticulate cry seeking sympathy and understanding. Yet the hypnotic quality of the eyes is not sustained, for the thin repetitive figures seem straitjacketed in unexpressive rigidity and the rest of the face of his ubiquitous female is an inane mask. Only in his self-portraits is there an Expressionist violence to match the emotional turmoil of haunted eyes.

In his still-lifes Maurer is quite another personality. Circumscribed by the esthetic limits of Cubism, he seemed to have found peace, for instead of emotional instability, there is esthetic balance, restraint, and taste. His Cubist paintings of the twenties are the finest produced in America. They were painted with an inventiveness of design, an intricacy of pattern, a subtlety of color, a richness of texture, a feeling for paint, and sometimes even a strength, unequalled by any of his contemporaries. There is a sense of completeness and fulfillment in them. It is as if he had found surcease while immersed in a circumscribed esthetic problem.

THE FAUVE TRADITION

IT MAY SEEM STRANGE to consider John Marin, Max Weber, Marsden Hartley, and Walt Kuhn as constituting a single artistic group. Indeed they can be said to belong together only insofar as they are individually part of no group. Each developed a personal style which, though it derived from many currents of modern art, was neither part of nor influential in any specific artistic tendency. Although they are in the first rank of artists who emerged during this formative period in American art, they were none of them individually important, as were their French contemporaries, in the creation and dissemination of new artistic ideas. Having derived inspiration from modernism, each has fulfilled the promise of his own talent, perhaps more completely than any of their contemporaries, yet without in any way propagating an artistic dynasty. Young American artists interested in modernism have apparently seen fit to go back to the sources of modern art rather than find inspiration in its most eminent American exponents.

Fauvism is the most consistent strain running through the art of this group of painters. Although

John Marin, *Woolworth Building No. 31*
Collection of Mr. & Mrs. Eugene Meyer, photograph courtesy The Museum of Modern Art

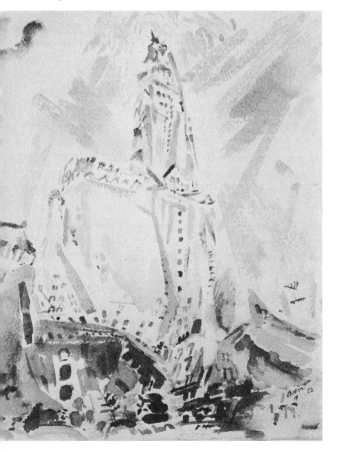

they were all influenced by Cubism to some extent, their allegiance to the Fauve tradition has been more lasting. Different as their individual styles may be, the common denominator in the art of all these men is Expressionist in its emotionalism, its "wildness," and its reliance upon distortion.

When John Marin came back to America in 1911, he was forty-one years old. He had acquired a slight reputation as an etcher and water-colorist. He had exhibited in several of the Paris salons, and the French government had bought one of his oils. On the whole he showed no exceptional promise. As an etcher, he was steeped in the Whistlerian tradition, searching for the romantic impression and the gray tone. As a water-colorist, the best he had done were the 1910 Tyrolean landscapes, which in their lightness and fluidity were suggestive of Chinese painting. It is difficult to find in the work of this man, already entering middle age, the abilities which were to make him preeminent in American art of his day.

In 1909 Marin was introduced to Edward Steichen by Arthur B. Carles in Paris. When Steichen brought Stieglitz to see him, it began a relationship which was to have a profound effect upon Marin's future. His contact with Stieglitz and "291," beginning in 1911, was to change the entire course of his development. It was there that he discovered the newest artistic movements with which he had apparently been unacquainted while abroad, and, almost as important, it was there that he developed the personal relationship with Stieglitz which helped to form Marin's artistic personality. The buffer of economic security and adulation which Stieglitz threw up around Marin protected him from more normal artistic contacts. It made it possible for him to develop a personal vision regardless of public favor. This, of course, did not make him the artist he is, but it did allow him to indulge his sensory reactions to nature without restraint, expanding and deepening the qualities of perception and expression which are the soul of his art and which give it individuality.

Marin's immediate reaction to modernism resulted in a style that was violent and Fauve-like in its intensity. The romantic aura and the lyrical linear rhythms which characterized the Tyrolean water colors of 1910 gave way, as in *Woolworth Building No. 31* (1912), to agitated shapes and dramatic brushwork. The many Brooklyn Bridge and Wool-

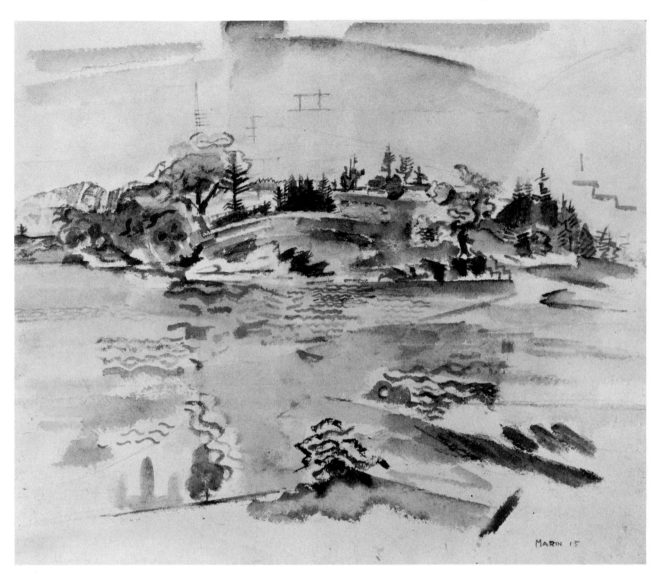

John Marin, *Marin Island*, *Small Point, Maine*. The A. E. Gallatin Collection, The Philadelphia Museum of Art

worth Building etchings done at the same time demonstrate even more clearly the disintegration of form and the erratic linear rhythms which characterized Marin's art of that period. The overpowering effect of the city dominates this whole series of etchings and water colors. The fear implicit in his attitude toward the gigantic industrial landscape of New York was expressed by Marin who wrote in reference to skyscrapers, ". . . at times one is afraid to look at them but feels like running away."[1] To Marin New York's man-made mountains were not precise structural units but dynamic forces, and he saw in them, as did the Futurists, a pervasive dynamic movement. "I see great forces at work; great movements; the large buildings and the small buildings; the warring of the great and the small; influences of one mass on another greater or smaller mass." Unlike the Futurists, however, he did not reduce this dynamism to regular rhythms, but ex-

pressed in his art a vertiginous chaos. Marin had returned to America at a time when New York was in the midst of tremendous construction, the immensity and excitement of which fired his imagination. At the time the Manhattan Bridge and the Merchants' and Manufacturers' Exchange had just been completed, the Woolworth Building had been begun, the New York Central Railroad Terminal was in process and the Municipal Building's steel frame was complete. Like a true Expressionist he attempted to impart the emotional turbulence of his own reactions to those material things which had engendered them—"Thus the whole city is alive; buildings, people, all are alive."[2] This is especially true in his etchings, where his own emotional energy, ascribed to static shapes, distorts and destroys the basic structure, exploding solid mass into a swaying, distorted, crazy-mirrored hallucination.

By 1915, after his return to Maine, a new element,

134

the influence of Cubism, was evident in his work. Having left the city for the more congenial atmosphere of nature, he seems to have regained some of his earlier calm. At least the turbulence of the sea or the drama of a sunset evoked less uneasiness. The paintings of this period differed from his earlier European landscapes in their more vigorous brushstrokes and in the introduction of a Cubist embroidery. The embroidery was like a linear obligato running through the sonorous sweeps of wash, trilling along in a wave pattern, supplementing and describing the foliage of a tree, or, in abstract rectangular movement, fortifying a shape or a section of a composition. In some cases, as in *Marin Island, Maine* (1915), he regained a good deal of the earlier Chinese feeling, expressing himself with calligraphic brushstroke patterns in the manner of the late Sung painters. By 1919, in a landscape like *Tree and Sea, Maine*. he had deserted natural forms for pure emotional expression and become almost abstract. The Fauve tendency was again evident in impassioned strokes and blots which, growing surer and purer with time, were to be the signature of his mature style.

During the twenties, Marin's basic Expressionism was tempered by a more profound Cubist influence. What had previously been embroidery now became an integral ingredient of his style. He turned to the city again but now it was the planimetric aspect of the city's canyons that he sought to express in a new structural manner. The writhing, tormented shapes of the earlier Expressionist period were replaced by a closely integrated structure of interlocking planes. The former spastic movement gave way to an ordered and controlled mobility. There was, however, still movement in his paintings, for Marin could never see either in nature or man-built cities the static forms discovered there by the Cubist-Realists. Life remained for him always a "warring" of parts in which the most an artist could do was to establish a precarious balance. The water colors of this period are kaleidoscopic in character, with sharp-angled forms shifting and slipping in front of and behind each other in an interplay of color-planes, all caught in a momentary equilibrium. At this time his style reached its point of greatest abstraction. Even nature, as in *The Harbor and Pertaining to Deer Isle, Maine* (1927), was reduced to a series of abstract geometric symbols.

These paintings have a dryness and an intellectuality which is uncommon in Marin's art. However,

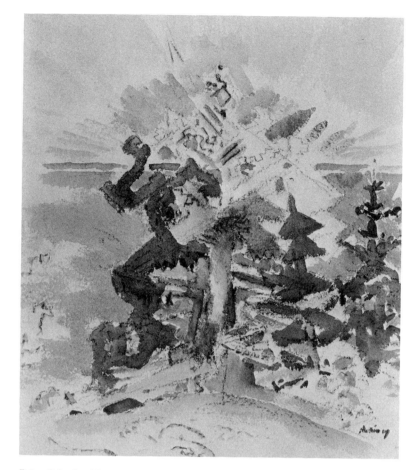

John Marin, *Tree and Sea*, *Maine*
Courtesy of The Art Institute of Chicago, Alfred Stieglitz Loan Collection

Marin's Expressionism could not long be constrained. Never a man for theory, he was not seduced by esthetic programs or even by his own experiments. His contact with nature was so personal and close, his esthetic reactions so direct and emotional, that he could not confine his experience within a formal mode as rigid as Cubism. The Fauve in him again got the upper hand. Indeed, it is questionable whether it had ever been completely subjugated, for some of his most Cubist efforts were disturbed by passages of emotional vehemence. Confronted with a fresh experience, even at the height of his involvement in abstraction, he could shed the formal paraphernalia of Cubism and revert to the directness and intensity of Expressionism.

It is hard to say why Marin's dependence upon Cézanne has been so excessively emphasized. Actually, he is only slightly related to the French master, and whatever resemblance there is, is largely superficial. At times the resemblance is due to nothing more than the fact that both worked in water color. Whereas Cézanne was obstinately concerned with form and structure, Marin is essen-

135

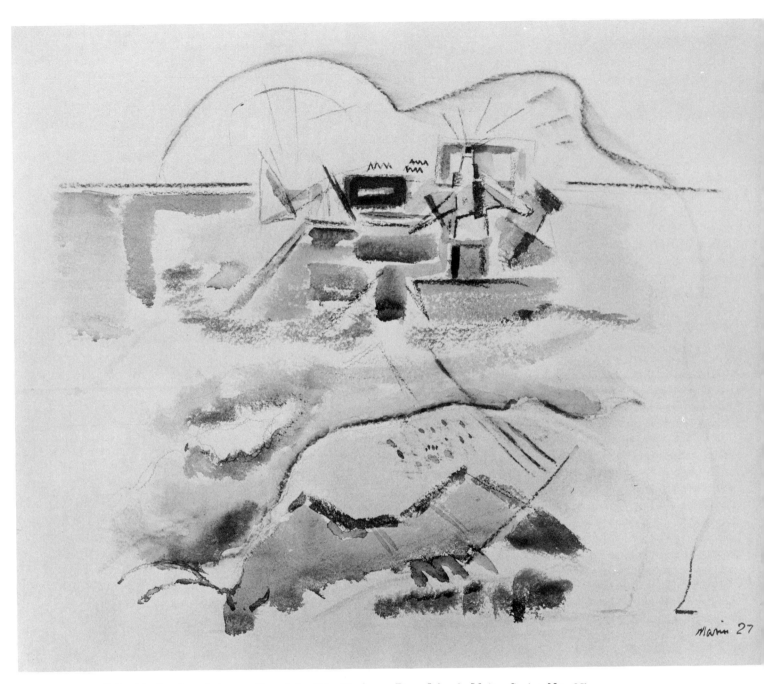

John Marin, *Pertaining to Deer Isle, The Harbour, Deer Island, Maine Series No. 27.*
Estate of Alfred Stieglitz, photograph courtesy The Museum of Modern Art

tially a lyrical colorist. His sense of form and structure is probably the weakest element in his art, his feeling for mood and beauty his strongest. Cézanne was never interested in atmosphere or texture—to him these were accidents of nature. Marin, on the other hand, is concerned almost exclusively with phenomena of weather, the fortuitous and poetic aspects of an ever-changing nature.

Marin's concept of structure is completely unlike Cézanne's. He is not interested in analyzing and recreating the essential character of matter, as Cé-

zanne was, but in arranging the elements of a picture into a structural entity, in seeing to it that the contrived parts are in esthetic order. The logic of the relationship of parts is the dominating consideration for Marin as it was for the Cubists. In such an art the frame takes on a special significance. When an artist recreates a segment of reality in terms of mass and space, the frame is merely a window limiting or containing vision, but when an artist contrives a relationship of forms whose spatial scheme is not strictly dependent upon reality, then

the frame becomes an essential factor of the composition. The flat picture surface too assumes a primary significance. As a result, the frame and the surface become fundamental ingredients in Marin's picture composition.

Marin's consciousness of the picture surface dominates his spatial vision, to the point of obsession. He has often described this attitude and in one case, eschewing his usual, cryptic, free-verse jargon, he says, ". . . on my flat plane I can superimpose, build up onto, can cut holes into but . . . I am not to convey the feel that it's bent out of its own individual flatness."[3] Our sight may, then, punch through the paper and rush into depth, but the recognition of the paper's existence must always remain; and, shuttling between surface and depth, we are always drawn back to its flatness.

The feeling for flatness is heightened by the "enclosure"[4] device which Marin developed out of his Cubist experiments. The enclosure lines or forms serve a dual function. First, they insist on the original flatness of the picture plane by echoing upon the surface the accents which occur in depth and in many cases they even create the illusion of an actual punching through of the paper. They also serve a necessary structural function. Since Marin is imbued with a sense of dynamism, a feeling for motion and rhythm, for the play of one form upon another, of one direction upon another, of one force upon another, he finds it a problem to contain this action within the frame of his picture. ". . . My picture must not make one feel that it bursts its boundaries. The framing cannot remedy. That would be a delusion and I would have it that nothing must cut my picture off from its finalities. And too I am not to be destructive within. I can have things that clash. I can have a jolly good fight going on. There is always a fight going on where there are living things. But I must be able to control this fight at will with a Blessed Equilibrium."[5]

However, this "Blessed Equilibrium" is not always inherent in Marin's compositions, and he has felt the need to stabilize the mobility of his forms. In spite of his desire not to cut his picture off from its finalities, he has sometimes done so with heavy, peripheral linear accents which, growing out of the central forms themselves, serve as a frame, replacing the arbitrary rectangle, and at the same time as compositional props to reinforce the stability of the structure. Unlike Cézanne, who lost interest in edges when the central structure became coherent, Marin,

who thinks always in terms of the picture, cannot leave it until the edges are trimmed.

It has been said of Max Weber, in a derogatory sense, that he is an eclectic, that he has borrowed too much from the past, that his art is a pastiche of modernism. Such criticism is based on the recognition of obvious influences on Weber's art, without however appreciating the personal qualities of his style. Weber has always been a student of the past and the past has found a place in his art, more so than with most artists, but he has managed to stamp the past with his own imprint.

Whereas Marin imbibed modernism without too much concern with its origin or theory and insulated himself in a prideful ignorance, Weber was an esthetic ferret. He lived in Paris during the period of great ferment, and unlike Marin he was aware of what was going on without needing a Stieglitz to show him the way. By himself he found Cézanne, whose art he worships passionately, Picasso, and Matisse. Unlike Marin, who avoids museums and would rather talk of his exploits as a woodsman, Weber's life has been dominated by art. Almost all the poetry he has written is concerned with art, and his essays on art are discussions of basic and eternal principles. Marin, wearing a cloak of Yankee hard-headedness and insularity, is interested quite simply

Max Weber. *Composition—Three Figures*
Collection Unknown

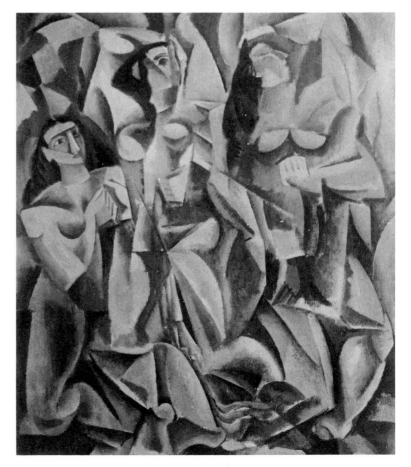

in himself and his painting. Weber, on the contrary, is the image of age-old culture, refinement, sensitivity, and poetry. The former, stifling his emotions behind a puritanical façade, explodes in art into a cold, objective fury, expressing himself in sharp bitten phrases, with a spontaneous and direct purity. The latter sings a sweet and poignant melody, full of pathos, rich in allusion, complex, and studied.

The influence of that famous art teacher, Arthur Wesley Dow, upon Max Weber, has been made much of, especially by Weber. Dow, who was on the staff of Pratt Institute when Weber was a student there, was at that time a pioneer in the teaching of design principles based on Chinese and Japanese art, with which he had become familiar through the work of Ernest Fenellosa, the leading American connoisseur and scholar of Far Eastern art. It was, perhaps, not so much Dow's esthetic theories as his introduction to Oriental art which prepared Weber for the future. When Max Weber arrived in Paris in 1905, he at least knew that there was an art outside the European tradition. When he became impatient with the Academy Julian version of that tradition, he sought inspiration in the great reservoir of the art of the past. Going back to the springs of European artistic tradition, he made discoveries for himself, achieving a deep and personal contact with the great masters and the great monuments of art. In 1906, at the Salon d'Automne, he discovered the modern master Cézanne who from then on was to be his lodestar. Weber's artistic horizon was thus widening to include not only the lesser known aspects of the past but also the emerging trends of modernism. He was also at that time cultivating a taste for the archaic and the primitive through the arts of Greece and Egypt. Under the tutelage of Matisse, with whom he studied for a short time in 1907-1908, he discovered the brilliant color of Persia and India. Matisse's concepts of the silhouetting of form, the simplification of line, flat color, and abstract pattern dovetailed with Weber's earlier training under Dow.

When Picasso and Braque began to experiment with African Negro art, Weber grasped its meaning immediately, just as he immediately loved the art of the "primitive" Henri Rousseau. Weber absorbed the concept of primitivism, which has always remained an important characteristic of his art, during the formative period of his style between 1905 and 1908. The primitive to Weber is not merely a source of artistic inspiration, a cult, or a passing phase. He

loves it sincerely. Even in his attitude toward Rousseau he differed from the Cubist entourage which saw the *douanier* as an interesting artistic freak. Their admiration for his art, although sincere, was tinged with cultism and preciosity. Weber on the other hand loved Rousseau as a human being, as a sweet, naive soul, and he loved Rousseau's art for its honesty and childlike simplicity.

Primitive art is the motif which recurs throughout Weber's groping search for agelessness, for eternity, for essentials. He has sought in the primitive a mystical and emotional identification with the art of the deep, almost fathomless past. In such a mood he has apostrophized the Toltec God, Chac-Mool, as a symbol of primeval artistic creation:

> "Thou art agent and medium of the infinity of
> all things.
> Would I were with thee, if I but could and
> knew how . . .
> Oh my brother in eternity, Chac-Mool of
> Chichen-Itza.
> Would that I could but hear thine unuttered
> speech in silence and heavenly mood,
> I feel our minds greet and kiss each other.
> A liquid sweetness of soul and peace,
> Flows living from me to thee and from thee
> to me."[6]

Even in his poetry Weber is impelled unconsciously to speak in an approximation of ageless biblical prose. After his return to America, he steeped himself still deeper in primitive art, more deeply than any of his contemporaries, studying at the American Museum of Natural History the art of the aborigines of America, Incas, Mayas, Aztecs, Pueblo, and Northwest Indians.

The woodcut series he made to illustrate *Primitives*, a group of his own poems, represented his personal assimilation of a wide range of primitive art, even though the influence of Picasso's African period is strong in them. The kind of archeological baggage which is evident in these woodcuts was dropped in his mature style, but some of the characteristics of physiognomy and proportion that are there persisted in later times too.

Weber's evolution after his return to America followed more or less faithfully, with a lag of several years, the general course of modern art. When Weber left Paris in 1908, Picasso was passing out of his African phase into analytical Cubism, and Weber's style until 1911 was reminiscent of Picasso's

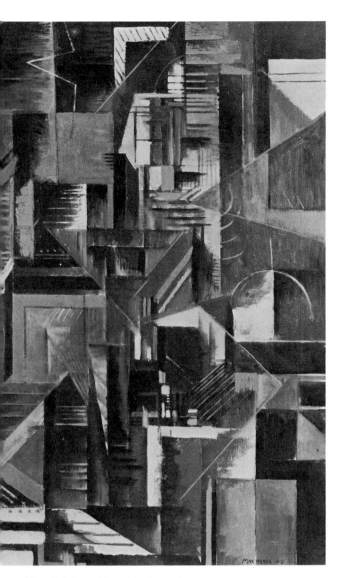

Max Weber, *New York at Night*
Paul Rosenberg and Co.

Les Demoiselles d'Avignon. He was concerned, as in his *Composition with Three Figures* (1910), with the translation of natural forms into massive cubical units. Weber's manner was, however, more conservative than Picasso's, relying less on the primitive than on Cézanne. Weber's *Three Figures*, for instance, although painted several years after Picasso's large composition, is stylistically a middle point between a Cézanne *Bather* group and *Les Demoiselles.* The restrained reduction of nature to prismatic shapes which resulted is reminiscent of the early style of Derain.

In 1911, analytical Cubism began to have its effect on him. The earlier simple and broad, three-dimensional treatment of matter was superseded by a disintegration of the large masses into a fabric of complex interlocking shapes. The entire surface of the canvas was broken up into a series of crystal-

like forms, paralleling the progressive dissolution of three-dimensionality in the development of Cubism, but resembling in pattern the late water colors of Cézanne. In contrast to the rational breakdown of form in analytical Cubism, this crystal period of Weber's evolution shows an almost excessive emotionalism, a violent distortion and, perhaps because of that, a turn toward El Greco's elongated nervous figures.

In 1915 Weber had shifted his ground again and was immersed in synthetic Cubism. Some of the paintings of this time—*New York at Night* (1915), *Rush Hour* (1915) and *Metropolitan Museum Lecture* (1917)—had more to do with Futurism in their subject matter and reiterative rhythms than with the pattern-like static arrangements of Cubism. They were also the most abstract paintings he ever did. But he was also producing such canvases as *The Piqué Shirt* (1916) and *The Cellist* (1917) which were closer to the Cubist tradition, except that his color was not monochromatic, but rich and varied. This geometric period was merely an interlude in Weber's development. The rigidity, dryness,

Max Weber, *The Two Musicians*
Collection The Museum of Modern Art, Bequest of Richard D. Brixey

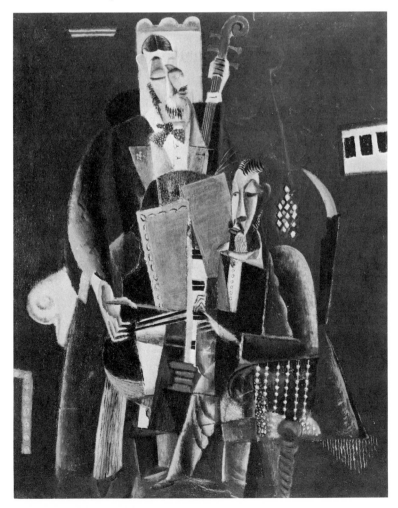

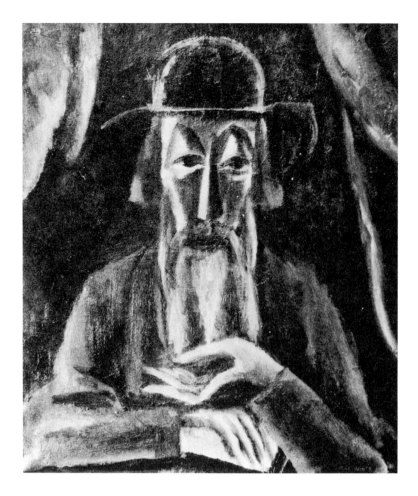

Max Weber, *The Rabbi*
Collection Unknown, formerly Mrs. Nathan J. Miller

and impersonalism of Cubism could not for long satisfy his warm poetic nature, no more than it could contain Marin's fury, and by 1917, realizing he had reached a dead end, Weber retraced his steps to his earlier years in Paris and reverted to the memory of Fauvism.

Weber's style, during the twenties was built on the foundation of Cézanne's experiments in structure and composition, Matisse's researches in color, and his own love of the primitive. There was a tendency for these various elements to separate, so that several almost distinct categories of production continued side by side. It was not until the thirties that his style coalesced in an integrated personal expression, so that it is difficult to characterize his manner of the twenties except as a medley of co-existent tendencies.

The pictures of women playing music, which begin in 1917 and continue through the twenties, are an example of Weber's return to Fauvism. They have the simple outlines and bold color areas of Matisse, together with the stolid, massive quality

of Derain. Indeed, Weber's resemblance to Derain in these works is marked, especially in their tight spatial compositions and their solidity of form. *The Rabbi* (1918), for instance, was a reversion to the structural Cubism which had so deeply influenced Derain around 1912.

In the early stages of his development Weber's dependence upon Matisse was pronounced. The simplification and distortion of forms and the bold use of color cropped up again and again in his early work and were revived to some extent in the early twenties. In his mature style, however, Weber evolved an original color sense which is almost antithetical to that of his master. Whereas Matisse's subtlety is one of relationship, Weber's is one of nuance; and whereas Matisse works in brilliant and aggressive areas of saturated color, Weber confines himself to silvery half-tones against the background of which there is a sprinkling of pure color.

Weber's greatest debt of course is to Cézanne. Few artists of our time have been as consciously indebted to Cézanne as Weber and as obviously influenced by him, and yet have been able to transform this dependence into an original and personal style. When he returned to Fauvism, he also retraced his steps to Cézanne. From him he learned two basic lessons—that of constructing form with color and that of composing tightly knit spatial units. At times he was openly imitative, as in *Still Life, Egyptian Pot* (1917), where he modeled objects and related them in space entirely in terms of color, or *Reclining Figures* (c. 1927), where he relied heavily on Cézanne's many *Bather* compositions, in spatial grouping and rhythmic relationships, in devices of broken and repeated contours, dynamic interplay of forms, and compositional distortions. And yet in both these works, the net result is far removed from the calm, impersonal and "classical" attitude of Cézanne. The elisions of form, the nuances of color, and the suppressed emotionalism are foreign to Cézanne. There are passages of color included simply because they are beautiful and not as structural bricks. There are distortions which transcend their compositional function and become charged with emotion. Underneath it all runs a vein of sentiment and poetic feeling which belongs entirely to Weber and no one else.

It is this emotional lyricism which is basic to all Weber's mature work and which transforms whatever may be his borrowings from other men and other times. It is this same emotional quality which

Max Weber, *Still-Life*, *Egyptian Pot*
Collection of the Artist

makes Weber brother, though slighter in stature, to Rouault. In comparison with Weber's muted and poignant lyricism, Rouault's emotional content appears barbarically violent, frenzied in its intensity, shocking in its power, and yet the result in both cases is a rich jewel-like encrustation of color or a complex web of transparent washes, expressive of the "spirit" rather than its external manifestations. Weber speaks often of this "spirit" which sings to us out of the depths of art and Rouault finds a similar "spirit" in a personalized religiosity. This similarity of feeling has extended to include a similarity of means. It is especially marked in Weber's gouaches in which color and line, freed of their structural tasks, have become the vehicles of emotion, as they are in Rouault. In the thirties, Weber's stylistic resemblance to Rouault of the Fauve period became even more pronounced; but already during the twenties, in these gouaches, Weber had developed a similar rich and fluid linear method of describing form.

As we have already indicated, the emotional content of Weber's art is a poignant lyricism, a quality just as evident in his writing and speech. His lyricism is the natural outgrowth of a deeply poetic nature, his poignancy the result of a quest for the eternal in memories of the past, a quest which loses itself in nostalgic thoughts. Weber dreams of a world in which the senses are ravished by beauty. Whether it be a still life on a table in the corner of a room, the trees, fields, lakes, and hills of Long Island, the mellifluous and involuted talk of Talmudists, or the fantasy of eastern harem life, there is poetry in Weber's painting of them.

Walt Kuhn began his career, like many American artists, as a newspaper cartoonist and magazine illustrator. But the call of the "fine" arts led him, as it did the members of the Ash Can School, to give up his commercial work and turn to painting. He studied abroad for several years in Paris and Munich, developing a style which was a cross between the high-keyed palette of Impressionism and the bold brush handling of Munich, a style akin to the work of the Ash Can group. *The Tow Team* (1908), is in the Bellows muscular tradition. Unlike Bellows, however, Kuhn retained a good deal of this youthful brashness in his mature style, and he was the only one of the "muscle men" who, even when confronted with modernism, adapted his vigorous realism to the new idiom.

The Armory Show itself and the assembling of it, in which Kuhn played so important a role, was the turning point of his career. As part of the young and growing realist group, Kuhn at first was unaware of modernism, but the excitement of arranging the Armory Show and the dramatic personal discovery of modern art had a tremendous effect upon his future. Through his close friendship with Davies and his position as John Quinn's artistic secretary, Kuhn was in constant contact with the best in European modernism, and for a time, like most young American artists, he was extremely susceptible to the various cross-currents of influence. He deserted the security of his earlier manner and embarked on a period of experimentation out of which he emerged some ten years later an artist of stature, with a personal and distinctive style.

Kuhn's first experiments in modernism were under the influence of Matisse. His dependence is most evident in such works as *Man and Sea Beach* (his contribution to the mural series done by him,

141

Walt Kuhn, *Caucus*
Collection Unknown

Davies, and Prendergast in 1915 for the Daniel Gallery in an unsuccessful attempt to inject some new life into mural painting in America) and *Caucus* (c. 1916). Both these canvases were derivative and rather strident, executed in a bold manner with distorted forms and strong primary colors. As early as this we find Kuhn showing an affinity with Derain, and it may even be that his borrowings from both Matisse and Picasso came to him through Derain as intermediary. His dependence upon Picasso is undeniable in *Harlequin* and *Tragic Comedians*, in which he had apparently mixed Picasso's blue and Cubist periods. Generally his borrowings from Cubism were superficial. Kuhn was never overly radical even in this period of his greatest experimentation, and his essential conservatism reasserted itself in the work of his maturity.

The emergence of his mature style dates back to the middle twenties. The first intimations that Kuhn was shedding his outer trappings of radicalism were apparent in such paintings as *Girl in Cocked Hat*, in spite of its still strong relation to Matisse, and *Head of Girl*, in spite of its similarity with Derain. In the still-lifes of that time, of game birds and rabbits, he goes so far as to return to an almost academic style. At no time, however, did he forget the basic concepts that he had learned from mod-

ernism—simplicity, solidity, and daring. The style he developed in the twenties subsequently changed very little except to mellow and grow richer. In the thirties he ventured to leave the realm of the characteristic single-figure paintings which engrossed him exclusively in the late twenties, and enlarged his repertory to include still-lifes, flower studies, and, finally, landscapes. In none of these subjects, however, did he match the brilliance of the single-figure pieces.

Perhaps Kuhn's most obvious characteristic is the limitation of his gamut. Whether intentionally or not, he stringently limited his vision to portraiture. Not that he was a portraitist in the usual sense; rather, each of his pictures is the portrait of a type. The type he chose was most often the circus performer, and yet Kuhn eschewed all the obvious dramatic possibilities, inherent color, and excitement of show business. Instead he abstracted single figures of performers from their natural environment of action, posed them statically against neutral backgrounds and then imbued them pictorially with the dynamic energy which is theirs in action. Within the strict confines of this attitude, Kuhn displayed an unusual expressive strength.

Simplicity is the primary ingredient of Kuhn's style. His art speaks invariably in declarative sentences. He uses no subterfuges of composition. He presents his characters as personalities in the trappings of their profession and occasionally with the paraphernalia of performance. The simple theme is monumentalized by a rigid squaring of the figure with the frame. Kuhn regularly presents his subjects in a stiff, posed frontality, giving them a dignity which one connects only with official portraiture. His chorus girl carries her scanty gaudiness as regally as a queen her tiara and ermine, his juggler is as sensitive as a poet, and his acrobat poses as proudly as a warrior in armor. It is not that they are always that prepossessing, but then neither is royalty except in its official state, and Kuhn sympathetically gives his people also the opportunity to pose at their best.

In a personal interview Kuhn said that his purpose was to paint "buckeyes," by which he meant that he would like to raise to the level of art the unsophisticated sentiments of the average man, to transform the blatant costume of a vaudevillian into an unforgettable esthetic experience. This he accomplished to a marked degree, except that in later years he tended to become more and more carried

away by the theatrical trappings themselves, and a greater percentage of his works became real "buck-eyes." At his best he managed to transcend the inherent discords in his subjects by a brilliant handling of color, by painting entirely in a high key, and by playing one dissonance against another so that the result is a blatantly shocking but powerful impression. Kuhn had a considerable ability to play the gaudy against the pretty, the commonplace against the romantic, and to achieve in the end a sincere and human document.

The similarity between the works of Kuhn and André Derain is often marked, although Derain is a much more sophisticated artist. Out of much experimentation Derain evolved a subtle, intellectual style, always painting with one eye on the past, whereas

Walt Kuhn, *Victoria*
Collection of Mr. Raphael Soyer

Walt Kuhn, *Harlequin*
Collection Unknown, formerly John Quinn

143

Kuhn's forte lay in directness and forcefulness. Kuhn painted without reference to the past or even to the artistic fashions of his own day. With singleness of purpose he painted that which he felt most closely and most profoundly and he painted it with intensity. He is substantial and conservative where Derain is versatile and eclectic. Both artists see and paint broadly, simplifying the whole to a series of large color areas, a method they both learned from the same modern sources. However, Kuhn emphasizes three-dimensionality more than Derain usually cares to; and while Derain finds his strength in an almost monochromatic reticence, confining himself to a prearranged gamut and producing a shorthand statement rather than a recreation of reality, Kuhn uses a rich and full impasto. On the whole, Kuhn's mood is more intense than Derain's emotionally as well as coloristically.

Curiously enough, Derain, like Kuhn, has a feeling for the "buckeye." However, Derain's concept of the "buckeye" is a completely different one. He is interested in the artistic "buckeye." Derain has made a practice of taking an artistic form which has achieved the status of disreputable or "popular" taste, a form which has been degraded through endless repetition to the level of a cliché, and has attempted through the originality and modernity of his treatment to present it as a fresh artistic experience. Thus, Derain's *La Femme au Canape* is the traditional Venus type, his *Jeune Fille a la Capeline* is a reminiscence of Corot and nineteenth-century romanticism, his many landscapes are directly related to the Italian landscapes of Corot and his *Woman Doing Her Hair* is an echo of Courbet. This transfiguration is achieved by a restatement of older forms in modern terms, in which the consciousness of the past is a constant and subtle reminder that the alchemy of genius is at work. Kuhn, on the other hand, goes to the "buckeyes" of life rather than of art and, instead of playing down the excruciating quality of their tawdriness, uses that as the very basis of his statement. When Kuhn is successful (and even Derain, with all his vaunted taste, fails in his own efforts all too frequently) he produces a vivid sensation of reality.

Kuhn paints with a massive solidity. He underlines his forms, accenting their cubical as well as their structural nature. The sense of power, both psychological and esthetic, is carried through from the conception of the picture to its consummation, from its formal pose through its simplification, mas-

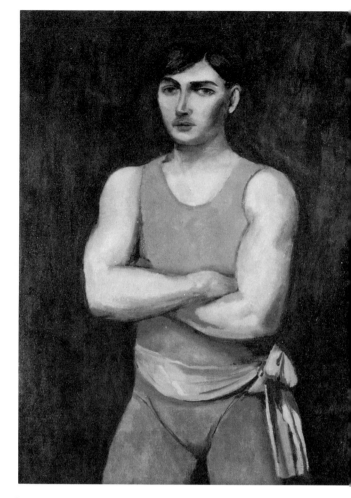

Walt Kuhn, *Acrobat in Green*
Addison Gallery of American Art, Phillips Academy, Andover, Mass.

siveness, and heavy impasto. Kuhn's Expressionism is conservative, but it has emotional depth.

It was probably Marsden Hartley's innate romanticism which links him with the German rather than the French modernists. Originally he stemmed from the indigenous romantic tradition of Martin, Fuller, and Ryder, which he himself has ably defined, and to which Blakelock, Eilshemius, and Hartley's contemporary, Charles Burchfield, also belong. It is a dark, brooding strain which goes back to the Puritan mysticism of Hawthorne and the Gothic mysticism of Poe. But in Hartley it is stripped of all literary connotations, twilight moods, and sorcery, and presented with a boldness which often approaches abstraction.

Even in his earliest, Impressionist style (c. 1907-1908) he was not as objective as the concept of Impressionism would imply. He painted with a vigor and rhythm which went beyond the naturalistic limits of purely visual experience. He was even then interested not in the exterior of things, but in

144

Marsden Hartley, *Maine Landscape, Autumn*. The Alfred Stieglitz Collection for Fisk Universit
Marsden Hartley, *The Dark Mountain*. Courtesy of The Art Institute of Chicag

Marsden Hartley, *Movements*, 1915
Courtesy of The Art Institute of Chicago, Alfred Stieglitz Loan Collection

These abstractions, which made quite an impression in Berlin where they were exhibited, largely because they were supposed to contain allusions to the war, had none of the Parisian formalism, geometry, precision, or taste. They were almost haphazard in conception and strident in color, imbued with a violence common to the Munich school. When the paintings were shown here in 1916, they were something new in American modernism, for they were Expressionist abstractions in contrast to the rational abstractions of Cubism. They were not formal statements of the material universe, but abstract symbols of emotional states.

In the ensuing years Hartley dropped abstraction completely and went through a period in which natural forms, though distorted, were not destroyed, while both mass and space were rationally conceived. By the twenties he had returned to nature. His expressive means were then already mature; he had assimilated a feeling for volume and a tendency toward abstraction from Cubism, and his inherent romanticism had been deepened and given power by his contact with Expressionism.

The landscapes of that period, done in New Mexico, recaptured the earlier allegiance to Ryder, and the romantic theme was now stated with a new forcefulness. The world was reduced to rudimentary forms, scored with black, and modeled with insistent plasticity. Here was dramatic power to replace the romantic lyricism of Ryder. True this was also romanticism, but in a more virile key, clamorous and full of discords, relying on blacks for emotional strength as well as for design. The stark landscape of New Mexico lent itself to Hartley's own esthetic frugality. He stated in simple, almost abstract terms, the romantic tragedy he saw in the rocky hills, in the eroded land, in the stunted and broken trees.

Similarly his still-lifes of that period are tragic poems, some of them scenes of violence in which white-heightened color clashes with charred blacks, in which brushstrokes, with frenzied independence, contradict the normal structure of matter. His colors against the black lines often glow, but without warmth, shouting in a kind of bitter antiphony.

During these years Hartley attained maturity and emotional depth. His style, though related to German Expressionism, evolved into something personal and original. His color, with all its dissonance, was controlled by then with an almost French feeling for taste. His use of white and black within the

their inner substance. The Impressionist paintings of Maine, behind the sparkling surface of his prismatic palette, already had the massive and brooding quality of his immediately subsequent style of 1909, in which he leaned heavily upon the romanticism of Ryder. The romantically conceived *Dark Mountain* (1909) is remarkably similar in scene and composition to the earlier impressionistic *Maine Landscape—Autumn* (1907), but with the exception that in the later work the Expressionism which was to come to fruition in his mature style was already pronounced. The dazzling surface of Impressionist color spots was replaced by a sombre gamut. Shapes were already expressing a torsion dictated by an inner mood. A tree twists in agony against the oppressive mass of distant mountains, at the base of which tiny houses cower, haunted by immensity, and in the sky clouds leap like flames. The whole series of landscapes done before his European sojourn are alike in their romantic expressionism, clearly dependent upon Ryder, but more violent, more concerned with the moods of nature than with poetic allusions.

Hartley must have been influenced by modernism when he contacted "291," where he had exhibited as early as 1909; he was at least prepared for it when he went to Europe in 1912. There he was at first influenced by Cubism. But he found a more congenial art in Germany. The paintings he did there in 1914 were in the manner of the Munich Expressionists and especially close to Kandinsky.

- literature expanded through newspapers
- art still limited
" revolt in art directed against outmoded forms

modernism was savage 20's dominated
 try moderate over realists
most of earlier generation died out
and Eakin - 1916
 Ryder - 1917
Sargent & Cassat continued till 1925

Impressionism at height of popularity
Ash can school finally popular
Sloan and Henri - adopted

Compromise

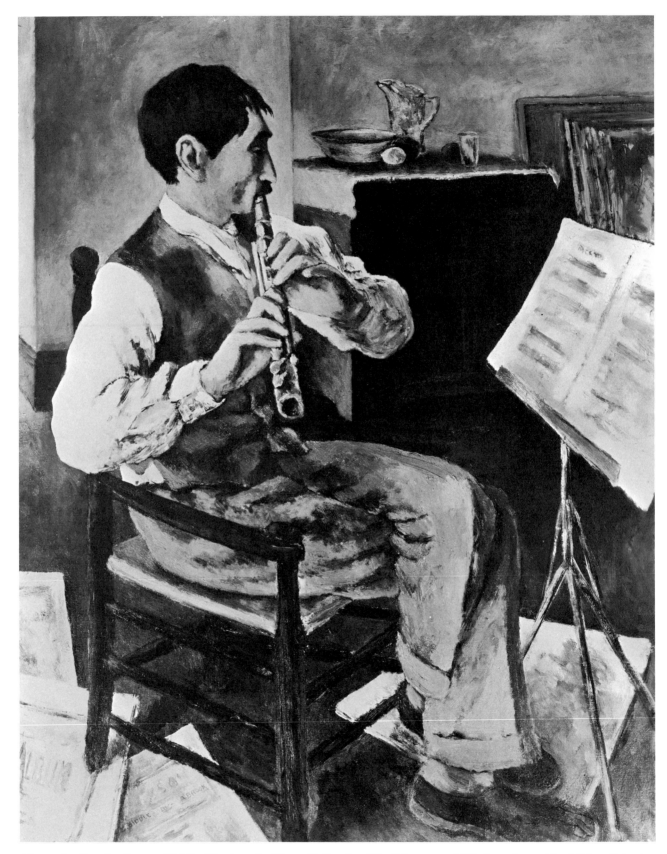

Alexander Brook, *George Biddle Playing the Flute*. Collection The Museum of Modern Art, gift of Mrs. John D. Rockefeller, Jr.

MODERNISM had transformed the art of a romantic like Davies and a realist like Sloan; it had even influenced for a brief span such academic painters as Kroll and Speicher. But there were two artists—Maurice Sterne and Samuel Halpert—who, though they played an active part in the earliest development of modernism, later revealed themselves as essentially conservative. Neither dabbled in extremism, nor were they swayed by every new wind of esthetic experimentation; each continued to work within the framework of his personal conviction and both eventually lost even the outer appearance of modernism.

As a young man, Maurice Sterne had a brilliant career. In 1902, at the age of 24, he held his first one-man show, from which William M. Chase bought a canvas, high honor indeed for a young artist. He was appointed assistant instructor in etching at the National Academy of Design the following year, and in 1904 he was awarded the Mooney Traveling Scholarship, the first recipient of that honor and the first Academy student to be sent abroad to study. At that time he was much under Whistler's influence and, by academic standards,

Maurice Sterne, *Resting at the Bazaar.* Collection The Museum of Modern Art, Mrs. John D. Rockefeller, Jr. Purchase Fund

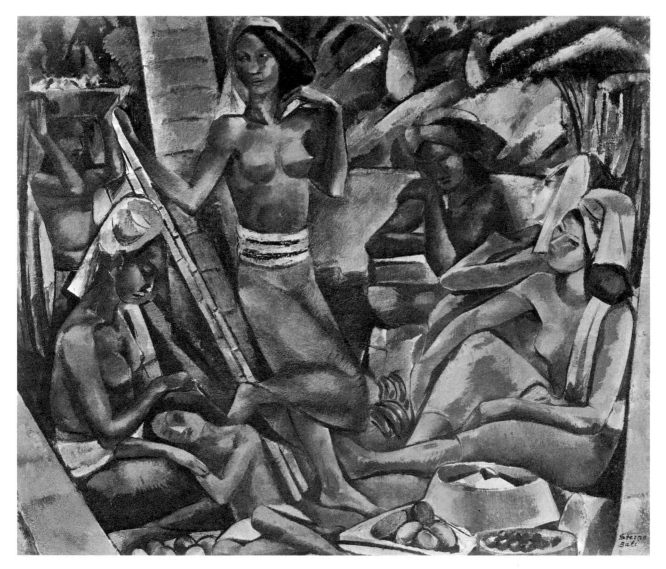

extremely proficient. In Europe he was received as one of America's young, bright lights. However, he became dissatisfied with his earlier work and set out to find himself anew. He began to study the past at first hand. He discovered Piero della Francesca, Pollaiuolo, Mantegna, and Dürer, then Cézanne and Manet and, later, Gauguin.

All this time he worked by himself, unlike Weber, Maurer, and Halpert who were in the midst of modern experiments. He worked in Italy, travelled in Egypt, India, and Burma, and spent two years in Bali. When he returned to America in 1915, he had developed a brand new artistic personality. The tonalism of Whistler, the incisive and detailed drawings which had linked him with Mantegna and Dürer were all of the past. His Balinese paintings and drawings made him a "modern" reputation. In subject matter and to some extent in color they were like Gauguin, but there the resemblance ended. Sterne lacked Gauguin's warmth and his decorative skill. His painting was harsh and rather brittle. The technique of building form with color was derived from Cézanne, but Sterne applied it in a decorative rather than a structural sense. The exoticism of the subject, the experimental character of the handling, the sensitivity to texture and materials, gave these early Bali studies an intimation of life which was missing in later work.

After the war he returned to Anticoli-Corrado, in Italy, to paint Italian peasants. But now his search for formal perfection began to destroy whatever innate fire he had once had. His intellectuality and estheticism were his undoing. His constant endeavor to achieve essentials, to equal the great masters, led through progressive simplification and over-refinement to aridity, and his supersensitivity to esthetic nuances seemed to drain his art of strength. All he could produce were meticulously constructed and carefully painted academic contrivances, resembling to a marked degree the work of his Italian contemporaries, who also painted with eyes on the past and with a fanatical concern for plasticity to hide the essential barrenness of their vision. Sterne saw a world of eternal beauty and formal perfection in the life of the peasants of the little Italian hill town; it is unfortunate that his pictures turned out to be carefully painted studies of sad-eyed Italian models posed rather stiffly in meaningless action. In the

still-lifes of the same period, unconstrained by visions of classical beauty, he painted with greater force and solidity, much more obviously dependent upon Cézanne in the modeling of form. Although still dry and rather harsh in color, he was on the whole more successful. He made efforts during the twenties to repaint his Balinese experiences but they inevitably were not equal to the earlier studies.

In spite of his early adherence to modernism, Samuel Halpert was a conservative artist. On his first visit to France in 1902 he came under Impressionist influence. Later, between 1907 and 1911, when he returned to America, the impact of Cézanne and Post-Impressionism on his art became evident. Cézanne took the ascendancy in pictures like *A Town in Portugal* (1915) and *Trees* (1917). Then Halpert turned to a restrained version of the early Fauve style of Marquet and Matisse, making paintings of New York which were straightforward studies of mass, space, and light seen in broad, simplified color areas; and finally, in a series of interior views, to a more complex and less radical version of Impressionism tempered by Cézanne's structural mode. But although Halpert's color took on the spectral hues of Impressionism and his form the structural stability of Cézanne, he was circumscribed by academic attitudes, and as early as 1919 his style had lost its modern mannerisms.

Halpert saw things simply and unpretentiously. He was not much concerned with theory or experiment. With a muted pleasure in the richness of life, he painted a whole range of visual experience—views of the city, sailboats on the river, landscapes, still-lifes, interiors. In this respect he resembled the later Impressionists like Bonnard. His interiors, vistas from one room into another, are the best examples of his solid grasp of the fundamentals of painting, his simplicity, his directness, and his warmth. The pictures are always neatly constructed, the spatial relations accurate, the compositional arrangement of forms orderly, the whole rendered with a feeling for light, color, and texture. They are remarkably close to Bonnard in subject matter and concept, although lacking the latter's preoccupation with the Impressionist handling of light, for they also reflected Halpert's interest in Cézanne, and more generally, in solid construction of matter.

152

Before his sudden death in 1930 he had become slightly more academic. His compositions looked more contrived, his painting tighter. But on the whole his powers as a painter, as an honest technician with a love for the richness of nature, had not diminished. Halpert, unlike Sterne, was not plagued by memories or superesthetic sensibilities. He managed to assimilate what he learned from the moderns into the more conservative body of his art without disturbing its individuality.

Samuel Halpert, *Notre Dame*, *Paris.* Courtesy of The Metropolitan Museum of Art

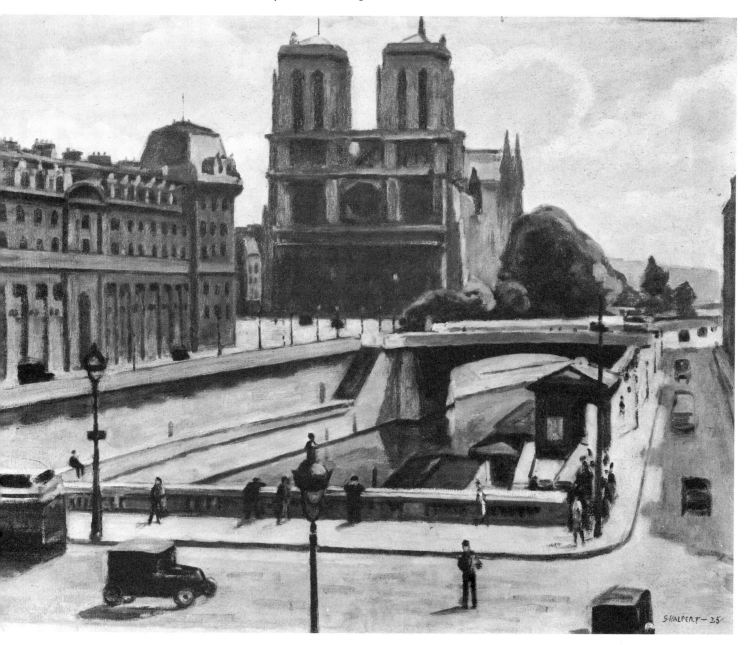

◈ THE STUDIO PICTURE

UNLIKE the modernists who were seeking the "essential realities" of art, or the realists who were seeking to record the realities of contemporary life, there was a "middle-of-the-road" group of painters who were satisfied with simply painting pictures. Most of these men were influenced to some extent by modern ideas, experimented for a time, but progressively dropped extremism as they matured. Most of them developed during the twenties. They were all of a younger generation to whom the issues of free exhibitions and free esthetics were no longer world-shaking problems. They had grown to maturity in a more tolerant artistic atmosphere. They no longer needed to flaunt their independence by wearing the ribbon of modernism. They could take it or leave it, and most of them took it for a while and then eventually left it.

These painters might be called the "studio group." The studio picture in its modern form had its origin

Jules Pascin, *Girl in Green and Rose*
Collection of Mr. Henry Pearlman

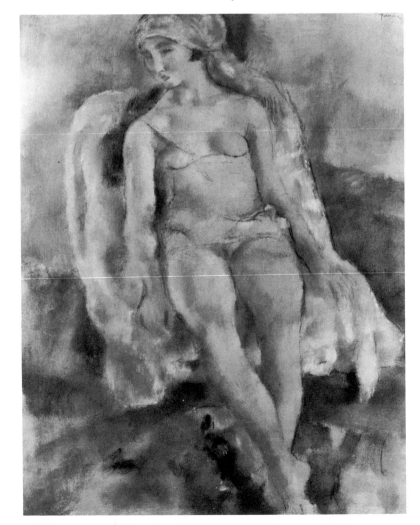

in the nineteenth century as one reflection of the artist's increasing isolation from normal social relationships. The picture of the artist in his studio, at work or play, has had an interesting and varied history. From Vermeer's *Studio* to Courbet's *Studio*, the subject was treated in many different ways, but always with a completeness which presented the studio as a segment of life, although a strange, fascinating, and picturesque segment. It is only in the twentieth century that the studio became the limit of artistic life and that the paraphernalia of the studio became a major subject matter of art. Studio life gave way to studio objects—the model, the guitar, the vase, the apple, the bottle. If the ultimate value of a picture is not in what it says, but in how it is said, then a bowl of fruit is the artistic equal of the crucifixion and apples take the place of madonnas. It was historically logical that, denied a legitimate place in society, the artist should lose interest in the social activity of man. One might even say that the basic concept of "significant form" is nothing but a philosophical rationalization of the disenfranchisement of the artist. For if an artist is socially and culturally limited to depicting a model arranging her hair or to creating an abstract invention, then he can compete with Giotto's *Visitation* or Michelangelo's *Creation* only by establishing a new set of values.

Certain nineteenth-century French painters like Renoir and Degas, who had perhaps the greatest influence upon the studio school, while using the model as a subject, created a type which was not strictly speaking a studio picture. The woman bathing or at her toilette, in the intimacy of her boudoir, became the most common type of figure painting. But it was not until the twentieth century, with Matisse, that it was customary to present the model simply and boldly, without subterfuge, as a model posed arbitrarily, and not as a woman caught in an act of intimate preparation and adornment. Studies from the model, which traditionally were the exercises of art students, now became a recognized subject of painting. Dependence upon the model as a source of inspiration became more and more pronounced while, at the same time, the figure was stripped of all human significance in itself and in its environment. This evolution was the result of a combination of factors—the historical development of artistic introversion, the acceptance of the doctrine that subject matter in art was extraneous, the search for "basic" esthetic factors, and the elevation

of the study and the sketch to the level of complete artistic expression.

The studio picture had a widespread influence in America during the twenties and thirties, fostered by a school of painters who confined themselves almost entirely to the production of nudes and still-lifes in every conceivable form and combination. Characteristic of this group are Bernard Karfiol, Alexander Brook, Emil Ganso, and Yasuo Kuniyoshi. Jules Pascin should be listed among them, for he had a tremendous influence upon the nature of American studio painting. His European origin and the short duration of his sojourn in America, even though he became an American citizen, make it difficult to rank him among our native artists. However, like Duchamp (although not as spectacular in any sense) he had an influence entirely out of proportion to his own artistic stature. This influence was subtle and almost imperceptible, but it grew with time and affected the entire studio group.

As a painter Pascin had a rare and delicate talent, sophisticated yet passionate, ethereal yet sensuous, at once tender, sharp, and bitter. His brilliance as an artist unfortunately was perverted and eventually consumed by personal aberrations; but even in its most pornographic manifestations his art retained its uncompromising honesty. Like Toulouse-Lautrec, Pascin was interested in the demi-monde of prostitution, however not in its social meaning but its uninhibited sensuality. He was, like Toulouse-Lautrec, a penetrating and acidulous draughtsman. However, he could transform a scrawny and undernourished whore into a vision of fragile and flowerlike delicacy, and the biting quality of his line could become gently lyrical, caressing a curve with feathery lightness.

Pascin's artistic lineage was as mixed as his parentage. After having worked for *Simplicissimus* for some time, in 1905 he migrated to Paris where he absorbed not only the heritage of Toulouse-Lautrec but also the lessons of Degas, Renoir, and Cézanne. He learned a great deal from Renoir's incomparable essays in the seductivity of feminine flesh. He lacked, however, that painter's robust and joyous expression of beauty. His attitude toward women was much more akin to the caustic realism of Toulouse-Lautrec and the cold aloofness of the late Degas. From the latter men, too, came his feeling for intimacy, which was transformed in his hands into sensuality. All this he combined with a painting technique derived directly from Cézanne.

Like Cézanne, he modeled with juxtaposed patches of color. Like Cézanne in his water-color manner, Pascin suggested more than he explicitly stated, allowing the accents to speak for the whole. He was less insistent upon space than was Cézanne, avoiding the latter's clear, brilliant color and confining himself to limpid, silvery half-tones. The result is not only less insistent in a three-dimensional sense, but also emotionally less virile. The subtle nuances of color create psychological nuances of something unfulfilled, adolescent, and fragile. But to save the whole from disintegrating into a smoky haze of indefiniteness there is always his spare and penetrating linearity.

Whether through direct influence from Pascin or from natural predilection, the American studio group developed along the lines of a subtle and delicate romanticism. One exception was Karfiol, who, for several years in the late twenties and early thirties, worked in the more lush tradition of Renoir. The development of Ganso was dominated by the art and personality of Pascin, who had befriended him and for a time shared a studio with him. Brook went through a Pascin phase, even such paintings of the late twenties and early thirties as *Sleeping Girl* (1929), *Yellow Fan* (1930), or *Girl with Flower* (1930) still showing a marked affinity for his style.

Bernard Karfiol, *Child Holding Apple*
Collection Unknown

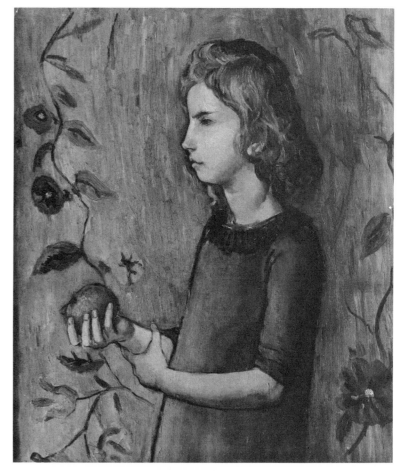

most promising of American painters. Exhibiting at the Armory Show in his youth, he was caught up in the whirl of modernism, evolving for a time in the tradition of Picasso's pink and blue periods. Toward the end of the twenties his style changed radically. Compared with the dark, thin, sensitive features and tortured shapes of such earlier examples as *Two Standing Figures* (1926), his later style shows a turn toward the heavy, full, and phlegmatic types of Renoir. In the *Seated Nude* (1929), one of the finest examples of the later style and one of the most satisfying of all Karfiol's output, the dependence upon Renoir is very marked. It has opulence and warmth, its color is rich with a hot red underglow, the forms are soft and fluent, and the drawing easy and loose. With all its reliance upon Renoir it is not as servile as the work of that other Renoir disciple, Glackens, and also it is less concerned with the Impressionist technique, for Karfiol had assimilated Cézanne as well. The linear accents, the broken edges, and the color brickwork are reminiscent of Cézanne rather than Renoir.

Karfiol's efflorescence was short-lived. By the

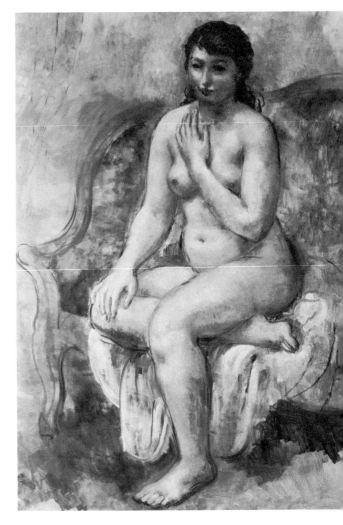

Bernard Karfiol, *Seated Nude*
Collection The Museum of Modern Art, gift of Mrs. John D. Rockefeller, Jr.

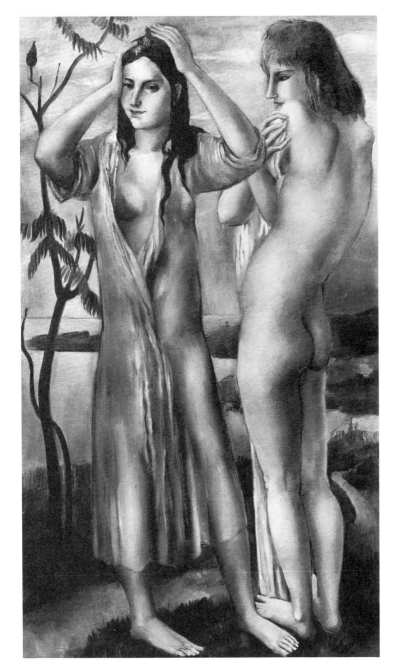

Bernard Karfiol, *Two Standing Figures*
Collection Unknown

Kuniyoshi's development was more independent, and yet his style of the thirties, with its supersensitive study of form, its delicate gray color nuances, and its nervous linearity, is the closest approximation of all to Pascin's attitude, both psychologically and artistically.

Bernard Karfiol in the twenties was one of the

156

middle thirties, the warm, full-bodied nudes became tight and hard. His attempts at larger compositions were apparently beyond the reach of his talents and his inability to relate the figure to its surroundings, already evident in his early work, became increasingly pronounced, so that he had to lean more and more on academic design and his large canvases became more formal and contrived.

The inclusion of Yasuo Kuniyoshi among the studio painters is possible only if we consider him in terms of his mature style of the thirties, since there is a marked differentiation between it and his manner of the twenties. Perhaps his later style was the result of a more general trend in American modernism toward less radical expression. At any rate, his art, after bobbing along like an irrepressible cork in the swift current of the art of the twenties, later came to rest in the more placid waters of the studio school.

Kuniyoshi came from Japan as a young boy. He received all his artistic training in this country, yet the belief that he synthesized the art of the Orient and the Occident—a belief to which Kuniyoshi himself subscribed—is constant in all discussions of his style. Objectively, it is difficult to see any historical relationship between Kuniyoshi and the body of Japanese pictorial tradition. He was certainly closer, in the twenties, to the Expressionism of Marc Chagall and Heinrich Campendonk, and, in the thirties, to the world of Pascin, than to anything in his native Japanese art. It may be that the quaintness of his style set him apart from the American tradition and led to the confused notion that this strangeness was an Oriental ingredient. Perhaps, after all, the quality of his humor and the delicacy of his charm, although not specifically developments out of a Japanese artistic heritage, were outgrowths of his Japanese cultural background, facets of his personality which became submerged as he himself became more westernized.

Kuniyoshi's early stylistic resemblance to Campendonk and Chagall is marked, in compositional pattern, in modified Cubist forms, in the doll-like figures with their large staring eyes and, curiously, in the almost fetishistic predilection for cows. Ku-

Yasuo Kuniyoshi, *Boy Stealing Fruit*. Ferdinand Howald Collection, The Columbus Gallery of Fine Arts

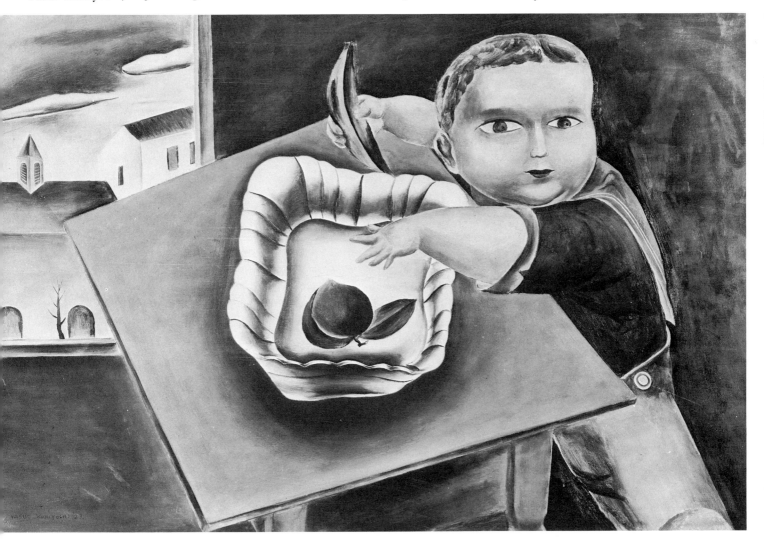

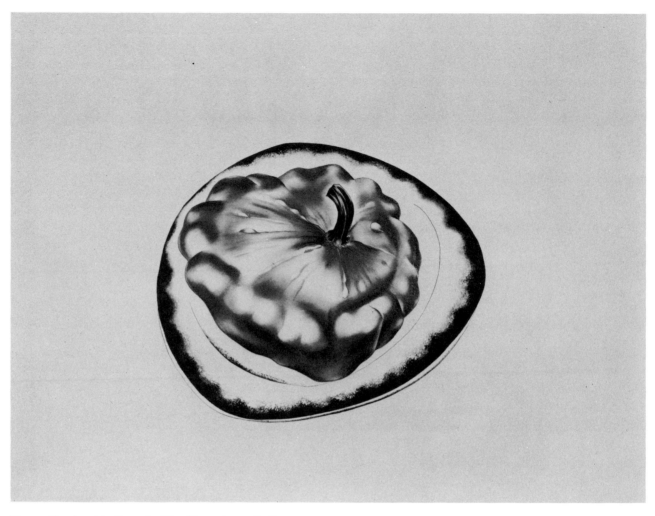

Yasuo Kuniyoshi, *Squash*. The Downtown Gallery

niyoshi was one of the few Americans who was dependent upon the German rather than the French phase of modernism. However, Kuniyoshi never assimilated the emotional turmoil, the legacy of postwar chaos, inherent in German Expressionism. Its philosophical overtones did not penetrate his naivety. He borrowed its external mannerisms for a while but he never became embroiled, as did the Expressionists, in the emotional problems of his protagonists. His little boy steals a peach with mischievous excitement, apparently unaware of the profound moral and ethical problems involved. His art, in spite of its sobriety of color, was gay and slyly witty.

When Kuniyoshi first exhibited two paintings at the Daniel Gallery in 1921, they made an immediate impression, largely because his work struck the critics as strange and was considered funny. Although he himself denied any pronounced intention toward humor, there were undertones of humor in his consciously naive vision which resulted in a kind of wide-eyed wonder at nature and human experience, so that his figures look about them with childlike surprise to discover that it is indeed a quaint and curious world in which we live. Kuniyoshi's humor, unlike Campendonk's, which was essentially fortuitous, was rooted in the imaginative fantasy which colored all he saw. His art chuckles, unburdened by either the poignancy or the torture inherent in the grotesque humor of Chagall.

His precise and patterned style, like Chagall's and Campendonk's, was dependent upon Cubism, but without its formal complications. In fact in some respects he resembled the Cubist-Realists in technique, although not in subject matter, as for example in such meticulously rendered drawings as *Squash* (1924). In his palette he confined himself to a limited gamut dominated by rich earth reds and brown, unlike the German Expressionists, whose color was spectral and high-keyed.

Pascin's influence became apparent toward the end of the twenties in such paintings as *Nude*

158

(1929), with which Kuniyoshi moved into the orbit of the studio painters. His entire artistic orientation changed from imaginative boldness to a sensitive exploration of visual phenomena. His color, though retaining its basic earth range, wandered off in search of the gray nuance, for the masterly handling of which he became famous in the thirties. His beautiful and sensitive drawing with its curious duality of expression, at once vague and moody, precise and descriptive, is an echo of Pascin. In calling an end to his early style, Kuniyoshi renounced his fantastic vision of the real world for a realistic vision of a contrived world, the studio world of girls, couches, and utensils. The fantasy, the wit, and the warmth of the twenties were supplanted by the virtuosity and the sensitivity of the thirties.

When Alexander Brook won the Logan medal and purchase prize at the Art Institute of Chicago in 1929, his style had reached maturity. It established him as one of America's leading studio painters. Brook had a solid technique, a sensuous feeling for mood and material, and a painterly virtuosity. The fact that with time Brook has become more engrossed in the perpetuation of his own mannerisms and that his style has become consequently attenuated, cannot deny the promise he showed in his youth.

In the early twenties he was painting rich and succulent still-lifes, perhaps a little precious in conception, but executed with robustness. In such paintings as *Intruder* or *Bouquet* (*c.* 1926) there was a joyful abandon to physical experience which was later vitiated by his progressive immersion in subtleties of mood and paint. His loss of vigor may be due in some measure to the influence of Pascin, which became apparent in 1928. The remarkable persuasiveness of Pascin's personality and style diverted Brook from hearty directness to a concern with the delicate rendering of psychological and esthetic overtones. In such examples as *Sleeping Girl* (1929) he was obviously copying Pascin, and to this day the shadow of Pascin haunts his feathery drawings. Like Ganso's echoes of Pascin, Brook's were successful only for an extremely short period and only

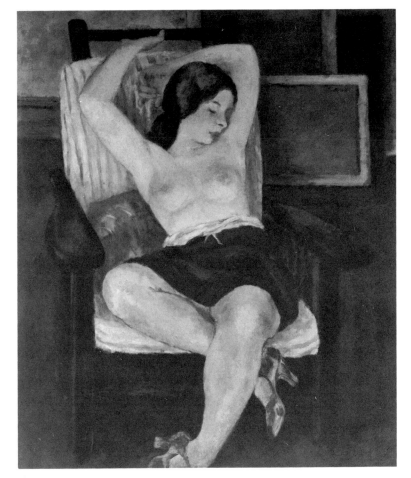

Alexander Brook, *Sleeping Girl*
Collection of Mr. Louis E. Stern

when under direct influence. Lacking Pascin's sophistication, neither of them could equal his psychological probity or his artistic sensitivity. They retained only the external form of his art, his world of déshabille. After leaving Pascin's company Ganso became gross and brittle, and Brook perverted Pascin's lyrical atmosphere into moody sentimentality and prettiness of paint. At times in the late twenties and occasionally in the thirties, Brook's inherent vigor managed to break through the silken veil of sensibility. Then he produced such honest portraits as those of Raphael Soyer (1929), George Biddle (1929), and Reginald Marsh (1929), and such intimate studies as *Interior* (1928), whose human warmth and forthrightness he has never again equalled.

THERE was one whole section of American art which, although motivated by a search for the new, was still unable to accept the apparently anarchic and completely individualistic attitude of the modernists. The modern movement had brought up the question of fundamentals in art and some American artists, bewildered by the imported and incomprehensible ideas, ideas supposedly more fitting for a decadent European civilization than for the lusty optimism of an expanding America, sought an answer in science, searched for fundamental principles, rules, and laws that would be as foolproof as mathematics.

This search gave us such theories as Jay Hambidge's dynamic symmetry, the theory of inhalation of Arthur B. Davies and Gustav Eisen, the esthetic system of Denman W. Ross, the form measurements, the set palettes, and the musical notation of color of Hardesty G. Maratta. These pseudo-scientific theorists—"scientific" because they consciously conceived of themselves as reconciling art and science, "pseudo" because they misapplied the principles and laws of science or misconceived their nature—affected many artists, archeologists, and teachers, and some of their theories are still being taught in schools and universities.

All these men believed in the compatability of science and art. Unfortunately, it was usually a simple-minded mechanical transfer that they made of scientific ideas into the field of art. It was earnestly believed that what was true for science was true for art and that science could be the salvation of art. Denman Ross, who as a collector and teacher in Boston and at Harvard helped form a whole generation of artists, claimed that painting was a "scientific process." In his book *On Drawing and Painting*, which attempted to systematize the fundamentals of design and color, he maintained that his method in art was that "which is followed by scientific men everywhere, and it can be followed just as well by artists if they are willing to become scientific in their methods."[1] Maratta, with all his mumbo-jumbo, thought he was supplying art with a scientific method. Hambidge certainly considered dynamic symmetry completely scientific.

Every one of them believed that once the laws of art were stabilized the production of art would be not only facilitated but raised to a higher level.

The problem was to find and regularize these laws or principles. While European artists, in a more truly scientific spirit, were investigating new esthetic concepts of form and color, Americans were attempting to establish immutable principles. While a Picasso or a Matisse was drawing inspiration from the wealth of historical styles, these men were searching in the past for some eternal principle which would anchor art so they could get aboard. The search took the form either of an eclectic combination of precepts derived from other art periods, discoveries in theories of light and color, fantastic systems for becoming a great artist in a hurry, or a combination of all three, for they were, of course, not mutually exclusive.

Since science had developed through a progressive accumulation of knowledge, they firmly believed that a similar progress was natural in art. If the accumulation of knowledge placed modern civilization above that of all other epochs, then naturally the accumulation of knowledge in art should make modern art superior to its predecessors. Some of them could never understand why this was not so. These men were struck by the vista of a greatness which would surpass the Greeks, for were we not more civilized and more scientific than the Greeks? All we needed was the formula. Willard H. Wright, for instance, believed that he had developed a "scientific esthetic." Wright conceived the entire development of painting as a consistent progression, as a scientific exploration of the properties of form and color, culminating in Synchromism which was based on the optical discoveries of the nineteenth century. He went so far as to maintain that painting had finally mastered its materials and from then onward—after 1914—there would be no more new movements or schools in art, only the creation of esthetic objects. Finally, in the twenties, he ended by renouncing painting as outmoded and heralding the color organ as the future instrument of visual expression.

The idea of the color organ brings us to one of the more interesting notions which ran through most of this theorizing, the attempted equation of color with music. The relation of color to sound has intrigued many minds, as far back as Aristotle. Newton was fascinating by the analogy between the intervals of the major colors of the spectrum and the notes of the diatonic scale, a notion which has recurred constantly in color theory. Also, the mathematical character of music gave it an added

fascination for those interested in a scientific rationalization of art. Hardesty G. Maratta, a painter who took to manufacturing pigment for artists according to a formula of his own, believed that there were child prodigies in music because there was a basic science or system in music which painting still lacked. He contended that the "harmony of sound relations may be reduced to harmony of color relations" and that "both may be determined by mathematical calculation."[2] Consequently he developed a color keyboard and spoke of mixtures in octaves, intervals, etc., working out an elaborate analogy between color and sound. Maratta had a good deal of influence. Such men as Henri, Sloan, and Bellows for several years used an arsenal of forty-eight tones in three shades which he prepared. Henri recommended it to his students and Denman Ross admitted his dependence on Maratta in his own development of set palettes, of which he devised some forty-eight, and the use of which he considered analogous to the harmonic and contrapuntal systems in music. In 1919 Ross wrote, "Considering the Art of Music and the use of musical instruments, it seems that the musician has a great advantage over the painter in having a fixed scale of tones and definite rules for using it. . . ."[3] He thought it possible for the painter to convert his palette into an instrument of precision and make the production of effects of light and color a well-ordered procedure.

While Wright was intrigued with the musical analogy insofar as it led to "pure" art, one of the theoretical goals of modern art, Ross and Maratta were more interested in the mathematical character of music and its scientific connotations, which they felt could be transferred to painting. Ross was of the opinion that "There is no getting on properly and successfully in any art without metrical systems or modes, in which it is possible to think definitely and express oneself in what will be recognized as good form. There is, indeed, no art which can be satisfactorily and successfully practiced without constant reference and obedience to mathematical principles, systems, and laws."[4] Maratta echoed this idea when he said that "The measurements used in the science of Sounds to determine proportion, and harmony may be used also to determine proportion, harmony in the sciences of Form and Color. . . . To produce harmony in a work of art we must use 'numbers' and *metrology, the science of measuring,* as all bodies and emotions are subject to numerical calculations."[5]

This reliance upon numerical calculation as a scientific method was at least in part simply a reaction against what seemed the incomprehensible character of the modern movements in art. While it was obvious that the older academic system was definitely antiquated, the seemingly anarchic attitude of the moderns, with their insistence upon the supremacy of the individual and upon intuitive methods, was unpalatable to our pseudo-scientific theoreticians. The attitude of a man like Stieglitz, for instance, was completely antithetical to science in its relation to art since he feared science's standardizing and democratizing tendencies, and this attitude was apparently common among the advanced guard. Marin wrote that "The object of science is to make easy for the many, the object of art to make hard for the many. Science is vulgar, art is exalted."[6] On the other hand, Hambidge, Ross, and Maratta saw in science a safeguard against hazard, against the vagaries of intuition. In a sense science was a refuge where standards and judgments could be regularized. In almost all cases we find these men attacking modern art as chaotic and degenerate. Ross was especially vehement; "The efforts of these self-sufficient 'artists' are a warning to us. Ignoring the art of the past, its ideals, and its technical standards, they proceed like little children, without knowledge and without training, and they express the states of mind which they happen to be in, no matter what they are. The result is, of course, the expression of ignorance."[7]

In the introduction to *The Elements of Dynamic Symmetry,* Hambidge wrote that he "was impelled to take up the study of symmetry because he could not entirely agree with the modern tendency to regard design as purely instinctive."[8] Maxwell Armfield, writing about dynamic symmetry, reiterated the same idea. "Mr. Hambidge's discovery comes at an opportune moment when the more thoughtful artists are searching for something more stable than mere personal likes and dislikes, upon which to base their practice."[9] Armfield, incidentally, believed that dynamic symmetry would democratize art, which heretofore had been a secret cult with methods and language beyond the range of the average person's criticism. If real laws were established, nonvariable laws like those of mathematics, art could have universal understanding and one would be able to spot the charlatan. He contended, naively, that in music there could be no fakers because the "technique is defined and traditional, and develops

along rational lines, so that musicians cannot be taken in by incompetency."[10]

All these men recognized the period as one of revolt and considered themselves progressive forces within the movement, demanding a scientific and universal rather than an individual and personal basis for it. And yet in a sense this entire tendency, in its search for universal principles, for system and law, reveals essentially a desire for the establishment of a more modern academy. The great error of which they were all guilty was a confusion of science with eternal principles. The idea that they could find immutable laws in the art of the past which would be applicable to both the present and the future is merely an extension of academic thinking. These men honestly believed that if one knew the rules that went into the making of a Greek temple or a Renaissance fresco, one could produce comparable works today, just as, if one knew the laws of engineering, one could build any number of bridges which would stand without falling.

This search for eternal principles often led to weird results. In many cases it was no more than a search for a magical formula, a panacea or patent medicine good for any situation. One of Hambidge's followers, writing almost in the language of the medicine-show quack, claimed that dynamic symmetry was good for artists, photographers, advertising agencies and printers, moving picture directors and camera men; "It can also be used by interior decorators, jewellers, and ceramic workers, as well as in other kindred arts," because his prescriptions are "based on Greek Proportion, which in turn was undoubtedly founded on Nature's own laws."[11]

The search for the alchemist's stone in art led these pseudo-scientists to ancient, and especially to Greek, art, which is not strange if we recognize the element of academic derivation in all these theories. The general pattern was a belief that these laws were originally known to the Egyptians, somehow discovered and developed to their highest stage by the Greeks, lost during the Hellenistic period and only vaguely guessed at in the Renaissance. It is in this phase of theorizing that we find the more fantastic manifestations, much closer to magic than to science.

Denman Ross was motivated by the idea of creating a scientific method for an age that had lost the empirical methods of workshop tradition, but some of the others were obsessed with a search for magical rules. Maratta believed, or at least claimed, that he had rediscovered the secret principles of art known to the Egyptians, which the Greeks had originally learned by masquerading as Egyptian priests. These traditions, jealously guarded, had come down through the church. Some of the Renaissance painters knew of them. Dürer is supposed to have come to Florence to learn them from a dying artist but, it seems, he arrived too late and, receiving only a hint, he spent the rest of his life trying to work them out. As the rediscoverer of these age-old principles, Maratta claimed he had designed a Parthenon, a sphinx, and a pyramid more perfect than any produced heretofore. Unfortunately, since the system was never published, it is now lost again.

Arthur B. Davies became connected with a curious theory called the "lift of inhalation" which was supposedly the basis of excellence in Greek art. This theory was the brain child of Gustav A. Eisen, a zoologist, and is explained extensively in a sumptuous publication called *The Great Chalice of Antioch*, which must be read to be believed. It was based on the idea that the thorax, not the brain, is the center of emotional life and that all Greek figures are depicted as consciously inhaling rather than exhaling. This drawing-in of the stomach was supposed to raise the general emotional tone of art. Of inhalation, Eisen says, "It is found in nature, and is applicable to any art, philosophy and religion, its effect everywhere being emotional and spiritual in the best sense of the word."[12] Davies experimented with the theory and did many chalk drawings on black paper in this connection. Eisen claimed in an obituary on Davies that the latter even retouched many of his earlier paintings to give them this added "lift of inhalation." In addition to inhalation, Eisen embraced, among other things, dynamic symmetry, the "occulted spiral," and something called the "deflected diagonal." He was apparently open-minded toward any "scientific" idea that came his way.

Of all these theories, dynamic symmetry was the most influential. Proposed by Hambidge as early as 1903, it came into prominence only in the early twenties because, according to Hambidge, "about the beginning of the great war, the field of design had become so disrupted by the reactions against Academic tradition that the attention of the art world was directed toward the many new movements of protest against accepted artistic practice."[13] Dynamic symmetry affected both artists and archeologists and many a bitter fight was waged

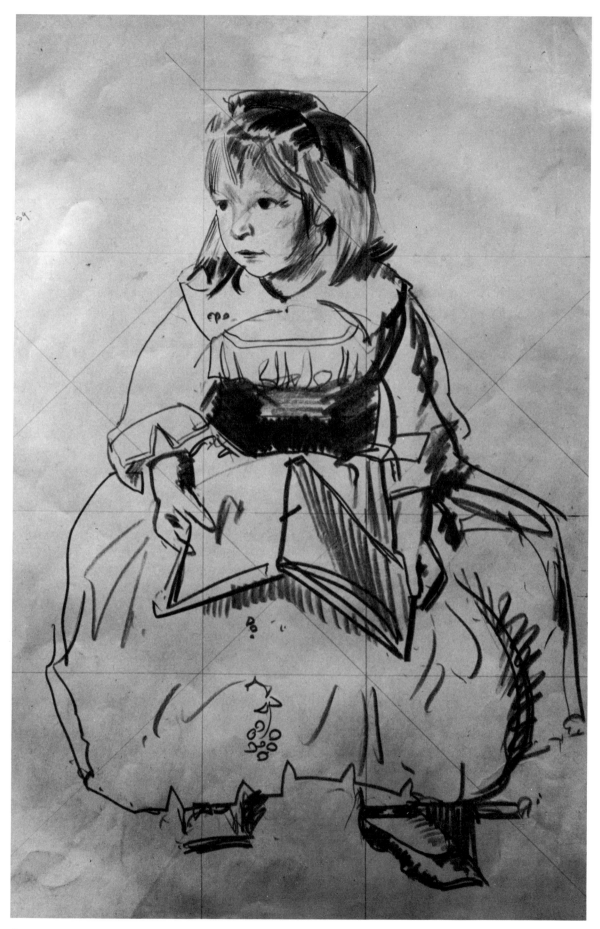

George W. Bellows, *Jean*. Courtesy of Albright Art Gallery, Buffalo, N.Y.

around it. Bellows, Henri, and Kroll were among those who used it in composition. Denman Ross accepted it in his teaching. L. D. Caskey, curator of Greek art at the Boston Museum of Fine Arts, wrote a book demonstrating its application to the measurement of Greek vases. G. M. A. Richter, curator of classical art at the Metropolitan Museum of Art, defended it against the attacks of Rhys Carpenter and Edwin M. Blake in the staid pages of the *American Journal of Archaeology*. Hambidge held a Sachs fellowship and lectured at Harvard in 1918-1919 and taught and published the *Diagonal* at Yale from November 1919 to October 1920. Hambidge presented dynamic symmetry as a mathematical system of composition of ancient origin which is based on the relationship of the diagonal to the sides of a rectangle. And to it was ascribed a sort of occult power because of its supposed conformity with certain phenomena of plant growth. The romance of ancient times, the Greek key to beauty, the mysteries of nature and the logic of mathematics all in one capsule was strong medicine. This is not the place for an adequate description of dynamic symmetry or its critical evaluation. Time at least has

relegated it practically to oblivion. As a theory it appealed because it combined a reputed discovery of an ancient formula and enough mathematical complication to appear scientific.

In all these theories one must keep in mind the coexistence of several elements. First, there was the desire to systematize existing esthetic knowledge. As Arthur Pope, a disciple of Ross, points out, "The art of the past has been largely a matter of rather narrow tradition—a concentrated study of the use of a limited range of materials and terms. The art of the present day must inevitably be based on a broad eclecticism—a rational eclecticism, I should like to call it. For this, in painting, as in architecture, a sound theoretical basis is a necessity."[14] But eclecticism, even when pseudo-scientific, is academicism. Second, there was the tendency to equate art with science, to use the methods and language of science, hoping thereby to create immutable laws. Lastly, there was the search for a mystic principle which would immediately rejuvenate art. All the theories were to some degree a mixture of these three elements—academy, science, and patent medicine.

164

Realism

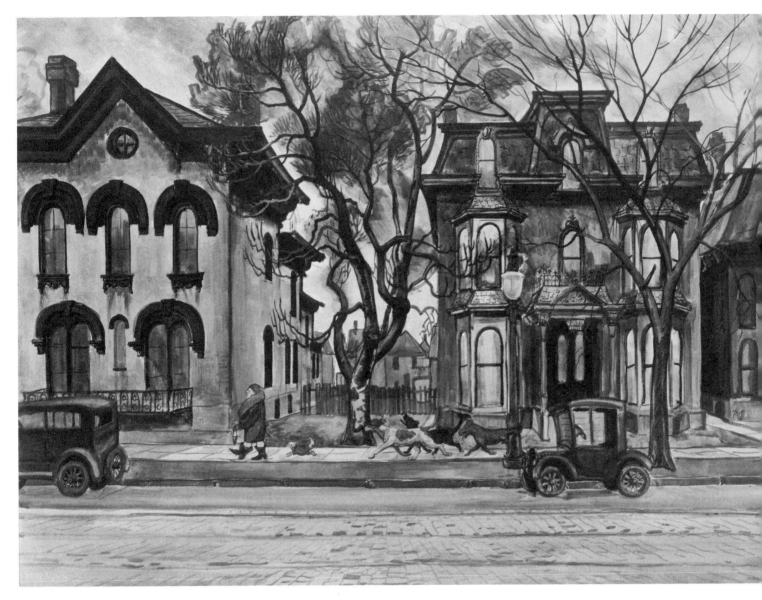

Charles Burchfield, *Promenade*. Collection of Mr. A. Conger Goodyear

THE realist strain which was in the ascendancy early in the century had been submerged, as we have already seen, by the spread of modernism after the Armory Show. In comparison with the esthetic innovations of the new art, the once reviled "revolutionary black gang" was now considered respectable by critics and public, and distinctly old-hat by artists. Most of the younger men and some of the older ones were now experimenting with new forms.

After the war, realism continued, with many changes in character, but as a minor and neglected phase of American art. The ranks of the realist had long ago been thinned. Shinn had virtually retired and Glackens had been converted. From the beginning of the century Henri had confined himself to the portrait and was only an "honorary" realist. That left Sloan and Luks of the original Philadelphia group to carry on the tradition of realism in the twenties. But Luks too had already deserted the Ash Can version of realism for slashing, bravura portraiture, and Sloan returned only occasionally to picturing city life. Sloan was now more interested in "art," in problems of form and color. Even his city pictures reflected a change in attitude. The social significance of his earlier paintings seemed to evaporate, leaving only the spectacle of urban activity. He was no longer concerned with Sixth Avenue, but sought instead the glamor and excitement of the city's show places.

Jerome Myers continued to paint the East Side as though it were a street in Samarkand, and Eugene Higgins found in the Irish peasant a romantic abstraction of man in relation to the elemental forces of nature, making pictures devoid of any immediate reality.

Of the younger men, George Bellows had also moved away from realism to the demonstration of technical brillance. The exploitation of facility displaced his earlier interest in life. He became more engrossed in the restricted milieu of his own family, as did Glackens also, and although he occasionally made as penetrating a portrait as *The Padre* (1917), there is no denying that the studio attitude had displaced the realism of the earlier years. His vitality remained undiminished; but instead of being expressed in vigorous composition it was expressed

in size and technique. In this period he turned from the city scene to the country or vacation picture; perhaps the worst examples of his entire artistic output are those luridly colored, lush landscapes of the early twenties, disfigured, like those of Sloan, by garish purples and greens. His more grandiose projects apparently were hamstrung by his limited intellectual capacity. *The Crucifixion* (1923) was an obvious attempt to rival the past. Here was America's great master, conscious of his own power, accepting the challenge of the ages, only to fail both as painter and as thinker. The composition is contrived and obviously immobilized

George W. Bellows, *Padre*
Courtesy of The Metropolitan Museum of Art

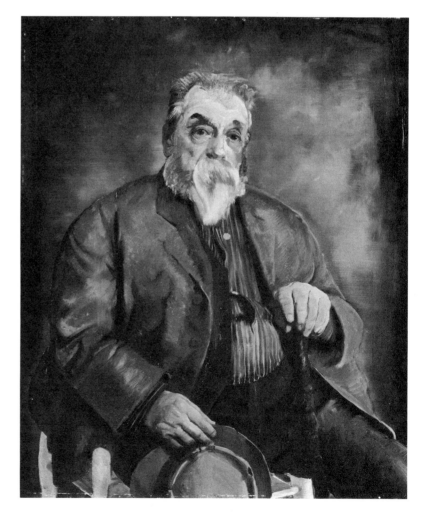

167

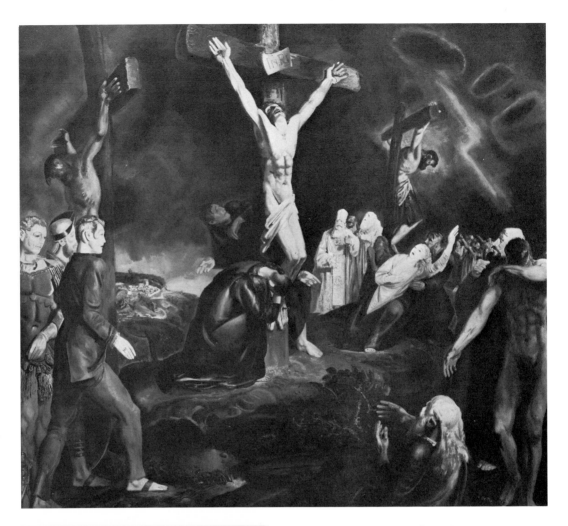

George W. Bellows, *Crucifixion*
Collection of Mrs. George Bellows

by dynamic symmetry, the action is meaningless, and the whole is devoid of any religious or human feeling. It is merely a large, painted machine, lacking the natural motivations and illustrative richness and accuracy of the *Cliff Dwellers* (1913) or the sheer animal vigor of *Sharkey's* (1909).

Guy Pène du Bois who, prior to the war, divided his time and talents between painting and criticism, had played an important role as critic and editor in the defense of realism and, for a short time, of modernism. As a student of Henri he had belonged to the younger generation of realists, together with Bellows, Kent, and Coleman. Then, after returning from a year in Paris in 1906, he became successively a newspaper reporter on the *New York American*, art critic for that paper, assistant to Royal Cortissoz on the *Tribune*, art critic for the *New York Evening Post*, and finally editor of *Arts and Decoration*. In the twenties he began to paint seriously again.

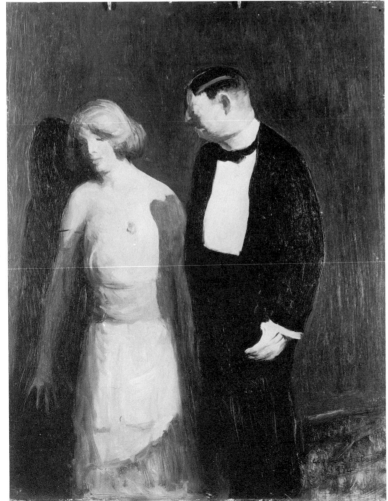

Guy Pène du Bois, *The Doll and The Monster*
Courtesy of The Metropolitan Museum of Art

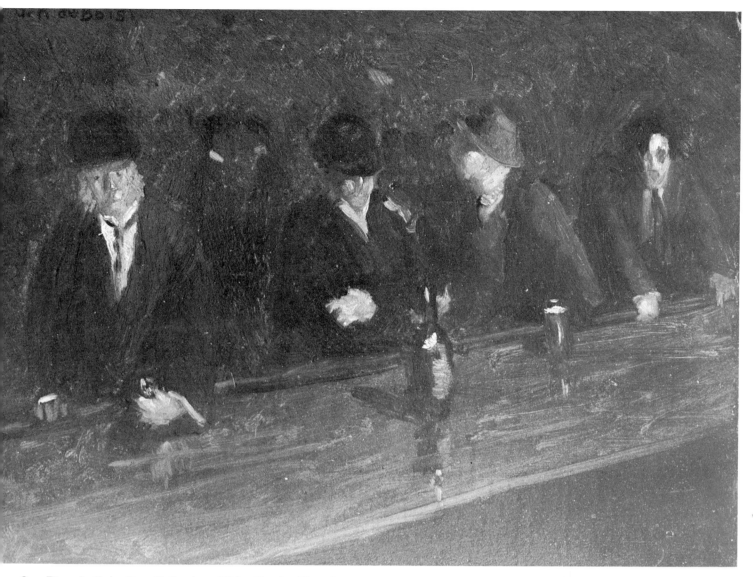

Guy Pène du Bois, *Bar*. Collection of Mr. Charles Hagedorn

Although never an artist of any depth or power, du Bois achieved some acclaim because his obviously satirical manner was in the "debunking" mode. His style, however, was predicated less on American realism than on the French nineteenth-century tradition of Daumier, Gavarni, Guys and Forain, on which he leaned heavily. Because of his predilection for that tradition, his French descent, and the many years he spent in France, his art took on a decidedly French flavor. Of all the realists he is the least attached to the American scene. It is often impossible to tell whether he is painting the Rue de la Paix or Fifth Avenue, the Riviera or Coney Island.

His earlier work, like *Bar* (1908), had the distinctive Ash Can mood and setting. In his later work the focus shifted to a satirization of the well-fed bourgeois in his moments of relaxation, at the horse

races, in restaurants, or theatres. He characterized the men as fat, repellent lechers and the women as sawdust-stuffed manikins. The puppet-like character of his figures offers an element of humor, but as a whole his art lacks the penetration into personality and the characterization of type which makes for important satire. By temperament and training as well as accident of birthdate du Bois was excluded from that moment in American realism when the Ash Can School allied itself in sympathy with the poor. Having reached his artistic maturity in the twenties, he became instead a debunker, scoffing at the sleek carnality of the wealthy. When he returned to America, after living in France from 1924 to 1930, he did not react to the social upheavals attendant upon the economic crash, nor did the situation effect an intensification of his satirical attitude. Instead, curiously enough, his satire lost

169

most of its critical sting and he became more and more a studio artist. His portraits, nudes, landscapes, and occasional subject pictures of the thirties, divested of the earlier satirical façade, reveal du Bois in all his uninspired mediocrity.

Among the realists, the most interesting and most profound case of change due to the influence of modernism occurred in the art of Glenn O. Coleman. But that change came late in the twenties and only a few short years before his untimely death in 1932. In Indianapolis, Coleman had served his first artistic apprenticeship on a newspaper, and when he came to New York in 1905 he gravitated toward the realist group. There he studied under Henri and Shinn. But, unlike Bellows, his fellow westerner, who had found New York an open oyster, he had to struggle for existence, working at all kinds of odd jobs from usher at Carnegie Hall to demonstrator in a five-and-ten-cent store. The pressing needs of physical survival often interfered with his artistic efforts. Coleman knew poverty by experiencing it. His interest in socialism and his drawings for the *Masses* were the result of self-identification with the poor rather than of theoretical conviction. Unlike Bellows, also, he was shy, sensitive, and quite lacking in vigor.

Coleman's art was permeated by a deep personal and lyrical romanticism. He had a poetic feeling for the picturesque aspects of New York, and each one of his pictures was a fresh discovery of some new byway of the city's life. He haunted Greenwich Village, the lower East Side, the riverfront, and Chinatown because he found there not only the imprint of humanity, but also the atmosphere of exoticism. The rest of the city was too new and too

Glenn O. Coleman, *Downtown Street*. Collection of: Whitney Museum of American Art, New York

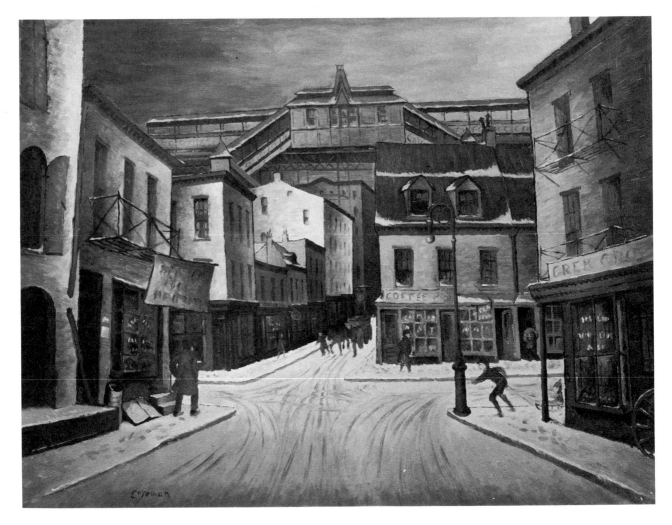

170

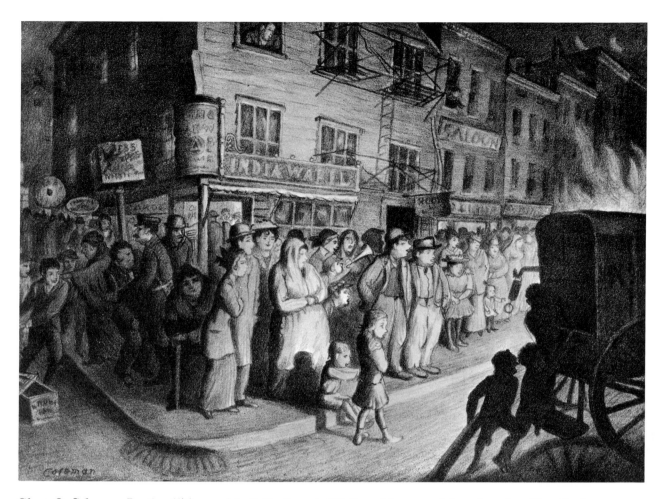

Glenn O. Coleman, *Bonfire* (lithograph). Collection of: Whitney Museum of American Art, New York

impersonal for his tastes. However, Coleman was never as directly concerned with people as Sloan was. Primarily he was intrigued with atmosphere, with the manner and form of life, rather than with individual experience.

His earlier paintings and drawings of about 1910 were dominated by a romantic and melodramatic content. His Chinatown scenes of this period were full of Oriental mystery. Also, they were richer and more precise in incident and local color than his later work. A group of lithographs of 1927 and 1928, based as they were on drawings of this earlier period, retained a good deal of sentimentality, but they reveal their later date in the comparative loss of the dark aura of mystery. During the twenties both his black-and-white work and his painting fell back even more strongly than before on a simplified, naive quality, as if he had consciously eschewed all artistic devices and dispensed with technical dexterity in order to present a more direct and sincere record of life. A good measure of Coleman's warmth and charm depends upon this childlike simplicity.

But as early as 1925 and 1926, and especially in his painting, change began to appear. The evocation of the past in such lithographs as *Coentie's Slip* and *Bonfire* (1927), although actually based on old drawings, ceased to be effective, and such expressions began to lose their interest. They were echoes of an art which looked hopelessly dated beside the esthetic experiments of the twenties. At that time Coleman was the purest survival of an art which had flourished two decades before, when he had first come to New York. But it was only as a survival that he was accepted. The quaint charm of another era appealed in its naivety to the sophisticated, prohibition-ridden twenties in the same way, and with about the same significance, as did the Hoboken revivals of Christopher Morley.

But Coleman's painting, even while it was creating these nostalgic visions of a dead past, was well on its way to a new style. Under the influence of Cubism, in the last years of his life, Coleman became almost completely concerned with the pattern of New York architecture, gradually eliminating the human element from his art. Coleman never went to extremes in his manipulation of modern

171

forms, but he did achieve a simple and extremely personal synthesis. In such a painting as *Minetta Lane* (1929) he retained the flavor of the picturesquely crooked streets of the Village, while the human figures were stripped of significance and became subservient to the cubical massing of tenements. Soon the great skyscrapers began to penetrate his vision, and they loomed larger and larger until, as in *Foothills and Peaks* (1929) or *The Ferry* (c. 1930), they almost completely blotted out the human beings who lived in them. *Bus View* (c. 1930) in a sense is Coleman's statement of his acceptance of the change which time had wrought in the city and himself. The "El," the old tenements, the crooked alley with its old-fashioned lantern light and the lonely figure on the street, have given way to the towering masses of inhuman masonry, in the same way that the warmth and sympathy of the Ash Can School had succumbed to the estheticism of modern art.

With the decline of the reform movement, the motivation for the Ash Can School disappeared. When the social struggles which had given significance to realism waned, Ash Can art was left rootless. It had lacked both trenchancy in criticism and the ability to initiate enthusiasm, and was eventually revealed as a sentimental reflection of social unrest. During the twenties, in the hands of Sloan and Coleman, it became less than that, a nostalgic memory of a past era. All implications of social criticism had vanished.

Glenn O. Coleman, *Bus View*
Collection Unknown, formerly Estate of Glenn O. Coleman

Realism was not dead; submerged though it was by the stronger and more sensational current of modernism, it still continued, its traditions intact, its horizons even widening. Realism in the twenties had two directions—the picturization of the appearance of American life, or what was later called the "American Scene," which, in spite of its surface objectivity often implied critical attitudes; and the more obviously critical art of social protest. The latter was kept alive in the pages of such radical publications as the *Liberator*, a direct descendant of the *Masses*; *Good Morning*, Art Young's attempt to rival such European journals as *Gil Blas, Assiette au Beurre, Jugend*, and *Simplicissimus*; and finally the *New Masses*, the new rallying place for a re-emerging art of social protest. While the spirit of political and social criticism was kept alive in the cartoons and drawings of these magazines, the continuation of the realist tradition in the more sanctified realm of the "fine" arts was spearheaded during this period by two artists—Edward Hopper and Charles Burchfield.

Edward Hopper had direct roots in the Ash Can tradition. But, although he had exhibited with the leading Henri pupils in 1908, when he sold his first picture, he was almost completely ignored for fifteen years (except for a painting sold at the Armory Show) while he worked as an illustrator. In 1923 he managed to sell another picture at the watercolor exhibition at the Brooklyn Museum. From then on he was recognized as one of America's leading painters. At about the same time, Charles Burchfield was heralded in England as an original and authentic American artist, which in turn led to his sudden discovery in this country.

It should be remembered that beginning with Henri, the spirit of nationalism was a fundamental of the realists' attitude. They accepted as axiomatic that an American art should deal realistically with life and, conversely, that a realistic art should concern itself with America. However, this inherent nationalism was tempered, among the early realists, by their theoretical adherence to an ideal of humanitarian internationalism and an insistence that American art could arise only through the free expression of the individual spirit. It was the latter doctrine

which led them to fight for the principles underlying the Armory Show and the Independents'. Their nationalism caused them a little later to fight the threat of foreign invasion. Hopper retained some of this theoretical idealism, but since he was active in a period of growing nationalism, he was much more insistent upon Americanism than was Henri, who was active in a period of internationalism. In the American artist, Henri always sought the *artist*, whereas the realists of the twenties always sought in him the *American*. Burchfield wrote of Hopper, "Edward Hopper is an American. . . . It is my conviction . . . that the bridge to international appreciation is the national bias. . . ."[1] And Hopper wrote an article on Burchfield called "Charles Burchfield: American." Thus while the early realists fought for the recognition of American art as a whole, the later realists fought for the recognition of the American subject. Though this latter attitude was decidedly more nationalist than the former it was not yet, as it became in the thirties, with Thomas Benton, Grant Wood and John Curry, outspokenly chauvinistic.

While Dreiser in literature like the early realists in painting, sought the fullness of life in the large cities, Sinclair Lewis and the later realists sought a peculiarly American form of life in the small towns. As part of the postwar isolationist revulsion against Wilsonian internationalism, these artists sought a native tradition, a center of life typical of America and innocent of sophistication. Among our writers this search for a stable heritage in the hinterland of small towns and farms was often converted into a critical attack upon the poverty and narrowness of such existence. It was at once a desire to find an anchor in a world of shattered illusions and at the same time a criticism of the anchor itself because it had chains. A similar attitude is evident in the art of Hopper and Burchfield. Both have gone back to the provincial aspects of American life and have pictured the most depressing and ugliest features of its physical appearance. They have found the architectural remains of another age, a symbol of the constrictions of an unlovely past, to be the echo of the barren present. Neither Burchfield nor Hopper are, however, unrelievedly critical, and the same may be said for such writers as Sinclair Lewis and Sherwood Anderson. Behind it all, more so in Burchfield than in Hopper, there is a deep attachment for the past and for the provincial, an attachment which is based not simply on the

173

sentimental regard for that which is their own, but on a romantic longing for an agrarian past. It may all be musty in decay and ugly; but it is native and symbolic of a more perfect era, and that for the "American Scenists" of the twenties was the important consideration. The Ash Can search for life had thus been transformed into a search for those specifically native characteristics which were to be found in the small town rather than the large city.

In any comparison between Hopper and Burchfield it should be remembered that Hopper had developed directly out of the Ash Can style. His earliest works were done in the gray tonalities and bold brushwork characteristic of that school. His contact with Impressionism, his eventual development of an individual style, and his later orientation toward the provincial scene did not wipe out those earlier memories. Hopper has never entirely forsaken the city as subject matter. Unlike Burchfield, who is interested only in the small town, Hopper's

horizon is wide enough to encompass both. Especially in such etchings as *East Side Interior* (1922) and *Evening Wind* (1921) and such paintings as *Two on the Aisle* (1927) he is still the outstanding inheritor of the Ash Can tradition, retaining in these some of the warmth that most of his other work lacks. On the whole, Hopper's turn toward the provincial affected his outlook upon the city. He sees it now as a stranger might, as a bleak and forbidding place where one wanders lost and alone. The city for Hopper is not a place where children play in the streets or women gossip, but a place where one rents a room for a night or eats a lonely meal in a brightly lit cafeteria.

This bleakness in Hopper's outlook became evident in the twenties. It arose out of his conception of provincial America, for the uncompromising harshness which he found in small-town life corresponded to his own ascetic concept of realism. This he expressed clearly in his article on Burchfield, in

Edward Hopper, *Two on the Aisle*. The Toledo Museum of Art

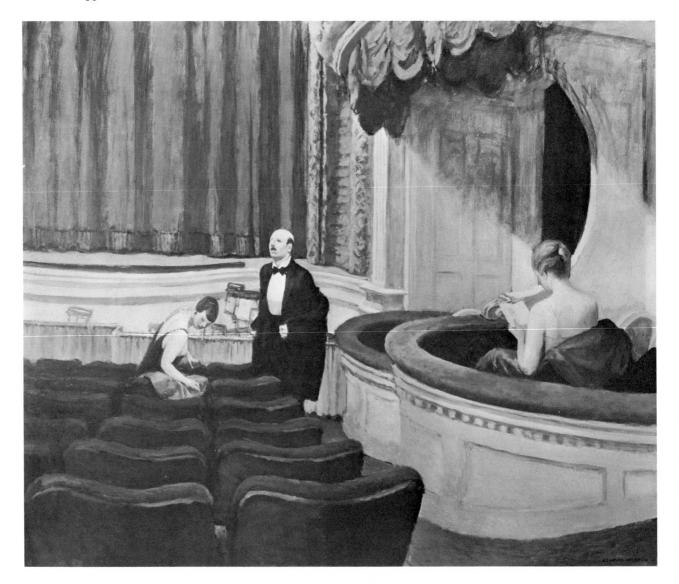

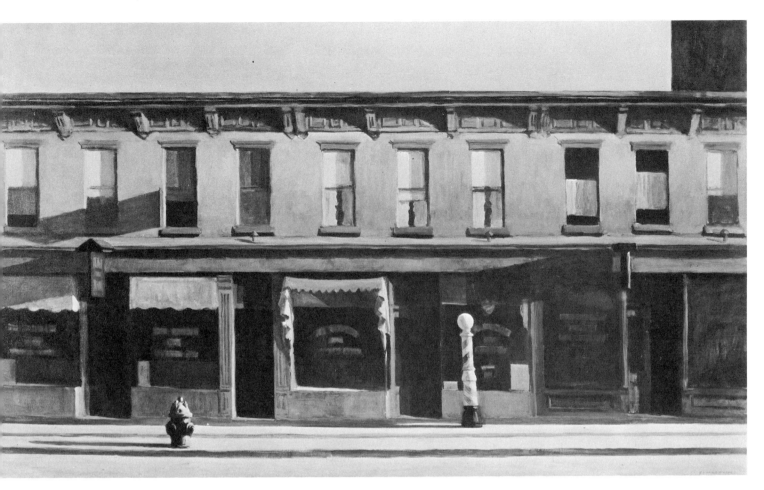

Edward Hopper, *Early Sunday Morning*. Collection of: Whitney Museum of American Art, New York

which he inadvertently describes his own art so well. He wrote, "Good painting (so-called), that degenerate legacy to us from the late Renaissance, has no place in this writing down of life; the concentration is too intense to allow the hand to flourish playfully about."[2] The truth is that Burchfield allows not only his hand but his mind "to flourish playfully about," but not so Hopper. His style is completely and unwaveringly realistic. His use of light, which is the trademark of his style, grows out of this same intensity of purpose; it is not a mannerism but an integral part of his peculiar brand of realism. Hopper uses a cold, hard illumination to make reality more concentrated, more intense. Although he originally developed his treatment of light out of Impressionism, he has no interest now in the varying phenomena of light. He eschews the diffusion of light or the beauty of color in favor of a sharp, clearly focused heightening of reality, as Caravaggio did in another age and with other means.

The America which Hopper paints is a bleak land. He finds no warmth in its streets, its houses, or its people, and the light with which he is so prodigal illuminates but never warms. He paints the closed look of a many-windowed tenement façade which Sloan would have brought alive with human incident. He paints the ugly scars which industry has made upon the landscape, the forbidding buildings of Blackwell's Island, or a monotonous row of closed stores on a Sunday morning. This is not the pretty side of American life, and it is because of this predilection for bleakness that a critical attitude is imputed to Hopper. Burchfield makes the claim that Hopper is not a satirist but an objective realist, a claim with which Hopper is in hearty agreement. Burchfield wrote of Hopper, "Some have read an ironic bias in some of his paintings; but I believe this is caused by the coincidence of his coming to the fore at a time when, in our literature, the American small towns and cities were being lampooned so viciously; so that almost any straightforward and honest presentation of the American scene was thought of necessity to be satirical."[3] Hopper's own statement, "My aim in painting has always been the most exact transcription possible of my most intimate impressions of nature,"[4] is a confirmation of his belief in his own objectivity. These opinions, however, were written about 1930 and so are not

175

necessarily an accurate analysis of the ideas which motivated Hopper as well as Burchfield in the twenties. Although Hopper pretends to objectivity, the very asceticism of his manner assumes a critical significance. His selection of material, which reflects his attitude toward the American scene, is in itself basically critical. Hopper, during the twenties and most of the thirties, found no beauty in America. He did find, sometimes in the twenties and more often in the thirties, a certain power and grandeur in the very sharp, biting glare of simple forms seen in brilliant, clear light.

It has been told of Hopper that once on a visit to New Mexico he wandered for days disconsolate because amidst all the splendor of the southwestern landscape he could find nothing to paint. He finally returned one day happy with a water color of an abandoned locomotive. Obviously, New Mexico did not conform to Hopper's idea of America. There was probably too much sheer beauty in it, too much natural composition. The locomotive must have made him feel at home, like an American tourist in the depths of Europe confronted by a sign advertising Coca-Cola.

Hopper's bland dictum that "anything will make a good composition"[5] is another reflection of his pretensions toward an unrelenting realism. He conceives of realism as unpremeditated and anti-formal. His vision is essentially snapshot; but whereas the same is true of the earlier realists—Sloan, for instance, insisted on the fleeting nature of incident—Hopper freezes his momentarily seen figures into the same stern immobility which rules all of his world. In a Hopper painting one feels the combination of the recording of the fleeting moment coupled with the insistence upon the permanent quality of matter, uncompromisingly stated as seen in the glare of bright light.

Charles Burchfield has none of Hopper's abhorrence of the personal and no pretensions to objectivity. Burchfield is a romantic and has been recognized as such. Yet he has always been counted among the realists. The explanation is simple enough. He is both. His art is a combination of the two opposing tendencies, on the one hand, a romanticism relying heavily on the "Gothic" and, on the other, a realism based upon a critical attitude toward modern industrialism.

Burchfield's romantic imagination found its strongest expression in his earliest artistic efforts, the water colors of 1916-1918. It took the form of a transcription of childhood emotions, a peculiar type of "Gothic" romanticism which is characteristic of Burchfield's artistic personality, though not at all unique, being common to a number of contemporary literary figures developed in the midwest. His youthful fantasies are a plastic counterpart of the many autobiographical stories and novels of Sherwood Anderson, Floyd Dell, and a host of other writers, a literature which, in spite of its realism, contains a romantic glorification of the free spirit of childhood, with all its latent potentialities, as it grows up in the midst of the stifling atmosphere of the small town. To these writers the child assumed the stature of a symbol of the individual's struggles against the stultification of provincial existence. Burchfield's water colors, however, have no such implications, being merely direct translations of daydreams and romantic fantasies. His endeavor to express the emotions of mystery and terror in almost abstract symbols is analogous to Edvard Munch's excursions into the realm of plastic transcription of emotional states. But Burchfield's sources are much simpler. His art comes out of a deep-seated and naive anthropomorphic folklore, which sees the world of nature peopled with lurking spirits and mysterious forces. Thus in *The Night Wind* (1918), as he himself explained, the roar of the wind fills the child's mind "full of visions of strange phantoms and monsters flying over the land."[6] In this same tradition, if slightly more explicit and literal, are Art Young's drawings in *Trees of Night*, some of which are strikingly similar to the early Burchfield water colors. The overtones of "Gothicism," which Sherwood Anderson attempted to rationalize through psychological and sexual motivation, and which Burchfield and Art Young treated simply as pictorial anthropomorphic fantasy, are related to the older romantic "Gothic" tradition of which Edgar Allan Poe and Albert P. Ryder are exponents.

The other aspect of Burchfield's art, his realism, must be seen in relation to his home town of Salem, Ohio, and the period in which he reached maturity, for it was there and then that he formed his concept of the American scene. Because Burchfield experienced the postwar industrial depression in Salem, an industrial and mining town of southeastern Ohio, with all the dreary meanness such conditions produce, his picture of America was essentially critical. He was, during the early twenties at least, in spite of his underlying romanticism, one of the most

uncompromising realists we have ever produced. Henry McBride even dubbed these first realistic water colors of about 1920 "Songs of Hate." Burchfield himself claimed in retrospect, "I was not indicting Salem, Ohio, but was merely giving way to a mental mood, and sought out the scenes that would express it—where I could not find, I created, which is perfectly legitimate. Much, however, I hated justly and would like to go on hating to my last breath—modern industrialism, the deplorable conditions in certain industrial fields such as steel-works and mining sections, American smugness and intolerance, and conceited provincialism—to mention only a few of our major evils."[7] In spite of the disavowal of any fundamental cause for this hatred except that of personal mood, Burchfield's art was an indictment of the effects of modern industrialism, of its resulting ugliness and poverty. The ramshackle clapboard houses of the poor, the fantastic Gothic mansions of the rich, the rows of false-fronted stores, the rutted, rain-soaked roads, the mines, the mills, and the railroads became his subject matter and the embodiment of his resentment. His palette borrowed drabness from the gray skies, the smoke, and the soot-covered landscape.

The emergence of Sherwood Anderson as a liter-

Art Young, *Trees*

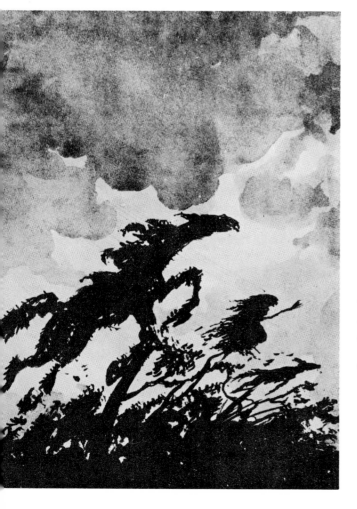

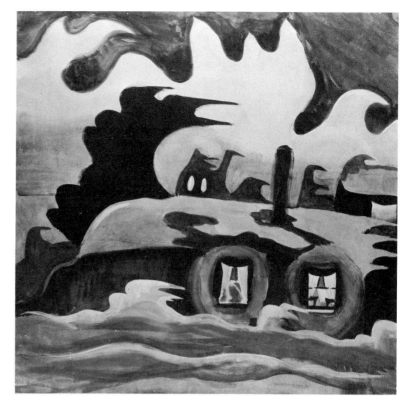

Charles Burchfield, *Night Wind*
Collection of Mr. A. Conger Goodyear

ary figure had a marked effect on Burchfield; according to his own testimony *Winesburg, Ohio* paved the way for his own acceptance of the mid-west as subject matter. Burchfield was very much like Sherwood Anderson in that his revolt against modern industrialism was not based on a knowledge of economic relations or causes, nor did it result in overt action for social or political change. The bogey of industrialism induced a common pessimism in a whole section of the middle class and dominated a great part of its cultural expression. This opinion was critical of the distortions which industrialism imposed on American life and culture. It was appalled by the prevailing cynical disregard of human values, the ruthless grasping for material gain regardless of consequences and the unscrupulous plundering of natural resources. Burchfield in Salem experienced the effects of such an unprincipled and untrammeled industrial expansion at its worst, for the small towns had not even the cloak of culture which the concentration of wealth could provide in large cities. He was the first artist to depict this deformation—the poverty, the drabness, the spiritual narrowness, the lack of refinement, the complete absence of beauty, the pervading sense of defeat and decay.

It is not strange, then, that ruins, which during the thirties became a symbol of industrial disloca-

Charles Burchfield, *Watering Time*. Santa Barbara Museum

tion and economic depression as well as of war, were for Burchfield in the twenties the characteristic feature of the small town without hope for the future and with only a haunting past. Ruin became the flavor of life and decay hung over it like a pall. Burchfield charged industrialism, on the one hand, with having created these ruins of the past without, on the other, having produced anything but a scabrous shell of material existence which from its very inception seemed much like a ruin. The dry rot which was undermining town life spread through the countryside. Burchfield depicted in *Watering Time* (*c*. 1925) the disintegration of an agricultural era which had been built on the richness of the soil. The great barns which were once monuments to labor, fruitfulness, and stability are crumbling into dilapidation. In such pictures he was echoing

the depression which struck agriculture after the war although throughout the twenties business was enjoying its great boom. The growth of monopoly in industry saw a comparable growth of larger units in agriculture, driving the small farmer into bankruptcy. Farms were deserted, machinery rusted, houses fell into decay, and the land lay idle, while those farmers who did survive were reduced to a submarginal existence. So in Burchfield's pictures the weeds grow higher and the wilderness begins to recover what it once lost to man's ingenuity and energy.

It cannot be denied that a good deal of this feeling for the ruin arises out of Burchfield's love of the picturesque and the romantic. He himself claims that as his sole interest. He also claims that after 1920 he was no longer holding small-town life up

Charles Burchfield, *House of Mystery*
Courtesy of The Art Institute of Chicago

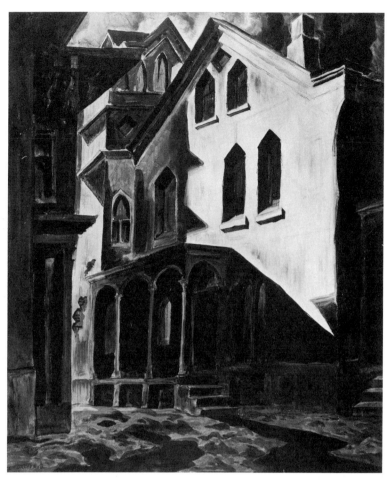

to scorn and ridicule and that, in representing the architecture of the past, he was romanticizing the tag end of pioneer days. "If I presented them in all their garish and crude primitiveness and unlovely decay, it was merely through a desire to be honest about them."[8] In some paintings, as in *House of Mystery* (1924), there was a return to his earlier romantic interest in the evocation of fear. But in most cases this romanticism was, as in *Winter Solstice* (1921), used to make more palpable the dreariness of a clapboard existence. As a realist, he made the life he knew his subject matter, as a romantic, he managed always to see a hidden spirit which animated that life. The black opaque windows of *Eating Place, East Salem, Ohio* (*c.* 1926) become the sightless eyes of a soul in torment. In *February Thaw* (1920), a row of stores and houses takes on the appearance of a gauntlet of fantastic monsters gaping and leering at the dismal world. But Burchfield's picture of the midwest is an honest picture for all its romanticism, and far from a pretty one.

As Burchfield matured, his romanticism became less obvious and more subservient to his realism.

Charles Burchfield, *February Thaw*. In the Brooklyn Museum Collection

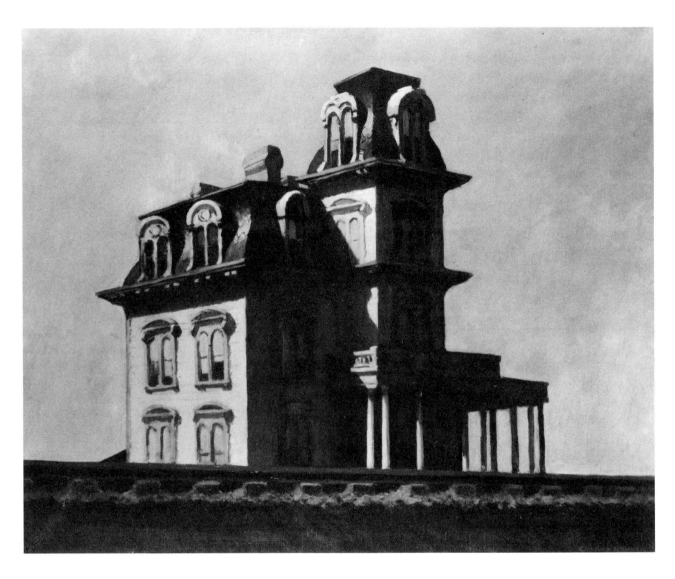

Edward Hopper, *House by the Railroad*. Collection The Museum of Modern Art

But the romantic ingredient gives his paintings an animation which Hopper's entirely lack. Burchfield's houses are personalities, his automobiles animals; there is a spiritual communication between animate and inanimate objects reminiscent of his earlier anthropomorphism. For instance, although Hopper and Burchfield both discovered false fronts and Victorian mansions as typically American subjects, their individual utilization of that material is very different. Hopper is interested in them as phenomena of American life. A row of false fronts or a Gothic house on a hill, because they are common to all small towns, become symbols of America. Burchfield never sees them with the same

objectivity. To him they are places frequented by people, they are houses people live in, and in this contact with the human they have assumed something of the living.

In Burchfield's *Promenade* (1928) every object has a specific and personal character, yet each has affected the others, each personality even in its individuality is dependent upon the others. The tree in the center grew that way because it had such fantastic neighbors, the houses would not be as friendly without the tree, the little "flivver" is real only because it stands in front of the red house, the promenade itself is natural on such a street. This richness of relationship and humor is lacking in

Hopper, whose Victorian buildings, like *Haskell House* (1924) or *House by the Railroad* (1925), are cold, aloof, isolated, interesting only as architectural mementoes. Burchfield with all his romanticism is a realist, and with all his critical attitude, warmly human.

During this period neither Hopper nor Burchfield was concerned with beauty in itself, Hopper through principle and Burchfield through instinct. Burchfield, more emotional, at times is impelled to create a mood of lyrical beauty; but when thus moved he will leave the realm of reality for that of sentimental romanticism, creating such symbolic landscapes as *October* (1924), which are failures simply because Burchfield, as a realist, cannot handle beauty in the abstract. That is why in both Burchfield and Hopper there are no isolated passages of beauty such as abound in the work of artists like Marin or Weber. In all of Burchfield's water colors there is no single brushstroke which can compare with the translucent brilliance of a Marin wash, in all of Hopper's work there is no patch of color to match the jewel-like richness of a Weber paint passage. This is no indictment of Burchfield and Hopper as artists; for to them technique is only the expressive means. The "degenerate legacy" of beautiful painting to all such artists is a frivolous intrusion upon a profound thought. The quality of their art depends upon the subordination of technique to the expression of the idea. When they become interested in beauty for its own end, they usually produce frightful "buckeyes." Although during the thirties many artists, motivated by similar social forces, were intrigued by the coincidence of the beautiful paint passage and the inherent ugliness of the scene, Burchfield and Hopper in the twenties rarely hedged on realism with side bets on beauty.

Charles Burchfield, *October*. Ferdinand Howald Collection, The Columbus Gallery of Fine Arts

THERE emerged in New York around Kenneth Hayes Miller toward the end of the twenties a new group of painters whose work, in its concern with city life, was almost a revival of the Ash Can School. This group developed as the urban counterpart of American Scene ruralism and, together with the later American Scenists following Benton, reached its height in the thirties.

For them, Fourteenth Street became the hub of artistic existence. In their search for "life" they may have turned to Union Square because it was physically near, since most had studios in the vicinity; but added to this was the colorful activity of the section which appealed to them as a spectacle. In the twenties the Square had a special flavor which it subsequently lost. Commercially it was, as it still is, the poor man's Fifth Avenue. But in addition to that, it was also the traditional center of radicalism, symbolic of free speech and free assembly. Here open-air meetings and demonstrations were held. It

was a place rich in memories of social struggle. However, it was not only a focal point for radical groups and publications, but also a center of artistic life, where, on the outskirts of Greenwich Village, many artists had their studios. In the hands of the "Fourteenth Street School" its environs were immortalized. The water towers of S. Klein's "On The Square," the women bargain-hunters, the sidewalk pitchmen, the soapbox orators, the political rallies, the park-bench philosophers, the Bowery bums, all became part of a new American folklore to match the false-fronts, the Gothic mansions, the railroad sidings of the small town.

Kenneth Hayes Miller, whose importance as a teacher—the most influential since Henri—far overshadows his efforts as a painter, turned to the city scene only at the end of the twenties, after he moved to Union Square.

Influenced at first by Davies and Ryder, Miller,

Kenneth Hayes Miller, *Fourteenth Street*. Collection Unknown

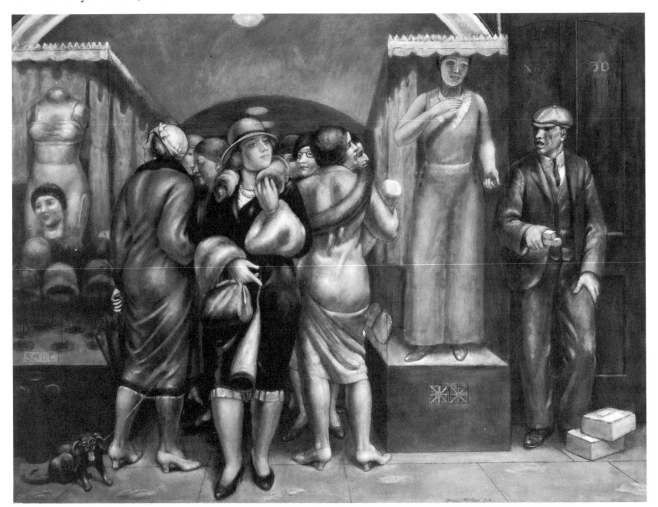

whose sentimentally romantic early style leaned heavily if not happily upon the Renaissance, was groping for idyllic beauty. Being primarily a teacher and having taught since the turn of the century, he was too prone to academicism, too concerned with theories and methods. Even in assimilating Renoir, after 1919, he managed to drain all the juice out of that master's lushness, producing globular, porcelain surfaces instead of warm, vibrant flesh. In straining for plasticity, he swelled all matter into bloated obesity.

When he began to paint the Fourteenth Street scene, he approached his subject with a pedantic precision which saw in humanity only material for his concepts of figure composition and form modeling. Unfortunately the activity of the Square did not lend itself readily to classical composition. His people never came to life, but remained wax dummies posed for effect, ciphers, although extremely substantial ones, in an esthetic formula.

Of Miller's students, Edward Laning began to paint the same subjects in the early thirties, borrowing bodily all his mentor's mannerisms. In Laning's painting, perhaps more than in Miller's, figures are motivated by compositional rather than human exigencies. Isabel Bishop, another Miller student, far surpassed her teacher both as painter and observer. Interested, as are most of Miller's protégés, in techniques, she has developed a method close to Rubens' sketching style, with its transparent shadows and loaded lights. At times her extremely limited palette and overzealous workmanship tend to obfuscate the keenness of her vision; but at her best she is a sensitive draughtsman and a sympathetic chronicler of New York's working girls. However, both Bishop and Laning, although they carry on the Fourteenth Street tradition, developed in the thirties and belong outside our range.

The outstanding exponents of the Fourteenth Street School working in the late twenties were Reginald Marsh, Morris Kantor, and Raphael and Moses Soyer. Marsh was an illustrator in the realist tradition for about ten years before he began to transpose his realism into paint. Influenced in his youth by the drawings of Boardman Robinson, a friend of his father, his allegiance to realism was established even before he studied with Sloan and Luks. Since both of Marsh's parents were artists, he learned to draw when quite young, so that when he came out of college in 1920, his style was already

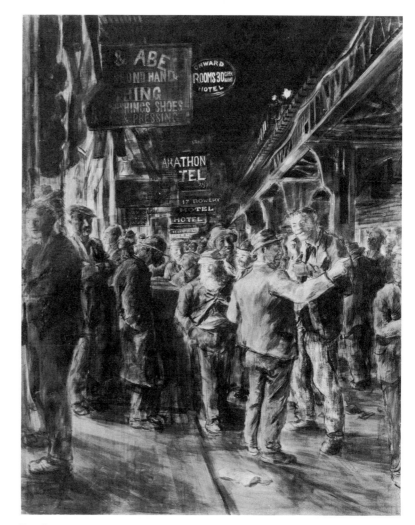

Reginald Marsh, *The Bowery*
Courtesy of The Metropolitan Museum of Art

almost completely formed. While working for *Vanity Fair, Harper's Bazaar*, and the *New York Daily News*, Marsh contributed spirited drawings of the city to various radical publications. If these efforts were not incisive social commentaries, they were at least in the liberal realist tradition.

Marsh's interest has always been in people, and, specifically, people in crowds. For Marsh, crowds are the distinguishing feature of American city life. His love of crowds is a natural concomitant of his love of spectacle; and in his depiction of the movement, the hurly-burly, the noise of New York life, he has extended the range of realist art. Of all the second-generation realists he was the most completely and consciously a reporter, drawing voraciously all that came within his vision. True, swallowing life as he did with a kind of uncritical relish, he was no profound social commentator. However, his choice of subject—the Bowery, Fourteenth Street, Coney Island—in itself reveals a concern with the common man.

183

In 1929, under Miller's influence, Marsh began to paint his scenes of the city. He always remained, however, a draughtsman at heart. Actually, what Marsh got from Miller was a preoccupation with technique and a predilection for Renaissance drawing and composition, both of which have too often disturbed the natural fluency of his style. At his best he is a competent though not brilliant draughtsman and his finest work is to be seen in his drawings, illustrations and etchings. Later, in his painting, the color, put on in successive layers of glaze, is not only technically but artistically an afterthought.

Almost from the beginning of their careers, the Soyers, Raphael and Moses, showed an affinity with the painters of the Ash Can School and especially with Sloan, whose feeling for intimacy and whose sympathy for people they have inherited. The same gentle pathos which characterized Sloan is recognizable in them, except that they have added a touch of melancholy to replace the older painter's unfailing sense of humor.

Though the debt to Sloan may be unconscious, perhaps the result of a similar viewpoint rather than of direct influence, their dependence upon Degas is clear and conscious. When Moses went to Paris in 1926, he sent Raphael a book of Degas reproductions. From then on, they have both been under the

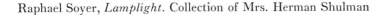

Raphael Soyer, *Lamplight*. Collection of Mrs. Herman Shulman

spell of that master in drawing, composition, and color, as well as in their love of the unguarded moment. Prior to this introduction to Degas, they were, Raphael to a very marked degree, influenced by Pascin, as were many other American painters of that period.

The brothers have always worked independently, even studying at different schools, Raphael at the Art Students League with du Bois and Moses at the Educational Alliance. They are both sensitive about their stylistic resemblances, feeling that such similarities denote dependence or influence of one on the other. Actually their styles are quite distinct, but basic to them both is a deep love of humanity and an attitude toward life which is tolerant, homely, and gentle. From the outset they have painted only the things they knew, the houses they lived in, the streets they walked through, their family and friends.

Moses exhibited for the first time in 1928 at J. B. Neumann's New Art Circle, and Raphael, in 1929 at the Daniel Gallery. Although they reached artistic maturity in the thirties, their styles then were already formed and their attitudes already shaped. Superficially they seemed to be studio painters. Except during the period of the depression, when they were impelled to go out into the streets to paint derelicts and breadlines, their work was almost entirely confined to the studio. Yet they were not studio painters. The studio was merely their locale. Though they did not wander in search of the more apparent aspects of social dislocation, it managed to permeate everything they did; for the studio was to them a thoroughfare through which life flowed. Almost everyone was bound to pass through at one time or other, the bum, the shopgirl, the dancer, the model, the art student, the prostitute, to sit for a while, to rest, and to talk. When a model posed, she did not become a symbol of beauty or a formal abstraction, she brought with her into the studio her life, her hopes, or her despair. In painting the studio, the Soyers painted a reflection of the world.

Moses Soyer, *Sad Interior.* Collection Unknown

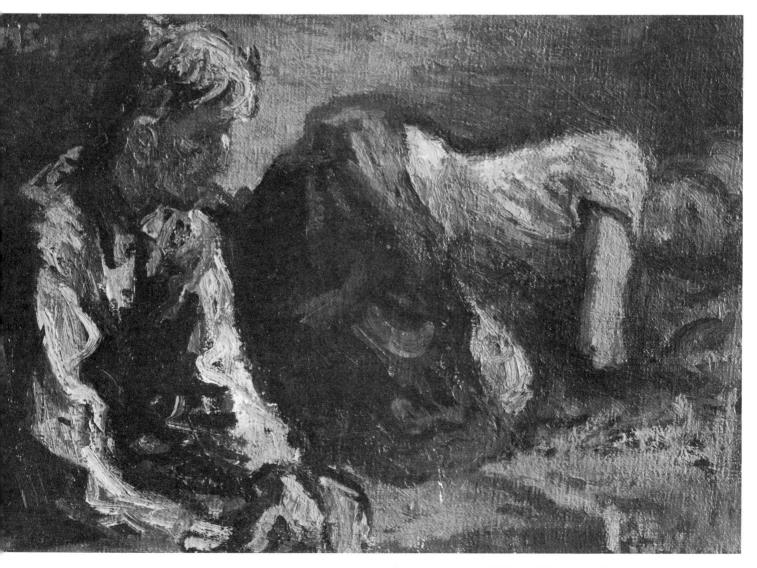

Morris Kantor, *Orchestra*
Collection of the Artist

Morris Kantor is included among the Fourteenth Street group not because his art was primarily motivated by the spectacle of city life, but because, for a very short time at the end of the twenties, when he had finally achieved an individual style, he was living on Union Square and painting its appearance. From 1919 to 1924 Kantor had been deeply influenced by Cubism, an influence which remained with him during the entire decade. His *Orchestra* (1922), with its unblushing reliance upon Duchamp's *Nude Descending a Staircase*, is an example of Kantor's years of experimentation. However, he attempted after 1924 to discard abstraction and return to nature, and evolved a brittle linear style, hard and precise, foreshadowing his later development in the thirties.

About 1928, with his discovery of Americana in New England and on Fourteenth Street, he finally hit his stride. Both aspects of his art, although distinct in subject matter, were dominated by a single vision, psychologically and artistically. These paintings were still dependent to some extent on Cubism, but Kantor had converted the influence to his own ends and was using it for specific effects. His multiplanar method, in which the various elements of the composition seem, like transparent backdrops or screens, to be in constantly changing relationship with each other, allowed for an inter-

play of space, time, and ideas, permitting him to combine exterior and interior, the past and the present, the objective and the subjective. The resulting jigsaw puzzle was not merely an abstract pattern, but served also to create a dream world in which the laws of reality had no existence, in which thoughts wandered ghost-like through time and space. In all these paintings there was a mood of romantic nostalgia remarkably close to that of the Neo-Romantics.

The romanticism which pervaded Kantor's vision of Union Square gave his paintings a sense of unreality. He was more interested in the Square's silent architecture than in its turbulent human activity. In spite of that, however, Kantor's versions of Union Square seen from his studio window were accurate and poignantly evocative of its quieter aspects. His *Farewell to Union Square* (1931), in which he placed a sprig of roses on the grave of a memory, is a gentle mood captured and presented with charm and humor.

The entire Fourteenth Street group was motivated by an interest in the picturesque, in spectacle, in action, and in local color. If there was criticism, it was only by implication. On the whole, they were more interested in the excitement of urban life.

Morris Kantor, *Farewell to Union Square*
Courtesy of The Newark Museum, Newark, N.J.

186

TOWARD the middle of the twenties the expression of social protest became more pronounced. A large section of the intellectual class was not satisfied with the haphazard potshots of the Mencken circle and was searching for a more consistent and deeper probing of the social scene. Resentment grew against attacks upon labor, radicals, and aliens, and against the brazen reaction of the Ku Klux Klan and kindred groups. As a result, when the *New Masses* was formed it found support among people of widely divergent social views who saw in it the possibility of a revival of the militant reformism of the old *Masses*. The *New Masses* was launched in May 1926, with as distinguished an array of artistic and literary sponsors as any magazine in America has ever had. Although its editorial board was dominated by such outspoken radicals as John Dos Passos, Joseph Freeman, Michael Gold, James Rorty, William Gropper, Maurice Becker, Hugo Gellert, and Louis Lozowick, it also included such liberals as John Sloan, Rex Stout, and Freda Kirchway, while among its contributing editors were listed the writers Sherwood Anderson, Carleton Beals, Van Wyck Brooks, Stuart Chase, Floyd Dell, Max Eastman, Waldo Frank, Susan Glaspell, John Howard Lawson, Lewis Mumford, Eugene O'Neill, Elmer Rice, Carl Sandburg, Upton Sinclair, Genevieve Taggard, Louis Untermeyer, Mary Heaton Vorse, and Edmund Wilson, and the artists Glenn O. Coleman, Miguel Covarrubias, Stuart Davis, Adolf Dehn, H. J. Glintenkamp, and Boardman Robinson.

The *Liberator* in 1918 had taken up where the suppressed *Masses* had left off, continuing the artistic tradition of journalistic realism which formed a reservoir of realism in American art. The Ash Can School had grown out of newspaper illustration and had been bolstered by the *Masses*. After its death the realist tradition was sustained in the pages of the *Liberator* and for a short time in *Good Morning*, Art Young's abortive effort to establish a monthly of artistic satire. In the *Liberator* the political cartooning style of Boardman Robinson, Robert Minor, and Maurice Becker held sway, recruiting to its ranks many new names, R. K. Chamberlain, Bruce A. Russell, Fred Ellis, Clive Weed of the *New York Sun* and Edmund Duffy of the *Baltimore Sun*. It also introduced another group of satirical realists

who derived their styles from other sources, among them William Gropper, Adolf Dehn, and Peggy Bacon.

While the group around Robinson and Minor had sprung from the French realism of Forain and Steinlen, the other group was working in the German satirical style of *Simplicissimus* and *Jugend*. Robinson's broad crayon technique, which had become the trademark of radical political cartooning, was supplemented by a new style of sharp, linear caricature. These two groups differed, however, in more than style. While the older men dealt with symbolic representation in the traditional cartoon manner, the younger were concerned with the critical depiction of particular aspects of social existence. While the former were expressing editorial opinions in graphic media, the latter, as critical realists, were dissecting social forms without pointed comment.

Both Dehn and Bacon were never political cartoonists; they were social satirists, and Gropper only later managed a synthesis between the political cartoon and critical realism. While contributing to the *New Masses* and the *Liberator,* Dehn and Bacon

Peggy Bacon, *The Blessed Damosel*
Collection of: Whitney Museum of American Art, New York

presented a striking similarity of style. They both used a thin, tight, nervous, and brittle line with sharp satirical intent. Their almost microscopic handling of detail heightened the sense of penetrating analysis and precise characterization. This was a new feature in American realism, a method which was being used in Germany with incomparable mastery by George Grosz, the greatest of the post-war satirists. All three, Gropper, Dehn, and Bacon learned a great deal from the German artist's bitter and devastating description of social decay and corruption.

During the twenties Dehn and Bacon were directing their criticism toward social ends. They ridiculed snobbery and pretense, philistinism and pomp as seen in the upper strata of society, turning occasionally to the exposure of social abuses. They were at that time on the side of the lower classes, and their criticism of the foibles of the wealthy was read as an indictment of a whole social system.

In the thirties Dehn, except for occasional efforts, left the field of satire, in which he had established a notable reputation through his dry wit, for that of water-color landscape painting. Like Grosz's, Dehn's development in these later years has been a denial of the principles of his earlier style. If Dehn moved more easily into the temple of "pure" art than did Grosz, it may be because he was less deeply rooted in critical realism, and therefore had less readjustment to make.

Peggy Bacon remains a satirist. She has abandoned her earlier social bias and from the criticism of a class she has turned to the criticism of individual types. The basis of her art has shifted until it rests now not on social satire, but upon wit. Since Peggy Bacon has plenty of wit, her characterizations have become synonymous with a kind of mocking urbanity.

Adolf Dehn, *The Sisters*. Collection of: Whitney Museum of American Art, New York

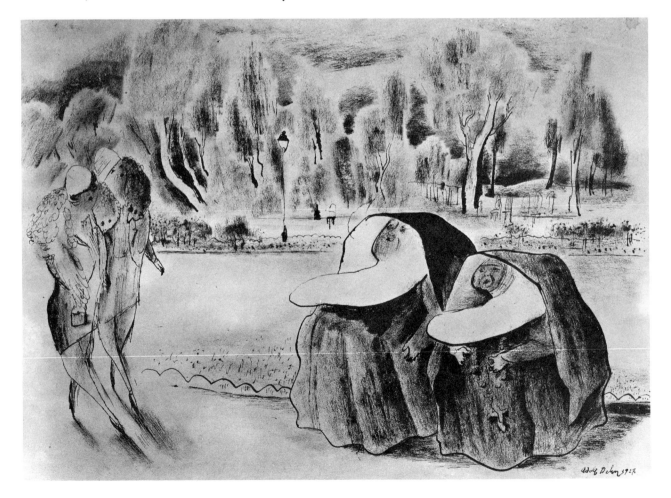

When William Gropper began to draw for the *New Masses*, he was a satirist rather than a political cartoonist. The development of his style during the twenties was characterized by the assimilation of the *Masses* tradition of political cartooning to his own satirical manner. Gropper's greatness as a cartoonist is dependent upon this balance between the symbolic, editorial attitude and the personalization of types through the medium of satirical realism. The heroic or villainous impersonal forces of society which were the protagonists of Robinson's cartoon-world were transformed by Gropper into more specific human types. He was able to strip an institution or a class of its official trappings and present it as a particular and ludicrous example of humanity. While the Robinson group attempted to inject a sense of reality into a composition of symbols through the expedient of realistic drawing, Gropper imbued his symbols with life through a psychological humanization.

As a newspaper illustrator, Gropper had developed a loose and fluid draughtsmanship which lent itself to his racy humor. On the *New Masses*, afterward, his style developed rapidly. Under the impact of Grosz's bitter satires of the bourgeoisie, his man-

William Gropper, *Dishwasher*
New Masses

William Gropper, *Steady Employment*
New Masses

ner became sharper and more trenchant. At the same time he achieved striking designs through a brilliant patterning of light and shade. He was the one cartoonist whose style displayed an awareness of the new modernist movements, which he assimilated effortlessly and within the limits of his primary intention of satirical realism. His natural fluency, expressed in his humor as well as his draughtsmanship, was also evident in this ability to assimilate artistic influences and to utilize them effectively.

During the late twenties his style owed much not only to Grosz and Cubism, but to Oriental art also, in its effects of flat pattern and brilliant calligraphy. His modernism, assimilated from many sources, found expression in compositional daring, unusual

189

angles of vision, expressive distortions of form, experiments in technique, a feeling for texture, and a bold use of black-and-white pattern. The designs he created grew logically out of the subject with a richness of invention and an aptness and wit unequalled in American cartooning.

In the late twenties and early thirties Gropper turned more toward realism. He began to draw with a greater fidelity to nature and with less concern for pattern in itself. During this period he was at his height as a cartoonist—bold in intention, penetrating in observation, brilliant in execution—combining in balanced measure the real with the abstract, the human with the symbolic. In later years, as his interest turned toward painting, his cartoons became more hurried and stereotyped, dependent too often upon symbolic clichés.

His career as a painter is outside our scope, for he began to paint seriously only in the middle thirties. In his work of the twenties, in the medium of the cartoon, he established himself as America's outstanding graphic artist. He brought to cartooning a fertile imagination, a sharply barbed wit, a broad Rabelaisian humor, a deep sympathy for the oppressed and a hearty optimism. Unlike Grosz, Gropper has always had an almost naive faith in humanity. Even his hate is one of strength rather than despair. His influence upon the social art of the thirties was profound, both as symbol and as example.

All three magazines—the *Liberator, Good Morning*, and the *New Masses*—opened their pages not only to social criticism, but to realism as a whole; to the mechanism of Louis Lozowick, Jan Matulka, and Gan Kolski; and even to the non-social, purely esthetic creations of such artists as George Bellows, Maurice Sterne, A. Walkowitz, Ben Benn, Morris Kantor, J. J. Lankes, Wanda Gag, Niles Spencer, Stuart Davis, David Burliuk, Jean Charlot, Ernest Fiene, Walt Kuhn, George Biddle, and the Mexicans Diego Rivera, Clemente Orozco, Rufino Tamayo, and Xavier Guererro. The importance of these journals was not only that they were illustrated by so many of our best artists, though that, of course, gives them intrinsic value, but that they fostered the development of a critical realism which could grow nowhere else. In their pages was being formed an art which was critically outspoken about the social scene, an art which was to unfold as the social realism of the thirties.

Realism and social art in America during the twentieth century were intimately tied to newspaper and magazine illustration and to the graphic media. However, this is not at all a unique phenomenon. Similar conditions obtained in nineteenth-century France, where the realist art of social comment continued in the pages of many periodicals in complete contrast to and with no appreciable effect upon the general course of French painting. One of the major reasons for this absence of a social consciousness in the "fine" arts was that such manifestations could find no patronage. It is axiomatic that a social art cannot exist in any strength or health on isolated individual patronage and without organized or institutional support. The only alternative to such patronage is in mass distribution or circulation, which then, and even now, limited the artist to the graphic media. As a result, social art was confined almost exclusively to drawings, which appeared as illustrations in magazines and newspapers or in radical or satirical publications. In the precincts of painting, social art was taboo. The attempt of the Ash Can School to break through the shell had met with characteristic and violent opposition, as we have seen. This attitude was so deeply ingrained that even John Sloan, who fought against it, finally accepted the unwritten law as part of his own artistic philosophy. He began to feel that social consciousness "should not be put into painting" but should be reserved in his case for etchings.[1] Periodicals therefore were the natural outlet for those artists who were interested in a social expression, and it was there that the tradition of social art was kept alive.

In Mexico the legitimacy of social art was officially recognized after the revolution, and flourished from 1921 on, when its leading painters were commissioned to decorate public buildings. In the United States that stage was not reached until, under the W.P.A. and the Treasury Department art programs, similar support for public art was instituted. However, prior to the inception of government aid, a struggle for the recognition of social comment as a legitimate aspect of the "fine" arts developed among the radical artists in New York.

Toward the end of the twenties, when social unrest was again emerging in strength, revolutionary communism was replacing reformist socialism as the spearhead of radical philosophy and activity, and was attracting to itself a large group of artists and writers. The *New Masses*, which was the voice of this group, began to deal with cultural problems

in relation to social change. Questions of social content and social purpose in art and literature became topics for wide and heated discussion. It was obvious that world ferment was cracking the isolationist shell which contained American art within proscribed areas. It was in the *New Masses* that the legitimacy of social content in art was argued, as against the dominant concept of art-for-art's sake. The formation of the John Reed Club in 1930 gave added impetus to the discussion and finally led to experiments along such lines.

Since the artists of the John Reed Club believed that the ascendancy of the working class was a prerequisite for the establishment of a new society, they were naturally interested not only in the cultural expression of the working class itself, but in the utilization of that culture as a weapon in the struggle against capitalism. They were interested in the development of a proletarian art which would serve as a cultural force to counteract what they thought of as the pernicious influence of bourgeois culture on the great mass of people. When they spoke for a social art, they also spoke for a proletarian art; for in their minds they were synonymous.

Although subsequently social art took many different forms, the early equation of "social" with "proletarian" has colored its history. Social art as a whole is still, after the experiments of the thirties and forties, thought of as artistic dynamite. While modernists have viewed the emergence of a social art as a lamentable reaction, others have seen it as a political danger, so that it has been caught in a critical crossfire. But in spite of its defamation, in the thirties social art invaded the sacred precincts of the "fine" arts and became a broad expression extending far beyond the limits its critics have implied, until today one cannot deny its importance in the history of American art.

MODERNISM had dominated American art for almost two decades, during which time the long-standing American tradition of realism continued as an undercurrent. As the twenties advanced, the realist current accumulated strength until, after 1929, it burst into prominence again. An early major crystallization of the new realistic tendencies was the mural series painted by Thomas Hart Benton in the New School for Social Research in 1930, and the Whitney Museum of American Art in 1932. They are considered here because they grew out of what was in preparation before, marking the limit of the period of which we have been speaking, at the same time that they initiated a new period. The Benton murals were not isolated phenomena. Of the men who were specifically associated with this realist revival, Grant Wood and John Steuart Curry also were already beginning the production of American Scene painting. Curry had painted *Baptism in Kansas* in 1928 and *Tornado over Kansas* in 1929; Wood had painted *Woman with Plants* in 1929, *American Gothic* in 1930 and *Daughters of the American Revolution* in 1932. The Benton murals are used here as a symbol of all this because they were large, spectacular, and well publicized, bringing the new development forcibly to the attention of art world and public.

Executed at the same time as Orozco's decorations for the same building, Benton's New School murals excited immediate public interest because they seemed to presage a revival of mural painting in America. The Boardman Robinson murals for the Kaufman Department Store in Pittsburgh (1929), which predated Benton's murals, had been influenced by Benton's campaign for mural decoration as well as by his technique and had dealt with an historical subject. Benton, however, treated contemporary subject matter, in both the New School and the Whitney Museum; and so they seemed to open new and exciting vistas for American art.

Benton has received much acclaim and has helped to foster the opinion that he was the originator of a new artistic movement. Although he was an innovator in the technique of fresco painting in the United States, he was artistically no more than the well-publicized culmination of the whole realist stream of the twenties. He embodied in his murals the ruralism and quaintness of the American Scene painters, the Fourteenth Street School's predilection for spectacle, as well as the critical attitude of the social realists. He added to these a disposition for sensationalism and a negative philosophy.

Thomas Benton's popular repute has always been somewhat out of proportion to his true stature as an artist, although his significance in the development of American art is incontrovertible. It is difficult to accept Thomas Craven's exaggerated opinions of Benton's abilities. In spite of the *post facto* efforts of Craven and Benton to ascribe to him the leading role in the emergence of the American Scene painter, the truth of the matter is that Benton was a little late in arriving and was one in a general movement toward a social art. Craven's desire to publicize Benton as the great American artist, the discoverer of our heritage, the progenitor of a new style, a titan who has set us back onto the high road of art, has led to a distortion of Benton's earlier artistic activity. The fervid breast-beating with which both Benton and Craven have recanted their earlier allegiance to modernism is calculated to give greater validity to their subsequent conversion. Benton's own evaluation of his development is, like Craven's, historically faulty. The truth is that Benton emerged as an important figure in the development of American Scene painting only in the thirties.

In his earliest work after his return to these shores from Europe in 1912 Benton was under the artistic domination of his friend, S. Macdonald-Wright. However, the amorphous character of Synchromism did not appeal to him long, and he became interested in other problems of form and composition. His contribution to the Forum Exhibition showed him grappling with the intricacies of figure composition in an endeavor to recapture in modern terms the principles of Renaissance art.

Although he dates the origin of his interest in American subject matter back to his service in the United States Navy from 1918 to 1919, he was still in the middle twenties largely concerned with abstract problems of form and composition. The first hint of such interest appeared in his studies for projected mural decorations, done between 1919 and 1924, which dealt with American history. How-

Thomas H. Benton, *Three Figures*. Collection Unknown, formerly John O'Hara Cosgrave

ever, this historical series which was called by Benton "My American Epic in Paint," was no world-shattering innovation, since the treatment of historical subjects was not new to American mural painting, as a matter of fact it was one of the major aspects of academic mural decoration. The series was a departure only in its style. In these studies, Benton was more engrossed in the design of form in space than in the story, and more in abstract shapes than in reality. These murals were primarily decorations, and subject matter was only an excuse for formal manipulation. Benton's absorption in problems of form, space, and composition, which to this day is evident in his art, expressed itself at that time in

193

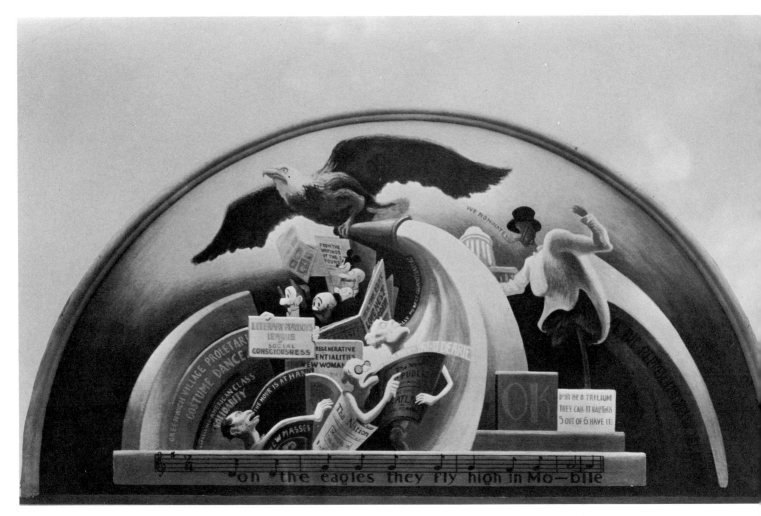

Thomas H. Benton, *Political, Business and Intellectual Ballyhoo (Ceiling Panel No. 6)*
Art Museum of the New Britain Institute

theoretical articles which he wrote for the *Arts*.

After the event, Craven and Benton seem to consider that by lumping these historical sketches together with his later pictures of contemporary life, they are establishing Benton's claim to priority in the development of American Scene painting. Actually, during the twenties Benton's American Scene efforts were confined to a number of drawings which dealt with rural landscapes and industrial scenes, all with an affinity to Burchfield's water colors. About 1925 he painted some portraits of American types which are among the earliest examples of his interest in the contemporary scene. It was not until 1928 that this interest became predominant.

When Benton was commissioned to paint the murals for the New School for Social Research, he achieved his dream of painting an epic of his country. The result was a cross section of American life, its variety, richness, and turbulence. He included scenes of agriculture, lumbering, construc-

tion, mining, power, steel, and oil, symbols of America's positive productive capacities. But side by side with this eulogy of material activity and progress ran a strain debunking our cultural heritage. This too was part of America, but it was told with a critical irony that often verged on caricature. Here was the burlesque house and the revivalist meeting, the dance hall and the movie house, the stockbroker and the subway rider, the chain gang and the prize fight.

In the Whitney murals, done during the height of the depression, Benton became more outspokenly critical, although still only as a debunker. These murals remain even today the most complete plastic illustration of Menckenism. They contain the usual jibes at American forms of entertainment, the popular art forms which were so revolting to the superior intellect—radio, motion pictures, jazz. Benton scoffs at prohibition with its attendant racketeering lineup of gangster, bootlegger, and capitalist. To him the South is a land of crapshooting and revivalism, and

194

the West a land of gunshooting, poker playing, square dancing, and broncobusting. It is interesting, as a hint of Benton's later renunciation of the "effete" and "radical" city, that in these pictures he is most sympathetic to the rural South and West. It presages the nature of his later ruralism also that in treating these areas his critical irony turns to quaint humor and native mythology, for what he describes of them is not their contemporary life, but their tradition.

Benton was conscious of the tradition of critical realism, as the murals themselves attest. Personally, however, he was already denying it for a kind of nationalistic romanticism. He was aware of unemployment and social unrest, of corruption and inequality; and yet, with Mencken, he slandered the reformer equally with the reactionary. The lunette which carries the first line of that ribald ditty "Oh, the eagles they fly high in Mobile" (the next and unquoted line is of course the true caption and an expression of Benton's cynical social attitude) is a denunciation of reform as well as of government corruption. With an irresponsible nihilism masquerading as social philosophy, he parodies equally the infantilism of the tabloid and the intellectuality of the liberal and radical press.

THE twenties were dominated by French modernism. German Expressionism had little importance, affecting only a few Americans in the twenties—Albert Bloch, Yasuo Kuniyoshi, Benjamin Kopman, and, to some degree, Marsden Hartley. The Cubist group, which owed allegiance to Cézanne and Picasso, developed along three divergent lines; from Cubism to a simplification of reality, as in the cases of Andrew Dasburg and Henry L. McFee; from Cubism to Cubist-Realism and an eventual turn toward meticulous realism, as in Sheeler; and from Cubism to abstraction, as in Arthur G. Dove and Stuart Davis. Matisse and Fauvism in general influenced another section of American painters, including Marin, Weber, Hartley, and Kuhn. The importance of Renoir and Degas and of Pascin became apparent later in the decade, influencing a whole school of studio painters.

There were of course cross influences, temporary allegiances, some painters going through periods of experimentation in more than one manner. The typical case history of the American modern artist of this period reveals a general evolution from fervent radicalism to conservatism, from experimentation with the brashest new forms to their assimilation for more conventional purposes or to their final abandonment.

Side by side with modernism, realism though submerged, grew with cumulative strength along various lines. Out of the Ash Can tradition emerged three distinct streams—the rural American Scenists, the Social Realists, and the Fourteenth Street School. Although all three gained momentum during the twenties, it was not until the economic debacle of 1929 and the subsequent depression of the thirties that new social relationships, basic changes in the function of art, and new esthetic conceptions were to thrust realism into prominence again.

Just as the twenties was the decade of modernism, the thirties was to be the decade of social art. This does not imply the sudden death of modernism, any more than the previous dominance of modernism had meant the death of realism. As a matter of fact, a large section of American artists reacted to the economic and political stress by retreating even further into themselves and into the particularized

problems of their craft, pursuing the exploitation of abstract form to more extreme conclusions than had ever before been done in American art. More characteristically, however, the shock of the depression was so great that many artists turned toward a direct concern with social reactions to economic events. The relationship between economic factors and artistic developments is in this case at least beyond cavil. Even an exponent of "pure esthetics" could not write an artistic history of the thirties without reference to economic and social facts. The effects of the depression may not have been immediate but they became far-reaching with time. The development of realism toward a sharper consciousness in the twenties prepared the way for the art of the thirties. What the depression did was to intensify this social consciousness and sharpen the division between the social and non-social artists, and between the various phases of social art itself.

By 1929 the doctrine of art-for-art's sake had already begun to lose its hold on American art. The impulse toward a social art was growing even before art achieved a recognized social function. The social realists were making social statements and Thomas Benton wanted walls upon which to paint his "Epic" even before conditions seemed ripe. The depression clarified such ideological directions. Also, it helped to reestablish the long-lost conditions for a social art, since willy-nilly, the government, in attempting to keep the millions of unemployed alive through works projects, recognized the cultural professions and provided the material conditions for the development of a social art. It accepted art, at least in principle, as a legitimate occupation with a social function, on the same level with road building or the conservation of natural resources.

Previously the artist had seen in democracy only freedom to create. But a new concept was arising which insisted on another aspect of democracy—the social responsibility of the individual. In a democracy where responsibility was being demanded with a new urgency of each individual as a partner in a social contract the artist cared less to argue his exceptionalism or make claim that his responsibility was to be free. He found that responsibility and freedom were contradictory only in the abstract. In the concrete he was finding it possible to be free yet work as a social being responsible to his fellow-citizens.

196

Footnotes

BACKGROUND

1. Frank W. Benson, Joseph De Camp, Thomas W. Dewing, Childe Hassam, Willard Metcalf, Robert Reid, Edward F. Simmons, Edmond G. Tarbell, John Henry Twachtman, Alden Weir. William M. Chase replaced Twachtman after the latter's death in 1902.

2. *Cf.* Chapter PSEUDO-SCIENCE.

3. The number of Academicians could not exceed 125 painters, 25 sculptors and 25 architects. The number of Associates was unlimited. Academicians could only be elected from the list of Associates. Each Academician and Associate was entitled to exhibit one work exempt from examination by jury at each regular exhibition of the Academy. Solicited works carried the guarantee of jury acceptance. Unsolicited works had to pass the jury of selection. *Cf.* National Academy of Design, New York, *Constitution and By-Laws, Amended and Adopted Jan. 15, 1907.* (n.p., n.d.)

4. M. D. Luhan, *Movers and Shakers*, 83.

HENRI AND THE ASH CAN SCHOOL

1. R. Henri, *The Art Spirit*, 100.
2. *ibid.*, 103.
3. *ibid.*, 220.
4. J. Myers, *Artist in Manhattan*, 49.
5. L. Baury, "The Message of the Proletaire," *Bookman*, XXXIV (Dec. 1911), 412.
6. R. Henri, *The Art Spirit*, 103.
7. R. Henri, "'My People,'" *Craftsman*, XXVII (Feb. 1915), 459.
8. "Everett Shinn's Paintings of Labor in the New City Hall at Trenton, N.J." *Craftsman*, XXI (Jan. 1912), 384.
9. J. Myers, *Artist in Manhattan*, 49.
10. *ibid.*, 48.
11. *ibid.*, 57.
12. Myers was elected an Associate in 1920 and achieved the status of Academician in 1929. His own statement in *Artist in Manhattan*, 71, is incorrect.
13. J. Spargo, "Eugene Higgins: An American Artist Whose Work Upon Canvas Depicts the Derelicts of Civilization as Do the Tales of Maxim Gorky in Literature," *Craftsman*, XII (May 1907), 141.
14. *ibid.*, 136.
15. *ibid.*, 136.

STIEGLITZ AND "291"

1. Reprinted in "Henri Matisse at the Little Galleries," *Camera Work*, no. 23, 11-12.
2. T. H. Benton, "America and/or Alfred Stieglitz," *Common Sense*, IV (Jan. 1935), 22.
3. S. H., "That Toulouse-Lautrec Print!" *Camera Work*, no. 29, 36-38.
4. T. Craven, *Modern Art*, 312.
5. Reprinted in "The Exhibitions at '291,'" *Camera Work*, no. 36, 31-32.
6. *ibid.*, 46.
7. Reprinted in "The Maurers and Marins at the Photo-Secession Gallery," *Camera Work*, no. 27, 43-44.

THE EVENT

1. "French Cubist Here," *Art News*, XI (Jan. 25, 1913), 4.

2. "An Art Awakening," *Art News*, XI (Mar. 15, 1913), 4.
3. Mar. 8, 1913, at Healy's Restaurant. *Cf. Art News*, XI (Mar. 15, 1913), 3.
4. Dec. 8, 1913, at the Bellevue-Stratford Hotel. *Cf. Art News*, XII (Dec. 27, 1913), 9.

THE CRITICAL ATTACK

1. "The Greatest Exhibition of Insurgent Art Ever Held," *Current Opinion*, LIV (Mar. 1913), 230.
2. "The American Section; The National Art," *Arts and Decoration*, III (Mar. 1913), 160.
3. E. Daingerfield, "Criticism of the Ultra in Art," *American Magazine of Art*, VIII (June 1917), 329.
4. K. Cox, "The 'Modern' Spirit in Art," *Harper's Weekly*, LVII (Mar. 15, 1913), 10.
5. R. Cortissoz, "The Post-Impressionist Illusion," *Century*, LXXXV (Apr. 1913), 813.
6. F. J. Mather, Jr., "Newest Tendencies in Art," *Independent*, LXXIV (Mar. 6, 1913), 512.
7. D. Phillips, "Fallacies of the New Dogmatism in Art, Part I," *American Magazine of Art*, IX (Dec. 1917), 46.
8. E. Daingerfield, "Criticism of the Ultra in Art," *op.cit.*, 329.
9. K. Cox, "Artist and Public," *Scribner's Magazine*, LV (Apr. 1914), 519.
10. F. J. Mather, Jr., "Newest Tendencies in Art," *op.cit.*, 510.
11. E. C. Maxwell, "Nationalism and the Art of the Future," *International Studio*, LXII (Sept. 1917), lxxvii.
12. K. Cox, "The 'Modern' Spirit in Art," *op.cit.*, 10.
13. K. Cox, "Artist and Public," *op.cit.*, 517.
14. F. J. Mather, Jr., "Old and New Art," *Nation*, XCVI (Mar. 6, 1913), 241.
15. D. Phillips, "Revolutions and Reactions in Painting," *International Studio*, LI (Dec. 1913), cxxiii, cxxvi.
16. "Frightfulness in Art," *American Magazine of Art*, VIII (Apr. 1917), 244-245.
17. R. Cortissoz, "The Post-Impressionist Illusion," *op.cit.*, 812.
18. K. Cox, "Artist and Public," *op.cit.*, 517.
19. "The New Art 'Movement,'" *Art News*, XI (Mar. 22, 1913), 6. An interview with Kenyon Cox reprinted from the *New York Times*.
20. Quoted in "Literature and Art," *Current Opinion*, LIV (Apr. 1913), 316.
21. F. J. Mather, Jr., "Old and New Art," *op.cit.*, 241-242.
22. F. J. Mather, Jr., "Newest Tendencies in Art," *op.cit.*, 509, 512.
23. D. Phillips, "Fallacies in the New Dogmatism in Art, Part I," *op.cit.*, 45, 44.
24. D. Phillips, "Revolutions and Reactions in Painting," *op.cit.*, cxxiii, cxxix.
25. H. R. Poore in a letter to the *American Art News*, XIII (Mar. 13, 1915), 4.
26. R. Cortissoz, "The Post-Impressionist Illusion," *op.cit.*, 808-809.
27. K. Cox, "The 'Modern' Spirit in Art," *op.cit.*, 10.
28. F. J. Mather, Jr., "Old and New Art," *op.cit.*, 242.
29. K. Cox, "The 'Modern' Spirit in Art," *op.cit.*, 10.
30. K. Cox, "The New Art 'Movement,'" *op.cit.*, 6.
31. T. Craven, *Modern Art*, 315-316.
32. J. Myers, *Artist in Manhattan*, 36-37.
33. "The European Art-Invasion," *Literary Digest*, LI (Nov. 27, 1915), 1224.
34. C. Brinton, "Evolution not Revolution in Art," *International Studio*, XLIX (Apr. 1913), xxvii.

35. R. Cortissoz, "The Post-Impressionist Illusion," *op.cit.*, 815.
36. "Is it a Temporary Craze?" *American Art News*, XIII (Mar. 27, 1915), 4.
37. D. Phillips, "Fallacies of the New Dogmatism in Art, Part I," *op.cit.*, 44.

AFTERMATH

1. *Cf.* Chapter PSEUDO-SCIENCE.
2. J. Sloan, *Gist of Art*, 44.
3. "New Academy Planned," *American Art News*, XII (Feb. 14, 1914), 1.
4. *The Forum Exhibition of Modern American Painters*, n.p. The following quotations and paraphrases are taken from the unnumbered pages of this catalogue.

INTERLUDE—THE WAR YEARS

1. Proposed by the Aero Club of America and the Conference Committee on National Preparedness. *Cf.* "Aero Club's Defense Posters," *American Art News*, XIV (Mar. 18, 1916), 1. (My italics)
2. M. Price, "The Artists' Call to Colors: The Opportunity of the Poster," *Art World and Arts and Decoration*, IX (July, 1918), 156. This article was originally issued by the National Committee of Patriotic Societies.
3. *Pictures of the Great War*, foreword, n.p.
4. Joseph De Camp, Edmund C. Tarbell, John C. Johansen, Douglas Volk, Irving R. Wiles, Charles S. Hopkinson, Cecilia Beaux and Jean McLane. *Cf.* National Art Committee, *Exhibition of War Portraits*.

THE TWENTIES

1. F. S. Flint, "The Younger French Poets," *Chapbook*, II (Nov. 1920), 12.
2. Inaugural address, Mar. 4, 1925. *Cf. New International Year Book*, 1925, 722.
3. Meeting of the American Society of Newspaper Editors, Dec. 1925. *Cf.* W. A. White, *A Puritan in Babylon*, 253 and note.
4. A. Kazin, *On Native Grounds*, 267.
5. *Cf.* M. Sullivan, *Our Times, the United States 1900-1925, VI: The Twenties*, 382 and note 7a. In 1929 twice as many new books were published as in 1919. In the ten years from 1919 to 1929, 100,000,000 *Little Blue Books* were sold by E. Haldeman-Julius. Mass circulation was fostered also by the inexpensive editions of the *Modern Library* series founded in 1919 and by the book clubs: the *Literary Guild*, founded in 1926, and the *Book of the Month Club*, founded in 1927.
6. *American Art News*, XXII (Oct. 27, 1923), 1.

CRITICS

1. F. J. Mather, Jr., "Old and New Art," *op.cit.*, 242.
2. F. J. Mather, Jr., "Newest Tendencies in Art," *op.cit.*, 509.
3. F. J. Mather, Jr., "Old and New Art," *op.cit.*, 242.
4. F. J. Mather, Jr., "Newest Tendencies in Art," *op.cit.*, 509.
5. "Our Creed," *Art World*, I (Oct. 1916), n.p.
6. *ibid.*, II (Sept. 1917), 533-540.
7. *ibid.*, II (Aug. 1917), 430.
8. *ibid.*, I (Oct. 1916), 65.
9. *ibid.*, I (Feb. 1917), 307.
10. *ibid.*, I (Nov. 1916), 126.
11. *ibid.*, I (Oct. 1916), 6-12.
12. *ibid.*, II (Sept. 1917), 525-527.

13. L. Stein, "Art and Common Sense," *New Republic*, XI (May 5, 1917), 14.
14. L. Stein, "Art and Society," *New Republic*, XLVI (Apr. 14, 1926), 225.
15. L. Stein, "Pablo Picasso," *New Republic*, XXXVIII (Apr. 23, 1924), 229-230.
16. L. Stein, *The ABC of Aesthetics*, 269-270.
17. C. Brinton, *Impressions of the Art at the Panama-Pacific Exposition*, 14.
18. C. Brinton, "Evolution not Revolution in Art," *op.cit.*, xxxiii.
19. W. H. Wright, *Modern Painting*, 10.
20. W. H. Wright, "An Abundance of Modern Art," *Forum*, LV (Mar. 1916), 332.
21. D. Phillips, "Revolutions and Reactions in Painting," *op.cit.*, cxxiii.
22. D. Phillips, *The Enchantment of Art, as Part of the Enchantment of Experience, Fifteen Years Later*, 3-4.
23. D. Phillips, *A Collection in the Making*, 14.
24. D. Phillips, *The Enchantment of Art*, 8.

COLLECTORS

1. *New York Post*, Dec. 30, 1908.
2. S. A. Lewisohn, "Personalities Past and Present," *Art News*, XXXVII (1939 Annual), 156.
3. A. C. Barnes, *The Art in Painting*, 21.
4. *ibid.*, x-xi.
5. Société Anonyme, Inc. (Museum of Modern Art), *Report, 1920-1921*, 11-13.

THE CUBIST TRADITION

1. P. Rosenfeld, *Port of New York*, 205.
2. L. Kalonyme, "Georgia O'Keeffe, A Woman in Painting," *Creative Art*, II (Jan. 1928), xl.
3. *ibid.*, xxxv.

THE FAUVE TRADITION

1. Letter to Stieglitz, 1911. H. J. Seligmann (ed.), *Letters of John Marin*, n.p.
2. "Notes on '291': Water Colors by John Marin," *Camera Work*, no. 42-43 (Apr.-July 1913), 18.
3. "John Marin by Himself," *Creative Art*, III (Oct. 1928), xxxvii.
4. *Cf.* E. M. Benson in *John Marin: Water Colors, Oil Paintings, Etchings*, Museum of Modern Art, 28.
5. "John Marin by Himself," *op.cit.*, xxxvii. In this and the preceding quotation, I have taken the liberty of supplying a minimum of punctuation.
6. M. Weber, "Chac-Mool of Chichen-Itza," *Primitives: Poems and Woodcuts*, n.p.

PSEUDO-SCIENCE

1. D. W. Ross, *On Drawing and Painting*, 113.
2. H. G. Maratta, "Colors and Paints," *Touchstone*, VII (June 1920), 249.
3. D. W. Ross, *The Painter's Palette*, v.
4. *ibid.*, 41.
5. H. G. Maratta, "A Rediscovery of the Principles of Form Measurement," *Arts and Decoration*, IV (Apr. 1914), 231-232.
6. H. J. Seligmann (ed.), *Letters of John Marin*, Letter of July 22, 1913, n.p.
7. D. W. Ross, *On Drawing and Painting*, 116-117.
8. J. Hambidge, *The Elements of Dynamic Symmetry*, xix.
9. M. Armfield, "Dynamic Symmetry and its Practical

Value Today," *International Studio,* LXXIV (Nov. 1921), lxxvii.

10. *ibid.,* lxxix.

11. M. Jacobs, *The Art of Composition: A Simple Application of Dynamic Symmetry,* vii.

12. G. A. Eisen, *The Great Chalice of Antioch,* 75.

13. J. Hambidge, *Dynamic Symmetry in Composition,* 6.

14. A. Pope, *An Introduction to the Language of Drawing and Painting. I: The Painter's Terms,* x.

AMERICAN SCENE

1. Museum of Modern Art, *Edward Hopper Retrospective Exhibition,* 16.

2. E. Hopper, "Charles Burchfield: American," *Arts,* XIV (July 1928), 9.

3. Museum of Modern Art, *Edward Hopper Retrospective Exhibition,* 16.

4. *ibid.,* 17.

5. *ibid.,* 13.

6. Museum of Modern Art, *Charles Burchfield: Early Watercolors,* 12.

7. C. Burchfield, "On the Middle Border," *Creative Art,* III (Sept. 1928), xxviii.

8. *ibid.,* xxx.

Bibliography

BIBLIOGRAPHIC NOTE

The intention of arranging this selective though extensive bibliography into a working instrument for the student and reader has led to the use of a topical and chronological rather than a purely alphabetical pattern. The major classification is topical, within which items are listed chronologically by year and alphabetically within the year. However, the nature of the material precludes a rigid topical classification and limited cross references have been made wherever it seemed most necessary. A bibliographical index has been added to facilitate further cross references.

The bibliography is divided into three major classifications:

1) a general bibliography listing all periodicals of the period which carried articles on contemporary art events and opinion, as well as subsequent art periodicals; reference dictionaries, encyclopedias and bibliographies; and books and articles dealing with the period in general;
2) a topical bibliography paralleling the subdivisions of the text;
3) a bibliography of personalities, including critics, collectors, and artists.

I. GENERAL

A. PERIODICALS

American Art News. (see *The Art News.*)

American Artist. New York, Watson-Guptill Publications, 1937 to date. (superseded *Art Instruction.*)

American Magazine of Art. (see *Magazine of Art.*)

The Architectural Record. New York, The Record and Guide (etc.), 1892 to date.

Art in America. New York, 1913 to date.

The Art Digest. Hopewell, N.J., 1926 to date.

Art and Life. (see *Lotus Magazine.*)

Art Lover. New York, J. B. Neumann, 1924-1937.

The Art News. New York, The American Art News Co. (1904-1929), 1902 to date. (1902-1904, *Hyde's Weekly Art News*; 1904-1923, *American Art News.*)

Art and Progress. (see *Magazine of Art.*)

Art and Understanding. (see *Bulletin of the Phillips Collection.*)

The Art World. New York, Kalon Publishing Co., 1916-1918. (1917, absorbed *The Craftsman*; 1917-1918, organ of the Art Society of America; 1918, combined with *Arts and Decoration.*)

The Arts. New York, 1920-1931. (1921, absorbed *Touchstone*; 1931, superseded by *The Arts Weekly.*)

Arts and Decoration. New York, 1910 to date. (1918, combined with *The Art World*, continued as *The Art World and Arts and Decoration*; 1919, original title resumed; 1930, incorporated *Arts and Decoration Quarterly.*)

Atelier. New York, 1931-1939. (published in London as *The Studio.*)

Atlantic Monthly. Boston, Phillips, Sampson and Co., 1857 to date.

Bookman. New York, 1895-1933. (1933, superseded by *The American Review.*)

Bulletin of the Phillips Collection. Washington, Phillips Memorial Art Gallery, 1927-1932. (1929-1930, *Art and Understanding.*)

Camera Work. New York, 1903-1917.

The Century. New York, 1870-1930. (1870-1881, *Scribner's Monthly*; 1930, absorbed by *Forum and Century.*)

College Art Journal. New York, College Art Association of America, 1941 to date. (1941, superseded *Parnassus.*)

The Craftsman. Eastwood, N.Y., 1901-1916. (1916, merged in *The Art World.*)

Creative Art. New York, A. and C. Boni, 1927-1933. (1927-1931, incorporated with *The Studio* of London; 1934, combined with *Magazine of Art.*)

The Critic. New York, Chevalier Publishing Corp., 1919-1920.

Current Literature. (see *Current Opinion.*)

Current Opinion. New York, Current Literature Publishing Co., 1888-1925. (1888-1912, *Current Literature*; 1903, absorbed *Current History*; 1925, merged with *Literary Digest.*)

The Dial. Chicago, Jansen, McClurg and Co., 1881-1918; New York, Dial Publishing Co., 1918-1929.

Formes (English edition). Paris, Édition des Quatres Chemins; Philadelphia, American Editorial Office, 1929-1933. (1934, merged with *L'Amour de l'Art.*)

The Forum. (see *Forum and Century.*)

Forum and Century. New York, The Forum Publishing Co., 1886-1940. (1886-1930, *The Forum*;

1930, absorbed *The Century*; 1940, absorbed by *Current History*.)

Good Morning. New York, Good Morning Co., 1919.

Harper's Bazaar. New York, 1867 to date.

Harper's Magazine. New York, 1850 to date. (1850-1900, *Harper's New Monthly Magazine*; 1900-1931, *Harper's Monthly Magazine*.)

Harper's Weekly. New York, 1857-1916. (1916, merged in *The Independent*.)

The Independent. New York, 1848-1928. (1916, absorbed *Harper's Weekly*; 1928, absorbed by the *Outlook*.)

International Studio. New York, 1897-1931. (1897-1921, American edition of *London Studio*; 1927-1931, associated with American edition of *The Connoisseur*; 1931, consolidated with *The Connoisseur*, continued as *Connoisseur; with Which is Incorporated the International Studio*.)

The Liberator. New York, 1918-1924.

The Literary Digest. New York, 1890-1938. (1906, absorbed *Public Opinion*; 1925, absorbed *Current Opinion*; 1937, absorbed *The Review of Reviews*; 1938, absorbed by *Time*.)

Lotus Magazine. New York, 1910-1920. (1910-1911, *The Lotus*; 1911-1919, *Lotus Magazine*; 1919-1920, *Art and Life, incorporating Lotus Magazine*; 1920, merged into *Art and Archaeology*.)

Magazine of Art. Washington, D.C., American Federation of Arts, 1909-1953. (1909-1915, *Art and Progress*; 1916-1936, *American Magazine of Art*.)

Manuscripts. New York, C. S. Nathan, Inc., 1922-1923.

Masses. New York, 1911-1917.

The Metropolitan Magazine. New York, 1895-1924. (1903, *New Metropolitan*; 1911-1924, *Metropolitan*; 1924, absorbed by *McFadden Fiction Lovers Magazine*.)

The Nation. New York, 1865 to date. (1921, absorbed *The Arbitrator*, which resumed separate publication Jan. 1922.)

New Masses. New York, New Masses, Inc., 1926-1948. (1948, united with *Mainstream* to form *Masses and Mainstream*.)

New Republic. New York, The Republic Publishing Co., 1914 to date.

North American Review. Boston (1815-1877), New York (1878-1940), 1815-1940. (1815-1827, *North American Review and Miscellaneous Journal*.)

The Outlook. New York, 1870-1935. (1928-1932, *The Outlook and The Independent*; 1932-1935, *The New Outlook*.)

Parnassus. New York, published for the members of the College Art Association of America, 1928-1941. (1941, superseded by the *College Art Journal*.)

Scribner's Magazine. New York, 1887-1939. (1939, absorbed *The Commentator*, which continued as *Scribner's Commentator*.)

The Seven Arts. New York, 1916-1917. (1917, absorbed by *Dial*.)

The Studio. London, New York, 1893 to date. (1897-1927, the American edition was called *The International Studio*; 1927-1931, *Creative Art* (American edition incorporating *The Studio*); 1931-1932, connection ceased with *Creative Art*, American edition called *Atelier*; 1932-1939, *The London Studio* (American edition of *The Studio*); 1939, American edition discontinued.)

The Touchstone. New York, Mary F. Roberts, Inc., 1917-1921. (1918, absorbed *The American Art Student*; 1921, merged into *The Arts*.)

Twice a Year. New York, 1938 to date.

291. New York, 1915-1916.

Vanity Fair. New York, Vanity Fair Publishing Co., 1913-1936. (1936, absorbed by *Vogue*.)

Vogue. New York, 1892 to date. (1936, absorbed *Vanity Fair*, continued as *Vogue, incorporating Vanity Fair*.)

World's Work. New York, 1901-1932. (1932, absorbed by *Review of Reviews* and continued as *American Monthly Review of Reviews*.)

B. REFERENCE WORKS

1899. Levy, F. N. (editor), *American Art Annual.* New York, American Art Annual, Inc., 1899-1912.

Who's Who in America; A Biographical Dictionary of Living Men and Women of the United States. Chicago, n.p., 1899-1900 to date.

1907. Thieme, U., and F. Becker, *Allgemeines Lexicon der bildenden Kuenstler von der Antike bis zur Gegenwart.* Leipzig, W. Engelmann, 1907-1939.

1913. Levy, F. N. (editor), *American Art Annual.* Washington, D.C., American Federation of Arts, 1913-1941.

1924. *Biographical Sketches of American Artists.* Lansing, Mich., Michigan State Library, 1924, fifth edition, revised and enlarged.

1926. Fielding, M., *Dictionary of American Painters, Sculptors, and Engravers.* Philadelphia,

Lancaster Press (c. 1926).

1930. Smith, R. C., *A Biographical Index of American Artists*. Baltimore, Williams and Wilkins Co., 1930.

1933. College Art Association, *Index of Twentieth Century Artists*. New York, College Art Association, 1933-1937, 4 vols.

1935. Mallett, D. T., *Mallett's Index of Artists, International-Biographical*. New York, R. R. Bowker Co., 1935.

1936. American Federation of Arts, *Who's Who in American Art; A Biographical Directory of Selected Artists in the United States Working in the Media of Painting, Sculpture, Graphic Arts, Illustration, Design, and the Handicrafts*. Washington, D.C., American Federation of Arts, 1936, 1938, 1940.

1940. *Current Biography*. New York, H. W. Wilson Co., 1940-1942.

Who's Who in America; Current Biographical Reference Service (supplement). Chicago, A. N. Marquis Co., 1940 to date.

1946. McCausland, E., "A Selected Bibliography on American Painting and Sculpture from Colonial Times to the Present," *Magazine of Art*, xxxix (Nov. 1946), 329-349.

1948. Monro, I. S., and K. M. Monro, *Index to Reproductions of American Paintings*. New York, H. W. Wilson Co., 1948.

C. GENERAL

1910. Blashfield, E. H., "The Actual State of Art Among Us," *North American Review*, cxci (Mar. 1910) 324-329.

1914. Blashfield, E. H., "Mural Painting in America," *Arts and Decoration*, v (Dec. 1914), 60-61, 76.

Eddy, A. J., *Cubists and Post-Impressionism*. Chicago, A. C. McClurg and Co., 1914.

1915. Laurvik, J. N., "Evolution of American Painting," *Century*, xc (Sept. 1915), 772-786.

Wright, W. H., *Modern Painting; Its Tendency and Meaning*. New York, J. Lane Co.; London, J. Lane, 1915.

1917. Bryant, L. M., *American Pictures and their Painters*. New York, J. Lane Co., 1917.

1921. General Federation of Women's Clubs, Art Division, *Study Outlines and Bibliography of American Art*. General Federation of Women's Clubs, 1921-1922.

Hartley, M., *Adventures in the Arts; Informal Chapters on Painters, Vaudeville, and Poets*. New York, Boni and Liveright (c. 1921).

Rosenfeld, P., "American Painting," *Dial*, lxxi (Dec. 1921), 649-670.

1922. Gallatin, A. E., *American Water-Colorists*. New York, E. P. Dutton and Co., 1922.

Pach, W., "Les Tendences Modernes aux États-Unis," *L'Amour de l'Art*, iii (1922), 29-30.

1923. Cortissoz, R., *American Artists*. New York, London, Charles Scribner's Sons, 1923.

Dreier, K. S., *Western Art and the New Era; An Introduction to Modern Art*. New York, Brentano's (c. 1923).

Le Gallienne, R., *Woodstock; An Essay*. Woodstock, N.Y., Woodstock Art Association, 1923.

1924. Cheney, S. B., *Primer of Modern Art*. New York, Boni and Liveright, 1924.

Rosenfeld, P., *Port of New York; Essays on Fourteen American Moderns*. New York, Harcourt, Brace and Co. (c. 1924).

1925. Barnes, A. C., *The Art in Painting*. New York, Harcourt, Brace and Co., 1925.

Ely, C. B., *The Modern Tendency in American Painting*. New York, F. F. Sherman, 1925.

1926. Phillips, D., *A Collection in the Making; A Survey of the Problems Involved in Collecting Pictures, Together with Brief Estimates of the Painters in the Phillips Memorial Art Gallery*. New York, E. Weyhe; Washington, D.C. Phillips Memorial Art Gallery (c. 1926), *Phillips Publication*, no. 5.

1927. Bulliet, C. J., *Apples and Madonnas; Emotional Expression in Modern Art*. Chicago, P. Covici, 1927.

Figure Painting. New York, Associated Dealers in American Paintings, Inc. (c. 1927), *Short Course in American Art*, iii.

Grant, W. M., and F. N. Price, *Modern Art*. New York, Associated Dealers in American Paintings, Inc. (c. 1927), *Short Course in American Art*, viii.

Isham, S., supplemental chapters by R. Cortissoz, *The History of American Painting*. New York, Macmillan Co., 1927.

Macbeth, R. W., *A Summarized History of American Art*. New York, Associated Dealers in American Paintings, Inc. (c. 1927), *Short Course in American Art*, ii.

Mather, F. J., Jr., C. R. Morey, and W. J. Henderson, *The American Spirit in Art.* New Haven, Conn., Yale University Press, 1927, *The Pageant of America,* XII.

1928. Berry, R. V. S., *What Do You Know About American Art? Eighty Questions Covering the Whole Field of American Art Fully Answered, with Extensive Bibliography and Club Programs.* New York, The Club Corner of Scribner's Magazine (c. 1928), chap. VII.

Duffus, R. L., *The American Renaissance.* New York, A. A. Knopf, 1928.

Frank, W., "The Re-discovery of America: XII, Our Arts," *New Republic,* LIV (May 9, 1928), 343-347.

Jackman, R. E., *American Arts.* New York, Chicago, San Francisco, Rand, McNally and Co. (c. 1928).

Mumford, L., "The Arts," in C. A. Beard (ed.), *Whither Mankind.* New York, Longman, Green and Co., 1928, 287-312.

Pach, W., *Modern Art in America.* New York, C. W. Kraushaar Art Galleries, 1928.

Phillips, D., "Contemporary American Painting," *Bulletin of the Phillips Collection* (Feb.-May 1928), 37-51.

1929. LaFollette, S., *Art in America.* New York, London, Harper and Bros., 1929.

1930. Kootz, S. M., *Modern American Painters.* New York, Brewer and Warren, Inc. (c. 1930).

Narodny, I., *American Artists.* New York, Roerich Museum Press, 1930.

Sayler, O. M., *Revolt in the Arts; A Survey of the Creation, Distribution, and Appreciation of Art in America.* New York, Brentano's (c. 1930).

Watson, F., "The All-American Nineteen," *Arts,* XVI (Jan. 1930), 301-311.

Wilenski, R. H., *A Miniature History of Art; With a Chapter on American Art by E. A. Jewell.* New York, Oxford University Press, 1930.

1931. Barker, V., *A Critical Introduction to American Painting.* New York, Whitney Museum of American Art (c. 1931).

Jewell, E. A., "American Painting," *Creative Art,* IX (Nov. 1931), 359-367.

Mumford, L., "El Arte en los Estados Unidos," *Sur,* I (1931), 49-82.

Neuhaus, E., *The History and Ideals of Amer-* *ican Art.* Stanford University, Cal., Stanford University Press; London, Humphrey Milford, Oxford University Press, 1931.

Phillips, D., *The Artist Sees Differently.* New York, E. Weyhe, 1931, *Phillips Publications,* no. 6.

Poore, H. R., *Modern Art—Why, What and How?* New York, London, G. P. Putnam's Sons, 1931.

Smith, S. C. K., *An Outline of Modern Painting in Europe and America.* New York, William Morrow and Co., 1931; London, Medici Society, 1932.

Whitney Museum of American Art, *Catalogue of the Collection.* Wm. E. Rudge for the Whitney Museum of American Art, 1931, 1935, 1937.

1932. Cahill, H., "American Art Today," in F. J. Ringel (editor), *America as Americans See It.* New York, Harcourt, Brace and Co., 1932, 246-266.

Cahill, H., *American Painting and Sculpture, 1862-1932.* New York, W. W. Norton and Co. for the Museum of Modern Art (c. 1932).

Craven, T., "American Men of Art," *Scribner's Magazine,* XCII (Nov. 1932), 262-267.

Coleman, L. V., *El Arte, la Literatura y la Musica en los Estados Unidos.* Washington, Pan American Union, 1932, *American Nation Series,* no. 19 A.

George, W., "Americanism and Universality," *Formes,* XXI (Jan. 1932), 196.

Grafly, D., "Art and America," *Formes,* XXI Jan. 1932), 207-208.

Hartmann, S., *A History of American Art.* Boston, L. C. Page and Co., 1932, II, revised edition.

Jacobson, J. Z. (editor), *Art of Today.* Chicago, L. M. Stein (c. 1932).

Lewisohn, S. A., "Is There an American Art Tradition?" *Formes,* XXI (Jan. 1932), 204-205.

Munro, T., "Present American Painting; a Report of Progress," *Formes,* XXI (Jan. 1932), 202-204.

Phillips, D., "Original American Painting Today," *Formes,* XXI (Jan. 1932), 197-201.

Saklatwalla, B. D., "Contemporary American Art," *Formes,* XXI (Jan. 1932) 205-207.

1933. Burrows, C., "The Rise of American Art,"

London Studio, v (Apr. 1933), 274-282.

Keppel, F. P., and R. L. Duffus, *The Arts in American Life*. New York, London, Mc-Graw-Hill Book Co., Inc., 1933, *Recent Social Trends Monographs*.

1934. Cahill, H., and A. H. Barr, Jr., *Art in America in Modern Times*. New York, Reynal and Hitchcock, 1934.

Cheney, S. B., *Expressionism in Art*. New York, Boni and Liveright (c. 1934).

Craven, T., *Modern Art; The Men, the Movements, the Meaning*. New York, Simon and Schuster, 1934.

Huyghe, R., "Les Pays Anglo-Saxon; Introduction," *L'Amour de l'Art*, xv (Oct. 1934), 457.

Murrell, W., *A History of American Graphic Humor*. New York, Whitney Museum of American Art, 1934.

Pach, W., "Histoire de l'Art Contemporain: Les États-Unis," *L'Amour de l'Art*, xv (Oct. 1934), 464-468.

1935. Cahill, H., and A. H. Barr, Jr., *Art in America; A Complete Survey*. New York, Reynal and Hitchcock (c. 1935).

LaFollette, S., "American Art: Its Economic Aspects," *American Magazine of Art*, xxviii (June 1935), 336-344.

Whitney Museum of American Art, New York, *Whitney Museum of American Art: History, Purpose and Activities*. New York, Whitney Museum of American Art (c. 1935).

1936. Barr, A. H., Jr., *Fantastic Art, Dada, Surrealism*. New York, Museum of Modern Art, 1936.

Baur, J. I. H., "Modern American Painting," *Brooklyn Museum Quarterly*, xxiii (Jan. 1936), 2-19.

Burroughs, A., *Limners and Likeness—Three Centuries of American Painting*. Cambridge, Mass., Harvard University Press, 1936.

Cahill, H., and others, *American Art Portfolios*. New York, Raymond and Raymond, Inc., 1936, series i.

Richardson, E. P., *Twentieth Century Painting*. Detroit, Detroit Institute of Art, 1936.

1937. American Federation of Arts, *American Artists in Color Reproductions*. Washington, D.C., American Federation of Arts, 1937, *A.F.A. Portfolio*, no. 1.

Baldinger, W. S., "Formal Change in Recent American Painting," *Art Bulletin*, xix (Dec. 1937), 580-591.

Effelberger, H., *Umrisse der amerikanischen Kultur und Kunst*. Frankfurt a. M., Moritz Diesterweg, 1937.

Lewisohn, S. A., *Painters and Personality; A Collector's View of Modern Art*. New York, Harper and Bros. (c. 1937).

1938. Baldinger, W. S., *The Development of Form in American Painting of the Twentieth Century*. University of Chicago, 1938, thesis.

Brimo, R., *L'Évolution du Goût aux États-Unis d'après l'Histoire des Collections*. Paris, J. Fortune (c. 1938).

Musée du Jeu de Paume, Paris, *Trois Siècles d'Art aux États-Unis, Exposition Organizée en collaboration avec le Museum of Modern Art, New York*. Paris, Éditions des Musées Nationaux, 1938, 27-32.

1939. Art Institute of Chicago, Chicago, *Half a Century of American Art*. Chicago, Art Institute of Chicago, 1939.

Boswell, P., Jr., *Modern American Painting*. New York, Dodd, Mead and Co., 1939.

Cheney, M. C., *Modern Art in America*. New York, London, Whittlesey House, McGraw-Hill Book Co., Inc. (c. 1939).

Living American Art; Color Plates of American Paintings. New York, Living American Art, Inc., 1939.

Pohl, L. V. A., *Die Entwicklung der Malerei in Amerika von 1913 bis 1938*. Bonn, J. F. Carthaus, 1939.

Richardson, E. P., *The Way of Western Art, 1776-1914*. Cambridge, Mass., Harvard University Press, 1939.

1940. Landgren, M. E., *Years of Art: The Story of the Art Students League of New York*. New York, Robert M. McBride and Co., 1940.

1941. Cheney, S., *The Story of Modern Art*. New York, Viking Press, 1941.

Medford, R. C., *American Painting*. Philadelphia, F. A. Davis Co. (c. 1941), *Continued Study Units in Cultural Life*, iii.

Read, H. A., *La Pintura Contemporanea Norte-Americana*. New York, William E. Rudge's Sons for the Museum of Modern Art, 1941.

Saint-Gaudens, H., *The American Artist and*

his Times. New York, Dodd, Mead and Co., 1941.

1942. Janis, S., *They Taught Themselves; American Primitive Painters of the Twentieth Century.* New York, Dial Press, 1942.

Mellquist, J., *The Emergence of an American Art.* New York, Charles Scribner's Sons, 1942.

Neumeyer, A., "Picasso and the Road to American Art," *Journal of Aesthetics and Art Criticism*, I, 6 (1942), 24-41.

Zigrosser, C., *The Artist in America.* New York, Alfred A. Knopf, 1942.

1943. Kootz, S. M., *New Frontiers in American Painting.* New York, Hastings House, 1943.

Pearson, R. M., *Experiencing American Pictures.* New York, London, Harper and Bros., 1943.

Soby, J. T., and D. C. Miller, *Romantic Painting in America.* New York, Museum of Modern Art, 1943.

Varga, M., "The Rise of American Art," *London Studio*, xxv (Apr. 1943), 113-121.

Janson, H. W., "The International Aspects of Regionalism," *College Art Journal*, II (May 1943), 110-115.

Frankfurter, A. M., "Forty Years of Art News," *Art Parade: Seeing the Past Forty Years Through Art News and the Frick Collection* by H. G. Wright and A. M. Frankfurter. New York, The Art Foundation, Inc., 1943, 17-28, 104-116.

Museum of Modern Art, New York, *American Realists and Magic Realists.* New York, Museum of Modern Art, 1943.

Porter, J. A., *Modern Negro Art.* New York, Dryden Press, 1943.

Whitney Museum of American Art, New York, *Memorial Exhibition: Gertrude Vanderbilt Whitney, Jan. 26-Feb. 28, 1943.* New York, Whitney Museum of American Art, 1943.

1944. Janis, S., *Abstract and Surrealist Art in America.* Reynal and Hitchcock, New York, 1944.

Museum of Modern Art, New York, *Modern Drawings.* New York, Museum of Modern Art, 1944.

Newark Museum, Newark, N.J., *A Museum in Action—Presenting the Museum's Activities. Catalogue of an exhibition of American paintings and sculpture from the museum's collections, Oct. 31 to Jan. 31, 1945.* Newark,

N.J., Newark Museum, 1944.

Phillips Memorial Gallery, Washington, D.C., *The American Paintings of the Phillips Collection, Apr. 9 to May 30, 1944.* Washington, D.C., Phillips Memorial Gallery, 1944.

1945. Goodrich, L., *American Watercolor and Winslow Homer.* Minneapolis, The Walker Art Center (c. 1945).

Pagano, G., *Catalogue of the Encyclopædia Britannica Collection of Contemporary American Painting.* Chicago, Encyclopædia Britannica, Inc., 1945.

1946. Cahill, H., "In Our Time," *Magazine of Art*, xxxix (Nov. 1946), 308-325.

Force, J. R., "The Whitney Museum of American Art," *Magazine of Art*, xxxix (Nov. 1946), 271, 328.

Huth, H., "Impressionism Comes to America," *Gazette des Beaux-Arts*, xxix (Apr. 1946), 225-252.

Whitney Museum of American Art, New York, *Pioneers of Modern Art in America.* New York, Whitney Museum of American Art, 1946.

1947. Born, W., *Still-Life Painting in America.* New York, Oxford University Press, 1947, 44-48.

Brown, M., "Forces Behind Modern U.S. Painting," *Art News*, xlvi (Aug. 1947), 16-17, 34-35.

1948. Born, W., *American Landscape Painting: An Interpretation.* New Haven, Yale University Press, 1948, 196-213.

Soby, J. T., *Contemporary Painters.* New York, Museum of Modern Art, 1948.

1949. Cahill, H., "Forty Years After: An Anniversary for the A. F. A.," *Magazine of Art*, xlii (May 1949), 169-178, 189.

Larkin, O. W., *Art and Life in America,* New York, Rinehart and Co., Inc., 1949.

Rowland, B., Jr., "American Painting Since 1900," *Phoenix: Maandschrift voor Bildende Kunst*, iv (1949), 85-111.

Whitney Museum of American Art, New York, *Juliana Force and American Art: A Memorial Exhibition, Sept. 24-Oct. 30, 1949.* New York, Whitney Museum of American Art, 1949.

Wight, F. S., *Milestones of American Painting in Our Century.* Boston, Institute of Contemporary Art; New York, Chanticleer Press, 1949.

206

1950. Flexner, J. T., *A Short History of American Painting.* Boston, Houghton Mifflin Co., 1950.

Myers, B. S., *Modern Art in the Making.* New York etc., McGraw-Hill Book Co., Inc., 1950, 383-406.

1951. Baur, J. I. H., *Revolution and Tradition in Modern American Art.* Cambridge, Mass., Harvard University Press, 1951, *The Library of Congress Series in American Civilization.*

McCausland, E., "The Daniel Gallery and Modern American Art," *Magazine of Art,* xliv (Nov. 1951), 280-285.

Motherwell, R. (editor), *The Dada Painters and Poets: An Anthology.* New York, Wittenborn, Schultz, Inc., 1951.

Riegner, H., "Die amerikanische Malerei den letzten fünfzig Jahre," *Werk,* xxxviii (Apr. 1951), 116-128.

Ritchie, A. C., *Abstract Painting and Sculpture in America.* New York, Museum of Modern Art, 1951.

Robb, D. M., *The Harper History of Painting: The Occidental Tradition.* New York, Harper and Brothers (c. 1951), 892-943.

II. TOPICAL

BACKGROUND

1910. Knauft, E., "Art Activities in the United States," *American Review of Reviews,* xli (Jan. 1910), 49-59.

Hartmann, S., "The American Picture World, its Shows and Shams," *Forum,* xliv (Sept. 1910), 295-304.

1922. Stearns, H. E. (editor), *Civilization in the United States; An Inquiry by Thirty Americans.* New York, Harcourt, Brace and Co., 1922.

1925. Kreymborg, A., *Troubadour; An Autobiography.* New York, Boni and Liveright, 1925.

Myers, G., *The History of American Idealism.* New York, Boni and Liveright, 1925, chaps. 11-14.

1927. Siegfried, A., *America Comes of Age,* translated by H. H. Hemming and D. Hemming. New York, Harcourt, Brace and Co., 1927.

Sullivan, M., *Our Times; The United States, 1900-1925.* New York, etc., Charles Scribner's Sons, 1927-1935, 6 vols.

1928. Mazur, P. M., *American Prosperity; Its Causes and Consequences.* New York, Viking Press, 1928.

Merz, C., *The Great American Bandwagon.* New York, Literary Guild of America, 1928.

1929. Frank, W. D., *Rediscovery of America; An Introduction to a Philosophy of American Life.* New York, London, Charles Scribner's Sons, 1929.

1930. Anderson, M. C., *My Thirty Years' War.* New York, Covici, Friede; London, A. A. Knopf, 1930.

Hapgood, N., *The Changing Years; Reminiscences of Norman Hapgood.* New York, Farrar and Rinehart, 1930.

Josephson, M., *Portrait of the Artist as American.* New York, Harcourt, Brace and Co. (c. 1930).

Sayler, O. M., *Revolt in the Arts; A Survey of the Creation, Distribution, and Appreciation of Art in America.* New York, Brentano's (c. 1930).

1931. Huddleston, S., *Back to Montparnasse; Glimpses of Broadway in Bohemia.* Philadelphia, London, J. B. Lippincott Co., 1931.

Schmalhausen, S. D. (editor), *Behold America.* New York, Farrar and Rinehart, 1931.

1933. Parry, A., *Garrets and Pretenders; A History of Bohemianism in America.* New York, Covici, Friede, 1933.

1934. Cowley, M., *Exiles Return; A Narrative of Ideas.* New York, W. W. Norton and Co. (c. 1934).

Frank, W., and L. Mumford, D. Norman, P. Rosenfeld, H. Rugg, *America and Alfred Stieglitz: A Collective Portrait.* Garden City, N.Y., Doubleday, Doran and Co., Inc., 1934.

1935. Cournos, J., *Autobiography.* New York, G. P. Putnam's Sons, 1935.

Jackson, J. H., *The Post War World: A Short Political History, 1918-1934.* London, V. Gollancz, Ltd., 1935, 389-407.

1936. Agar, H., *What is America.* London, Eyre and Spottiswoode, 1936.

Luhan, M. D., *Movers and Shakers.* New York, Harcourt, Brace and Co. (c. 1936).

1938. Davidson, D., *The Attack on Leviathan; Regionalism and Nationalism in the United*

States. Chapel Hill, University of North Carolina Press, 1938.

Pach, W., *Queer Thing, Painting; Forty Years in the World of Art*. New York, London, Harper and Bros., 1938.

Stearns, H. E. (editor), *America Now; An Inquiry into Civilization in the United States by Thirty-six Americans*. New York, Charles Scribner's Sons, 1938.

White, W. A., *A Puritan in Babylon; The Story of Calvin Coolidge*. New York, Macmillan Co., 1938.

1939. Hapgood, H., *A Victorian in the Modern World*. New York, Harcourt, Brace and Co., 1939.

1940. Branston, R., and J. Stuart, *The Fat Years and the Lean*. New York, Modern Age Books (c. 1940).

1942. Kazin, A., *On Native Grounds; An Interpretation of Modern American Prose Literature*. New York, Reynal and Hitchcock (c. 1942).

1946. McBride, H., *Florine Stettheimer*. New York, Museum of Modern Art, 1946.

NEW YORK REALISTS (General)

1900. Armstrong, R., "New Leaders in American Illustration, part IV: The Typists: McCarter, Yohn, Glackens, Shinn and Luks," *Bookman*, XI (May 1900), 244-251.

1908. Edgerton, G., "The Younger American Painters: Are They Creating a National Art?" *Craftsman*, XIII (Feb. 1908), 512-532.

1909. "Foremost American Illustrators: Vital Significance of Their Work," *Craftsman*, XVII (Dec. 1909), 266-280.

1911. Baury, L., "Message of Bohemia," *Bookman*, XXXIV (Nov. 1911), 256-266.

Baury, L., "Message of the Proletaire," *Bookman*, XXXIV (Dec. 1911), 399-413.

1915. Cournos, J., "Three Painters of the New York School," *International Studio*, LVI (Oct. 1915), 239-246.

du Bois, G. P., "Despotism and Anarchy in Art," *Arts and Decoration*, V (Jan. 1915), 97-98, 114.

1916. Mather, F. J., Jr., "Some American Realists," *Arts and Decoration*, VII (Nov. 1916), 13-16.

Gallatin, A. E., *Certain Contemporaries*. New York, J. Lane Co., 1916.

1922. Ely, C. B., "The Modern Tendency in Henri, Sloan, and Bellows," *Art in America*, X (Apr. 1922), 132-143.

1925. Ely, C. B., *The Modern Tendency in American Painting*. New York, F. F. Sherman, 1925.

1937. Whitney Museum of American Art, New York, *New York Realists, 1900-1914*. New York, Whitney Museum of American Art, 1937.

1943. Brooklyn Institute of Arts and Sciences, The Brooklyn Museum, Brooklyn, N.Y., *The Eight*. Brooklyn, N.Y., Brooklyn Museum Press, 1943.

1944. Pach, W., "The Eight Then and Now," *Art News*, XLII (Jan. 1-14, 1944), 25, 31.

1945. Philadelphia Museum of Art, Philadelphia, "Artists of the Philadelphia Press," *Philadelphia Museum Bulletin*, XLI (Nov. 1945).

1946. Read, H. A., *Robert Henri and Five of His Pupils. Loan exhibition of paintings, Apr. 5-June 1, 1946*. New York, Century Association, 1946.

STIEGLITZ AND "291"

1903. *Camera Work: A Photographic Quarterly*. New York, A. Stieglitz, 1903-1917.

1915. "Who's Who in American Art—Alfred Stieglitz," *Arts and Decoration*, V (Apr. 1915), 235.

291. New York, 1915-1916.

1922. *Manuscripts*. New York, C. S. Nathan, Inc., 1922-1923.

1924. Rosenfeld, P., *Port of New York*. New York, Harcourt, Brace and Co. (c. 1924), 237-279.

1934. Frank, W., L. Mumford, D. Norman, P. Rosenfeld, and H. Rugg. *America and Alfred Stieglitz*. Garden City, N.Y., Doubleday Doran and Co., Inc., 1934.

1935. Benton, T. H., "America and/or Alfred Stieglitz," *Common Sense*, IV (Jan. 1935), 22-24.

1938. *Twice a Year; A Semi-annual Journal of Literature, the Arts, and Civil Liberties*. New York, 1938 to date.

1944. Philadelphia Museum of Art, Philadelphia, *History of an American: "291" and after; selections from the Stieglitz Collection*. Philadelphia, Philadelphia Museum of Art (c. 1944).

1945. Philadelphia Museum of Art, Philadelphia, "An American Collection," *Philadelphia*

Museum Bulletin, xl (May 1945).

1947. Larkin, O., "Alfred Stieglitz and '291,'" *Magazine of Art,* xl (May 1947), 179-183.

Norman, D., "Was Stieglitz a Dealer?" *Atlantic Monthly,* clxxix (May 1947), 22-23.

Norman, D., "In Memoriam: six happenings (and a conversation recorded by Dorothy Norman)," *Twice a Year,* no. 14-15 (1947), 188-202.

Norman, D. (editor), *Stieglitz Memorial Portfolio: 1864-1946. Reproductions of 18 photographs by Alfred Stieglitz. Tributes in Memoriam.* New York, Twice a Year Press, 1947.

ARMORY SHOW

1913. "An Art Awakening," *American Art News,* xi (Mar. 15, 1913), 4.

"An Opportunity to Study New Art Tendencies," *Outlook,* ciii (Mar. 1, 1913), 466-467.

"Art Revolutionists on Exhibition in America," *American Review of Reviews,* xlvii (Apr. 1913), 441-448.

Association of American Painters and Sculptors, *Catalogue of International Exhibition of Modern Art, at the Armory of the Sixty-Ninth Infantry, Feb. 15 to Mar. 15, 1913.* New York, n.p., 1913.

"Bedlam in Art," *Current Opinion,* liv (Apr. 1913), 316-317.

Brinton, C., "Evolution not Revolution in Art," *International Studio,* xlix (Apr. 1913), xxvii-xxxv.

Brinton, C., "Fashions in Art—Modern Art," *International Studio,* xlix (Mar. 1913), ix-x.

Cortissoz, R., "The Post-Impressionist Illusion," *Century Magazine,* lxxxv (Apr. 1913), 805-815.

Cox, K., "The Modern Spirit in Art," *Harper's Weekly,* lvii (Mar. 15, 1913), 10.

(Davies, A. B.), "Chronological Chart Made by Arthur B. Davies Showing the Growth of Modern Art," *Arts and Decoration,* iii (Mar. 1913), 150.

Davies, A. B., "Explanatory Statement: The Aim of the A. A. P. S.," *Arts and Decoration,* iii (Mar. 1913), 149.

Dodge, M., "Speculations, or Post-Impressionism in Prose," *Arts and Decoration,* iii (Mar. 1913), 172, 174.

du Bois, G. P., "The Spirit and the Chronology of the Modern Movement," *Arts and Decoration,* iii (Mar. 1913), 151-154, 178.

Fisher, W. M., "Sculpture at the Exhibition," *Arts and Decoration,* iii (Mar. 1913), 168-169.

Gregg, F. J., "A Remarkable Art Show," *Harper's Weekly,* lvii (Feb. 15, 1913), 13-16.

Gregg, F. J., "The Attitude of the Americans," *Arts and Decoration,* iii (Mar. 1913), 165-167.

G(regg), F. J., "The Extremists: An Interview with Jo Davidson," *Arts and Decoration,* iii (Mar. 1913), 170-171, 180.

"Lawlessness in Art," *Century,* lxxxvi (May 1913), 150.

Mather, F. J., Jr., "Newest Tendencies in Art," *Independent,* lxxiv (Mar. 6, 1913), 504-512.

Mather, F. J., Jr., "Old and New Art," *Nation,* xcvi (Mar. 6, 1913), 240-243.

McColl, W. D., "The International Exhibition of Modern Art," *Forum,* l (July 1913), 24-36.

Meltzer, C. H., "New York Sees Things," *Hearst's Magazine,* xxiii (Apr. 1913), 635-636.

"Mob as Art Critic," *Literary Digest,* xlvi (Mar. 29, 1913), 708-709.

"New Tendencies in Art," *American Review of Reviews,* xlviii (Aug. 1913), 245.

Pattison, J. W., "Art in an Unknown Tongue," *Fine Arts Journal,* xxvii-xxix (May 1913), 293-307.

Phillips, D., "Revolutions and Reactions in Painting," *International Studio,* li (Dec. 1913), cxxiii-cxxix.

Quinn, J., "Modern Art from the Layman's Point of View," *Arts and Decoration,* iii (Mar. 1913), 155-158, 176.

Roberts, M. F., "Science in Art, as Shown in the International Exhibition of Painting and Sculpture," *Craftsman,* xxiv (May 1913), 216-218.

Roosevelt, T., "A Layman's View of an Art Exhibition," *Outlook,* ciii (Mar. 29, 1913), 718-720.

Simons, T. LeF., "The New Movement in Art: From a Philosophic Standpoint," *Arts*

and Decoration, III (Apr. 1913), 214.

"The American Section; The National Art; An Interview with the Chairman of the Domestic Committee, William J. Glackens," *Arts and Decoration,* III (Mar. 1913), 159-164.

"The Greatest Exhibition of Insurgent Art Ever Held," *Current Opinion,* LIV (Mar. 1913), 230-232.

1914. Alexander, J. W., "Is Our Art Distinctively American?" *Century,* LXXXVII (Apr. 1914), 826-828.

Blashfield, E. H., "The Painting of Today," *Century,* LXXXVII (Apr. 1914), 837-840.

Blumenschein, E. L., "The Painting of Tomorrow," *Century,* LXXXVII (Apr. 1914), 845-850.

Cox, K., "Artist and Public," *Scribner's Magazine,* LV (Apr. 1914), 512-520.

Hambidge, J., and G. Hambidge, "The Ancestry of Cubism," *Century,* LXXXVII (Apr. 1914), 869-875.

Pach, W., "The Point of View of the Moderns," *Century,* LXXXVII (Apr. 1914), 851-864.

S(tein), L., "Panic in Art," *New Republic,* I (Nov. 7, 1914), 20-21.

"This Transitional Age in Art," *Century,* LXXXVII (Apr. 1914), 825-875.

1915. "European Art Invasion," *Literary Digest,* LI (Nov. 27, 1915), 1224-25.

1938. Kuhn, W., *The Story of the Armory Show.* New York, W. Kuhn (c. 1938).

1939. Kuhn, W., "The Story of the Armory Show," *Art News Annual,* XXXVII (1939), 63-64, 168-174.

1943. Mellquist, J., "The Armory Show 30 Years Later," *Magazine of Art,* XXXVI (Dec. 1943), 298-301.

AFTERMATH

PANAMA-PACIFIC EXPOSITION

1915. Brinton, C., "American Painting at the Panama-Pacific Exposition," *International Studio,* LVI (Aug. 1915), xxv-xxxii.

Brinton, C., "Exhibition Defeating Itself," *Literary Digest,* LI (Aug. 1915), 404-405.

Brinton, C., "Foreign Painting at the Panama-Pacific Exposition," *International Studio,* LVI (Sept.-Oct. 1915), xlvii-liv, lxxxix-xcvi.

Laurvik, J. N., and J. E. D. Trask (editors), *Catalogue de Luxe of the Department of Fine Arts, Panama-Pacific International Exposition.* San Francisco, Paul Elder and Co. (c. 1915).

1916. Brinton, C., *Impressions of the Art at the Panama-Pacific Exposition.* New York, John Lane Co., 1916.

Parker, E. S., "An Analysis of Futurism," *International Studio,* LVII (Apr. 1916), lix-lx.

FORUM EXHIBITION

1915. Wright, W. H., "The Truth about Painting," *Forum,* LIV (Oct. 1915), 443-454.

1916. Anderson Galleries, New York, *The Forum Exhibition of Modern American Painters, Mar. 13 to Mar. 25, 1916.* New York, M. Kennerley, 1916.

Buchanan, C. L., "Paint and Progress," *International Studio,* LVIII (June 1916) cxii-cxv.

Mather, F. J., Jr., "Forum Exhibition," *Nation,* CII (Mar. 23, 1916), 340.

Weichsel, J., "Another New Art Venture: The Forum Exhibition," *International Studio,* LVIII (June 1916) cxv-cxvii.

Wright, W. H., "Forum Exhibition at the Anderson Galleries," *Forum,* LV (Apr. 1916), 457-471.

INDEPENDENTS' EXHIBITION

1917. "Art Exhibition with a Punch," *Literary Digest,* LIV (June 9, 1917), 1780-1781.

"Attempt to Abolish Juries and Prizes for Works of Art," *Current Opinion,* LXII (Mar. 1917), 202.

Catalogue of the First Annual Exhibition of the Society of Independent Artists, Grand Central Palace, from Apr. 10 to May 6. New York, Society of Independent Artists, Inc., 1917.

"Duchamps Resigns from 'Independents,'" *American Art News,* XV (Apr. 14, 1917), 1.

Glackens, W. J., "The Biggest Art Exhibition in America and, incidentally, the War," *Touchstone,* I (June 1917), 164-173.

Henri, R., "The 'Big Exhibition,' the Artist and the Public," *Touchstone,* I (June 1917), 174-177.

M., L., "The Independents' Exhibition," *American Magazine of Art,* VIII (June 1917), 323-324.

"Mobilizing the Artists of America in a Democratic Paint Circus," *Current Opinion,* LXII (June 1917), 423-424.

210

Simonson, L., "The Painters' Ark," *The Seven Arts*, II (June 1917), 202-213.

MISCELLANEOUS

1921. *A Protest against the Present Exhibition of Degenerate "Modernistic" Works in the Metropolitan Museum of Art,* signed: a Committee of Citizens and Supporters of the Museum. (New York), (c. 1921).

Brooklyn Museum, Brooklyn, N.Y., *Painting by Modern French Masters Representing the Post Impressionists and Their Predecessors.* Brooklyn, N.Y., Brooklyn Museum Press, 1921.

Metropolitan Museum of Art, New York, *Loan Exhibition of Impressionist and Post-Impressionist Paintings.* New York, Metropolitan Museum of Art, 1921.

Worcester Art Museum, Worcester, Mass., *Exhibition of Paintings by Members of the Société Anonyme.* Worcester, Mass., Worcester Art Museum, 1921.

1924. Veritas, *Bolshevism in Art and Its Propagandists.* New York, Veritas Publishing Co., 1924.

WAR YEARS

1915. "Artistic Inspiration of the War," *International Studio*, LVII (Nov. 1915), 76.

Galsworthy, J., "Art and the War," *Atlantic Monthly*, CXVI (Nov. 1915), 624-628.

Mortimer-Lamb, H., "Canadian Artists and the War," *International Studio*, LVI (Oct. 1915), 259-264.

Senseney, G., "The Effect of this War on Art," *Arts and Decoration*, V (Mar. 1915), 175-177, 204.

" 'War' by Young Sculptors," *American Art News*, XIII (May 1, 1915), 2.

1916. "Aero Club's Defense Posters," *American Art News*, XIV (Mar. 18, 1916), 1.

"German View of War and Art," *Literary Digest*, LIII (July 1916), 71.

Harrison, B., "Art and the European War," *Art and Progress*, VII (May 1916), 270-272.

Price, C. M., "The Opportunity of the Poster," *Arts and Decoration*, VI (Aug. 1916), 467.

"What Art Pays for War," *Literary Digest*, LIII (Apr. 1916), 1063.

1917. Bailey, V. H., Drawings and Lithographs of

War Work in America. New York, Arthur H. Hahlo and Co., 1917.

Exhibition of War Posters of the Allied Nations for the Benefit of the American Red Cross. New York, Arden Gallery, 1917.

"Munitions Work: Sixteen Full-page Pictures of Mr. Joseph Pennell," *The Times History and Encyclopedia of War.* London, 1917, X, 321-324.

Newark Free Public Library, Newark, N.J., *Posters and American War Posters: Historical and Explanatory.* Newark, N.J., The Free Public Library, 1917.

Smith, J. A., "Notes on Camouflage," *Architectural Record*, XLII (Nov. 1917), 468-477.

Smithsonian Institution, National Collection of Fine Arts, Washington, D.C., *Catalogue of an Exhibition of Lithographs of War Work in Great Britain and the United States by Joseph Pennell.* Washington, D.C., Government Printing Office, 1917.

1918. American Art Association, *Allied War Salon, Dec. 9-Dec. 24, 1918,* introduction by A. E. Gallatin. New York, American Art Galleries, 1918.

Carnegie Institute, Department of Fine Arts, Pittsburgh, *Pictures of the Great War: An Exhibition of Drawings, Paintings and Prints, including United States Official Drawings.* Pittsburgh, Carnegie Institute, 1918.

Cornelius, Capt. J. R., "The Value of Landscape Targets, Their Use in Musketry," *Scribner's Magazine*, LXIV (Oct. 1918), 433-440.

Embury, A., "Nature's Camouflage and Man's," *New Country Life*, XXXIV (June 1918), 26-40.

Holliday, R. C., "Posing the War for the Painter," *Bookman*, XLVII (July 1918), 512-516.

McCormick, W. B., "Unmasking the Museum Conspirators," *Chronicle* IV (Oct. 1918).

McDonald, H. A., "The Story of the War Posters," *Sea Power*, V (Aug. 1918), 92-95.

Moses, M. J., "Making Posters Fight," *Bookman*, XLVII (July 1918), 504-513.

Pennell, J., *Joseph Pennell's Pictures of War Work in America: Reproductions of a Series of Lithographs of Munitions Works Made by Him with the Permission and Authority*

of the U. S. Government. Philadelphia, J. B. Lippincott Co., 1918.

Phillips, D., "Art and the War," *American Magazine of Art*, IX (June 1918), 303-308.

Phillips, D., "The Heroic Soul of France: Lucien Jonas' War Lithographs," *American Magazine of Art*, IX (Oct. 1918), 497-503.

Price, C. M., "The Artists' Call to Colors: The Opportunity of the Poster," *Art World and Arts and Decoration*, VIII (July 1918), 155-157.

Price, C. M., and H. Brown, *How to Put in Patriotic Posters the Stuff that Makes People Stop—Look—Act!* Washington, D.C., National Committee of Patriotic Societies, 1918.

Recruiting Posters: Issued by the United States Navy since the Declaration of War. Press, U. S. Navy Recruiting Bureau, 1918.

Rihani, A. F., "Artists in Wartime," *International Studio*, LXVI (Dec. 1918), xxix-xxxvii.

Street, J., "Our Fighting Posters," *McClure's Magazine*, LI (July 1918), 12-13, 34.

"What Is the Matter with American Art," *Art World and Arts and Decoration*, VIII (May 1918), 5.

Wyer, R., "Germany and Art," *International Studio*, LXVI (Dec. 1918), xli-xlii.

1919. "Art at the Peace Table," *New York Tribune* (Jan. 5, 1919), part II, 1.

Buchanan, C. L., "Nationalism and American Painting," *International Studio*, LXVII (Mar. 1919), x-xv.

Carnegie Institute, Department of Fine Arts, Pittsburgh, *Pictures of the Great War: An Exhibition of Drawings, Paintings and Prints, including United States Official Drawings, Jan. 9-31, 1919.* Pittsburgh, Carnegie Institute (c. 1919).

Cortissoz, R., "How Germany Can Pay in Terms of Art," *New York Tribune* (Jan. 5, 1919), part V, 7.

Foster, W., "A Day with a Sketch Book on the Front," Illustrations from the Author's Sketches, *Scribner's Magazine*, LXV (Apr. 1919), 449-455.

Gallatin, A. E., "American Artists and the War," *Valentine's Manual of the City of New York*, III (1919), 250-262.

Gallatin, A. E., *Art and the Great War.* New York, E. P. Dutton and Co., 1919.

Glass, C., "Practical Patriotism in American Art," *Art and Life*, x (June 1919), 295-297.

Harding, Capt. G., "The American Artist at the Front," *American Magazine of Art*, x (Oct. 1919), 451-456.

Malleterre, General, "How the War Was Won," illustrated by L. G. Hornby, *Harper's Magazine*, CXXXVIII (Mar. 1919), 433-445 (Apr. 1919), 598-612.

Parker, J. F., "Art and the Great War," *International Studio*, LXIX (Nov. 1919), xli-xlvi.

Phillips, D., "The Allied War Salon," *American Magazine of Art*, x (Jan. 1919), 115-123.

Rihani, A. F., "Artists in Wartime," *International Studio*, LXVIII (July 1919), iii-ix.

United States Public Information Committee, *Victory Dinner and Dance of the Division of Pictorial Publicity, Feb. 14, 1919, Hotel Commodore.* New York, 1919.

1920. Hardie, M., and A. K. Sabin, *War Posters Issued by Belligerent and Neutral Nations, 1914-1919.* London, A. and C. Black, Ltd., 1920.

Special Exhibition of Sculpture: A Plastic History of the War, by Jo Davidson, Apr.-May 1920. New York, Henry Reinhardt and Son, 1920.

1921. National Art Committee, *Exhibition of War Portraits; Signing of the Peace Treaty, 1919, and Portraits of Distinguished Leaders of America and of the Allied Nations Painted by Eminent American Artists for Presentation to the National Portrait Gallery.* Washington, D.C., National Gallery of Art (c. 1921).

1922. Pag, H., "War and Art," *Art Review*, I (Aug. 1922), 6, 25.

1931. Slosson, P. W., *The Great Crusade—And After, 1914-1928.* New York, Macmillan Co., 1931.

1944. Kirstein, L., *American Battle Painting, 1776-1918.* Washington, D.C., National Gallery of Art, 1944.

PSEUDO-SCIENTIFIC THEORY

1876. Bezold, W. von, *Theory of Color in its Relation to Art and Art Industry*, translated by S. R. Koehler. Boston, L. Prang and Co., 1876.

1905. Frackelton, S. S., "Our American Potteries:

Maratta's and Albert's work at the Gates Potteries," *Sketch Book*, v (Oct. 1905), 73-80.

1907. Ross, D. W., *A Theory of Pure Design*. New York, Peter Smith, 1907.

1912. Rimington, A. W., *Colour Music*. London, Hutchinson and Co., 1912.

Ross, D. W., *On Drawing and Painting*. Boston, New York, Houghton Mifflin Co., 1912.

1913. Keller, H. G., and J. J. R. Macleod, "Application of the Physiology of Color Vision in Modern Art," *Popular Science*, LXXXIII (Nov. 1913), 450-465.

1914. Maratta, H. G., "A Rediscovery of the Principles of Form Measurement," *Arts and Decoration*, IV (Apr. 1914), 230-232.

1918. Luckiesh, M., *The Language of Color*. New York, Dodd, Mead and Co., 1918.

1919. Hambidge, J. (editor), *The Diagonal*, New Haven, Conn., Yale University Press, 1919-1920.

Hambidge, J., *Dynamic Symmetry*. Boston, n.p., 1919.

Hambidge, J., "Symmetry and Proportion in Greek Art," *American Architect*, CXVI (1919), 597-605.

Ross, D. W., *The Painter's Palette; A Theory of Tone Relations; An Instrument of Expression*. Boston, New York, Houghton Mifflin Co., 1919.

1920. Hambidge, J., *Dynamic Symmetry: The Greek Vase*. New Haven, Yale University Press (c. 1920).

Hambidge, J., "Greek Design," *Journal of the Royal Institute of British Architects*, XXVII (1920), 213-223.

Maratta, H. G., "Colors and Paints," *Touchstone*, VII (June 1920), 249-250.

1921. Armfield, M., "Dynamic Symmetry and its Practical Value Today," *International Studio*, LXXIV (Nov. 1921), lxxvi-lxxxiv.

Blake, E. M., "Dynamic Symmetry: A Criticism," *Art Bulletin*, III (Mar. 1921), 107-127.

Carpenter, R., "Dynamic Symmetry: A Criticism," *American Journal of Archaeology*, XXV (1921), 18-36.

Winstanley, J., "The Modern Merlin and His Palette Recipes," *International Studio*, LXXIII (Apr. 1921), lix-lxii.

1922. Caskey, L. D., *Geometry of Greek Vases: Attic Vases in the Museum of Fine Arts Analyzed According to the Principles of Proportion Discovered by Jay Hambidge*. Boston, Museum of Fine Arts, 1922.

Pope, A., *Tone Relations in Painting*. Cambridge, Harvard University Press, 1922.

Richter, G. M. A., "Dynamic Symmetry from the Designer's Point of View," *American Journal of Archaeology*, XXVI (1922), 59-73.

1923. Eisen, G. A., *The Great Chalice of Antioch, on Which Are Depicted in Sculpture the Earliest Known Portraits of Christ, Apostles and Evangelists*. New York, Kouchakji Frères, 1923, 2 vols.

Hambidge, J., *Dynamic Symmetry in Composition, as Used by the Artists*. New York, Brentano's (c. 1923); Cambridge, Mass., The Author, 1923.

1924. Hambidge, J., *The Parthenon and other Greek Temples: Their Dynamic Symmetry*. New Haven, Yale University Press, 1924.

1925. Richter, G. M. A., *Dynamic Symmetry as Applied to Pottery*. Columbus, O., American Ceramic Society, 1925.

1926. Hambidge, J., *The Elements of Dynamic Symmetry*. New York, Brentano's (c. 1926).

Jacobs, M., *The Art of Composition; A Simple Application of Dynamic Symmetry*. Garden City, N.Y., Doubleday, Page and Co., 1926.

1927. Sargent, F. L., *A Working System of Colour*. New York, Henry Holt and Co., 1927.

1929. Pope, A., *An Introduction to the Language of Drawing and Painting*. Cambridge, Mass., Harvard University Press, 1929, I: *The Painter's Terms*.

1932. Hambidge, J., *Practical Applications of Dynamic Symmetry*, edited by M. Hambidge. New Haven, Yale University Press; London, H. Milford, Oxford University Press, 1932.

1936. Fletcher, F. M., *Colour Control*. London, Faber and Faber, Ltd., 1936.

III. PERSONALITIES

A. CRITICS

GENERAL

1911. Hyslop, T. B., "Post-Illusionism and Art in the Insane," *Nineteenth Century*, LXIX (Feb. 1911), 270-281.

1913. "Art and Insanity in the Light of an Exhibi-

213

tion of Pictures by Lunatics," *Current Opinion*, LV (Nov. 1913), 340.

1914. Blashfield, E. H., "The Painting of Today," *Century*, LXXXVII (Apr. 1914), 837-840.

1915. du Bois, G. P., "Despotism and Anarchy in Art: The Symbolism Dedicated to the Future and the Realism of the Present," *Arts and Decoration*, V (Jan 1915), 95-98, 114.

Dow, A. W., "Talks on Art Appreciation," *Delineator*, LXXXVI (Jan. 1915), 15; LXXXVI (Apr. 1915), 14-15; LXXXVII (July 1915), 15; LXXXVIII (Feb. 1916), 15.

"Is it a Craze?" *American Art News*, XIII (Mar. 27, 1915), 4.

"The European Art-Invasion," *Literary Digest*, LI (Nov. 27, 1915), 1224.

De Zayas, M., "Modern Art: Theories and Representations," *Forum*, LIV (Aug. 1915), 221-230.

1916. Lippmann, W., "Lost Theme," *New Republic*, V (Apr. 8, 1916), 258-260.

Pach, W., "Modern Art Today," *Harper's Weekly*, LXII (Apr. 29, 1916), 470-471.

De Zayas, M., "Cubism?" *Arts and Decoration*, VI (Apr. 1916), 284-286, 308.

1917. Beckwith, C., "Our Younger Brother in Art; An Open Letter," *American Magazine of Art*, VIII (June 1917), 328.

Daingerfield, E., "A Criticism of the Ultra in Art," *American Magazine of Art*, VIII (June 1917), 328-329.

Dow, A. W., "Modernism in Art," *American Magazine of Art*, VIII (Jan. 1917), 113-116.

"Frightfulness in Art," *American Magazine of Art*, VIII (Apr. 1917), 244-245.

Maxwell, E. C., "Nationalism and the Art of the Future," *International Studio*, LXII (Sept. 1917), lxxvi-lxxviii.

1918. Borglum, G., "The Revolt in Art; Insurgency or the Modern Spirit in Aesthetics," *Lotus Magazine*, IX (Feb. 1918), 215-217.

Hamilton, A. M., "Insane Art," *Scribner's Magazine*, LXIII (Apr. 1918), 484-492.

Hudnut, A. M., "Tendencies of Modern Art," *International Studio*, LXIV (June 1918), cxviii-cxix.

Winans, W., "The Ugly Side of the Cubist-Futurist-Vorticist Craze," *Lotus Magazine*, IX (Feb. 1918), 217-221.

1919. Dosch, R., "The Optimist and the Modern Art Movement," *International Studio*, LXIX

(Dec. 1919), lxi-lxv.

Whittemore, T., "The Bolshevist and the Cubist," *Touchstone*, IV (Jan. 1919), 318-321.

1920. Rosenberg, J. N., "Ghosts—The Exhibition of the New Society," *International Studio*, LXXII (Dec. 1920), lxi-lxii.

1924. Peets, O. H., "Paris and the Creation of an American Art," *American Magazine of Art*, XV (Aug. 1924), 418-420.

1926. Adams, A., "Of Gains Tossed Aside," *American Magazine of Art*, XVII (Sept. 1926), 488-490.

1929. Braum, J. F., "Why Nationalism in Art," *American Magazine of Art*, XX (Oct. 1929), 569-570.

CHRISTIAN BRINTON

1900. *St. Nicholas*, Apr. 1900-June 1900.
Critic, 1900-1904.

1904. *Century*, 1904-1912.

1905. *Bookman*, 1905-1908.
Harper's Monthly Magazine, 1905-1910.
International Studio, 1905-1923.

1906. *Scribner's Magazine*, 1906-1917.

1907. *Putnam's Magazine*, 1907-1909.

1909. *Craftsman*, 1909-1910.

1911. *Woman's Home Companion*, Apr. 1911-Oct. 1911.

1913. "Evolution not Revolution in Art," *International Studio*, XLIX (Apr. 1913), xxvii-xxxv.
"Fashions in Art—Modern Art," *International Studio*, XLIX (Mar. 1913), ix-x.

1915. "American Painting at the Panama-Pacific Exposition," *International Studio*, LVI (Aug. 1915), xxv-xxxii.
"Exhibition Defeating Itself," *Literary Digest*, LI (Aug. 1915), 404-405.
"Foreign Painting at the Panama-Pacific Exposition," *International Studio*, LVI (Sept. 1915), xlvii-liv (Oct. 1915), lxxxix-xcvi.

1916. *Impressions of the Art at the Panama-Pacific Exposition and an Introductory Essay on the Modern Spirit in Contemporary Painting*. New York, J. Lane Co., 1916.

1921. "Modernism in Museums," *Arts and Decoration*, XVI (Dec. 1921), 146.

1926. *Modern Art at the Sesqui-Centennial Exhibition*. New York, Société Anonyme, Inc., Museum of Modern Art, 1926.

214

1930. "Plight of Painting," *Country Life*, LVIII (May 1930), 35-39.

JAMES BRITTON

1913. *American Art News*, 1913-1919.
1919. *Art Review International* (editor), May 1919-Oct. 1919.

CHARLES H. CAFFIN

1897. *Harper's Weekly*, 1897-1901, 1907-1909.
1900. *Harper's Monthly Magazine*, 1900-1916.
1901. *International Studio*, 1901-1905, 1917.
 The Sun, New York, 1901-1904.
 World's Work, 1901-1906.
1903. *Critic*, 1903-1905.
1904. *St. Nicholas*, 1904-1905, 1909.
1905. *American Magazine*, 1905-1906.
1907. "American Illustration," *Independent*, LXIII (Nov. 21, 1907), 1217-1219.
 Putnam's Magazine, Nov. 1907-Dec. 1907.
 The Story of American Painting. The Evolution of Painting in America from Colonial Times to the Present. New York, F. A. Stokes Co. (c. 1907).
1908. "Beginning and Growth of Mural Painting in America," *Bookman*, XXVIII (Oct. 1908), 127-139.
 Century, 1908, 1916-1919.
1910. "Certain Criticism of Art in America," *North American Review*, CXCI (June 1, 1910), 785-794.
1913. *New York American*, 1913-1918.
1914. *How to Study Modern Painters; By Means of a Series of Comparisons of Paintings and Painters from Watteau to Matisse, with Historical and Biographical Summaries and Appreciations of the Painter's Motives and Methods.* London, Hodder and Stoughton (c. 1914).

ROYAL CORTISSOZ

1892. *The New York Tribune*, 1892-1924.
1903. *Atlantic Monthly*, 1903-1906.
 North American Review, 1903-1904.
 Scribner's Magazine, 1903-1912, 1922-1930.
1904. *Lamp*, Apr. 1904-Nov. 1904.
1905. *Outlook*, 1905-1907.
1911. *Century*, 1911-1913.
1913. *Art and Common Sense.* New York, Charles Scribner's Sons, 1913.
 "The Post-Impressionist Illusion," *Century Magazine*, LXXXV (Apr. 1913), 805-815.

1923. *American Artists.* New York, London, Charles Scribner's Sons, 1923.
1924. *The New York Herald Tribune*, New York, 1924-1948.
1925. *Personalities in Art.* New York, London, Charles Scribner's Sons, 1925.
1928. *International Studio*, 1928-1929.
1930. *The Painter's Craft.* New York, London, Charles Scribner's Sons, 1930.
1931. *Arthur B. Davies.* New York, Whitney Museum of American Art, 1931, *American Artists Series*.
 Guy Pène du Bois. New York, Whitney Museum of American Art, 1931, *American Artists Series*.

KENYON COX

1903. *Architectural Record*, 1903-1909.
 Nation, 1903-1917.
1904. *Century*, 1904, 1911-1913.
 Scribner's Magazine, 1904-1917.
1905. *Old Masters and New. Essays in Art Criticism.* New York, Fox, Duffield and Co., 1905.
1907. *Painters and Sculptors. A Second Series of Old Masters and New.* New York, Duffield and Co., 1907.
1911. *The Classic Point of View.* New York, Charles Scribner's Sons, 1911.
1913. "The 'Modern' Spirit in Art," *Harper's Weekly*, LVII (Mar. 15, 1913), 10.
 "The New Art 'Movement,'" *American Art News*, XI (Mar. 22, 1913), 6.
1914. "Artist and Public," *Scribner's Magazine*, LV (Apr. 1914), 512-520.
 Artist and Public, and Other Essays on Art Subjects. New York, Charles Scribner's Sons, 1914.
1916. *Art World*, 1916-1917.
1917. *Concerning Painting, Considerations Theoretical and Historical.* New York, Charles Scribner's Sons, 1917.

J. N. LAURVIK

1908. *Century*, 1908, 1915-1916.
 International Studio, 1908-1912.
1911. *Woman's Home Companion*, 1911-1914.
1912. "The Water Colors of John Marin," *Camera Work*, no. 39 (July 1912), 36-38.
1913. *Is it Art? Post-Impressionism, Futurism, Cubism.* New York, International Press, 1913.
1915. Laurvik, J. N., and J. E. D. Trask (editors),

Catalogue De Luxe of the Department of Fine Arts, Panama-Pacific Exposition. San Francisco, Paul Elder and Co. (c. 1915).

"Collecting Art Exhibits in War-Ridden Europe," *Review of Reviews,* LI (Apr. 1915), 462-464.

"Evolution of American Painting," *Century,* XC (Sept. 1915), 772-786.

1918. *Overland Monthly,* Mar. 1918-Sept. 1918.

"Contemporary Art in California," *Art World,* IX (May 1918), 13-15.

FRANK J. MATHER, JR.

1902. *Atlantic Monthly,* 1902-1934.

Forum, 1902-1903.

Independent, 1902-1906, 1913, 1921.

1903. *World's Work,* 1903-1922.

1907. *Century,* 1907-1910.

Nation, 1907-1917.

1908. *Scribner's Magazine,* 1908-1923.

1912. *The Collectors: Being Cases Mostly under the Ninth and Tenth Commandments.* New York, Henry Holt and Co., 1912.

1913. "Newest Tendencies in Art," *Independent,* LXXIV (Mar. 6, 1913), 504-512.

"Old and New Art," *Nation,* XCVI (Mar. 6, 1913), 240-243.

1915. *Unpopular Review,* 1915-1916.

1916. *Art and Archaeology,* 1916, 1925.

Estimates in Art. New York, Charles Scribner's Sons, 1916.

"Forum Exhibition," *Nation,* CII (Mar. 23, 1916), 340.

"Some American Realists," *Arts and Decoration,* VII (Nov. 1916) 13-16.

1919. *Review,* 1919-1921.

Unpartisan, 1919-1920.

1920. *Arts and Decoration,* June 1920-Dec. 1920.

1926. *Saturday Review of Literature,* 1926-1940.

1927. Mather, F. J., C. R. Morey, and W. J. Henderson, *The American Spirit in Art.* New Haven, Conn., Yale University Press, 1927, *Pageant of America,* no. 7.

Modern Painting, A Study of Tendencies. New York, Henry Holt and Co. (c. 1927).

1929. *International Studio,* 1929-1930.

1931. *Estimates in Art.* New York, Henry Holt and Co. (c. 1931), series II.

Eugene Speicher. New York, Whitney Museum of American Art, 1931, *American Artists Series.*

HENRY McBRIDE

1913. *The Sun,* New York, 1913-1950.

1920. *Dial,* 1920-1929.

"Modern Forms: Foreword," *Dial,* LXIX (July 1920), 61-62.

1924. "Walkowitz and the Parks," *International Studio,* LXXX (Nov. 1924), 156-159.

1925. "Water Colours by Charles Demuth," *Creative Art,* V (Sept. 1925), 634-635.

1926. "Modern Art," *Dial,* LXXXI (July 1926), 86-88.

1928. "Burchfield," *Creative Art,* III (Sept. 1928), xxxii.

1930. *Matisse.* New York, A. A. Knopf, 1930.

1931. "Peggy Bacon," *Arts,* XVII (May 1931), 583-585.

1939. "Collecting from a Critical Viewpoint," *Art News,* XXXVII (1939 annual), 65-66, 178-180.

1946. *Florine Stettheimer.* New York, Museum of Modern Art, 1946.

1950. *Art News,* 1950 to date.

FREDERICK W. RUCKSTUHL (also RUCKSTULL)

1916. *Art World,* 1916-1918.

1921. "A Protest against the Present Exhibition of Degenerate 'Modernistic' Works in the Metropolitan Museum of Art," unsigned article reprinted in *American Art News,* XIX (Sept. 17, 1921), 4.

1924. Veritas (F. W. Ruckstuhl?), *Bolshevism in Art, and its Propagandists.* New York, Veritas Publishing Co., 1924.

1925. *Great Works of Art and What Makes Them Great.* New York, London, G. P. Putnam's Sons, 1925; Garden City, N.Y., Garden City Publishing Co., Inc. (c. 1934).

LEO STEIN

1914. "Panic in Art," *New Republic,* I (Nov. 7, 1914), 20-21.

1916. *New Republic,* 1916-1926.

1917. "Art and Common Sense," *New Republic,* XI (May 5, 1917), 13-15.

"Introductory to the Independent Show," *New Republic,* X (Apr. 7, 1917), 288-290.

1925. "Tradition and Art," *Arts,* VII (May 1925), 265-269.

1926. "Art and Society," *New Republic,* XLVI (Apr. 14, 1926), 224-225.

1927. *The A. B. C. of Aesthetics.* New York, Boni and Liveright, 1927.

Dial, July 1927-Sept. 1927.
1947. *Appreciation: Painting, Poetry and Prose.*
New York, Crown Publishers, 1947.

WILLARD H. WRIGHT
1913. *Forum,* 1913-1916.
"Impressionism to Synchromism," *Forum,* L
(Dec. 1913), 757-770.
1915. *International Studio,* 1915-1917.
"Modern American Painters—and Winslow
Homer," *Forum,* LIV (Dec. 1915), 661-672.
Modern Painting. New York, John Lane Co.;
London, John Lane, 1915, 277-304.
"Synchromism," *International Studio,* LVI
(Oct. 1915), xcvii-c.
"The Truth about Painting," *Forum,* LIV (Oct.
1915), 443-454.
1916. Tridon, A., "America's First Aesthetician,"
Forum, LV (Jan. 1916), 124-128.
"Abundance of Modern Art," *Forum,* LV
(Mar. 1916), 318-334.
"Aesthetic Struggle in America," *Forum,* LV
(Feb. 1916), 201-220.
"Art, Promise, and Failure," *Forum,* LV (Jan.
1916), 29-42.
"Forum Exhibition at the Anderson Galleries,"
Forum, LV (Apr. 1916), 457-471.
"Modern Art: The New Spirit in America,"
International Studio, LX (Dec. 1916), lxiv-
lxv.
"Morituri Salutamus," *Forum,* LV (May 1916),
601-613.
*The Creative Will: Studies in the Philosophy
and Syntax of Aesthetics.* New York, John
Lane Co., 1916.
1917. "Modern Art: An American Painter of Prom-
ise," *International Studio,* LXI (May 1917),
xcv-xcvi.
"Modern Art: From Daumier to Marsden
Hartley," *International Studio,* LXI (Mar.
1917), xxx-xxxii.
"Modern Art: A Full Harvest of the New
Painting," *International Studio,* LXI (Apr.
1917), lxii-lxiv.
"The New Painting and American Snobbery,"
Arts and Decoration, VII (Jan. 1917), 129-
130, 152, 154.
1921. "Modern Art and isms," *Mentor,* IX (Oct.
1921), 32-33.
1923. *The Future of Painting.* New York, B. W.
Huebsch, Inc., 1923.

B. COLLECTORS

GENERAL
1912. Roberts, W., "Evolution of American Picture
Collecting," *American Art News,* XI (Oct.
19, 1912), 2.
1938. Brimo, R., *L'Évolution du Goût aux États-Unis
d'après l'Histoire des Collections.* Paris, J.
Fortune (c. 1938).
1939. Lewisohn, S. A., "Personalities Past and Pres-
ent," *Art News,* XXXVII (1939 annual), 69-
70, 154-156.
Kelekian, D. G., "The Old and the New," *Art
News,* XXXVII (1939 annual), 67-68, 153-
154.
McBride, H., "Collecting from a Critical
Viewpoint," *Art News,* XXXVII (1939 an-
nual), 65-66, 178-180.
1948. Kimball, F., "Discovery from America," *Art
News,* XLVII (Apr. 1948), 29-31, 54.
Pach, W., *The Art Museum in America.* New
York, Pantheon, 1948.

WALTER C. ARENSBERG
1906. *Mr. Pennell's Etchings of London.* New York,
De Vinne Press, 1906.
1914. *Poems.* Boston, Houghton Mifflin Co., 1914.
1916. *Idols.* Boston, Houghton Mifflin Co., 1916,
New Poetry Series.
1920. McBride, H., "Modern Forms: Foreword,"
Dial, LXIX (July 1920), 61-62.
1921. *The Cryptography of Dante.* New York, A. A.
Knopf, 1921.
1922. *The Cryptography of Shakespeare, Part I.*
Los Angeles, H. Bowen, 1922.
1923. *The Secret Grave of Francis Bacon at Lich-
field.* San Francisco, J. Howell, 1923.
1924. *The Burial of Francis Bacon and his Mother
in the Lichfield Chapter House; An Open
Communication to the Dean and Chapter
of Lichfield Concerning the Rosicrucians.*
Pittsburgh, 1924.
1929. *Francis Bacon, William Butts, and the Pagets
of Beaudesert.* Pittsburgh, 1929.
1930. *The Magic Ring of Francis Bacon.* Pittsburgh,
1930.
1938. Rourke, C., *Charles Sheeler, Artist in the
American Tradition.* New York, Harcourt,
Brace and Co. (c. 1938), 45-49.

ALBERT C. BARNES
1916. "Cubism—Requiescat in Pace," *Arts and Dec-*

oration, VI (Jan. 1916), 121-124.

1925. *The Art in Painting.* Merion, Pa., Barnes Foundation Press, 1925.

Barnes Foundation Journal, 1925-1926.

1931. Barnes, A. C., and V. De Mazia, *The French Primitives and their Forms; From their Origin to the End of the Fifteenth Century.* Merion, Pa., Barnes Foundation Press (c. 1931).

1933. Barnes, A. C., and V. De Mazia, *The Art of Matisse.* New York, London, Charles Scribner's Sons, 1933.

1935. Barnes, A. C., and V. De Mazia, *The Art of Renoir.* New York, Minton, Balch and Co., 1935.

1939. Barnes, A. C., and V. De Mazia, *The Art of Cézanne.* New York, Harcourt, Brace and Co. (c. 1939).

1942. McCardle, C. W., "The Terrible Tempered Dr. Barnes," *Saturday Evening Post,* CCXIV (Mar. 21, 1942), 9-11ff.; (Mar. 28, 1942), 20-21ff.; (Apr. 4, 1942), 18-19ff.; (Apr. 11, 1942), 20-21ff.

How it Happened. Merion, Pa., A. C. Barnes (c. 1942).

LILLIE P. BLISS

1931. Museum of Modern Art, New York, *Memorial Exhibition; The Collection of the Late Lizzie P. Bliss.* New York, Museum of Modern Art, 1931.

1934. Museum of Modern Art, New York, *The Lillie P. Bliss Collection.* New York, Plantin Press, 1934.

ETTA CONE

1931. Baltimore Museum of Art, Baltimore, *Cone Collection of Modern Paintings and Sculpture.* Baltimore, Baltimore Museum of Art (c. 1931).

1934. *The Cone Collection of Baltimore, Maryland: Catalogue of Paintings, Drawings, Sculpture of the Nineteenth and Twentieth Centuries.* Baltimore, Etta Cone, 1934.

1941. Baltimore Museum of Art, Baltimore, *A Century of Baltimore Collecting, 1840-1940.* Baltimore, Baltimore Museum of Art, 1941.

1944. Rewald, J., "The Cone Collection in Baltimore," *Art in America,* XXXII (Oct. 1944), 201-204.

1949. "Cone Bequest Number," *Baltimore Museum of Art News,* XII (Oct. 1949).

1950. "Cone Memorial Issue," *Baltimore Museum of Art News,* XII (Jan.-Feb. 1950).

1951. Bell, C., *Modern French Painting; The Cone Collection.* Baltimore, The Johns Hopkins Press, 1951.

KATHERINE S. DREIER

1913. Van Gogh, E. D., *Personal Recollections of Vincent Van Gogh,* translated by K. S. Dreier. Boston, Houghton Mifflin Co., 1913.

1920. *Five Months in the Argentine; from a Woman's Point of View, 1918 to 1919.* New York, F. F. Sherman, 1920.

1923. *Western Art and the New Era.* New York, Brentano's (c. 1923).

1926. Brinton, C., *Modern Art at the Sesqui-Centennial Exhibition,* foreword by K. S. Dreier. New York, Société Anonyme, Inc., Museum of Modern Art, 1926.

1933. Academy of Allied Arts, *Katherine S. Dreier.* New York, 1933.

Shawn the Dancer. London, J. M. Dent and Sons, Ltd., 1933.

1944. *Burliuk.* New York, Société Anonyme, Inc. and Color and Rhyme, 1944.

Dreier, K. S., and M. Echaurren, *Duchamp's Glass: La mariée mis a nu par ses célibataires, mêmes.* Société Anonyme, Inc., 1944.

1949. "'Intrinsic Significance' in Modern Art," *Three Lectures on Modern Art.* New York, Philosophical Library, 1949.

1950. Yale University Art Gallery, New Haven, Conn., *Collection of the Société Anonyme: Museum of Modern Art 1920.* New Haven, Conn., Yale University Art Gallery, 1950.

ARTHUR J. EDDY

1901. *The Law of Combinations Embracing Monopolies, Trusts and Combinations of Labor and Capital.* Chicago, Callaghan and Co., 1901.

1902. *Delight the Soul of Art.* Philadelphia, J. B. Lippincott Co., 1902.

Two Thousand Miles on an Automobile. Philadelphia, London, J. B. Lippincott Co., 1902.

1903. *Recollections and Impressions of James A. McNeill Whistler.* Philadelphia, J. B. Lippincott Co., 1903.

1907. *Tales of a Small Town; By One Who Lived There.* Philadelphia, London, J. B. Lippincott Co., 1907.

1908. *Ganton and Co.; A Story of Chicago Com-*

mercial and Social Life. Chicago, A. C. McClurg and Co., 1908.

1912. *The New Competition.* New York, D. Appleton and Co., 1912.

1914. *Cubists and Post-Impressionism.* Chicago, A. C. McClurg and Co., 1914.

1921. *Property.* Chicago, A. C. McClurg and Co., 1921.

ALBERT E. GALLATIN

1904. *Whistler's Art Dicta; And Other Essays.* Boston, C. E. Goodspeed, 1904.

"Ernest Lawson," *International Studio,* LIX (July 1906), xiii-xv.

G(allatin), A. E., "Everett Shinn's Decorative Paintings," *Scrip,* I (Aug. 1906), 358-360.

"Studio Talk: Everett L. Shinn," *International Studio,* XXX (Nov. 1906), 84-87.

1907. *Whistler: Notes and Footnotes and Other Memoranda.* New York, Collector and Art Critic Co., 1907.

1910. "Art of William J. Glackens," *International Studio,* XL (May 1910), lxviii-lxxvi.

1912. *Whistler's Pastels and Other Modern Profiles.* New York, J. Lane Co., 1912.

1913. *The Portraits and Caricatures of James McNeill Whistler: An Iconography.* London, J. Lane Co., 1913.

"Whistler: The Self-Portraits in Oils," *Art in America,* I (July 1913), 151-158.

1916. *Certain Contemporaries.* New York, J. Lane Co., 1916.

"Etchings, Lithographs and Drawings of John Sloan," *International Studio,* LVIII (Mar. 1916), xxv-xxviii.

Notes on Some Rare Portraits by Whistler. New York, J. Lane Co., 1916.

1918. *Portraits of Whistler: A Critical Study and an Iconography.* New York, J. Lane Co., 1918.

1922. *American Water-Colorists.* New York, E. P. Dutton and Co., 1922.

1925. *John Sloan.* New York, E. P. Dutton and Co., 1925.

1927. *Charles Demuth.* New York, William Edwin Rudge, 1927.

New York University, Museum of Living Art, *Catalogue of Opening Exhibition.* New York, 1927.

1940. New York University, Museum of Living Art, *Museum of Living Art, A. E. Gallatin Collection.* New York, New York University (c. 1940).

FERDINAND HOWALD

1925. Watson, F., "American Collections: no. 1, the Ferdinand Howald Collection," *Arts,* VIII (Aug. 1925), 65-95.

1931. Bolander, K. S., "Ferdinand Howald and his Collection," *Bulletin of the Columbus Gallery of Fine Arts,* I (Jan. 1931), 7-12.

1934. "Ferdinand Howald," *Bulletin of the Columbus Gallery of Fine Arts,* IV (May 1934).

DUNCAN PHILLIPS

1913. "Revolutions and Reactions in Painting," *International Studio,* LI (Dec. 1913), cxxiii-cxxix.

1914. *The Enchantment of Art; As Part of the Enchantment of Experience.* New York, J. Lane Co. (c. 1914).

1916. "The American Painter, Arthur B. Davies," *Art and Archaeology,* IV (Sept. 1916), 169-177.

"Fallacies of the New Dogmatism in Art," *American Magazine of Art,* IX (Dec. 1917), 43-48; (Jan. 1918), 101-106.

"Jerome Myers," *American Magazine of Art,* VIII (Oct. 1917), 481-485.

"What Instruction in Art Should the College A.B. Course Offer the Future Writer on Art?" *American Magazine of Art,* VIII (Mar. 1917), 177-182.

1924. Phillips, D., and others, *Arthur B. Davies.* Cambridge, Mass., The Riverside Press (c. 1924), *Phillips Memorial Art Gallery Publications,* no. 3.

"Maurice Prendergast," *The Arts,* V (Mar. 1924), 125-131.

Price, F. N., "Phillips Memorial Gallery," *International Studio,* LXXX (Oct. 1924), 8-18.

1926. *A Collection in the Making.* New York, E. Weyhe; Washington, D.C., Phillips Memorial Art Gallery (c. 1926), *Phillips Publications,* no. 5.

1927. *Bulletin of the Phillips Collection,* 1927-1932 (1929-1930, *Art and Understanding*).

The Enchantment of Art; As Part of the Enchantment of Experience; Fifteen Years Later. Washington, D.C., Phillips Publications (c. 1927).

1928. "Contemporary American Painting," *Bulletin of the Phillips Collection* (Feb.-May 1928), 37-51.

1931. *The Artist Sees Differently.* New York, E.

Weyhe; Washington, D.C., Phillips Memorial Art Gallery (c. 1931).

1932. "Original American Painting Today," *Formes*, XXI (Jan. 1932), 197-201.

1944. "Marsden Hartley," *Magazine of Art*, XXXVII (Mar. 1944), 83-87.

1947. "Arthur G. Dove, 1880-1946," *Magazine of Art*, XL (May 1947), 193-197.

1952. Phillips Collection, Washington, D.C., *The Phillips Collection: A Museum of Modern Art and its Sources: Catalogue*. Washington, 1952.

JOHN QUINN

1913. *A Plea for Untaxed Contemporary Art: Memorandum in Regard to the Art Provisions of the Impending Tariff Bill*. New York, Association of American Painters and Sculptors, Inc., 1913.

"Modern Art from the Layman's Point of View," *Arts and Decoration*, III (Mar. 1913), 155-158, 176.

1924. Walsh, J. J., "John Quinn: Lawyer, Booklover, Art Amateur," *Catholic World*, CXX (Nov. 1924), 176-184.

1926. *John Quinn, 1870-1925; Collection of Paintings, Water Colors, Drawings, and Sculpture*, foreword by F. Watson. Huntington, N.Y., Pidgeon Hill Press (c. 1926).

Memorial Exhibition of Representative Works Selected from the John Quinn Collection, Jan. 7-30, 1926. New York, Art Center, 1926.

Watson, F., "The John Quinn Collection," *Arts*, IX (Jan. 1926), 5-22; (Feb. 1926), 77-92.

1927. "Sale of the Quinn Collection is Completed," *Art News*, XXV (Feb. 19, 1927), 1, 6-8, 10-11.

C. ARTISTS

GEORGE AULT

1949. A. R., "Ault of Woodstock," *Art News*, XLVIII (Sept. 1949), 46.

Lowengrund, M., "George Ault—1891-1948," *Art Digest*, XXIII (Sept. 15, 1949), 20.

PEGGY BACON

1922. Murrell, W., *Peggy Bacon*. Woodstock, N.Y., W. M. Fisher, 1922.

1923. Brook, A., "Peggy Bacon," *Arts*, III (Jan. 1923), 68-69.

1925. Kirk, E. B., "Peggy Bacon," *New Republic*,

XLIV (Aug. 26, 1925), 16-17.

Bacon, P., *Funerealities*. New York, Aldergate Press, 1925.

1928. Demuth, C., *Peggy Bacon*. New York, Intimate Gallery, 1928.

1931. Cary, E. L., "Peggy Bacon and Wanda Gag, Artists," *Prints*, I (Mar. 1931), 13-24.

McBride, H., "Peggy Bacon," *Arts*, XVII (May 1931), 583-585.

Rosenfeld, P., "Caricature and Peggy Bacon," *Nation*, CXXXII (June 3, 1931), 617-618.

Sweeney, J. J., "Caricatures in Pastel," *Creative Art*, VIII (June 1931), 444-445.

1933. College Art Association, *Index of Twentieth Century Artists*. New York, College Art Association, 1933-1937, II, no. 1, 12-15, no. 12, ii-iii; III, no. 11-12, vi.

GEORGE W. BELLOWS

1912. McIntyre, R. G., "George Bellows—An Appreciation," *Art and Progress*, III (Aug. 1912), 679-682.

1914. Buchanan, C. L., "George Bellows: Painter of Democracy," *Arts and Decoration*, IV (Aug. 1914), 370-373.

1917. Bellows, G., "The Big Idea: George Bellows Talks about Patriotism for Beauty," *Touchstone*, I (July 1917), 269-275.

1919. "Bellows in Chicago," *Arts and Decoration*, XII (Nov. 1919), 10.

1920. Rihani, A., "Luks and Bellows: American Painting, Part III," *International Studio*, LXXI (Aug. 1920), xxi-xxvii.

1921. Ries, E. H., "The Relation of Art to Everyday Things," *Arts and Decoration*, XV (July 1921), 158-159, 202.

1924. Frohman, L. H., "Bellows as an Illustrator," *International Studio*, LXXVIII (Feb. 1924), 421-425.

1925. Flint, R., "Bellows and His Art," *International Studio*, LXXXI (May 1925), 79-88.

Metropolitan Museum of Art, New York, *Memorial Exhibition of the Work of George Bellows*. New York, Metropolitan Museum of Art, 1925.

Roberts, M. F., "George Bellows, An Appreciation," *Arts and Decoration*, XXIII (Oct. 1925), 38-40, 76.

Watson, F., "George Bellows," *Arts*, VII (Jan. 1925), 4.

1927. Bellows, E. S., and T. Beer, *George W. Bellows: His Lithographs*. New York, London,

A. A. Knopf, 1927; revised edition, 1928.

1929. Bellows, E. S., *The Paintings of George Bellows*. New York, A. A. Knopf, 1929.

Brown, R. W., *Lonely Americans*. New York, Coward-McCann, Inc., 1929.

E(ggers), G. W., "George Bellows' Painting 'The White Horse,'" *Bulletin of the Worcester Art Museum*, xx (Oct. 1929), 72-79.

Gutman, W., "George Bellows," *Art in America*, xvii (Feb. 1929), 103-111.

1931. Bolander, K. S., "The George Bellows Exhibition," *Bulletin of the Columbus Gallery of Fine Arts*, i (Jan. 1931), 15.

Eggers, G. W., *George Bellows*, New York, Whitney Museum of American Art, 1931, *American Artist Series*.

1933. College Art Association, *Index of Twentieth Century Artists*. New York, College Art Association, 1933-1937, i, no. 6, 81-94, no. 12, i; ii, no. 12, iii; iii, no. 11-12, v.

1940. Wheelock, W., "George Bellows: Most American of Our Painters," *American Artist*, iv (Feb. 1940), 5-9.

1942. Boswell, P., Jr., *George Bellows*. New York, Crown Publishers (c. 1942).

1946. Art Institute of Chicago, Chicago, *George Bellows: Paintings, Drawings and Prints, Jan. 1 through Mar. 10*. Chicago, Art Institute of Chicago, 1946.

Rich, D. C., "Bellows Revalued," *Magazine of Art*, xxxix (Apr. 1946), 139-142.

Sweet, F. A., "23 Years after Dempsey-Firpo," *Art News*, xliv (Jan. 15, 1946), 12-13, 27-28.

1952. Paris, W. F., "George Bellows: Painter of the American Scene," *The Hall of American Artists*, vii. New York, New York University, 1952, 87-98.

THOMAS H. BENTON

1917. Wright, W. H., "Modern Art; An American Painter of Promise," *International Studio*, lxi (May 1917), xcv-xcvi.

1924. Benton, T. H., "Form and the Subject," *Arts*, v (June 1924), 303-308.

1925. Craven, T., "An American Painter," *Nation*, cxx (Jan. 7, 1925), 22.

1926. Benton, T. H., "Mechanics of Form Organization in Painting," *Arts*, x (Nov. 1926), 285-289; (Dec. 1926), 340-342; xi (Jan. 1927), 43-44; (Feb. 1927), 95-96; (Mar. 1927), 145-148.

1928. Benton, T. H., "My American Epic in Paint," *Creative Art*, iii (Dec. 1928), xxxi-xxxvi.

1931. Glassgold, C., "Thomas Benton's Murals at the New School for Social Research," *Atelier*, i (Apr. 1931), 285-287.

Goodrich, L., "The Murals of the New School," *Arts*, xvii (Mar. 1931), 399-403.

1932. Benton, T. H., *The Arts of Life in America; A Series of Murals by Thomas Benton*. New York, Whitney Museum of American Art (c. 1932).

1933. College Art Association, *Index of Twentieth Century Artists*. New York, College Art Association, 1933-1937, ii, no. 7, 97-100, no. 12, i; iii, no. 11-12, v.

Rosenfeld, P., "Ex Reading Room," *New Republic*, lxxiv (Apr. 12, 1933) 245-246.

1934. Lieban, H., "Thomas Benton, American Mural Painter," *Design*, xxxvi (Dec. 1934), 26, 31-35.

1937. Benton, T. H., *Tom Benton's America; An Artist in America*. New York, R. M. McBride and Co. (c. 1937).

1939. Craven, T., *Thomas Hart Benton: A Descriptive Catalogue of the Works of Thomas Hart Benton*. New York, Associated American Artists, 1939.

1945. *Thomas Hart Benton*. New York, American Artists Group, 1945.

1946. Benton, T. H., Introduction to *The Rape of La Belle* by Harry Hahn. Kansas City, Frank Glenn Publishing Co., 1946, xvii-xxvi.

Janson, H. W., "Benton and Wood, Champions of Regionalism," *Magazine of Art*, xxxix (May 1946), 184-186, 198-200.

OSCAR BLUEMNER

1926. McBride, H., "Modern Art," *Dial*, lxxxi (July 1926), 86-88.

1934. Beer, R., "As They Are," *Art News*, xxxii (Feb. 24, 1934), 11.

1935. "Abstract," *Art Digest*, ix (Mar. 15, 1935), 9.

1938. "Obituary," *Art Digest*, xii (Jan. 15, 1938), 19.

1939. "Exhibition, Co-operative Gallery, Newark," *Art Digest*, xiii (Feb. 1, 1939), 14.

"Newark: Bluemner and Weingaertner at the Co-operative Gallery," *Art News*, xxxvii (Feb. 4, 1939), 18.

PETER BLUME

1932. Godsoe, R. U., "Peter Blume, A New Vision,"

Creative Art, IX (Sept. 1932), 10-11.

Soupault, P., "Un Peintre d'Amerique, Peter Blume," *La Renaissance,* XV (Oct. 1932), 157-160.

1933. College Art Association, *Index of Twentieth Century Artists.* New York, College Art Association, 1933-1937, III, no. 8, 285-286, no. 11-12, i.

1934. Blume, P., "After Superrealism," *New Republic,* LXXX (Oct. 3, 1934), 338-340.

1943. Rothenstein, J., "State Patronage of Wall Painting in America," *The Studio,* CXXVI (July 1943), 1-10.

Soby, J. T., "History of a Picture: South of Scranton," *Saturday Review of Literature,* XXX (Apr. 26, 1943), 30-32.

Soby, J. T., "Peter Blume's Eternal City," *Museum of Modern Art Bulletin,* X (Apr. 1943), 1-6.

1948. Soby, J. T., *Contemporary Painters.* New York, Museum of Modern Art, 1948, 51-55.

1949. Hunningher, B., "De amerikaanse schilder Peter Blume," *Kronick van Kunst en Kultur,* X (May 1949), 172-174.

GUY PÈNE DU BOIS

1913. McCormick, W. B., "Guy Pène du Bois— Social Historian: The Similarity of the Spirit Animating the Paintings of du Bois and Daumier," *Arts and Decoration,* IV (Nov. 1913), 13-16.

1918. Gutman, W., "Guy Pène du Bois," *Creative Art,* III (Sept. 1918), 203-205.

1922. "Guy Pène du Bois by Guy Pène du Bois," *International Studio,* LXXV (June 1922), 242-246.

1925. Ely, C. B., *The Modern Tendency in American Painting.* New York, F. F. Sherman, 1925, 72-77.

1929. Gutman, W., "Guy Pène du Bois," *Art in America,* XVIII (Dec. 1929), 25-28.

1931. Cortissoz, R., *Guy Pène du Bois.* New York, Whitney Museum of American Art, 1931, *American Artists Series.*

1933. College Art Association, *Index of Twentieth Century Artists.* New York, College Art Association, 1933-1937, II, no. 2, 28-32, no. 12, ii; III, no. 11-12, v.

1935. Watson, F., "Guy Pène du Bois," *American Magazine of Art,* XXVIII (Feb. 1935), 116-117.

1939. O'Connor, J., Jr., "Thirty Years of Guy Pène

du Bois," *Carnegie Magazine,* XII (Jan. 1939), 237-239.

1940. du Bois, G. P., *Artists Say the Silliest Things.* New York, American Artists Group, Inc., Duell, Sloan and Pearce, Inc. (c. 1940).

Medford, R. C., *Guy Pène du Bois.* Hagerstown, Md., Washington County Museum of Fine Arts, 1940.

ALEXANDER BROOK

1922. Murrell, W., *Alexander Brook.* Woodstock, N.Y., W. M. Fisher, 1922, *Younger Artists Series,* no. 2.

1923. Brook, A., articles in *Arts,* 1923-1924.

1929. Brook, A., "Alexander Brook, Painter," *Creative Art,* V (Oct. 1929), 713-718.

1930. Watson, F., *Alexander Brook.* New York, Art Publishing Corp., 1930, *The Art Portfolio Series.*

1931. Jewell, E. A., *Alexander Brook.* New York, Whitney Museum of American Art, 1931, *American Artists Series.*

1933. College Art Association, *Index of Twentieth Century Artists.* New York, College Art Association, 1933-1937, I, no. 5, 77-80, no. 12, ii; II, no. 12, iv; III, no. 11-12, vii.

1934. Brace, E., "Alexander Brook," *American Magazine of Art,* XXVII (Oct. 1934), 520-529.

"Paintings by Alexander Brook," *Carnegie Magazine,* VIII (Apr. 1934), 16-18.

1945. *Alexander Brook.* New York, American Artists Group, 1945.

CHARLES BURCHFIELD

1922. "'Discovers' an Ohio Artist in London," *American Art News,* XXI (Oct. 28, 1922), 2.

1925. McCormick, W. B., "A Small Town in Paint," *International Studio,* LXXX (Mar. 1925), 466-470.

1928. Burchfield, C., "On the Middle Border," *Creative Art,* III (Sept. 1928), xxv-xxxii.

Hopper, E., "Charles Burchfield, American," *Arts,* XIV (July 1928), 5-12.

McBride, H., "Burchfield," *Creative Art,* III (Sept. 1928), xxxii.

1930. Museum of Modern Art, New York, *Charles Burchfield: Early Water Colors (1916-1918).* New York, Museum of Modern Art, 1930.

1933. College Art Association, *Index of Twentieth Century Artists.* New York, College Art

Association, 1933-1937, ii, no. 3, 37-40, no. 12, i-ii; iii, no. 11-12, v.

1935. Henry, H. M. L., "Charles Burchfield, American," *The Proceedings of the Cheraka Club, Columbia University,* viii (1935), 135-139

1942. "Charles Burchfield," *American Artist,* vi (May 1942), 4-11.
Watson, E. W., *Color and Method in Painting as Seen in the Work of 12 American Painters.* New York, Watson-Guptill Publications, Inc., 1942, 1-11.

1944. Buffalo Fine Arts Academy, Buffalo, *Charles Burchfield: A Retrospective Exhibition of Water Colors and Oils, 1916-1943, Apr. 14-May 15, 1944.* Buffalo, Buffalo Fine Arts Academy, Albright Art Gallery, 1944.
"Burchfield's Buffalo," *Art News,* xliii (May 1-14, 1944), 12-13.
Richardson, E. P., "Charles Burchfield," *Magazine of Art,* xxxvii (Oct. 1944), 208-212.

1945. *Charles Burchfield.* New York, American Artists Group, 1945.
Goodrich, L., *American Watercolor and Winslow Homer.* Minneapolis, The Walker Art Center (c. 1945), 79-86.

1946. Rowland, B., Jr., "Burchfield's Seasons," *Bulletin of the Fogg Museum of Art,* x (Nov. 1946), 155-161.

1948. Soby, J. T., *Contemporary Painters.* New York, Museum of Modern Art, 1948, 21-27.

GLENN O. COLEMAN

1909. "Undercurrents of New York Life Sympathetically Depicted in the Drawings of Glenn O. Coleman," *Craftsman,* xvii (Nov. 1909), 142-149.

1910. "An Artist of the New York Underworld," *Current Literature,* xlviii (Mar. 1910), 326-330.

1923. Davis, S., "A Painter of City Streets," *Shadowland,* viii (Aug. 1923), 11, 75.

1928. Goodrich, L., "Glenn Coleman's Lithographs of New York," *Arts,* xiv (Nov. 1928), 261-265.
Mannes, M., "Glenn Coleman," *Creative Art,* ii (Mar. 1928), xxxvi-xli.

1930. du Bois, G. P., "Glenn O. Coleman," *Arts,* xvii (Dec. 1930), 155-160.

1932. Glassgold, C. A., *Glenn O. Coleman.* New York, Whitney Museum of American Art, 1932, *American Artists Series.*

Whitney Museum of American Art, New York, *Glenn O. Coleman Memorial Exhibition.* New York, Whitney Museum of American Art, 1932.

1933. College Art Association, *Index of Twentieth Century Artists.* New York, College Art Association, 1933-1937, iii, no. 3, 205-208, no. 11-12, i.

JOHN COVERT

1952. Hamilton, G. H., "John Covert, Early American Modern," *College Art Journal,* xii (Fall 1952), 37-42.

ANDREW DASBURG

1923. Dasburg, A., "Cubism—Its Rise and Influence," *Arts,* iv (Nov. 1923), 279-284.

1924. Brook, A., "Andrew Dasburg," *Arts,* vi (July 1924), 19-26.

1931. "Andrew Dasburg," *Art News,* xxix (Mar. 28, 1931), 13.

1933. College Art Association, *Index of Twentieth Century Artists.* New York, College Art Association, 1933-1937, iii, no. 8, 289-290, no. 11-12, ii.

1936. Dasburg, A., "Coming of Age," *Art Digest,* x (Apr. 1, 1936), 16-17, 21.

ARTHUR B. DAVIES

1913. Huneker, J. G., *The Pathos of Distance.* New York, Charles Scribner's Sons, 1913, 103-124.

1916. Phillips, D., "The American Painter, Arthur B. Davies," *Art and Archaeology,* iv (Sept. 1916), 169-177.

1918. *Loan Exhibition of Paintings, Watercolors, Drawings, Etchings, and Sculpture by Arthur B. Davies.* New York, Macbeth Galleries, 1918.
Sherman, F. F., "The Early and the Later Work of Arthur B. Davies," *Art in America,* vi (Oct. 1918), 295-299.

1919. Sherman, F. F., *American Painters of Yesterday and Today.* New York, privately printed, 1919, 47-51.

1920. Hartley, M., "The Poetry of Arthur B. Davies' Art," *Touchstone,* vi (Feb. 1920), 277-284.

1921. Hind, C. L., *Art and I.* New York, John Lane Co.; London, John Lane, The Bodley Head, 1921, 126-130.

1922. Price, F. N., "Davies the Absolute," *International Studio,* lxxv (June 1922), 213-219.

1923. Burroughs, A., *The Art of Arthur B. Davies.*

New York, E. Weyhe, 1923.

1924. Phillips, D., D. Williams, R. Cortissoz, F. J. Mather, Jr., E. W. Root, G. A. Eisen, *Arthur B. Davies; Essays on the Man and His Art.* Cambridge, Mass., Riverside Press (c. 1924), *Phillips Publications*, no. 3.

1928. Eisen, G. A., "Arthur B. Davies (Obituary)," *Art News*, xxvii (Dec. 22, 1928), 12.

1929. Burroughs, B., "Arthur B. Davies," *Arts*, xv (Feb. 1929), 79-93.

Clark, E., "Arthur B. Davies," *Art in America*, xvii (Aug. 1929), 234-242.

E(ggers), G. W., "A Painting by Davies," *Bulletin of Worcester Art Museum*, xix (Jan. 1929), 78-85.

Price, F. N., *The Etchings and Lithographs of Arthur B. Davies.* New York, M. Kennerley. London, M. & M. Kennerley, Jr., 1929.

1930. Metropolitan Museum of Art, New York, *Catalogue of a Memorial Exhibition of the Works of Arthur B. Davies.* New York, Metropolitan Museum of Art, 1930.

1931. Cortissoz, R., *Arthur B. Davies.* New York, Whitney Museum of American Art, 1931, *American Artists Series.*

1933. College Art Association, *Index of Twentieth Century Artists.* New York, College Art Association, 1933-1937, iv, no. 5, 385-400.

1952. Watson, F., "Arthur Bowen Davies," *Magazine of Art*, xlv (Dec. 1952), 362-368.

STUART DAVIS

1912. "Shadow," *Harper's Bazaar*, xlvi (May 1912), 226-228.

1931. "Self-interview," *Creative Art*, ix (Sept. 1931), 208-211.

"Stuart Davis, A. Gorky," *Creative Art*, ix (Sept. 1931), 212-217.

1932. "Stuart Davis, the Difficult," *Art Digest*, vi (Apr. 1, 1932), 2.

1935. "Artist Today," *American Magazine of Art*, xxviii (Aug. 1935), 476-478.

1945. Cahill, H., "Stuart Davis: In Retrospect 1945-1910," *Art News*, xliv (Oct. 15, 1945), 24-25, 32.

Stuart Davis. New York, American Artists Group, 1945.

Sweeney, J. J., *Stuart Davis.* New York, Museum of Modern Art, 1945.

ADOLF DEHN

1923. Burroughs, A., "Young America—Adolf Dehn," *Arts*, iii (Apr. 1923), 270-271.

1931. du Bois, G. P., "Adolf Dehn," *Creative Art*, ix (July 1931), 32-36.

1933. College Art Association, *Index of Twentieth Century Artists.* New York, College Art Association, 1933-1937, iii, no. 7, 269-270, no. 11-12, i-ii.

1934. "Biographical Note," *London Studio*, vii (Feb. 1934), 59.

1936. Brace, E., "Adolf Dehn," *American Magazine of Art*, xxix (Feb. 1936), 92-99.

Loran, E., "Artists from Minnesota," *American Magazine of Art*, xxix (Jan. 1936), 25-27.

1945. Goodrich, L., *American Watercolor and Winslow Homer.* Minneapolis, The Walker Art Center (c. 1945), 87-93.

CHARLES DEMUTH

1923. Watson, F., "Charles Demuth," *Arts*, iii (Jan. 1923), 74-80.

1924. Kenton, E., "Henry James to the Ruminant Reader: The Turn of the Screw with Drawings by Charles Demuth," *Arts*, vi (Nov. 1924), 245-255.

1927. Gallatin, A. E., *Charles Demuth.* New York, William Edwin Rudge, 1927.

1929. Demuth, C., "Across a Greco is Written," *Creative Art*, v (Sept. 1929), 629-634.

McBride, H., "Water Colours by Charles Demuth," *Creative Art*, v (Sept. 1929), 634-635.

1931. Murrell, W., *Charles Demuth.* New York, Whitney Museum of American Art, 1931, *American Artists Series.*

Rosenfeld, P., "Charles Demuth," *Nation*, cxxxiii (Oct. 7, 1931), 371-373.

Wellman, R., "Pen Portraits: Charles Demuth: Artist," *Creative Art*, ix (Dec. 1931), 483-484.

1933. College Art Association, *Index of Twentieth Century Artists.* New York, College Art Association, 1933-1937, ii, no. 10, 147-150, no. 12, i; iii, no. 11-12, iii.

1936. Lane, J. W., "Charles Demuth," *Parnassus*, viii (Mar. 1936), 8-9.

1937. Whitney Museum of American Art, New York, *Charles Demuth Memorial Exhibition, Dec. 15, 1937 to Jan. 16, 1938.* New

York, Whitney Museum of American Art (c. 1937).

1942. Lee S. S., "The Illustrative and Landscape Water Colors of Charles Demuth," *Art Quarterly*, v (Spring 1942), 158-175.

1948. Malone, Mrs. J. E., "Charles Demuth," *Papers of the Lancaster County Historical Society*, LII (1948), 1-18.

Soby, J. T., *Contemporary Painters*. New York, Museum of Modern Art, 1948, 9-15.

1950. Faison, S. L., Jr., "Fact and Art in Charles Demuth," *Magazine of Art*, XLIII (Apr. 1950), 123-128.

McBride, H., "Demuth: phantoms from literature," *Art News*, XLIX (Mar. 1950), 18-21.

Ritchie, A. C., *Charles Demuth*. New York, Museum of Modern Art, 1950.

PRESTON DICKINSON

1924. Watson, F., "Preston Dickinson," *Arts*, v (May 1924), 284-288.

1930. "Preston Dickinson," *Art News*, XXIX (Dec. 20, 1930), 16.

1931. Kootz, S., "Preston Dickinson," *Creative Art*, VIII (May 1931), 339-340.

1933. College Art Association, *Index of Twentieth Century Artists*. New York, College Art Association, 1933-1937, III, no. 4, 217-218, no. 11-12, i.

1938. "Reviving a Memory," *Art Digest*, XII (Apr. 15, 1938), 20.

ARTHUR G. DOVE

1924. Rosenfeld, P., *Port of New York*. New York, Harcourt, Brace and Co. (c. 1924), 167-174.

1926. Frank, W., "Art of Arthur Dove," *New Republic*, XLV (Jan. 27, 1926), 269-270.

1932. Phillips, D., "Original American Painting of Today," *Formes*, XXI (Jan. 1932), 198.

Rosenfeld, P., "The World of Arthur G. Dove," *Creative Art*, X (June 1932), 427-430.

1933. College Art Association, *Index of Twentieth Century Artists*. New York, College Art Association, 1933-1937, III, no. 4, 219-220, no. 11-12, i.

1940. Rosenfeld, P., "Dove and the Independents," *Nation*, CL (Apr. 27, 1940), 549.

1947. Phillips, D., "Arthur G. Dove, 1880-1946," *Magazine of Art*, XL (May 1947), 193-197.

MARCEL DUCHAMP

1915. "A Complete Reversal of Art Opinions by Marcel Duchamp, Iconoclast," *Arts and Decoration*, v (Sept. 1915), 427-428, 442.

"Iconoclastic Opinions of M. Marcel Duchamp Concerning Art and America," *Current Opinion*, LIX (Nov. 1915), 346-347.

1920. McBride, H., "Modern Forms: Foreword," *Dial*, LXIX (July 1920), 61-62.

1934. *La Mariée Mise à Nu par Ses Célibataires Même*, Paris, Édition Rrose Sélavy (c. 1934).

"Notice Historique sur Dada et le Surréalisme," *L'Amour de l'Art*, xv (1934), 343.

1937. Kiesler, F. J., "Design-Correlation," *Architectural Record*, LXXXI (May 1937), 53-60.

1938. "Marcel Duchamp's Frankenstein," *Art Digest*, XII (Jan. 1, 1938), 22.

1938. Breton, A., "Some Passages from the Lighthouse of the Bride," *London Bulletin*, no. 4-5 (July 1938), 17-19.

1944. Dreier, K. S., and M. Echaurren, *Duchamp's Glass: La mariée mise à nu par ses célibataires, même*, Société Anonyme, Inc., 1944.

1945. Ford, C. H., and others, (Marcel Duchamp Number), *View*, v, 1 (1945), 1-54.

Hamilton, G. H., "Duchamp, Duchamp-Villon, Villon," *Bulletin of the Associates in Fine Arts at Yale University*, XIII (Mar. 1945), 1-7.

1949. Kuh, K., "Four Versions of 'Nude Descending a Staircase,'" *Magazine of Art*, XLII (Nov. 1949), 264-265.

WILLIAM J. GLACKENS

1910. Gallatin, A. E., "The Art of William J. Glackens," *International Studio*, XL (May 1910), lxviii-lxxi.

1914. du Bois, G. P., "William Glackens, Normal Man; The Best Eyes in American Art," *Arts and Decoration*, IV (Sept. 1914), 404-406.

1916. Gallatin, A. E., *Certain Contemporaries*. New York, J. Lane Co., 1916, 3-10.

1920. Watson, F., "William Glackens: An Artist Who Seizes the Colorful and Interesting Aspects of Life," *Arts and Decoration*, XIV (Dec. 1920), 103, 152.

1923. Watson, F., "William Glackens," *Arts*, III (Apr. 1923), 246-261.

Watson, F., *William Glackens*. New York, Duffield and Co., 1923, *The Arts Monographs*.

1931. du Bois, G. P., *William Glackens*. New York, Whitney Museum of American Art, 1931, *American Artist Series*.

1933. College Art Association, *Index of Twentieth Century Artists*. New York, College Art Association, 1933-1937, ɪɪ, no. 4, 61-64, no. 12, ii; ɪɪɪ, no. 11-12, iv.

1938. Whitney Museum of American Art, New York, *William Glackens Memorial Exhibition*. New York, Whitney Museum of American Art, 1938.

1939. Carnegie Institute, Department of Fine Arts, Pittsburgh, *Memorial Exhibition of Works by William J. Glackens, Feb. 1-Mar. 15, 1939*. Pittsburgh, Carnegie Institute, 1939.

1945. Shinn, E., "William Glackens as an Illustrator," *American Artist*, ɪx (Nov. 1945), 22-27, 37.

WILLIAM GROPPER

1923. De Fornaro, C., "Groping of Gropper," *Arts and Decoration*, xvɪɪɪ (Mar. 1923), 14-15.

1932. Lozowick, L., "Art," *Nation*, cxxxɪv (Feb. 10, 1932), 176-177.

1936. Benson, E. M., "Two Proletarian Artists: Joe Jones and Gropper," *American Magazine of Art*, xxɪx (Mar. 1936), 188-189.

"Fellow Citizens; Four Drawings of Contemporaries," *Forum*, xcv (May 1936), 288-289.

"Portrait," *Newsweek*, vɪɪ (Feb. 22, 1936), 288-289.

1937. Brace, E., "William Gropper," *Magazine of Art*, xxx (Aug. 1937), 467-471.

1940. Pearson, R. M., "His First Twenty Years as Cartoonist and Painter," *Forum*, cɪɪɪ (May 1940), 288.

"Twenty Years of Gropper," *Time*, xxxv (Feb. 19, 1940), 41.

SAMUEL HALPERT

1922. Comstock, H., "S. Halpert, Post-Impressionist," *International Studio*, ʟxxv (Apr. 1922), cxlv-cl.

1930. "Obituary," *Art News*, xxvɪɪɪ (Apr. 12, 1930), 14.

"Obituary," *Art Digest*, ɪv (Apr. 15, 1930), 7.

1935. "Pioneer Modernist," *Art Digest*, ɪx (Jan. 1, 1935), 16.

Watson, F., "Armory Show," *American Magazine of Art*, xxvɪɪɪ (Feb. 1935), 113.

MARSDEN HARTLEY

1921. Hartley, M., *Adventures in the Arts*. New York, Boni and Liveright (c. 1921).

Seligmann, H. J., "The Elegance of Marsden Hartley, Craftsman," *International Studio*, ʟxxɪv (Oct. 1921), li-liii.

1924. Rosenfeld, P., *Port of New York*. New York, Harcourt, Brace and Co. (c. 1924), 83-101.

1925. Rosenfeld, P., *Men Seen; Twenty-four Modern Authors*. New York, L. MacVeagh, Dial Press, 1925, 177-188.

1928. Hartley, M., "Art and the Personal Life," *Creative Art*, ɪɪ (June 1928), xxxi-xxxiv.

1933. College Art Association, *Index of Twentieth Century Artists*. New York, College Art Association, 1933-1937, ɪɪɪ, no. 4, 221-223, no. 11-12, i.

1940. Hartley, M., *Androscoggin*. Portland, Me., Falmouth Publishing House, 1940.

1941. Hartley, M., *Sea Burial*. Portland, Me., Leon Tebbetts Editions, 1941.

1944. Museum of Modern Art, New York, *Lyonel Feininger, Marsden Hartley*. New York, Museum of Modern Art, 1944, 53-96.

Phillips, D., "Marsden Hartley," *Magazine of Art*, xxxvɪɪ (Mar. 1944), 83-87.

1945. Wells, H. W., "The Pictures and Poems of Marsden Hartley," *Magazine of Art*, xxxvɪɪɪ (Jan. 1945), 26-30, 32.

Hartley, M., *Selected Poems*, New York, Viking Press, 1945.

1948. Gallup, D., "The Weaving of a Pattern: Marsden Hartley and Gertrude Stein," *Magazine of Art*, xʟɪ (Nov. 1948), 256-261.

1952. McCausland, E., *Marsden Hartley*. Minneapolis, University of Minnesota Press, 1952.

ROBERT HENRI

1909. Henri, R., "Progress in Our National Art Must Spring from the Development of Individuality of Ideas and Freedom of Expression: A Suggestion for a New Art School," *Craftsman*, xv (Jan. 1909), 386-401.

1910. Henri, R., "The New York Exhibition of Independent Artists," *Craftsman*, xvɪɪɪ (May 1910), 160-172.

1912. du Bois, G. P., "Living American Painters: 13, Robert Henri, Realist and Idealist," *Arts and Decoration*, ɪɪ (Apr. 1912), 213-215, 230.

1914. Henri, R., "The Ideal Exhibition Scheme: The

Official One's Failure," *Arts and Decoration*, v (Dec. 1914), 49-52, 76.

1915. Henri, R., "My People," *Craftsman*, xxvii (Feb. 1915), 459-469.

"Who's Who in American Art—Robert Henri," *Arts and Decoration*, vi (Nov. 1915), 33.

1921. Yarrow, W., and L. Bouche (editors), *Robert Henri: His Life and Works*. New York, Boni and Liveright, 1921.

1922. Poussette-Dart, N., *Robert Henri*. New York, F. A. Stokes Co. (c. 1922).

1923. Henri, R., *The Art Spirit*, compiled by M. Ryerson. Philadelphia, London, J. B. Lippincott Co., 1923.

1931. Metropolitan Museum of Art, New York, *Catalogue of a Memorial Exhibition of the Work of Robert Henri*. New York, Metropolitan Museum of Art, 1931.

Read, H. A., *Robert Henri*. New York, Whitney Museum of American Art, 1931, *American Artists Series*.

1933. College Art Association, *Index of Twentieth Century Artists*. New York, College Art Association, 1933-1937, ii, no. 4, 49-60, no. 12, i; iii, no. 11-12, iii.

1949. Paris, W. F., "Robert Henri: Pioneer of Modernism in American Art," *The Hall of American Artists*, iv. New York, New York University, 1949, n.p.

EUGENE HIGGINS

1907. Spargo, J., "Eugene Higgins: An American Artist Whose Work upon Canvas Depicts the Derelicts of Civilization as Do the Tales of Maxim Gorky in Literature," *Craftsman*, xii (May 1907), 135-145.

1915. De Kay, C., "Eugene Higgins; His Etchings," *Arts and Decoration*, v (Feb. 1915), 134-135, 164-165.

1919. Roberts, M. F., "Eugene Higgins; A Painter of the Shadow-World," *Touchstone*, v (Aug. 1919), 360-369.

1930. Narodny, I., *American Artists*. New York, Roerich Museum Press, 1930, 50-60.

EDWARD HOPPER

1924. Barker, V., "The Etchings of Edward Hopper," *Arts*, v (June 1924), 323-325.

1927. Goodrich, L., "The Paintings of Edward Hopper," *Arts*, xi (Apr. 1927), 168-178.

1931. du Bois, G. P., "The American Paintings of Edward Hopper," *Creative Art*, viii (Mar.

1931), 187, 191.

du Bois, G. P., *Edward Hopper*. New York, Whitney Museum of American Art, 1931, *American Artists Series*.

Watson, F., *Edward Hopper*. New York, The Arts Publishing Co. (c. 1931), *The Arts Portfolio Series*.

1933. College Art Association, *Index of Twentieth Century Artists*. New York, College Art Association, 1933-1937, i, no. 10, 157-160, no. 12, i-ii; ii, no. 12, iii; iii, no. 11-12, ii.

Museum of Modern Art, New York, *Edward Hopper Retrospective Exhibition*. New York, Museum of Modern Art, 1933.

1945. *Edward Hopper*. New York, American Artists Group, 1945.

Goodrich, L., *American Watercolor and Winslow Homer*. Minneapolis, The Walker Art Center (c. 1945), 69-78.

1948. Soby, J. T., *Contemporary Painters*. New York, Museum of Modern Art, 1948, 34-39.

Tyler, P., "Edward Hopper: Alienation by Light," *Magazine of Art*, xli (Dec. 1948), 290-295.

1949. Goodrich, L., *Edward Hopper*. Harmondsworth, Middlesex, Penguin Books, 1949.

1950. Burchfield, C., "Hopper: Career of Silent Poetry: Retrospective at Whitney Museum," *Art News*, xlix (Mar. 1950), 14-17, 62-64.

Whitney Museum of American Art, New York, *Edward Hopper Retrospective Exhibition, Feb. 11-Mar. 26, 1950*. New York, Whitney Museum of American Art, 1950.

MORRIS KANTOR

1933. College Art Association, *Index of Twentieth Century Artists*. New York, College Art Association, 1933-1937, i, no. 3, 46-48, no. 12, i; ii, no. 12, v; iii, no. 11-12, vii.

1935. E. L., "Morris Kantor," *Art News*, xxxiii (Jan. 26, 1935), 9.

Watson, F., "Morris Kantor," *American Magazine of Art*, xxviii (Feb. 1935), 113.

1940. Kantor, M., "Ends and Means; Autobiography," *Magazine of Art*, xxxiii (Mar. 1940), 138-147.

1946. Shepherd, R., "M. Kantor 1946," *Art News*, xlv (July 1946), 38-41, 57-58.

BERNARD KARFIOL

1923. Lockett, E., *Exhibition of Paintings and*

Drawings by Bernard Karfiol. New York, Brummer Gallery, 1923.

1924. Slusser, J. P., "Bernard Karfiol," *Arts*, VI (Aug. 1924), 76-82.

1925. Soyer, M., "Meštrovič, Zuloaga, Karfiol," *Guardian*, I (Mar. 1925), 217-218.

1930. Slusser, J. P., *Bernard Karfiol.* New York, Arts Publishing Corp., 1930, *Arts Portfolio Series.*

1931. Slusser, J. P., *Bernard Karfiol.* New York, Whitney Museum of American Art, 1931, *American Artists Series.*

1932. Cahill, H., "Bernard Karfiol," *Creative Art*, X (Mar. 1932), 181-189.

1933. College Art Association, *Index of Twentieth Century Artists.* New York, College Art Association, 1933-1937, I, no. 6, 94-96, no. 12, ii; II, no. 12, iv; III, no. 11-12, v-vi.

1934. "One Form of French Influence—Karfiol," *Art Digest*, VIII (June 1, 1934), 12.

1939. Carnegie Institute, Department of Fine Arts, Pittsburgh, *An Exhibition of Paintings, Water Colors and Drawings by Bernard Karfiol, May 9-June 4, 1939.* Pittsburgh, Carnegie Institute, 1939.

ROCKWELL KENT

1917. "Spiritual Adventures of an American Artist in Newfoundland," *Current Opinion*, LXII (Apr. 1917), 277-278.

1921. Freund, F. E. W., "Amerikanische Künstlerprofil: III Rockwell Kent," *Jahrbuch der jungen Kunst*, n.v. (1921), 313-318.

1924. Price, F. N., "Rockwell Kent, Voyager," *International Studio*, LXXIX (July 1924), 272-276.

1930. Narodny, I., *American Artists.* New York, Roerich Museum Press, 1930, 70-82.

1932. Armitage, M., *Rockwell Kent.* New York, A. A. Knopf, 1932.

1933. College Art Association, *Index of Twentieth Century Artists.* New York, College Art Association, 1933-1937, I, no. 7, 104-110, no. 12, i-ii; II, no. 12, iv; III, no. 11-12, v-vi.

Kent, R., *Rockwellkentiana; A Few Words and Many Pictures by R. K. and, by Carl Zigrosser, a Bibliography and List of Prints.* New York, Harcourt, Brace and Co., 1933.

1940. Kent, R., *This is My Own.* New York, Duell, Sloan and Pearce (c. 1940).

1945. *Rockwell Kent.* New York, American Artists Group, 1945.

BENJAMIN KOPMAN

1928. Tofel, J., *B. Kopman.* Paris, Éditions "Le Triangle" (c. 1928), *Les Artistes Juifs.*

1930. Ignatoff, D., *Kopman.* New York, E. Weyhe, 1930.

LEON KROLL

1930. Gutman, W., "Leon Kroll," *Art in America*, XVIII (Oct. 1930), 299-303.

Narodny, I., *American Artists.* New York, Roerich Museum Press, 1930, 83-88.

1933. College Art Association, *Index of Twentieth Century Artists.* New York, College Art Association, 1933-1937, I, no. 4, 59-64, no. 12, ii; II, no. 12, iv; III, no. 11-12, vi.

Kroll, L., "Art Chronicle," *Hound and Horn*, VI (Apr.-June 1933), 472-474.

1942. "Leon Kroll; An Interview," *American Artist*, VI (May 1942), 4-11.

Watson, E. W., *Color and Method in Painting as Seen in the Work of 12 American Painters.* New York, Watson-Guptill Publications, Inc., 1942, 85-95.

1946. *Leon Kroll.* New York, American Artists Group, 1946.

WALT KUHN

1923. Matthias, B., "Walt Kuhn," *Prairie*, I (Mar.-Apr. 1923), 37-38.

1928. *Exhibition of Drawings by Walt Kuhn*, introduction by A. Burroughs. New York, M. Knoedler and Co., 1928.

1930. *Exhibition of Paintings by Walt Kuhn*, introduction by A. Burroughs. New York, Marie Harriman Gallery, 1930.

1931. *Landscape Drawings by Walt Kuhn*, introduction by G. Taggard. New York, Marie Harriman Gallery, 1931.

Strawn, A., "Walt Kuhn," *Outlook and Independent*, CLVII (Mar. 4, 1931), 350.

1932. Freund, F. E. W., "Walt Kuhn," *Creative Art*, X (May 1932), 347-349.

1933. College Art Association, *Index of Twentieth Century Artists.* New York, College Art Association, 1933-1937, IV, no. 2, 345-348.

1938. Kuhn, W., *The Story of the Armory Show.* New York (c. 1938).

1940. Bird, P., *Fifty Paintings by Walt Kuhn.* New York, London, Studio Publications, Inc. (c. 1940).

1941. "Walt Kuhn's Philosophy," *Newsweek*, XVII (Apr. 14, 1941), 78.

1943. Frost, R., "Clowns in a Great Tradition," *Art News*, XLII (May 1, 1943), 11.

Hanna, M., "Nude no. 3000," *Collier's*, CXI (May 8, 1943), 26-27.

1949. Adams, P. R., "Walt Kuhn," *College Art Journal*, IX (Autumn 1949), 37-38.

YASUO KUNIYOSHI

1922. Murrell, W., *Yasuo Kuniyoshi*. Woodstock, N.Y., William M. Fisher, 1922, *Younger American Artists Series*, no. 4.

1924. Brook, A., "Yasuo Kuniyoshi," *Arts*, V (Jan. 1924), 24-27.

1932. Brace, E., "Yasuo Kuniyoshi," *Creative Art*, XI (Nov. 1932), 184-188.

1933. College Art Association, *Index of Twentieth Century Artists*. New York, College Art Association, 1933-1937, I, no. 7, 110-112, no. 12, II; II, no. 12, IV; III, no. 11-12, VI.

1940. Kuniyoshi, Y., "East to West," *Magazine of Art*, XXXIII (Feb. 1940), 72-83.

1945. *Yasuo Kuniyoshi*. New York, American Artists Group, 1945.

1948. Louchheim, A. B., "Kuniyoshi: Look My Past," *Art News*, XLVII (Apr. 1948), 46-48ff.

Whitney Museum of American Art, New York, *Yasuo Kuniyoshi Retrospective Exhibition, Mar. 27 to May 9, 1948*. New York, Whitney Museum of American Art, 1948.

ERNEST LAWSON

1916. du Bois, G. P., "Ernest Lawson, Optimist," *Arts and Decoration*, VI (Sept. 1916), 505-507.

Gallatin, A. E., "Ernest Lawson," *International Studio*, LIX (July 1916), xiii-xv.

Gallatin, A. E., *Certain Contemporaries*. New York, London, J. Lane Co., 1916, 13-19.

1919. "Jerome Meyers, Ernest Lawson," *Arts and Decoration*, X (Mar. 1919), 257-259.

Sherman, F. F., "The Landscape of Ernest Lawson," *Art in America*, VIII (Dec. 1919), 32-39.

"Sketch," *Arts and Decoration*, X (Mar. 1919), 257-258.

1921. Rihani, A., "Landscape Painting in America: Ernest Lawson," *International Studio*, LXXII (Feb. 1921), cxiv-cxvii.

1922. Ely, C. B., "The Modern Tendency in Lawson, Lever, and Glackens," *Art in America*, X (Dec. 1921), 31-37.

1924. Price, F. N., "Lawson of the 'Crushed Jewels,'" *International Studio*, LXXVIII (Feb. 1924), 366-370.

1931. Strawn, A., "Ernest Lawson," *Outlook*, CLVII (Apr. 22, 1931), 573.

1932. du Bois, G. P., *Ernest Lawson*. New York, Whitney Museum of American Art (c. 1932), *American Artists Series*.

LOUIS LOZOWICK

1923. Reimann, B., "Louis Lozowick," *Jahrbuch der jungen Kunst*, n.v. (1923), 312-315.

1924. Garfield, J., "Louis Lozowick," *Das Zelt*, I (1924), 330-331.

1926. Wolf, R., "Louis Lozowick," *Nation*, CXXII (Feb. 17, 1926), 186.

1927. Gaer, Y., "Louis Lozowick," *B'nai B'rith Magazine*, XLI (June 1927), 378-379.

1928. Gosudarstvennyi Muzei Novogo Zapadnogo Iskusstva, Moscow, *Exhibition of Drawings by Louis Lozowick* (Rus.). Moscow, 1928.

1933. College Art Association, *Index of Twentieth Century Artists*. New York, College Art Association, 1933-1937, III, no. 7, 275-277; no. 11-12, iii-iv.

1934. Potamkin, H. A., "Louis Lozowick," *Young Israel*, XXVI (Jan. 1934), 3-4.

1936. Cary, E. L., "Reflections on Modern Prints," *Parnassus*, VIII (Apr. 1936), 14.

GEORGE B. LUKS

1900. Armstrong, R., "The New Leaders in American Illustration, Part IV, The Typists: McCarter, Yohn, Glackens, Shinn, and Luks," *Bookman*, XI (May 1900), 250-251.

1907. Spargo, J., "George Luks: An American Painter of Great Originality and Force, Whose Art Relates to All the Experiences and Interests of Life," *Craftsman*, XII (Sept. 1907), 599-607.

1911. Baury, L., "The Message of Proletaire," *Bookman*, XXXIV (Dec. 1911), 400-404.

1914. McCormick, W. B., "George Luks, Agitator," *Arts and Decoration*, IV (July 1914), 335-337, 358.

1915. Cournos, J., "Three Painters of the New York School," *International Studio*, LVI (Oct. 1915), 241-242.

"Who's Who in American Art—George Luks," *Arts and Decoration*, V (Mar. 1915), 189.

1916. Mather, F. J., Jr., "Some American Realists,"

Arts and Decoration, VII (Nov. 1916), 13-16.

1920. Huneker, J., *Bedouins*. New York, Charles Scribner's Sons, 1920, 106-117.

Rihani, A., "Luks and Bellows: American Painting, Part III," *International Studio*, LXXI (Aug. 1920), xxi-xxvii.

Roberts, M. F., " 'Painting Real People' Is the Purpose of George Luks' Art," *Touchstone*, VIII (Oct. 1920), 32-38.

1923. Cary, E. L., "George Luks," *American Magazine of Art*, XIV (Feb. 1923), 74-80.

du Bois, G. P., "George Luks and Flamboyance," *Arts*, III (Feb. 1923), 107-118.

1931. Cary, E. L., *George Luks*. New York, Whitney Museum of American Art, 1931, *American Artists Series*.

du Bois, G. P., *George B. Luks*. New York, Arts Publishing Corp., 1931, *Arts Portfolio Series*.

du Bois, G. P., "Exhibitions—George B. Luks," *Arts*, XVII (Feb. 1931), 345-349.

1933. College Art Association, *Index of Twentieth Century Artists*. New York, College Art Association, 1933-1937, I, no. 7, 97-104, no. 12, i; II, no. 12, iii; III, no. 11-12, v.

1934. Newark Museum Association, Newark, N.J., *Catalog of an Exhibition of the Work of George Benjamin Luks, Oct. 30, 1933 to Jan. 6, 1934*. Newark, N.J., Newark Museum, 1933.

1950. *Paintings, Watercolors and Drawings by George B. Luks: Public Auction Sale Apr. 5 at 8 P. M.* New York, Parke-Bernet Galleries, Inc., 1950.

STANTON MACDONALD-WRIGHT

1915. Wright, W. H., *Modern Painting*. New York, J. Lane Co.; London, J. Lane, 1915, 277-304.

Wright, W. H., "Synchromism," *International Studio*, LVI (Oct. 1915), xcvii-c.

1921. "Modern Art and isms," *Mentor*, IX (Oct. 1921), 32-33.

JOHN MARIN

1909. Caffin, C. H., "Maurers and Marins at the Photo Secession Gallery," *Camera Work*, no. 27 (July 1909), 41.

1910. Mac Coll, W. D., "Exhibition of Water Colors, Pastels and Etchings of John Marin," *Camera Work*, no. 30 (Apr. 1910), 41-47.

1912. Laurvik, J. N., "The Water Colors of John Marin," *Camera Work*, no. 39 (July 1912), 36-38.

1913. "Notes on '291'—Water Colors by John Marin," *Camera Work*, no. 42-43 (Apr.-July 1913), 18.

1921. Hartley, M., *Adventures in the Arts*. New York, Boni and Liveright, 1921, 96-101.

Hind, C. L., *Art and I*. New York, John Lane Co.; London, John Lane, The Bodley Head, 1921, 175-179.

Seligmann, H. J., "American Water Colors in Brooklyn," *International Studio*, LXXIV (Dec. 1921), clix-clx.

1922. Gallatin, A. E., *American Water-Colorists*. New York, E. P. Dutton and Co., 1922, 17-22.

Haskell, E., "John Marin," *Arts*, II (Jan. 1922), 201-202.

Rosenfeld, P., "The Water-Colours of John Marin," *Vanity Fair*, XVIII (Apr. 1922), 48ff.

Strand, P., "John Marin," *Art Review*, I (Jan. 22, 1922), 22-23.

1924. Barker, V., "The Water Colors of John Marin," *Arts*, V (Feb. 1924), 65-83.

Craven, T., "John Marin," *Nation*, CVIII (Mar. 19, 1924), 321.

Eglington, G., "John Marin, Colorist and Painter of Sea Moods," *Arts and Decoration*, XXI (Aug. 1924), 31-34, 65.

Rosenfeld, P., *Port of New York*. New York, Harcourt, Brace and Co. (c. 1924), 153-166.

1926. Mumford, L., "Brancusi and Marin," *New Republic*, XLIX (Dec. 15, 1926), 112-113.

Phillips, D., *A Collection in the Making*. New York, E. Weyhe; Washington, D.C., Phillips Memorial Art Gallery, 1926, 59.

1927. Frank, W., "The American Art of John Marin," *McCall's Magazine*, LIV (June 1927), 27, 61-62.

Mather, F. J., Jr., *The American Spirit in Art*. New Haven, Conn., Yale University Press, 1927, *Pageant of America*, XII, 164, 267ff.

1928. "John Marin, by Himself," *Creative Art*, III (Oct. 1928), xxxv-xxxix.

Kalonyme, L., "John Marin, Promethean," *Creative Art*, III (Oct. 1928), xl-xli.

Meier-Graefe, J., "A Few Conclusions on American Art," *Vanity Fair*, XXXI (Nov. 1928), 83ff.

Strand, P., "Marin not an Escapist," *New*

Republic, LV (July 25, 1928), 254-255.

1929. Barker, V., "John Marin," *Art and Understanding*, I (Nov. 1929), 106-109.

McBride, H., "Modern Art," *Dial*, LXXXVI (Feb. 1929), 174-175.

1930. Goodrich, L., "November Exhibitions: Marin," *Arts*, XVII (Nov. 1930), 120-121.

Kootz, S. M., *Modern American Painters*. New York, Brewer and Warren, 1930, 45-47.

Rosenfeld, P., "Marin Show," *New Republic*, LXII (Feb. 26, 1930), 48-50.

1931. Seligmann, H. J. (editor), *Letters of John Marin*. New York, privately printed for An American Place, 1931.

1932. Rosenfeld, P., "Essay on Marin," *Nation*, CXXXIV (Jan. 27, 1932), 122-124.

1933. College Art Association, *Index of Twentieth Century Artists*. New York, College Art Association, 1933-1937, I, no. 1, 12-16, no. 12, iii; II, no. 12, iv; III, no. 11-12, vi-vii.

1934. Benson, E. M., "The American Scene," *American Magazine of Art*, XXVII (Feb. 1934), 57-58.

1935. Benson, E. M., *John Marin: The Man and His Work*. Washington, D. C., American Federation of Arts, 1935.

1936. Flint, R., *John Marin*. New York, Raymond and Raymond, 1936, *American Art Portfolios*.

Museum of Modern Art, New York, *John Marin; Watercolors, Oil Paintings, Etchings*. New York, Museum of Modern Art (c. 1936).

1937. Rosenfeld, P., "John Marin's Career," *New Republic*, XC (Apr. 14, 1947), 289-292.

1939. Marin, J., "A Few Notes," *Twice a Year*, II (Spring-Summer 1939), 176-180.

Marin, J., "Some Unpublished Letters," *Twice a Year*, II (Spring-Summer 1939), 181-199.

1942. Josephson, M., "Leprechaun on the Palisades," *New Yorker*, XVIII (Mar. 14, 1942), 26-35.

1945. Goodrich, L., *American Watercolor and Winslow Homer*. Minneapolis, The Walker Art Center (c. 1945), 57-67.

Mellquist, J., "John Marin: Painter from the Palisades," *Tricolor*, III (May 1945), 58-64.

1947. Institute of Modern Art, Boston, *John Marin: A Retrospective Exhibition: 1947*. Boston, Institute of Modern Art, 1947.

1948. Helm, M., *John Marin*. Boston, Pellegrini and Cudahy in association with the Institute of

Contemporary Art, 1948.

"John Marin: From: Writings," *Art and Action* (10th Anniversary Issue of *Twice a Year*), (1948), 307-322.

Soby, J. T., *Contemporary Painters*. New York, Museum of Modern Art, 1948, 16-21.

1949. Mellquist, J., "John Marin: Painter of Specimen Days," *American Artist*, XIII (Sept. 1949), 56-59, 67-69.

Norman, D. (editor), *The Selected Writings of John Marin*. New York, Pellegrini and Cudahy, 1949.

1950. *John Marin: Drawings and Water Colors*. New York, The Twin Editions, 1950.

REGINALD MARSH

1923. Burroughs, A., "Young America—Reginald Marsh," *Arts*, III (Feb. 1923), 138-139.

1931. Burroughs, A., "Reginald Marsh," *Creative Art*, IX (Oct. 1931), 301-305.

1933. Blossom, F. A., "Reginald Marsh as a Painter," *Creative Art*, XII (Apr. 1933), 257-265.

College Art Association, *Index of Twentieth Century Artists*, New York, College Art Association, 1933-1937, III, no. 2, 193-195; no. 11-12, ii.

1935. Watson, F., "Reginald Marsh," *American Magazine of Art*, XXVIII (Jan. 1935), 62.

1944. Marsh, R., "Let's Get Back to Painting," *Magazine of Art*, XXXVII (Dec. 1944), 293-296.

1945. Goodrich, L., *American Watercolor and Winslow Homer*. Minneapolis, The Walker Art Center (c. 1945), 95-103.

ALFRED H. MAURER

1934. Godsoe, R. U., *Memorial Exhibition; Works of the Late Alfred Maurer; Oils and Gouaches Covering Work of Thirty-five Years*. New York, Uptown Gallery, Continental Club, 1934.

1943. McCausland, E., *Alfred H. Maurer, 1868-1932*. New York, Buchholz Gallery: Curt Valentin (c. 1943).

1949. McCausland, E., *A. H. Maurer 1868-1932*. Minneapolis, Walker Art Center, 1949.

1951. McCausland, E., *A. H. Maurer*. New York, A. A. Wyn, 1951.

HENRY L. McFEE

1923. Brook, A., "Henry Lee McFee," *Arts*, IV (Nov. 1923), 251-261.

1929. Cary, E. L., "Henry Lee McFee," *Creative Art*, IV (Mar. 1929), xxxiii.

McFee, H. L., "My Painting and Its Development," *Creative Art*, IV (Mar. 1929), 29-31.

1931. Barker, V., *Henry Lee McFee*. New York, Whitney Museum of American Art, 1931, *American Artist Series*.

1933. College Art Association, *Index of Twentieth Century Artists*. New York, College Art Association, 1933-1937, II, no. 3, 41-44, no. 12, ii; III, no. 11-12, vi.

1934. Brace, E., "Henry Lee McFee," *American Magazine of Art*, XXVII (July 1934), 375-382.

1950. *Henry Lee McFee: Twenty-eight Reproductions of Paintings*. Claremont, Cal., Fine Arts Foundation of Scripps College, 1950.

KENNETH H. MILLER

1921. Garret, G., "The Painting of Kenneth Hayes Miller," *New Republic*, XXVII (July 27, 1921), 244-245.

1923. Cahill, E., "Kenneth Hayes Miller," *Shadowland*, VIII (Apr. 1923), 11, 71.

1924. Rosenfeld, P., *Port of New York*. New York, Harcourt, Brace and Co., 1924, 135-152.

1928. Burroughs, A., "Kenneth Hayes Miller," *Arts*, XIV (Dec. 1928), 300-307.

1930. Goodrich, L., *Kenneth Hayes Miller*. New York, Arts Publishing Corp., 1930.

Gutman, W., "Kenneth Hayes Miller," *Art in America*, XVIII (Feb. 1930), 86-92.

1931. Burroughs, A., *Kenneth Hayes Miller*. New York, Whitney Museum of American Art, 1931, *American Artists Series*.

1933. College Art Association, *Index of Twentieth Century Artists*. New York, College Art Association, 1933-1937, III, no. 2, 197-200; no. 11-12, iii.

1952. Bishop, I., and R. Marsh, "Kenneth Hayes Miller," *Magazine of Art*, XLV (Apr. 1952), 168-171.

JEROME MYERS

1914. du Bois, G. P., "Jerome Myers," *Art and Progress*, V (Jan. 1914), 89-94.

1915. "Jerome Myers, as an Etcher and a Student of Human Nature," *Craftsman*, XXIX (Oct. 1915), 25-32.

1916. Morris, L. R., "The Gospel of Jerome Myers," *International Studio*, LVII (Feb. 1916), cxxv-cxxviii.

1917. Phillips, D., "Jerome Myers," *American Magazine of Art*, VIII (Oct. 1917), 481-485.

1919. "Jerome Myers; Ernest Lawson," *Arts and Decoration*, X (Mar. 1919), 257-259.

Roberts, M. F., "Summertime in New York Shown in Etchings by Jerome Myers," *Touchstone*, V (Aug. 1919), 396-399.

1928. *Exhibition of Portrait Drawings by Jerome Myers, Apr. 9-21, 1928*. New York, Babcock Galleries, 1928.

1940. Myers, J., *Artist in Manhattan*. New York, American Artists Group, Inc. (c. 1940).

1941. Whitney Museum of American Art, New York, *Jerome Myers Memorial Exhibition, Apr. 22 to May 29, 1941*. New York, Plantin Press, 1941.

1942. Virginia Museum of Fine Arts, Richmond, *A Memorial Exhibition of the Work of Jerome Myers, Virginia-born Master, Jan. 26-Feb. 27, 1942*. Richmond, Virginia Museum of Fine Arts, 1942.

GEORGIA O'KEEFFE

1917. Murrell, W., "The Georgia O'Keeffe Drawings and Paintings at '291,'" *Camera Work*, no. 49-50 (June 1917), 5.

1921. Hartley, M., *Adventures in the Arts*. New York, Boni and Liveright, 1921, 116-119.

1922. Rosenfeld, P., "The Paintings of Georgia O'Keeffe," *Vanity Fair*, XIX (Oct. 1922), 56, 112.

1924. Rosenfeld, P., *Port of New York*. New York, Harcourt, Brace and Co., 1924, 199-210.

1926. Frank, W. D., *Time Exposures*. New York, Boni and Liveright, 1926, 31-35.

1927. Mumford, L., "O'Keeffe and Matisse," *New Republic*, L (Mar. 2, 1927), 41-42.

O'Brien, F., "Americans We Like," *Nation*, CXXV (Oct. 12, 1927), 361-362.

1928. Kalonyme, L., "Georgia O'Keeffe; A Woman in Painting," *Creative Art*, II (Jan. 1928), xxv-xl.

1931. Luhan, M. D., "Georgia O'Keeffe in Taos," *Creative Art*, VIII (June 1931), 407-410.

"Paintings of Georgia O'Keeffe in Taos," *Atelier*, I (June 1931), 438-440.

Rosenfeld, P., "After the O'Keeffe Show," *Nation*, CXXXII (Apr. 8, 1931), 388-389.

1933. College Art Association, *Index of Twentieth Century Artists*. New York, College Art Association, 1933-1937, III, no. 4, 225-228;

no. 11-12, ii.

1939. *A Portfolio of Paintings by Georgia O'Keeffe*. New York, Dial Press (c. 1939).

1943. Rich, D. C., *Georgia O'Keeffe*. Chicago, Art Institute of Chicago, 1943.

1944. Rich, D. C., "The New O'Keeffes," *Magazine of Art*, xxxvii (Mar. 1944), 110-111.

1950. Pollitzer, A., " 'That's Georgia,' " *Saturday Review of Literature*, xxxiii (Nov. 1950), 41-43.

JULES PASCIN

1911. Holitscher, A., "Julius Pascin," *Kunst und Künstler*, ix (1911), 290-294.

1914. Scheffler, K., "Julius Pascin," *Kunst und Künstler*, xii (1914), 585-589.

1919. Birnbaum, M., *Introductions: Painters, Sculptors, and Graphic Artists*. New York, F. F. Sherman, 1919.

19—. *Ein Sommer: Skizzenbuch von Pascin*. Berlin, Bruno Cassirer (c. 1920).

1920. Scheffler, K., "Ein Sommer: Ein Skizzenbuch von Julius Pascin," *Kunst und Künstler*, xix (Dec. 1920), 104-107.

1922. George, W., "Pascin," *L'Amour de l'Art*, iii (June 1922), 176-178.

1925. Fels, F., *Propos d'Artistes*. Paris, La Renaissance du Livre, 1925, 131-136.

1926. Warnod, A., "Pascin," *L'Art Aujourd'hui*, iii (Summer 1926), 17-20.

1928. Charensol, G., *Jules Pascin*. Paris, Éditions "Le Triangle," 1928, *Les Artistes Juifs*.

1929. Goll, I., *Pascin*. Paris, Les Éditions G. Cres et Cie. (c. 1929), *Les Artistes Nouveaux*.

1930. Lievre, P., "Pascin," *L'Amour de l'Art*, xi (Apr. 1930), 177-181.

MacOrlan, P., "Pascin," *L'Art Vivant*, xvi (July 1, 1930), 513-514.

1931. Morand, P. (preface), *Pascin*. Paris, Éditions des Chroniques du Jour (c. 1931).

1934. Guenne, J., "Pascin," *L'Art Vivant*, clxxxi (Feb. 1934), 62-63.

1944. Seoane, L., *Jules Pascin*. Buenos Aires, Editorial Poseidon, 1944.

1946. Brodsky, H., *Pascin*. London, Nicholson and Watson, 1946.

MAURICE B. PRENDERGAST

1924. Phillips, D., "Maurice Prendergast," *Arts*, v (Mar. 1924), 125-131.

1926. Milliken, W. M., "Maurice Prendergast, American Artist," *Arts*, ix (Apr. 1926), 181-192.

1931. Breuning, M., *Maurice Prendergast*. New York, Whitney Museum of American Art, 1931, *American Artists Series*.

1933. College Art Association, *Index of Twentieth Century Artists*. New York, College Art Association, 1933-1937, ii, no. 6, 93-96, no. 12, i; iii, no. 11-12, iii.

1934. Whitney Museum of American Art, New York, *Maurice Prendergast Memorial Exhibition, Feb. 21 to Mar. 22, 1934*. New York, Whitney Museum of American Art, 1934.

1938. Phillips Academy, Andover, Mass., Addison Gallery of American Art, *The Prendergasts; Retrospective Exhibition of the Work of Maurice and Charles Prendergast*. Andover, Mass., Addison Gallery of American Art, Phillips Academy, 1938.

1945. Goodrich, L., *American Watercolor and Winslow Homer*. Minneapolis, The Walker Art Center (c. 1945), 51-55.

1946. Basso, H., "Glimpse of Heaven," *New Yorker*, xxii (July 27, 1946), 24-30; (Aug. 3, 1946), 28-37.

MAN RAY

1921. Hind, C. L., *Art and I*. New York, John Lane Co.; London, John Lane, The Bodley Head, 1921, 180-185.

1924. Ribemont-Dessaignes, G., *Man Ray*. Paris, Librairie Gallimard, 1924, *Peintres Nouveaux*, no. 37.

1925. Ribemont-Dessaignes, G., "Man Ray," *Les Feuilles Libres*, no. 40 (May-June 1925), 267-269.

1926. Ray, M., *Revolving Doors 1916-1917*. Paris, Éditions Surréalistes, 1926.

1929. Desnos, R., "The Work of Man Ray," *transition*, no. 15 (Feb. 1929), 264-266.

1934. *Photographs by Man Ray: Paris 1920-1934*. Hartford, Conn., James Thrall Soby (c. 1934).

1948. Ray, M., *To be continued unnoticed: Some papers by Man Ray in connection with his exposition, December 1948*. Beverly Hills, Copley Galleries, 1948.

1951. Motherwell, R. (editor), *The Dada Painters and Poets: An Anthology*. New York, Wittenborn, Schultz, Inc., 1951.

1953. Wechser, P., "Man Ray as Painter," *Magazine of Art*, xlvi (Jan. 1953), 31-37.

BOARDMAN ROBINSON

1915. Robinson, B., *Cartoons on the War*. New York, E. P. Dutton and Co., 1915.
1916. Gallatin, A. E., *Certain Contemporaries*. New York, J. Lane Co., 1916, 61-63.
1919. "Design in Cartoons: An Interview with Boardman Robinson," *Touchstone*, VI (Oct. 1919), 78.
1920. "Boardman Robinson, Artist and Student of Humanity," *Touchstone*, VI (Jan. 1920), 207-211.
1930. Goodrich, L., "Mural Paintings of Boardman Robinson," *Arts*, XVI (Feb. 1930), 390-393, 438.
1932. Metzer, C. H., "An Appreciation of Vigor and Imagination in Art," *Arts and Decoration*, XV (Aug. 1932), 228-229.
1933. College Art Association, *Index of Twentieth Century Artists*. New York, College Art Association, 1933-1937, II, no. 7, 106-108, no. 12, iii; III, no. 11-12, viii.
1937. Biddle, G., *Boardman Robinson: Ninety-three Drawings*. Colorado Springs, Col., Colorado Springs Fine Arts Center (c. 1937).
1946. Christ-Janer, A., *Boardman Robinson*. Chicago, University of Chicago Press, 1946.

MORGAN RUSSELL

1915. Wright, W. H., *Modern Painting*. New York, John Lane Co.; London, J. Lane, 1915, 277-304.
 Wright, W. H., "Synchromism," *International Studio*, LVI (Oct. 1915), xcvii-c.
1921. Wright, W. H., "Modern Art and isms," *Mentor*, IX (Oct. 1921), 32-33.

MORTON SCHAMBERG

1919. Pach, W., "The Schamberg Exhibition," *Dial*, LXVI (May 17, 1919), 505-506.

CHARLES SHEELER

1923. Craven, T., "Charles Sheeler," *Shadowland*, VIII (Mar. 1923), 11, 71.
 Watson, F., "Charles Sheeler," *Arts*, III (May 1923), 335-344.
1926. "An American in the Classic Tradition," *Literary Digest*, LXXXIX (June 26, 1926), 24-25.
 Parker, R. A., "The Classical Vision of Charles Sheeler," *International Studio*, LXXXIV (May 1926), 68-72.
1932. Brace, E., "Charles Sheeler," *Creative Art*, XI (Oct. 1932), 97-104.

1933. College Art Association, *Index of Twentieth Century Artists*. New York, College Art Association, 1933-1937, III, no. 4, 229-231; no. 11-12, ii.
1938. Rourke, C., *Charles Sheeler, Artist in the American Tradition*. New York, Harcourt, Brace and Co. (c. 1938).
1939. Museum of Modern Art, New York, *Charles Sheeler: Paintings, Drawings, Photographs*. New York, Museum of Modern Art, 1939.

EVERETT SHINN

1906. G(allatin), A. E., "Everett Shinn's Decorative Paintings," *Scrip*, I (Aug. 1906), 358-360.
 Gallatin, A. E., "Studio-Talk: Everett L. Shinn," *International Studio*, XXX (Nov. 1906), 84-87.
1907. Gallatin, A. E., *Whistler: Notes and Footnotes*. New York, Collector and Art Critic Co.; London, E. Mathews, 1907, 79-83.
1912. "Everett Shinn's Paintings of Labor in the New City Hall at Trenton, N.J.," *Craftsman*, XXI (Jan. 1912), 378-385.
1913. Gallatin, A. E., *Whistler's Pastels, and Other Modern Profiles*. New York, J. Lane Co.; London, J. Lane, 1913, 59-63.
1914. Price, C. M., "A Revival of Eighteenth Century French Art," *International Studio*, LI (Jan. 1914), clxviii-clxx.
1915. du Bois, G. P., "An Eighteenth Century Revival; The Work of Everett Shinn, Revivalist," *Arts and Decoration*, VI (Dec. 1915), 77-80.
1916. Wilhelm, D., "Everett Shinn, Versatilist," *Independent*, LXXXVIII (Dec. 4, 1916), 398.
1923. Frohman, L. H., "Everett Shinn, the Versatile," *International Studio*, LXXVIII (Oct. 1923), 85-89.
1924. Edgerton, G., "Modern Murals Done in French Spirit of Decoration," *Arts and Decoration*, XXII (Nov. 1924), 27-29.
1945. Kent, N., "The Versatile Art of Everett Shinn," *American Artist*, IX (Oct. 1945), 8-13, 35-37.

JOHN SLOAN

1897. *Posters in Miniature*, foreword by P. Pollard, introduction by E. Penfield. New York, R. H. Russell; London, J. Lane, 1897.
1909. Barrell, C. W., "The Real Drama of the Slums, as Told in John Sloan's Etchings," *Craftsman*, XV (Feb. 1909), 559-564.

1914. Pach, W., "L'Art de John Sloan," *L'Art et les Artistes*, xviii (Feb. 1914), 222-226.

1915. McCormick, W. B., "The Realism of John Sloan," *Arts and Decoration*, v (Aug. 1915), 390-391.

1916. Gallatin, A. E., *Certain Contemporaries*. New York, J. Lane Co., 1916, 23-30.

Gallatin, A. E., "The Etchings, Lithographs, and Drawings of John Sloan," *International Studio*, lvii (Mar. 1916), xxv-xxviii.

"Who's Who in American Art—John Sloan," *Arts and Decoration*, vi (Mar. 1916), 237.

1917. Yeats, J. B., "John Sloan's Exhibition," *Seven Arts*, ii (June 1917), 257-259.

1925. Gallatin, A. E., *John Sloan*. New York, E. P. Dutton and Co., 1925.

1926. Pach, W., "The Etchings of John Sloan," *Studio*, xcii (Aug. 1926), 102-105.

1927. Hopper, E., "John Sloan and the Philadelphians," *Arts*, xi (Apr. 1927), 169-178.

Sloan, J., "The Independent, an Open Door," *Arts*, xi (Apr. 1927), 187-188.

1929. Weitenkampf, F., "John Sloan in the Print Room," *American Magazine of Art*, xx (Oct. 1929), 554-559.

1931. du Bois, G. P., *John Sloan*. New York, Whitney Museum of American Art, 1931, *American Artists Series*.

1933. College Art Association, *Index of Twentieth Century Artists*. New York, College Art Association, 1933-1937, i, no. 11, 167-174, no. 12, i-ii; ii, no. 12, iii; iii, no. 11-12, v-vi.

1938. Phillips Academy, Andover, Mass., Addison Gallery of American Art, *John Sloan; Retrospective Exhibition, 1938*. Andover, Mass., The Andover Press, Ltd. (c. 1938).

1939. Sloan, J., *Gist of Art; Principles and Practice Expounded in the Classroom and Studio*, recorded with the assistance of H. Farr. New York, American Artists Group (c. 1939).

1945. *John Sloan*. New York, American Artists Group, 1945.

1949. Coates, R. M., "After Enough Years Have Passed," *New Yorker*, xxv (May 7, 1949), 36-51.

1950. Bohrod, A., "On John Sloan," *College Art Journal*, x (Autumn 1950), 3-9.

1952. Brown, M. W., "The Two John Sloans," *Art News*, l (Jan. 1952), 25-27, 56-57.

Goodrich, L., *John Sloan*. New York, Macmillan Co., 1952.

Watson, F., "John Sloan," *Magazine of Art*, xlv (Feb. 1952), 62-70.

Whitney Museum of American Art, New York, *John Sloan 1871-1951, Jan. 10-Mar. 2*. New York, Whitney Museum of American Art, 1952.

MOSES SOYER

1939. Soyer, M., "Three Brothers," *Magazine of Art*, xxxii (Apr. 1939), 201-207.

1944. Smith, B., *Moses Soyer*. New York, A.C.A. Gallery Publication, 1944.

RAPHAEL SOYER

1930. Gutman, W., "Raphael Soyer," *Creative Art*, vi (Apr. 1930), 258-260.

1934. Beer, R., "Soyer at Thirty-four," *Art News*, xxxii (Jan. 13, 1934), 13.

1939. Soyer, M., "Three Brothers," *Magazine of Art*, xxxii (Apr. 1939), 201-207.

1946. *Raphael Soyer*. New York, American Artists Group, 1946.

1948. Watson, E. W., "The Paintings of Raphael Soyer," *American Artist*, xii (June 1948), 28-33, 64.

EUGENE SPEICHER

1912. Watson, F., "Eugene Speicher: A New Arrival," *International Studio*, xlvi (Mar. 1912), xix-xxii.

1924. Barker, V., "Eugene Speicher: Painter and Artist," *Arts*, vi (Dec. 1924), 314-327.

1930. Narodny, I., *American Artists*. New York, Roerich Museum Press, 1930, 99-110.

Palmer, M., *Eugene Speicher*. New York, Arts Publishing Corp., 1930, *Arts Portfolio Series*.

1931. Mather, F. J., Jr., *Eugene Speicher*. New York, Whitney Museum of American Art, 1931, *American Artists Series*.

1933. College Art Association, *Index of Twentieth Century Artists*. New York, College Art Association, 1933-1937, i, no. 3, 37-42, no. 12, i; ii, no. 12, iv; iii, no. 11-12, vi.

1942. Watson, E. W., *Color and Method in Painting as Seen in the Work •of 12 American Painters*. New York, Watson-Guptill Publications, Inc., 1942, 13-23.

1945. *Eugene Speicher*. New York, American Artists Group, 1945.

1950. Buffalo Fine Arts Academy, Buffalo, *Eugene*

Speicher: A Retrospective Exhibition of Oils and Drawings: 1908-1949: Sept. 29-Oct. 26, 1950. Buffalo, Buffalo Fine Arts Academy, Albright Art Gallery, 1950.

NILES SPENCER

1925. Watson, F., "A Note on Niles Spencer," *Arts*, VIII (Sept. 1925), 166-169.
1930. Mannes, M., "Niles Spencer, Painter of Simplicities," *Creative Art*, VII (July 1930), 58-61.
1944. Watson, E. W., "Niles Spencer: Interview," *American Artist*, VIII (Oct. 1944), 14-17.
1952. Cahill, H., "Niles Spencer," *Magazine of Art*, XLV (Nov. 1952), 313-315.

JOSEPH STELLA

1918. "Joseph Stella: Painter of the American Melting Pot," *Current Opinion*, LXIV (June 1918), 423-424.
1921. Field, H. E., "Joseph Stella," *Arts*, II (Oct. 1921), 25-27.
1924. Freund, F. E. W., "Joseph Stella," *Jahrbuch der jungen Kunst*, n.v. (1924), 310-318.
1926. Williams, H. L., "Joseph Stella's Art in Retrospect," *International Studio*, LXXXIV (July 1926), 76-80.
1930. Lancellotti, A., "Un Pittore di Avanguardia: Giuseppe Stella," *Emporium*, LXXI (Feb. 1930), 67-76.
1939. Newark Museum, Newark, N.J., *Joseph Stella: Catalog of Paintings and Drawings in a Retrospective Exhibition, Opened Apr. 22, 1939.* Newark, N.J., Newark Museum, 1939.
1943. *Stella—1943.* New York, A.C.A. Gallery, 1943.
n.d. *New York: Five Oils by Joseph Stella; The Brooklyn Bridge (A Page of My Life),* copyright Joseph Stella, n.d.

MAURICE STERNE

1902. Bixby, A. C., "A Promising Young Painter-Etcher, Maurice H. Sterne," *Brush and Pencil*, X (May 1902), 99-110.
1912. Birnbaum, M., "Maurice Sterne," *International Studio*, XLVI (Mar. 1912), iii-xiii.
1915. "The Monumental Simplicity in the Pictorial Art of Maurice Sterne," *Current Opinion*, LIX (Dec. 1915), 425-427.
1917. Defries, A. D., "Maurice Sterne at Bali," *International Studio*, LXI (Apr. 1917), liii-lvii.
1919. Birnbaum, M., *Introductions.* New York, F. F. Sherman, 1919, 40-50.

1921. Freund, F. E. W., "Amerikanische Künstlerprofil: I. Maurice Sterne," *Jahrbuch der jungen Kunst*, n.v. (1921), 305-309.
1922. *Exhibition of Paintings, Drawings and Sculptures by Maurice Sterne, Apr. 1 to Apr. 22, 1922.* New York, Bourgeois Galleries, 1922.
1925. Stein, L., "Tradition and Art," *Arts*, VII (May 1925), 265-269.
Tavolato, I., *Maurice Sterne.* Rome, Valori Plastici Pub., 1925.
1933. College Art Association, *Index of Twentieth Century Artists.* New York, College Art Association, 1933-1937, I, no. 5, 72-77, no. 12, i-ii; II, no. 12, iii-iv; III, no. 11-12, vi.
Museum of Modern Art, New York, *Maurice Sterne: Retrospective Exhibition (1902-1932). Paintings, Sculpture, Drawings.* New York, Museum of Modern Art, 1933.
1941. "An Hour in the Studio of Maurice Sterne," *American Artist*, V (Dec. 1941), 5-9, 39.

ABRAHAM WALKOWITZ

1913. Bluemner, O., "Walkowitz," *Camera Work*, XLIV (Oct. 1913), 25-38.
1917. Wright, W. H., "Modern Art: Walkowitz, Monet, and Burlin," *International Studio*, LX (Feb. 1917), cxxxii-cxxxiii.
1924. McBride, H., "Walkowitz and the Parks," *International Studio*, LXXX (Nov. 1924), 156-158.
1925. McBride, H., J. Weichsel, C. Vildrac, W. H. Wright, *One Hundred Drawings by A. Walkowitz.* New York, B. W. Huebsch, Inc., 1925.
1944. Brooklyn Institute of Arts and Sciences, *One Hundred Artists and Walkowitz, Brooklyn Museum, Feb. 9 to Mar. 12, 1944.* Brooklyn, N.Y., Brooklyn Museum, 1944.
1945. Walkowitz, A., *A Demonstration of Objective, Abstract, and Non-Objective Art.* Girard, Kan., Haldeman-Julius Publications, 1945.
Walkowitz, A., *Isadora Duncan in her Dances.* Girard, Kan., Haldeman-Julius Publications, 1945.
1947. Walkowitz, A., *Barns and Coal Mines around Girard, Kansas.* Girard, Kan., Haldeman-Julius Publications, 1947.
1948. Walkowitz, A., *Improvisations of New York: A Symphony in Lines.* Girard, Kan., Haldeman-Julius Publications, 1948.
1951. Walkowitz, A., *Art From Life to Life.* Girard, Kan., Haldeman-Julius Publications, 1951.

MAX WEBER

1914. Weber, M., *Cubist Poems*. London, Elkin Mathews, 1914.

1916. Weber, M., *Essays on Art*. New York, W. E. Rudge, 1916.

Wright, W. H., "Aesthetic Struggle in America," *Forum*, LV (Feb. 1916), 216-218.

1921. Bridgman, C., "Modernist," *Touchstone*, VIII (Jan. 1921), 319-322.

1925. Gilliam, F., "Max Weber: Humanist," *Menorah Journal*, XI (Dec. 1925), 580-582.

1926. Weber, M., *Primitives: Poems and Woodcuts*. New York, Spiral Press, 1926.

1930. Cahill, H., *Max Weber*. New York, Downtown Galleries, 1930.

Museum of Modern Art, New York, *Max Weber; Retrospective Exhibition (1907-1930), Mar. 13-Apr. 2*. New York, Museum of Modern Art, 1930.

Strawn, A., "Rebel Triumphant," *Outlook*, CLVI (Oct. 29, 1930), 351.

1933. College Art Association, *Index of Twentieth Century Artists*. New York, College Art Association, 1933-1937, IV, no. 2, 349-352.

1945. *Max Weber*. New York, American Artists Group, 1945.

1948. Johnson, U. E., "The Woodcuts and Lithographs of Max Weber," *Brooklyn Museum Bulletin*, IX (Summer 1948), 7-12.

Soby, J. T., *Contemporary Painters*. New York, Museum of Modern Art, 1948, 28-34.

1949. Cahill, H., "Max Weber, A Reappraisal in Maturity," *Magazine of Art*, XLII (Apr. 1949), 128-133.

Whitney Museum of American Art, New York, *Max Weber: Retrospective Exhibition*. New York, Whitney Museum of American Art, 1949.

1950. Riegner, H., "Der amerikanische Maler Max Weber," *Werk*, XXXVII (Feb. 1950), 55-61.

ART YOUNG

1927. Young, A., *Trees at Night*. New York, Boni and Liveright, 1927.

1928. Young, A., *On My Way: Being the Book of Art Young in Text and Picture*. New York, H. Liveright, 1928.

1939. Beffel, J. N. (editor), *Art Young, His Life and Times*. New York, Sheridan House, 1939.

1944. Beffel, J. N., and others, "Art Young Number," *Direction*, Darien, Conn., VII (Apr.-May 1944), 1-18.

Kent, R., and others, "Art Young, His Life and Times," *New Masses* issue, L (Feb. 1, 1944).